EYE, FILM, AND CAMERA

IN

COLOR PHOTOGRAPHY

NEW YORK • JOHN WILEY & SONS, INC.

London

RALPH M. EVANS

Director, Color Technology Division

Eastman Kodak Company

EYE, FILM, AND CAMERA

IN

COLOR PHOTOGRAPHY

778.6
E v 16

PREFACE

This book is the outcome of many years of thinking and working in the field of color photography and more especially in that phase of the subject which relates to vision. No one can spend thirty years in color photography, as it has been my privilege to do, without being strongly impressed by one fact. What an observer sees when he looks at a scene, can be and usually is very different from what he sees when he looks at an "accurate" color photograph of that scene. The contents of this book are the result of twenty years of continuing investigation into this difference in its various aspects. This has been done both to learn what the differences are and to find out how the photographer may either offset them or make use of them for his particular purposes.

With minor exceptions the material presented here is taken from the many lectures that I have given on this subject. As far as is practical all of the material from all of these lectures is included.

For those familiar with Evans, Hanson, and Brewer's *Principles of Color Photography* this book attempts to give a report on the status of our present knowledge of the "psi function" (pp. 663 ff). This function concerns the visual relationship between the scene and the photograph. The material is presented, however, in terms of the photographer rather than the theory of color photography, and no attempt is made here to deduce quantitative relationships.

v

The fact that nearly all of the material included has been presented before scientific audiences has given me a unique opportunity to discuss the subject with many people. For this reason it is almost impossible to give credit to those who have contributed in one way or another to molding the thoughts that appear here. It is likely that, except perhaps for their application to photography, very few of the thoughts expressed are strictly original. I, however, must assume the responsibility for their interpretation and for the conclusions that are reached with respect to photographers and photography.

It is a real pleasure to acknowledge the direct assistance of those who have helped in the production of this book. Miss Jeannette Klute, who over the years has made all the photographs for my lectures, is again responsible for all the photographs in this book. Incidentally, all of the original photographs are in color and should be so interpreted where possible. Many of them are taken from the lectures and many others have been photographed for this book. Miss Bonnie Kindig is responsible for the diagrams of Chapter 3, assisted by Mrs. Helen Jordan. Mrs. Barbara Erbland has been responsible for the arrangement and preparation of the pictures, and Miss Dorothy Miller has made many of the Dye Transfer Prints from which some of the pictures have been copied. It is a pleasure also to acknowledge the valuable editorial and stenographic assistance of my secretary, Miss Carol Rowden. Dr. Sidney M. Newhall has assisted materially in the selection of the bibliography, particularly in the psychological and related fields and has given much valuable criticism of the text as have also Miss Klute and Miss Kindig. Mr. Warren Rhodes of the Rochester Institute of Technology has given very valuable assistance, which is greatly appreciated.

Ralph M. Evans

Rochester, N. Y.
July, 1959

CONTENTS

vii

C H A P T E R 1

THE NATURE

OF

COLOR PHOTOGRAPHY

Photography is today one of the most powerful known means of communication. It is, above all else, a descriptive medium, one which in a single picture can give certain kinds of description in a way that is wholly beyond the power of words. Ease of description in fact is not only photography's greatest asset; it is also its own worst enemy. Because photographs carry such tremendous conviction, produce such a feeling that one was present when they were made, it is difficult even for the expert to bear in mind that they seldom look much like the things photographed. To show that they do not, why, and what this means to the users of photography are the main purposes of this book. We shall find that this lack of exactness of description, the ease with which the photographer can modify, mold, and aid the description, places photography squarely in the class of art media in general.

It is as difficult to reproduce the exact appearance of an object by photography as it is by painting, and in many situations a painter could do a better job. On the other hand, many of the things attempted by painters could be done much better by photography. That every medium has its proper field of natural expression is as true of photography as it is of painting or etching or music and the drama. The field of photography ranges far and wide, but it neither wholly includes nor excludes the other media. Just as we do not use pastel crayons to produce a line

1

engraving, we do not use photography to produce a water-color sketch. The equivalent of the line engraving can sometimes be produced by photography and the equivalent of the water color sometimes by pastel crayons, and there are subjects suitable for all four media.

These thoughts suggest that the best place to start in trying to understand photography is just this matter of the uses for which it is best suited. All of these cannot become apparent until we have finished our study. But we can take a first grand sweeping look over the whole of the field. Later, we can approach some of the separate areas more closely.

First, let's face it squarely, our medium deals always with **objects**, with **light**, and with **vision**. The words must be interpreted broadly but there must always be radiant energy (light) in some form to produce an affect on the photographic material, something (object) that modifies this energy in either space or time, and something (vision) that reacts to the results in its own characteristic way. These three, along with the photographic material that is used, are the basic building blocks of photography. In actual use, however, each one of these may enter into the sequence of events not once but often several times. In what might be called the "normal" use of photography, light by way of the objects and the lens exposes the film. After further treatment of this exposed film a photograph is produced. This photograph is a new object. Light by way of the photograph enters the eye of the observer where after further treatment by the brain it becomes a perceived image in the observer's mind. A more realistic sequence, then, involves five steps rather than three and may be represented as: light—objects—photograph—light—observer.

From this sequence one of the basic definitions of photography is at once apparent. Photography may be defined as one link in a chain of communication by which changes in radiant energy at one place are made to produce effects at another at any desired time interval after they have occurred. It is not the only medium which will do this. Other examples are the so-called picture recording on magnetic tape for television, the memory devices used in electronic computing equipment and so on.

Several quite important points emerge from this rather abstract definition. First, photography is a time **delay** device with the time between making and using as long as desired up to the life of the material. Second, it is reproducible as often as desired. Third, there is nothing in the nature of the communication chain of itself which says that the effect at the end of the chain will have any **simple** relation to the light changes which produced it. In plain English these say that photography is a

medium that we use when we want to record something to look at later or to produce something that can be looked at whenever we want to, or both. There is nothing in the nature of the operation that requires that what we see will have any simple relation to what was used to produce it. On the other hand there is nothing to prevent us from trying to produce such a result if we want to. Many other facts about photography can be deduced from this definition, but they can be picked up as we go along. We are trying to understand photography, not just to catalog its infinite variations.

If we center our attention on each one of the five steps of our simplified chain from light through to observer and consider how it can be varied, we come upon all of the possible uses of photography. Although this book is restricted largely to images produced from visible objects, all the possibilities, potentially at least, apply to color photography. Color photography is simply three or more separate photographic images whose differences are apparent through color when they are shown superimposed. Anything that will expose a photographic material can be made to expose one record of a color photograph.

There are many basic variables in the production of a photograph. At the risk of being tedious it is well to humble ourselves by considering the list of their combinations and the applications to which they lead. It should teach us how ridiculous it is to try to make any general statements about "photography" at all unless we state pretty clearly what we are not including in our generalization.

We are all familiar with the great number of subjects that could be used for pictures and to a somewhat less extent the many different ways in which photographers work. It is seldom that anyone stops to think about the enormous number of kinds of photography within nearly all of which there is this same infinite variety of subject matter and method of working.

There are some fifteen or twenty basic independent variables in the subject of photography. We schematically noted only five above. Let's list a few of them, without attempting to exhaust the possibilities. A few notes are added by way of explanation.

1. **The area** of the image may vary:
 Very small, pinhead size (micro-photography, secret document transmission)
 Small (8 and 16mm motion picture film, Recordak)
 Medium small (35mm still pictures, small cameras)
 Medium (roll film, small professional sizes)
 Large (commercial films, aerial photography)

Note that size of the image is independent of magnification of the object within optical and photographic limitations. The area may also vary with time (variable area sound-track recording).

2. The position of the area on the film may vary:

Oscillograph recording of all types from very slow to very fast

Perhaps internally ejected particles in nuclear track photography

Astronomical position studies (stellar parallax etc.)

Position comparisons of all kinds

Stereophotography can be included here

3. The magnification may vary with respect to the object:

Great reduction (micro-photography etc.)

Reduction (amateur photography in general)

Same size (much commercial photography, copying)

Medium enlargement (photomicrography)

Great enlargement (electron microscopy)

4. The intensity of the radiation as a whole may vary:

The intensity may vary from the faintest recordable intensities where even on special materials exposures may run to days (astronomy), up through very high intensities (electronic flash, photographs of explosions). In between lie studio light, daylight, flash bulbs and the like.

It may be the variation itself that is to be recorded (variable density sound recording, photographic photometry).

5. The radiation intensity may not be uniform over the area:

This is the normal picture case, but where intensity only is of interest (black-and-white photography). It can be broken down into contrast ranges over which detail must be recorded: very low (aerial photography, some document copying); very high (amateur photography, objects in full sunlight with details in deep shadow); medium (properly lighted everyday photography). Many subjects are of too high contrast to consider, such as the sun directly into the lens.

6. This radiation variation may change with time:

Normal speed (motion picture photography)

Very fast (slow motion photography)

Very slow (time-lapse photography, astronomical photography—variable magnitude stars, novae etc.)

Very, very fast (high-speed photography—explosives etc.)

7. The quality of the radiation may vary as a whole:

This, with items 8 and 9, is the equivalent of items 4, 5, and 6, but the interest here lies in color as distinct from intensity. The field as a whole is only partially developed as yet, but some ex-

amples can be given. Under this heading would come the recording of color as such from the palest tints to the strongest possible colors, the reproduction of spectral colors, and so on. Color photography is not yet ready for most of this.

For photography as a whole there are some ten or twelve kinds of radiant energy to which photographic materials are sensitive. They cover the range from cosmic rays to infrared, each being a specialized field with visible light only one of the group.

8. The quality of the radiation may not be uniform over the area:

This is present day color photography. The field divides along the lines of the subtlety of the color schemes involved: very pale pastel effects, delicate color lighting, normal colors of objects, landscapes etc.; strong color contrasts, bold color effects; and pleasing opposed to accurate reproduction (amateur versus scientific photography).

9. The quality of the radiation may change with time:

Color changes and their rates are significant in many fields but again, through lack of suitably developed processes, photography cannot yet be applied to them. An exception is the "Color Index of Stars in Astronomy" done with filters on black-and-white film and so falling either here or under item 4 above.

10. The time of exposure may vary widely:

This is an essentially independent variable and produces different effects under different conditions. Thus it may be used to produce a blur or to prevent it, etc.

11. The method of making the exposure may vary:

There are many, many ways in which exposures can be made: camera stationary, film moving, continuous exposure, intermittent exposure, synchronous camera and film motion, etc. (aerial slit photography, sound recording, astronomical photography, printing—no camera, etc.).

12. The kind of photographic material may vary:

Obviously all kinds cannot be used for all purposes but they can be selected for graininess, speed, resolution, color rather than black-and-white, contrast, etc., within the limits of overlap.

13. The method of handling the material may vary:

The same photographic material may be made to produce many different kinds of results from the same exposure: speed, contrast, color of a single image, tone reproduction, color reproduction, etc.

14. The method of viewing may vary for the same photograph:

We might list projection in a dark or light room, viewing by reflected light, on light, dark or colored backgrounds, from a short

or long distance, alone or in comparison with other pictures and many other ways.

Let us arbitrarily say that for each of these fourteen variables we will take only four variations; in magnification for instance let us say (1) very great reduction as in microphotography, (2) moderate reduction as in the ordinary camera, (3) considerable enlargement as in enlarging, (4) great magnification as in photomicrography, and so on for all the other thirteen. If it were not for the fact that many combinations lead to essentially the same result, we would come out with over 250 million kinds of photography that are theoretically possible. Even so the number must be very large indeed.

The point in introducing this calculation here is to suggest the caution with which any broad generalizations on "photography" should be made. Photography is not one subject; it is, literally, millions of subjects each having in common the use of a photographic material sensitive to the radiation being used, and capable of forming a relatively permanent image which may be viewed either by the eye or by some special reading device.

Our subject in this book is very largely visible light color photography. Yet in a sense, large as the subject will be found to be, it is a very small part of the broad subject of photography. It is, for example, only one of the kinds of radiant energy. We shall restrict ourselves largely to objects lighted so that they can be seen by the eye, yet photography can give images of millions of stars too faint to be visible. We shall restrict ourselves to objects that are stationary or moving at reasonably slow speeds, thus omitting the whole subject of high-speed photography. Infrared and ultraviolet photography will not be considered nor will X-ray nor nuclear work. Yet it is in these regions that photography for many, many people has its greatest values. It is in these regions that photography can make visible to us things we shall never see directly, in which it truly and literally extends our vision.

It is true, of course, that much that will be discussed here will apply to such photographs, but we must be careful of pat phrases applied to our little branch of the subject and try to search for real causes for the effects we observe. To say, for example, that "the camera sees more truly than the eye" or that photography is an "extension of vision" when we are talking about ordinary photographs is to cover up with a neat phrase the important properties of photography that we should be conscious of and be ready to use. The camera "sees" better if the man is too frightened to look or the object is moving too fast to see, but in these cases it is not vision that is extended but time to look. The camera doesn't "see" nearly

as well as the observer if there is time and light enough to look. It doesn't extend his vision; it restricts it severely except under conditions where he can't see at all. So let us try to get down to the basic things done by means of photography that can be done poorly or not at all by the observer looking directly at the scene.

Photography stops time

Perhaps the most important single property of photography by visual light and often by other forms of radiant energy is its ability to stop the flight of time. It is surprising, in fact, how often this is the main urge behind picture making even though some other immediate reason may be given if the question is raised.

In the most obvious cases, of course, a motion is too fast for careful study even though it may be slow enough to be seen clearly. A swimmer dives from a springboard. He can be seen clearly but there is not time to study his form carefully. A pole vaulter cannot be criticized in enough detail by the coach. And so pictures are made that catch a brief period of time and preserve it for further study.

If the motion is so fast it cannot be seen at all, it still can be studied by speed lamps. If there is not enough light and the phenomenon is re-current, it can be photographed by a synchronized stroboscopic lamp. In all of these and the thousands of other similar possibilities photography is freezing an action in time too brief for desired contemplation.

In more subtle cases, however, this may still be the important fact. Photography stops time permanently for the little segment of experience that it records. Man lives, whether consciously or not, in a perpetual competition with time. Everything that he values changes constantly for better or for worse and often suddenly. The parents with the young child know that he is growing up and may never be as cute again. The owners of a puppy know he will soon be a grown dog. The grown people with aging parents want to remember how they look. The roots of the motives for photography sometimes lie very deep in human nature.

Yet, while the fact that photography stops time for further study may be basic in many cases, it seldom is the only reason that photography is used. It is perhaps no exaggeration to say that there are as many motives for making a picture as there are varieties of photography itself and that the reasons may be just as complex. The picture of the child may be taken basically because of the fear of his changing. It is also taken to send to his grandparents, to use for boasting or conversation with

friends, to enter in a baby contest, and so on. Some of the basic properties on which their uses depend are noted below. Underlying most of them, however, is just this simple fact that by a relatively simple operation some semblance of the aspect of things is frozen for future reference.

Pictures are often made for no other reason than that the act demonstrates the power of the photographer over time, the partial fulfillment of a deeply rooted wish.

The ability of photography to stop time, however, is based on its primary capacity as a descriptive medium. We shall examine this presently but should note here that its combined ability to freeze a moment of time and its ability to describe result in a further fact of some importance. Since different moments may be frozen and then brought together, photography presents the unique opportunity of comparing simultaneously two moments of time which may have been far apart. If matters can be arranged so that the photographer does not influence the comparison, this represents a unique and very important property of photography. Several sciences use this as their principle tool, and in a secondary manner it is used by nearly everyone at one time or another. "This is the way she looked at six years and look at her now!" "View of Main Street 1884."

Photography describes

Photography is essentially analogous to literature and speech and it covers about the same range from the depths of banality of casual greetings to the heights of the best poetry or prose. It cannot, however, be considered as perfectly analogous because its limitations and possibilities are quite different. Descriptive prose, for example, can present broad generalizations, relate the objects to things not present at the time, speak of the effect of the objects on people or civilization. These things photography does only lamely or at least awkwardly. But when it comes to the exact description of complex detail of an existing object, or the exact relationship of its parts, or its location with respect to other objects, or the relationships of many articles to each other, photography can go far beyond the possibilities of verbal description. On the other hand photography has limitations in this respect also and can be exceeded by such forms of technical art as medical and anatomical drawing, which describe structure more accurately than the casual observer can see looking at the real objects. Again many objects, being opaque, have internal peculiarities which cannot be seen at all but can be described by such

processes as engineering drawing. Photography for descriptive purposes, therefore, finds itself somewhere intermediate between the best descriptive prose and technical drawing and limited to appearances essentially as they exist.

This is not a severe limitation. In fact this field in which its powers of description of appearance are greater than those of words, even if somewhat less than other possibilities, is so large that it is considered by many people to be the only "legitimate" use for photography. We shall see that this is a narrow and unnecessary point of view. It is certainly true that the easiest way to get a rough description of an appearance from a particular point of view is to make a picture from that spot. On the other hand, to get an accurate description which will be correctly interpreted may call for as great skill as any other possible means.

We must regard description, then, as one of the main inherent possibilities of photography but not be carried away by it to the extent of forgetting the limitations.

Photography's power of description can be used for many different purposes and in many different ways. Like most applications of photography its descriptive properties may be extended in time sequence as well as used to record a single instant. This leads to such extensions of experience as time lapse photography in which a motion too slow to see, like the growth of a plant, is described at clearly visible rates and motion too fast to see is slowed to within our limited range by high-speed photography.

In both time lapse and high-speed motion picture photography we are dealing with descriptions of events that are **distorted** by photography as far as visual appearance is concerned. They are distorted deliberately so that the description obtained will tell us what we want to know. Many applications of photography use methods which produce a deliberately distorted photograph. As long as we know the distortion, we can "read" the description. Thus an X-ray photograph is in fact a record of a shadow of invisible light passing through semitransparent objects and with the contrast greatly magnified by photography. Such a picture bears little relation to anything in visual experience and has little to do with the appearance of anything and yet it is one of the most important of all uses of photography. Photography by infrared light and by ultraviolet produce descriptions often not obtainable by other means and so on. The important point, however, and it cannot be repeated too many times, is that all photographs of any kind are always distorted relative to reality. Barring the trivial case of a photographic copy of a photograph which might in theory be made exact, all photographs require one

of two things before they give accurate descriptions. Either the observer must understand the distortions and interpret them properly or the photographer must introduce the proper modifications or counter-distortions so that the untrained observer will interpret them correctly. The need for the first was well illustrated by the great effort needed during World War II to train "interpreters" for aero photographs. Such photographs have little or no descriptive value for the layman but are mines of information for those trained to read them correctly. The same is true for X-ray photographs, of course, but aero photographs are reasonably correct descriptions of appearance from the point at which they are taken (aside from possible magnification, of course). In this case nearly everyone is an untrained observer because his normal experience does not include understanding what he can see from the air.

For photographs of ordinary situations and events, particularly by color photography, most people are relatively well trained to interpret what they can see. Roughly correct interpretations can be made by anyone for the majority of such pictures, particularly if the camera was held at eye level pointing directly forward. But it requires very little departure from this convention and very little of the unusual in a picture before the interpretation may become even grossly incorrect. To have such a picture correctly read by the majority of people and to have any picture correctly read in all of its description the photographer must take active steps to offset their errors. It will develop as we proceed that most of these errors are a result of the way our normal processes of seeing apply to an exact two-dimensional projection of the scene onto a photographic material. It is not often due to defects of the photograph as such. Similar errors could occur on viewing the camera image as produced by the lens. They could also occur from the scene itself if looked at with one eye from the position of the camera lens, especially if viewed through an aperture the same size as the picture.

Although it is well at all times to consider the limitations of photography, we want just at this point to go on with our discussion of the things it does the best—the things that make it unique as a medium. One of these certainly is the power it gives the photographer through proper understanding of his medium, to emphasize and call attention to aspects of his subject matter that would ordinarily be overlooked. He can do this through suppression of unwanted detail, choice of point of view and lighting, most favorable magnification, and in many other ways. He can also, and oftentimes must, make multiple photographs from different angles and at different magnifications for simultaneous viewing and comparison, an act not always possible with the object itself.

Photography illustrates words

In one sense photography always illustrates words. It seems to be a more or less universal human trait to give everything we see a name. Whenever we run into something new we assign it to some known class that is familiar to us and proceed to think of it as related to that class. Photographs are no exception in this regard.

Photographs can be used in two general ways. They can be presented alone or in a group with no words presented with them. Then, they must speak for themselves, stand on their own feet as it were. Or, they may be presented either accompanied by words, or as an adjunct to the words in a text for which they illustrate some point.

The latter case, in which the photograph serves as illustration for (throwing light on) some form of writing or speech, is so far the more common of the two as to make it almost the exclusive use of picture photography. The former example, however, in which the photograph is seen only by itself, is so important to the photographer himself that he should consider it carefully for every picture that he makes. Words will be supplied by the observer as he looks at the picture before he does the text. It is desirable that they have some relation to the intention of the photographer.

It is easier to consider the relation of picture to text if we make the somewhat unlikely assumption that a person reads the words first. Actually what appears to happen is that most observers look and reserve judgment, read and reserve judgment and then attempt to synthesize the two impressions. It is this synthesis so obtained that we want to consider first.

There can be little doubt that a descriptive text accompanied by adequate pictures is the most successful known means of conveying ideas from one person to another. It is true to some extent that a picture alone conveys ideas and, of course, to a far greater extent that ideas can be conveyed by words, but each has severe shortcomings. The combination of the two goes far toward complete communication. Photographs cannot convey such a concept as date, place and time (unless recognition is involved) without either words appearing in the picture or some artificial reference to a well known event or the like. Words cannot convey the specific nature of the specific idea without calling on what the author assumes to be the common experience of the people he is addressing. It is true that this reference to a common experience is also necessary for the picture but to a far lesser extent than for the words. Words and pictures together can, in fact, considerably extend the experience of the

observer if they are handled properly. Either alone will tend to be understood only with reference to past experience.

Photographers do well to remember that oftentimes the words are just as necessary to the picture as the picture is to the words. In this day of candid and down-to-earth photography there seems to be a growing assumption that the average observer can interpret almost any picture made under almost any circumstance. This is just plain not so. It requires great skill to produce a picture that will carry the observer into the scene and make him feel any great part of the original situation. As Shakespeare noted, "There's no art to find the mind's construction in the face!" An actual picture of a woman screaming because ,of great tragedy may well be acceptable as reaction to an amusement device or a difficult passage in a song. Unless the observer knows what he is looking at he cannot interpret what he sees. What is not in the picture must be supplied by words or, at least, by other pictures. The thrill the photographer gets from the picture, knowing the situation, is largely missing in the observer who was not present. Some clue is necessary, but it is often surprising how little clue is necessary.

The success of some pictures among those who "know" comes largely if not wholly from the observer's awareness of the kind of pictures that particular photographer always makes. If he is known to be always cynical, or gloomy, or apprehensive, his pictures will be seen to express these qualities even though the naive person might take them as incomprehensible or even gay. To claim too much for photography is to appear ridiculous to the layman who knows better. He knows, for example, that it is almost impossible to obtain a portrait of his wife that he will agree really "looks like" her. He seldom will go further than "not too bad."

It is this need for a clue, for some statement of the attitude to be taken toward the picture that makes the public demand that pictures have titles or captions. They are demanded because in a high percentage of cases they are necessary. They are necessary not always because of lack of imagination or lack of desire to cooperate with the photographer or artist, but often for exactly the reverse reason on both counts. His imagination supplies too many alternatives, and he finds himself unable to cooperate and try to understand as he would like to do.

On the other hand the relationship between the artist and the public is an intimate one, and both parties must have respect for the intelligence of the other. The observer does not like to be ordered to place himself in a certain mood by a single word command any more than the photographer likes to be told his mood picture looks like a good spot for a picnic.

Taken together and properly used, words and pictures are the most powerful means of communication known to us. However presented they will convey some sort of idea powerfully. They should be used with the same respect for what the audience will think that any lecturer feels in person when he stands up to address a group. It is just as easy for a photographer to appear foolish as it is for a lecturer, and he has just as much if not more chance to put his ideas across to his public.

Photography is international

Certainly one of the great facts about photography is that it can cross language barriers to a greater extent than can other forms of communication. It is easy to become expansive on the subject and dream of the great good that photography can do mankind in this respect. At a time when a universal language and universal understanding are so badly needed it is easy to think we see in photography just such an international medium.

Because it is of such great importance that international communication be handled with great care, it is necessary that we think clearly about what photography can and cannot do in this respect.

In the first place, we must remember that a photograph, transplanted from its country of origin to another land becomes a representation of a possible scene or situation in that other land. It loses all of its former background of customs and manners and ways of living and takes on those of its new location. The new observers can see it only in terms of their own backgrounds of experience.

It is difficult to think of a single object or situation that could be presented in a picture so that it would be interpreted as we see it in any country much different than ours. It is easy enough to say that we will photograph our manners and customs and thus show other people what we are like. But we do not wear top hats and carry umbrellas going to work in the morning even in New York or Washington. Do we understand these English customs just because we have seen pictures of them? We do not. We have to know the background of men's fashions in England to understand the top hat and we have to experience the soot from a London rain to understand the umbrella. Pictures cannot do this job by themselves.

What pictures can do, in a way that nothing else can possibly do, is to lend the very strong conviction that they carry to the words that they accompany. The customs and ways and environment of one country,

when they differ much from that of another, necessarily have an air of unreality. If a thing is new to one's experience, it requires some time and some proof before it can be accepted. Where there is also skepticism about what one is being told, words are apt to fall short of conviction. It is here that photography can step in. Accompanying a text in which the presentation in their native language takes careful count of the differences in customs between the two countries and tries to explain in terms of their backgrounds, the picture can often act as the final convincing proof that what the text says is true. This is an extraordinarily valuable tool. It is also extraordinarily difficult to write such a text. Without it the picture is just as likely to be either wholly misinterpreted as far as our intended meaning is concerned or simply make us look ridiculous.

We come back to the statement of the previous section. The properly used combination of words and pictures is our most powerful means of communication, both nationally and internationally. Improperly used, it is dangerous to the same extent.

Photography multiplies events

There has been implicit in the last several sections the fact that by means of photography and its ally the printing press momentary situations and experiences can be multiplied and distributed without limit. We in this country, at least, think at once of the newspapers with their wire photos syndicated to all cities, of *Life* magazine with its millions of copies and so on. There is little doubt, of course, that such multiplication and consequent sharing of events and situations is one of the strong forces for unity among similar people in the world today.

Colored motion pictures with sound, handled by competent news photographers can increase the effective attendance at an event from an audience numbered in thousands to one numbered in millions and in addition, if well done, let them see more than they probably would have seen if present in person.

This sort of multiplication of events is a fairly obvious property of photography. Photography also multiplies events in another way which in a sense is even more important. Because of the permanence of the material used, photographs may be viewed repeatedly over several generations and by copying if necessary this may be extended indefinitely. This property makes photography not only the most important historical recording means we have ever had but also at the other extreme makes it the most intimate personal recording means known.

The number of snapshots made each year in the United States alone numbers about 2 billion. Of these all but a negligible percentage are pictures of people or pets or houses or gardens. People want photographs of the things near and dear to them so they can go on looking at them wherever they are and whenever they want to. For the individuals involved it will refresh their memories; for those not present it will at least help in letting them share it.

So strong is this urge that the number of individual pictures made for this reason alone far exceeds the number of individual scenes photographed in motion pictures per year, both amateur and professional. We shall consider this somewhat more fully when we come to consider the intentions of the photographer. For now we want to go on with our brief survey of the properties of photography which make it such an important medium.

Photography can change magnification

Only those familiar with the work and possibilities of professional and commercial photographers know of the power that change of magnification places in the hands of the photographer. The range of interest of human beings in the things in the world around us, even with unaided vision, ranges from detail within a fraction of an inch up to many miles. Over the entire range we are constantly confronted with the inadequacy of vision as compared to our interests. Although we become resigned to what we cannot see, we can take real pleasure from a photograph so made that everything we want to see is clearly visible.

Although it is true that except for objects shown larger than their true size in nature, ordinary photography can show us nothing we could not have seen directly, it is also true that with proper lighting and adequate techniques and above all a proper choice of subject, the photographer can make us **feel** that we are seeing all there is to see of that subject. Study of such a photograph can be a more satisfying experience than viewing the object itself, largely because of the lack of visual frustration which is often present unconsciously in a real situation. The observer gets the feeling that the photographer is showing him more than he would have seen if present.

In the broader sense, of course, photography by increasing the magnification can show us more than we can see with the unaided eye, and by decreasing it can call attention to broader patterns that we would not otherwise have noticed. In a sense in this respect, the photographer is simply doing our hunting for us. All that he can show us with few excep-

tions we could have seen using the same optical means to do so. However, we do not go around with a full kit of enlarging and reducing glasses and microscopes. Because of this we miss the interesting and beautiful things which are under our noses and in front of our faces and must rely on those who direct their attention to such matters to show them to us.

We border here, of course, on the process of selection which is so much a part of the photographer's art. There is so much to see in the world, and we are so busy with other matters that only the trained and experienced person can select from the infinity of possible things to look at those that are significant and important and worth repeated viewing. As a photographer trying to show us such things, he chooses the magnification which will enclose within the picture's borders only what he wants us to see. Our attention is no longer diverted by other things and we are free to look at what he suggests without interference.

Photographers create

Both in the foregoing sense and in many others the photographer is or can be a creative artist. We shall see later how little relation there may be between the appearance of a picture to an observer and the appearance the real scene would have had to him. This lack of direct appearance relation may be, and often must be, utilized by the photographer to create the impression he wants in his picture.

In the sense of the preceding section the photographer always creates. Selection, emphasis, idea, and technique are just as much tools of the photographer as they are of the painter. In calling attention to a particular scene or event or person he produces an experience in the observer that he would not otherwise have had. Although such experiences may be, and usually are, trivial, there is nothing in the basic operation that prevents it from rising to great heights.

In the enormous range of human activities and environments there are an infinitude of possible juxtapositions of events and objects. Many of these if seen as a deliberately made photograph can convey ideas of great importance. It is one of the creative possibilities of the photographic medium to make such pictures and to convey such ideas. The photographer in making such a picture is not limited to the meaning of the actual situation. He is free to use anything in front of the camera for any purpose that he has in mind. He is not limited to the actual meaning of the scene. Anyone who has seen a large motion picture set in

action will realize that the meaning of the scene produced is quite different from the meaning as a whole of the situation in which it was produced.

In fact it is this difference between the meaning of the picture in his situation and the meaning of the event in its situation that introduces the photographer into the picture. It is ridiculous to say that photography does not express the photographer. The very selections he makes in deciding to make a picture at all expresses him, even though unimportantly. If he has something to say and enough knowledge of his medium to say it, he can do so just as forcibly and intelligently as can the best painter in the land. We tend to think of photography as not creative simply because most photographers are not trying to say anything with the medium or, if they are, do not know how to handle the problem. A large part of this book is devoted to a study of the properties of cameras and photographs which may be used to create pictures which will convey the photographer's ideas to the observer. We shall find that the most important field of knowledge for the purpose, however, lies in the facts which help him to judge what the observer will see when he looks at the picture.

We should not leave this section without noting that the photographer, perhaps contrary to popular prejudice, is not restricted to showing us the real world. He is just as free to enter the realm of the imaginative and can be just as successful when he attempts it. The bizarre and unusual, of course, have been pushed by the illustrators to the point of becoming a school of photography but little of this work shows imagination in the sense here intended. The imagination of most of these pictures is one of means and contrivance rather than conveyance of an imaginative idea. The photographer can, if he will, show us vistas beyond our everyday world, suggest possibilities beyond our normal visual experiences, and urge us on to greater things in life.

When the photographer works in this manner he is not only using the power of the medium for creative purposes, but he is also enriching our lives through our visual senses in the true manner of the great artists.

In like manner and to just as great an extent it is not necessary that a photograph be interpretable in terms of the objects to convey meaning and give pleasure to the observer. It is perhaps questionable how important a meaning can be transmitted to an observer if he finds himself wondering what the object was that was photographed. But there can be little question that wholly uninterpretable pictures may be made which are, in themselves, objects of great beauty. This is perhaps more particularly true of color photographs than of black and white.

What the photographer encounters here is not a limitation of his medium but a limitation of capacity of enjoyment through the visual sense on the part of the observer. It is exceedingly doubtful that many people can get the enjoyment through seeing alone, external as it always is, that they can get through the sense of hearing which is much less or not at all projected into the outer world. The rhythm of music is felt within the observer, that of a picture is seen as static on a flat surface however much the kinetics of the order of viewing may produce rhythm in the observer's eyeballs. This does not mean that rhythm of good spacing is not important to a picture, it means that rhythm in a picture and in music are not the same thing and should not be confused. A teen-ager is not likely to be as affected by a picture as by a dance band.

We can say, then, that one of the great possibilities of photography lies in the fact that artist photographers can use it to create pictures in the same sense as paints and crayons are used to create pictures by the painters and plastic artists of all types. He is not restricted to the everyday world and his pictures are not necessarily interpretable in terms of objects and situations. They may exist as created objects in their own right.

Photography extends vision

It has become a sort of fashionable thing in recent years to say that photography extends our normal human vision and then to go on from there to deduce all sorts of theorems for the photographer. When we attempt to analyze the phrase, we find as in most such cases that it is so ambiguous that it can mean almost anything and so must be correct. As we have noted above, in its primary meaning as interpreted by the phrase "the camera sees better than the eye" it is obviously not correct. On the other hand, if we take the broadest possible meaning and understand it as saying that because of photography we of today see far more than our peers of a hundred years ago there can be no argument about it at all. A perusal of a large Sunday newspaper takes us all over the world, reading a current magazine can give us a taste of what is going on among our fellow countrymen, a study of a book on flowers can show us beauties we ourselves could not see from nature and so on ad infinitum. The world is placed before us by photography and more recently, with or without the help of photography, by television, to which most of the statements in this book also apply.

We should be hesitant, however, in assessing all this added wealth of experience, lest we go too far in saying that what we see represents

accurately what we would have seen if we had been fortunate or unfortunate enough to be present. Photography has, in fact, created a new kind of world, one which we can see from the comfort of our chairs rather than as the result of arduous travel or accidental circumstances. It is hardly necessary to point out that the world seen in this manner, quite aside from any aberrations of the transmitting medium, is quite different from the world of actual experiences.

So we have to say that while photography has tremendously increased our range of experience, it has done so by the introduction of a sort of pseudo experience of the world which seldom moves us deeply nor excites us greatly and is seldom as humorous as a pointed cartoon. This does not mean that photography is not a great medium; it is. It means that the photographer must not imagine that the exciting or moving scene he photographs with such difficulty will cause anything like the reaction that he had to the scene. If he does his job well, it will be in the same direction but far different in intensity. We are overlooking here the cases in which the photographer deliberately makes the scene better or worse than it was.

On the other hand, if the photographer works towards showing us the beauties of nature, or toward using nature or whatever comes to hand to produce pictures which are in themselves beautiful, he can produce pleasure far in excess of that the real objects or scene would have given the observer. He does this not by any extension of the observer's vision but by a creative act of his own which results in a beautiful object. This can be multiplied by photography or printing to be contemplated and enjoyed by many people. The same, of course, can be done for the ugly, the offensive, and the mundane.

The photographer, then, can extend our experiences by giving us some idea of events at which we were not present. Through the creative process he can extend our vision by making our experience of his picture greater than would have been caused by the objects.

We have noted already the extension given by change of magnification. There is, of course, also the extension to things not visible even to the aided eye. But here the situation has changed markedly in recent years. It was formerly proper to say that we could not see by infrared nor by ultraviolet and that photography permitted us to do so. This is still true to a great extent but the development of the infrared "snooperscope" and better fluorescent materials no longer leaves photography alone in these fields. Add the fact that such images can be transmitted by television, and we have to be careful about what we mean by the range of vision.

The fact remains, however, that photography is of tremendous benefit to us in fields where objects are normally invisible. We shall not go into them extensively in this book since our interests will center mainly around color photography. In thinking of photography as a whole, how-ever, we must not forget that they, taken as a whole, perhaps outweigh in importance all other uses of photography. Taken individually, only X-ray photography compares in magnitude with the usage by visible light.

Photography is a hobby

We must not omit in this quick survey of the things photography can do for us, the fact that for many, many people photography is an exciting and rewarding hobby. It is not alone a hobby in itself, but also one that breeds many others.

The forms that the photographic hobby may take are far too numer-ous to list. There is the man who uses it to record family events and maintains his own personal history by means of a scrapbook. There is the one who seriously attempts artistic pictures, although unfortunately he is rather in the minority—unfortunately because it is only because he thinks he can't do it. Then there is the large group of people to whom photography means beautifully built and operating equipment. Few other fields open to the amateur in which equipment with such fine workmanship and design are available.

Then there are the people, a larger and ever-growing group, for whom photography has opened up fields of interest that might never have been opened in any other way. Perhaps the process was something like this. A person has always loved, let us say, trees. He photographs a tree that he likes particularly. His friends see the picture and admire it but ask what kind of tree it is. Perhaps he goes on photographing other trees and the collector's instinct so strong in most of us suggests to him that he should make a large collection of pictures of different kinds of trees, or the same kind under different conditions or what not. He has now acquired a new hobby—one that he will find exacting and difficult and tremendously rewarding. The persistent question he will almost always get, "what kind is it," will, if he is equally persistent in knowing the answer, soon make him a local authority on trees.

For "trees" in the foregoing, substitute your own field of interest. Photography for many people has been the gateway to some fascinating field of the descriptive sciences they would not have attempted by other means. As a technique for forming collections, it combines the fact that

the objects do not have to be purchased with the fact that the pictures take up little space. Few people could afford to make an actual collection of locomotives, but there are many who have them in scale model and still more who have collections of pictures of them. And so on for geological formations, lakes, wild flowers, architecture, boats, automobiles, mountains—anything that can arouse a collector's interest. There are people who travel the world over just to add pictures to their collections.

Summary

We have seen, then, that photography is a tremendously broad subject. It is one that does not lend itself to broad generalizations and slips out from under us when we try to define it as a field. We shall not attempt to do either but will confine ourselves to pointing out as completely as possible the factors which are involved in color photography by visible light. Even within this restricted compass we shall find the field so large that parts of it will get scant attention.

The review just completed has shown us somewhat sketchily the breadth and manifold nature of what photography can do for us. Even though in this review an attempt has been made not to exaggerate the claims and a number of warnings have been given about limitations, it seems well at this point to look ahead a little. We shall find there are many things which photography does not do successfully without conscious action on the part of the photographer. It may be well to note some of them before we enter the range of the subject itself.

In order for us really to understand photography and the photographic process, it is necessary for most of us to get rid of some preconceived notions as to what it is capable of doing. It can do so much that its stature is not reduced by showing its limitations, and only through knowledge of photography's limitations can its full capacities be used. It is in this attitude of desire to be helpful rather than critical that the following list is presented. Each item of the list represents something that the photographer himself must bear in mind and do something about if it will hurt the effect he is trying to produce. Conversely each item represents a tool that he may use for his own purposes.

1. If the lighting of a scene is nonuniform or if there are shadows, the lighting will, in general, appear more nonuniform and the shadows darker in the picture than in the original scene. This is a purely visual

effect having nothing to do with the photographic process as such. It can be of very large magnitude. It can often be corrected by the use of a reflector near the object or a flash bulb at the camera.

2. At very low intensities, such as those of the evening, the eye works differently than at daylight levels. Color is gone, and the relative brightnesses of the different colors change. Black-and-white photography can imitate the effect, but color photography can do it only through some convention.

3. A locally illuminated colored object, lighted to a higher intensity than its surroundings, appears in direct vision to have much more intense coloring than its surroundings. This effect can sometimes be reproduced in projected pictures, but almost never in reflection prints. To a considerable extent the same is true of objects that are backlighted and the color seen by transmitted light, as with sunlight through leaves or blossoms and the like.

4. The true depth from front to back in a scene is almost never seen correctly in a picture. It may appear exaggerated or sharply compressed; it is seldom correct unless the photographer has taken pains to make it so.

5. A corollary to failure of depth indication, of course, is that no true indication of size is given unless objects of recognizable size are present in the picture. Even with such objects present, unless their exact position is also known errors result.

6. There is a considerable change in the way the eye works as the absolute intensity of the illumination changes from low to high levels, say from a well lighted interior to full summer sunlight. At each level of intensity, the range of brightnesses in which detail may be seen is different. Detail may be seen over a very long range at high levels and over a quite restricted range at the low. Saturations of colors vary in like manner, the same physical colorant giving low saturation at low intensities and high at high ones. These effects are directly reproduced by the photograph as an object that shows the same relationship to intensity. But the reproduction of high intensity effect when the photograph is seen at low intensity necessarily involves manipulation on the part of the photographer.

7. An observer in a room illuminated by colored light soon adapts to this light and sees colored objects as reasonably similar to their daylight colors. Some colors, however, are markedly different. Color photographic processes work rather differently. Within their limitations color photographs are an attempt to reproduce the characteristics of the colorants of the objects by a mixture of three dyes. There is considerable error in the

process but the photograph seen in daylight or tungsten light will tend to look like the object in daylight or tungsten light, regardless of the color of light used to make the picture. This is true, of course, only if the photograph has been correctly made, that is, only if the proper filter was used if one was called for. To make a photograph seen in daylight appear of exactly the same color as the object seen in colored illumination calls for distortions of the process not generally available.

8. In the preceding paragraph the color (hue and saturation) of the objects in a picture was considered. A somewhat similar effect holds for the relative brightnesses of objects of different colors. Except in this case the eye now works differently again. The eye adapts to the color of an illuminant but the relative brightnesses of objects of different colors depends on the energy distribution of the light source independently of its color. This rather surprising situation means that if a red and a blue match for brightness in tungsten light, the blue will be very much brighter than the red if seen in daylight. A good photograph does exactly the same thing. Regardless of the light used to make the picture if a red and a blue would have matched for brightness under tungsten light, in a "perfect" process they would match in the photograph as seen under tungsten light and the blue would be much brighter than the red if the photograph is seen in daylight. It follows that if relative brightness of different colors is an important consideration in a picture, the subject must be arranged under the color of illumination that is intended for viewing the final result. This can be of considerable importance if any part of the scene is to be painted for the purpose as is done frequently for professional motion pictures.

These eight items are not presented as an exhaustive list, nor has any attempt been made to so express them that they hold without exception. The intention is rather to prepare the reader for the sort of outlook on the subject that he will find extended in some detail in the following chapters and, taken with the sections on what photography can do, to give him some idea of what is meant by the nature of color photography. It is a subject that is fascinating wherever one touches on it. As a subject, it is nearly always complex but seldom difficult. In use it is nearly always satisfying, often pleasing, sometimes thrillingly beautiful but seldom exact enough for scientific purposes where exact color reproduction is needed. In some of its forms it surpasses the techniques of the best painters, in others it lags far behind, but the fields in which each excels are not always those of popular belief.

CHAPTER **2**

HOW WE
SEE
THINGS

Color photography, like its forerunner black-and-white photography, is a semimechanical method for the production of pictures. To the extent that we shall consider it here, it does this by means of a camera containing a lens and a sensitive photographic material. The lens produces an optical image on the film by means of the light sent to it from the objects in front of it. This image at each of its points is directly related in its color to that of the light from the objects. The sensitive film has the property of recording these colors in more or less accurate fashion and may later be so handled that a color photograph results. This may be viewed by the photographer or by others. The photographer has used his vision twice in the operation, once to look at the scene and once to look at the photograph. The others may have seen the photograph only. We want to consider in some detail why what is seen in the photograph may be quite different from the scene itself even though the photographic process is assumed to be quite accurate.

To do this we must first consider the manner in which we see anything and then later apply this knowledge to photographs. It is only in this way and by those means that we can learn to modify the photographic results usefully.

The eye and the brain

When the light from any point in a scene passes through the lens of the stationary eye, it is imaged as a more or less sharp point at the back of the eye. Light from points all over an area in the subject form an area, and points lying along any line form a similar line. In this way there is built up in the eye an optical image of the whole scene.

The quality of the image thus formed, as compared to any standards to which we are accustomed in photography is exceedingly poor. No camera could be sold which produced such a distorted and unsharp result.° At or near the center of the rear surface of the eye, however, is a small area over which a quite good image is formed, and in the center of this area is a region in which the receiving nerves of the eye are closely spaced and are highly sensitive to color differences.

When we look at a scene, we do not keep the eyes stationary but constantly move them about, directing this region of sharpest vision first to this part of the scene and then that, sweeping it jerkingly along curves, hopping it from one object to the next, etc. Whenever the eye is moved, of course the position of the image is changed and it is accordingly in almost constant motion, sweeping back and forth and up and down across the back of the eye.

What we see, however, when we look at a stationary scene, is not a rushing around of images of the scene but a well balanced and quite stationary world. This is true even if we walk around touching objects and look in detail at first one thing and then another. It seems logical to conclude that this more stationary image is not the one formed in the eye but that it is formed at higher levels somewhere in the brain. In like manner the sharpness of this mental image is not consistent with the quality of the image formed by the eye lens except perhaps at its center. Everything appears quite sharp to the normal eye. The lack of sharpness can be seen only when the eye is held stationary by looking intently at a single spot, and then only in the outlying regions of the field.

Perhaps the closest analogy to the formation of an image such as must be formed in the brain is that formed by a television camera and receiver. In the camera the scene is "scanned" from point to point and what is "seen" at each point is translated into electrical signals and sent to the "receiver." Here a moving spot of light is affected by these signals, and an image is formed on the screen. The receiver does not ever image the whole of the scene but only a small area at a time.

*G. H. Gliddon, "An Optical Replica of the Human Eye for the Study of the Retinal Image," Archiv für Ophthalmologie, 2: 138–163 (1929).

Some such mechanism must be involved in vision. The eye response to light is transmitted to the brain electrically through the optic nerves. It is well established that the eye responds mostly to changes in light intensity rather than to steady illumination. The television analogy seems fairly complete except for the fact that when the eye is held steadily pointed in one direction, we can see a whole section of a scene, whether sharply or not. We have to assume, accordingly, that while the sharp image is mental and formed by scanning with the center of the eye, the messages from the rest of the eye are capable of contributing to this image. For this we have no satisfactory analogy, but it is no more difficult to comprehend than the process of seeing itself. The outer areas of the eye image seem to be used for orientation and the central part for sharp vision.

Perspective and the moving eye

The general subject of geometrical perspective will be considered in some detail in a later chapter when we come to consider the formation of images by camera lenses. It is perhaps sufficient to say here that perspective as considered for the stationary eye and for the moving eye is quite different. In particular, the perspective seen by the moving eye is free from some of the distortions that artists find necessary to correct in the classical fixed viewpoint perspective.

If we look directly at a sphere, its outline is always seen to be a circle. Because we look directly at anything we want to see sharply, all spheres are seen to have circular outlines wherever they may be located. Similar, although somewhat more complex, facts hold for the outlines of all other shapes. In classical perspective, however, all such objects are progressively distorted as they get farther away from the assumed fixed line of sight. We shall see that this is the case with camera images.

The moving eye, on the other hand, especially if the head is also allowed to turn, embraces a much wider angle of view than is ever attempted in strict perspective or will be given by any but unusually wide angle camera lenses. Under these conditions another fact becomes important which needs to be considered here.

The (young) eye is so constructed that when we look at an object at any distance up to a point quite near the eye, it stays in sharp focus. At the same time the distance from the lens to the back of the eye does not change appreciably. As each point of the image formed by the eye lens can be connected with each point in the scene by a straight line, it

follows that the dimensions of the images of any two identical objects are inversely proportional to their distances from the eye. Accordingly if one object is seen at a distance of 10 feet and another identical object is seen at 100 feet, the second forms an image one-tenth the dimensions of the first. A person at 10 feet produces ten times the dimensions of image that he does at 100 feet.

If we stand on one side of a street in the middle of a block where all the houses on the other side have the same actual height, those at each end of the block will form much smaller images than those directly across the street. If the ratio of distance is 5 to 1, then those across the street form images five times as large. Since the buildings are all the same height for the whole block but the distances vary continuously, this means that the image heights vary continuously.

There is a type of camera which was popular some years ago known as the panoramic camera. In this device the lens and camera rotated through a rather wide angle and the film moved in synchronism.

The formation of the image in this camera is identical in principle to that formed by the horizontally moving eye. Unfortunately, in order to see the result correctly it is necessary that it be curved into a cylinder of the same radius as the original lens to film distance and viewed from the lens position with one eye. Under these conditions there is no distortion, the outline of a sphere is circular in all positions, etc. Unfortunately, such prints are usually laid out flat for viewing and under these conditions a new type of distortion is introduced in that horizontals above and below the line of sight show a relatively great curvature. When properly viewed, though, these lines can be seen as straight and parallel.

It is quite apparent, however, even to a casual observer that what he sees looking at such a picture, even when all the viewing conditions are perfect, is not at all what he sees while standing behind the camera and looking up and down the street. The story of what he does see and what it means in terms of the way we see everything is considered in the following sections. It is necessary first to consider how we can see whether a thing is far away or near and how we can judge the approximate distance.

Depth

To a person first considering the matter, space and depth seem obvious and given. It is difficult to form any concept other than that "the space is there and we see it, and that's that." A little closer consideration dis-

closes that the whole subject is one of considerable, and deep mystery. How is it, for example, that when we tip our heads, verticals remain vertical and horizontals remain horizontal? How do we know that one object is 10 feet away, another is a hundred or more and another could be reached if we were to put out our hand?

These matters have received much attention from psychologists, and many theories have been proposed for their explanation. We can consider the matter as follows. Each person, in the process of growing up, develops a feeling for the vertical which becomes very strong and is eventually localized outside himself. This development is possible, of course, because of the attraction of gravity which he has to resist with his own muscles to keep from falling to the ground. If he leans over, the pull of gravity remains in the same relation to the objects around him although it has changed with respect to his body. In this way the vertical (which is defined, incidentally, as a line parallel to the pull of gravity) becomes a very strong part of his relationship to the outside world.

A horizontal is a line at right angles to the vertical. It is perhaps not quite as easy to see how a feeling for this relationship develops, although the sense of muscular balance of the body may be enough to indicate a direction of motion which is neither up nor down. In any case a horizontal is, again by definition, a line in a plane so placed that there is no component of gravity along its surface in any direction. In other words a smooth table is horizontal if a ball placed on it will not roll. Vertical, horizontal, and right angle, therefore, are usually assumed as the basic concepts behind the space in which the observer feels himself to be. They define two of the directions which it is necessary for him to know if he is to know his position relative to something else. The third element necessary, since three are necessary for a three-dimensional world, can be any of a number of possibilities. For most people it is simply "in front of" and "behind." However, it is often taken as the observer's position with respect to the North Pole. This is apparently not a felt relationship, even though many people are strangely accurate in the matter. A compass is considered a necessary tool if we go far into the wilderness.

This space structure of the observer is retained in all ordinary circumstances. It is based fundamentally on the experiences of the observer in relation to the outside world as that world has reacted on his actions since he was born. Its foundation in experience rather than innate knowledge is at once apparent if his customary surroundings are replaced by unusual ones. Those of us who have had the experience of trying to walk through a room tilted up on one corner, as can be found at many of our

amusement parks, do not need to be persuaded that the orientation of our space can be changed with great ease. It is exceedingly difficult to walk through such a room at all, and after a few moments any true concept of vertical and horizontal disappears even while standing still.

In addition to this space orientation of the observer there is the question of the size of the space. Here again the visual perception of distance from the observer, or depth, is almost necessarily a matter of the experience of the observer. In order to be able to reach out and touch something, or to be able to throw a ball so that it reaches a certain point, it is necessary to make an estimate of the distance. These abilities supply convenient units of distance (the yard is reputedly such a unit, the length of the arm of King Henry I of England) mental multiples of which give us a way of **seeing** the distance to an object. The way in which the unit itself is seen, or rather the visual factors that make it possible to learn whether we can reach an object, will be considered presently. Here it should be pointed out that the distance we think we can see may or may not have much relation to reality. The same distance will appear short at one time and long at another. Thus a range of mountains bordering a flat plain will seem nearby and towering one day and remote and small another; distances in the Alps are often seriously misjudged by the newcomer, and distances at sea are all but meaningless when estimated by a landlubber.

The distance that we **see** is what we **think** it is, not the reverse. After seeing an object as rather close by, any new fact which we have not noticed and which indicates a greater distance to the object, may make the object appear to retreat at once and the distance seen to the object become greater. The estimate comes first and the seeing second although usually so closely together as to be indistinguishable.

It might be well to note that what is meant here and later in the book by the verb "to see" is what is called "visual perception" in more technical writing to distinguish it from "sensation." It is true, of course, that the real first step in the visual process is the automatic reaction of the eye to light as such (sensation). The perception resulting from these sensations determines what we see, but this perception is based on knowledge and experience. In other words we see objects and situations, not just the complex light patterns that would be the only automatic result of the sensations.

We face, then, the question: what kinds of effects make us see greater and lesser distances? Since distance is one of the important variables in a photograph, this will be considered in some detail. The depth factors can be divided into three groups: those due to the motion of the ob-

Figure 2–1. *Displacement of camera right to left changes relative position of nearby objects. Camera here has been moved 3 feet.*

30

server, those due to the use of two eyes rather than one, and those that are effective whether one eye or both are used. These are known, respectively, as motion parallax, stereoscopic or binocular parallax, and the monocular depth clues. We shall see in a later chapter how all of them may be used to produce depth perception from photographs.

Motion parallax

If a motionless observer looks at a vista with one eye, he finds that certain of the objects are partly covered up by others. (This is itself a monocular depth clue to be discussed presently.) If he moves his head from side to side, he finds that parts of the objects previously covered are now visible, first more on one side and then more on the other. Experience has taught him that this means the partially covered object is behind the other by a distance proportional to the extent of the uncovering. Thus if one object is twice as far away as another but both are near, then there will be a large amount of the far object disclosed by moderate head movement. If the two are nearly touching, there will be very little change in their relationship. If all objects are distant, there is little change even for objects widely separated from each other. An attempt to illustrate these effects is shown in the photographs of Figures 2–1, 2–2.

Furthermore, because of this varying amount of what can be seen behind the nearer objects there is seen to be a relative motion of the two. If the head is moved to the right, distant objects appear to move to the right and nearer objects to the left. This is particularly apparent looking out the window of a moving train. Under these conditions the landscape appears almost to be rotating, and depths of many miles can be perceived directly if the landscape permits. The moving center of rotation is determined by the direction of fixation of the eyes.

Binocular vision

If a motionless observer looks with both eyes at objects closer than some 50 to 100 feet, the images formed by the two eyes are sufficiently different so that the difference can be detected (Figure 2–3). Under normal conditions, however, the observer sees not different images, but solid objects in depth. A great deal has been written on how such differences produce this effect. It is perhaps sufficient for our purpose to note that it does, that this is a major cause of depth perception for nearby

Figure 2–2. *Displacement of camera right to left affects positions of distant objects very little. Camera has again been moved 3 feet.*

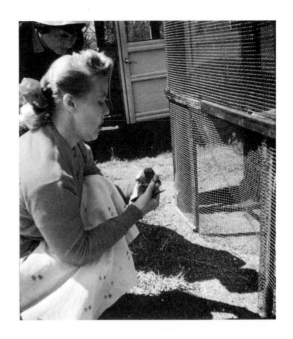

Figure 2–3. *Objects close to camera change relative position rapidly with camera movement. Here camera has been moved only 3½ inches. (Stereoscopic pair.)*

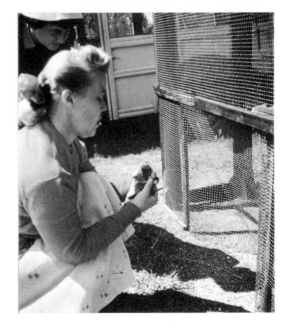

objects, and that the effect ceases at distances greater than about 100 feet. We might note in passing that the fact that two slightly different views (giving a stationary parallax displacement) are formed in the mind into an image of a three-dimensional object is not much stranger than that a whole rapid sequence of darting views around a room can create a mental image of a stationary three-dimensional room.

Perhaps we have here the crux of the matter, and there is certainly nothing in what follows to deny it. What we call vision in the ordinary sense of seeing is not a matter controlled in detail by the particular properties of the eyes as such. It is much more a matter of using the eyes to give the mind pieces of information which it can build up into an image. We do not see everything in front of our eyes. There is much more there that we do not see than that we do. This is not because it could not be seen but because we are not interested to look for it. It requires only a little practice to see that the images formed by the two eyes are different for nearby objects with both of them wide open. The writer believes it is the motion along the objects necessary to make the images coincide from point to point that makes it possible for the eye to "feel out" the depth of an object and so get to know its dimensions in much the same way as feeling the object with the hand and noting the necessary muscular displacement. Normally what we want to see and so look for is the depth so indicated not the difference between the eye images. We shall see that this question of the interest of the observer is a very important one in photography.

Monocular depth clues

We come, then, to the rather long list of factors in a scene which mean depth to an observer and hence make him see depth even though he stands still and closes one eye. They are the causes of seen depth also for vision with both eyes for objects at a distance. All of them are operative in color photographs along with a number of others peculiar to photography and painting but not found in nature.

It is important to note that the word "clue" as used here does not have quite the same meaning as in everyday speech. We think of the word as meaning the cause which leads us to find or learn something. Here it is used in the sense of causing us to see, not to find out and then see. The observer sees depth directly because of the clue, not the clue and then the depth. The clue is thought of as sort of a trigger mechanism which releases the perception directly. It is true, however, that in some cases the

Figure 2–4. *In any natural scene parallel lines are seen as converging toward a point. This is quite apparent in railroad tracks and the like.*

clues are used consciously and the depth perceived later. In fact this was the origin of the use of the word.

Perhaps the most important of the depth clues is the **convergence of lines** known or thought to be parallel. This convergence to a point of all parallel lines in a scene is the basis of geometrical perspective. Its usual common experience example is the convergence of straight railroad tracks when one stands between them (Figures 2–4 and 2–5). Many of its other manifestations in everyday life are not so apparent because they are confused by the phenomena connected with the apparent size of objects. Convergence is and remains, however, one of the most powerful of all indications of distance.

A second clue, already mentioned, is that due to one object **covering up** part of another, and called "overlay" by the late Professor Adelbert Ames, Jr.° Even without observer motion the fact that one object obscures our view of another is sufficient evidence of its being in front. Given a sufficient number of objects this factor alone, especially taken in connection with perception of size is enough to make depth appear both realistic and in its true dimensions (Figure 2–6). It is, of course, easy to design a set-up in which no trace of depth is visible due to lack of knowledge of the nature of the objects being observed. Here again knowledge first and seeing second.

A third clue is that given by **shadows.** Knowing the position and nature of the source of light, the size, shape, and position of shadows gives us many indications about the nature of the depth before us and so permits us to see it directly (Figure 2–7). In addition it often is a determining factor in seeing the shape of an object so placed that its characteristic shape is not visible. Shadows can do this in two ways, either by their shape when cast by the objects, or by the shape of the shadows of the known objects when they fall on them. It is worth noting that a landscape with shadows in nature is often seen as much deeper than the same one without. This is particularly easy to see in the case of a steep hillside covered with trees at a time of year when the leaves have fallen. If such a hillside is seen with the sun behind the observer so that the shadows fall behind the trees and are little seen, the side of the hill may look so steep as to defy scaling. Seen with the sun well to one side, however, it may appear as a moderately gentle slope. The difference is due

*The writer is deeply indebted to the late Professor Adelbert Ames for two sessions given him personally at Hanover, N. H. in 1948 of the indescribably convincing demonstrations of these depth clues for which Ames if famous. No one could see the demonstrations and hear him state that "what the eye sees is the mind's best bet as to what is out front" without being wholly convinced of the experiential basis of at least most of vision.

Figure 2–5. *Convergence toward a point is less noticeable in more complex objects. The two photographs are identical. Objects in parallel lines have been connected below.*

to the apparent depth of the growth from front to back and is a general phenomenon. Any loss of depth perception in looking at an upward slope will make it appear much steeper. The effect may, in fact, even make level ground appear to slope upward.

As the fourth clue we note the aerial haze or atmospheric perspective of the painter. The air often contains enough dust and moisture particles

Figure 2–6. *The fact that one object obscures another indicates that it is in front. Taken with relative size the two alone can produce good depth perception.*

Figure 2–7. *Even relatively small shadows give a clear indication of depth. The raised figure on the vase is apparent only when the lighting forms shadows (right).*

so that it scatters the light which passes through it from the sun and sky. On relatively clear days at long distances this scattering may be of the same nature as that of the sky and so take on a bluish coloration. Under these conditions distant dark objects are partially covered over by this bluish haze in front of them and so take on a bluish misty cast. Bright objects seen through it take on a relatively yellowish cast due to loss of blue light by the same scattering. These effects are common enough to have come to be associated with distance in the mind of the observer. In the absence of conflicting clues a blue haze seen over objects at a distance makes them appear further away than when they are seen clearly. In a similar way any haze may have the same effect (Figure 2–8). It is true, for example, of heavy fogs, and writers are fond of speaking of objects "looming up" out of the fog. Nearby objects can sometimes appear tremendous in these circumstances, simply because the hazy appearance suggests too great a distance and the error is seen as increased size.

A fifth clue is the **knowledge of size** of objects. While it is true that distant familiar objects look considerably larger to us than they should if eye image size were the only factor, it is also true that image size is one indication of distance. Whatever the actual relation to distance may be in a given case, it is still true that the further an object is away from us the smaller its image appears. A church steeple or any building seen

Figure 2–8. *Distances appear greater when there is haze or a light fog in the air. (Note: These pictures were not made from exactly the same camera position.)*

against the skyline or in a distant village is compared mentally (although usually unconsciously) with the appearance of similar buildings familiar in our experience and the distance seen is largely a matter of the size of its image (Figure 2–9). Here again, as in all the other clues, we should note that it is the action of all the effective clues which produces the result, not just one.

As sixth we have **motion in the scene.** A person walking, an automobile going along a road, a train traveling in the distance, moves. Experience of the normal rates of travel and their appearances at different distances gives us a rather accurate guide to the distance in a particular case. In the absence of other factors a train at twice the distance would appear to be traveling at half the speed but experience tells us it is probably not and in conjunction with its decreased size, we again see the effect as distance from us.

As seventh there is **loss of detail** in familiar objects. The seen detail in a tree, for example, gradually decreases as distance is increased. At considerable distances only the general shape is visible, and beyond this perhaps only clumps of trees may be seen with the individuals "lost in the

Figure 2–9. *The buildings are seen as distant because we have a good idea of their sizes.*

Figure 2–10. *Loss of detail with distance also gives a good clue to distance.*

distance" (Figure 2–10). This is again one of the means by which the painter shows depth, and both here and in nature it produces a direct perception.

An eighth clue which is important occasionally is that **brighter objects** tend to appear nearer than darker ones. Usually in nature other clues are sufficient to indicate whether or not this is correct but if they do so indicate the depth is enhanced. This is a special case of the so-called figure-ground relations.

The list could be made longer but perhaps this is enough to indicate that the perception of depth, at least beyond considerable distances or with one eye is largely a matter of the experience of the observer. This is also apparent in the ease with which one familiar with theater backdrops can make a distant part of a landscape appear to be painted on such a drop behind the foreground objects. A photographer may even be able to see it as a paper print—but this is a little different.

Unfamiliar scenes

We should not leave this subject without again noting the important fact that when an observer is confronted with totally unfamiliar sights,

his sense of distance may desert him in whole or in part. An underground cavern, a first landing in an airplane, two ships in a fog, an unknown road by moonlight, any one of these can make a person acutely aware of the limitations of his ability to see distance and form accurately. The process of seeing is that of putting together the facts as we recognize them from our experience. If experience does not apply, we see inaccurately. It is only at such times that the process becomes a conscious one except for persons with special training. Then we say "I can't quite make it out but I think it is so and so," or "it looks as though it were fifty feet away, but I can't be at all sure of it," until someone points out a fact we had overlooked and then we see it all quite clearly. This is the nature of vision—a sort of feeling with the eyes, which, like feeling with the hands, calls for repeated excursions over and around the objects before their shapes and locations become well defined concepts.

Size of objects

We are now in position to consider the important question of the apparent size of objects as affected by distance. We saw earlier that actual retinal size of the image of an object decreases in direct proportion to the distance.

It is a well established fact that the apparent size of objects does not change with distance according to this simple rule. If the rule held, there would be no problem to consider at this point because to a first approximation the world does appear as though the rule held. That is, horizontal lines, such as that of the rooftops discussed earlier, appear straight and convergent toward a point just as the rule would predict.

When we start actually estimating the change in size of objects with distance, however, we find that size does not fall off as rapidly as the rule suggests, and that the relationship is not that of a simple proportion. In other words, from such data a frontal horizontal line ought to appear curved.

Consider another example to introduce a slightly different concept. When we see at a distance a person whom we recognize, what we see is the person and his distance from us. We know he is 6 feet tall and this characteristic is apparent to us, let's say by comparison with his surroundings. We also see he is distant. There are, then, two factors at work. We may look to see how tall he is, or we may look to see the size of the optical image in order to judge the distance. In the two cases we will see different sizes.

This general situation is a common one in vision and we shall en-

counter it again in at least two other important connections (shape and brightness). We can for any reason look for the physical properties of the objects, or we can look for the visual stimulus that permits us to see the objects at all. Where these are different, we have what some psychologists call a "constancy" situation, in the present case "size constancy." An attempt to see the relative image size is biased by our estimate of the actual object size and the image looks larger than it is. An attempt to see the real object size is biased by our knowledge of its decreased image size and the real object size looks smaller than it is. Thus what we see falls somewhere along the line connecting the real stimulus and the real object, the exact perception depending on the personality, environment and experience of the observer. The perception usually lies between the two although some observers in special situations may over-correct and actually go outside of these limits.

One such over-correction is a rather common, although always startling experience. When a person believes that what he is seeing is located somewhere other than in its true location, its size may be judged according to the assumed location. The object, accordingly, will appear much larger or smaller than it actually is. One such situation has occurred to the writer and to a number of his acquaintances. If one is standing at a window looking out into the street, he thinks that all he sees must be on the street. If a fly walks across the window pane in front of his eyes, there will be at least a moment, and a most surprising one, in which a fly the size of a large truck or even larger is seen walking in the street. An example on a much calmer level is shown in Figure 2–11. In these pictures the distance to the table can be seen as rather great in the upper picture if the table is assumed to be of normal size. The lower picture, made from the opposite side, does not permit this interpretation.

Size and distance, then, are reciprocal variables and the size or the distance seen depend on the observer's beliefs concerning one or the other.

There is still another factor involved in the seen size of objects. There appears to be little doubt that as far as the mind is concerned the eye does not work at constant magnification. It is difficult to describe what is meant by this term but a description of the phenomenon runs as follows. When an observer is intent on looking at a particular part of a scene—it may be a single object, or a group of objects—it seems to him afterward that the whole field of his vision had been filled completely by this part of the field. Vaughn Cornish has given an interesting description of this phenomenon in his little book called **Scenery and the Sense of Sight.** We shall return to it later under the headings of angle of view in photog-

Figure 2–11. *The front view (above) suggests a long distance to the table and considerable height. The rear view (below) does not allow this interpretation.*

raphy. It should be noted here, however, that the phenomenon is very general and applies to all our seeing habits.

Without making any attempt to theorize on the visual problem it still is a fact that the full moon by far is not always the same size—that it depends on nearby clouds as well as buildings, that the face of a friend at some little distance may seem to fill our whole field of view, that the apparent size of the constellations has little relation to the actual angles subtended, and that we can sit a whole evening completely absorbed in a motion picture which can be covered by a postage stamp held nearly at arm's length. To those for whom these are new concepts it may be worthwhile to take a pair of opera glasses to the next stage show they see. The stage and the actors do not look larger through the glasses, they look nearer (unless the glasses are powerful enough to separate out individuals). Often only when the glasses are held so that one eye sees through the glasses and the other around them is it possible to realize that real image magnification is taking place.

Perceived size, then, is variable and depends on many factors, but is associated primarily with perceived distance and personal beliefs, on both of which it depends in a complex rather than simple manner.

The work of Lüneberg

As a direct consequence of the work of the late Adelbert Ames Jr. on the single eye clues to depth, the late Rudolf Lüneburg was able to derive mathematical equations which, among other things, permitted prediction of the size which an observer would estimate for a given target at a given distance. Corroboration of these results has come from their agreement with the results of Samuel Renshaw on the variation of perceived size with distance. Although the mathematics is too complex for the present treatment, it may be of interest to some readers to know of the existence of the equations and their nature. Lüneburg has shown that the facts of depth perception require that the visual space of an individual be non-Euclidean, that is, that the relationships cannot be expressed in simple rectangular coordinates.° This result follows directly from the facts of approximate size constancy and the fact that horizontal lines in a frontal plane are not seen as curved. On the other hand, the fact that vision takes place at variable (mental) magnification implies that the metrics of

*Rudolf K. Lüneburg, *Mathematical Analysis of Binocular Vision*, Princeton, N. J.: Princeton University Press, 1947. Rudolf K. Lüneburg, "The Metric of Binocular Visual Space," *Journal of the Optical Society of America*, 40: 627–642 (1950).

these equations are not constant but vary from experience to experience with the individual. Apparently what the Lüneburg space metric says is that the compromise effected by an individual in trying to see distance and hold size constant at the same time results in a space perception which can be described in terms of hyperbolic geometry. If this is true and if the parameters for the various situations can be found, this may turn out to be one of the greatest contributions to the theory of perception in many years.

Shape

The subjects of distance and size, taken in their smaller aspects, make up the subject of shape, at least from a logical point of view. It is probably true that for large objects of uncertain shape, these factors do predominate and what we see may be predictable on this basis. For the more familiar shapes, however, other more important factors are involved. These factors may be classed generally under the heading of a tendency to see forms as particular examples of their types where any doubt is present as to their true nature. Ellipses tend to be seen as circles, angles as right angles, etc., even when to do so does some violence to the properties of other objects seen at the same time.

This tendency has been called by some writers "shape constancy" and may be described as follows. If a circular object, such as a penny, is revolved about an axis parallel to the observer, he sees the penny as circular at all angles even though it forms an elliptical image in his eyes. He can see the ellipse too if he tries but the penny remains circular. Hence if he sees an ellipse in a paradoxical position in his field of view, he will tend very strongly to see this as a circle at an angle, especially if there is any indication at all that this may be the case (Figure 2–12).

Similarly, if a cube with one corner toward the observer is rotated so this corner moves vertically, the angle formed by the adjacent edges of the cube (either top or bottom) passes through a whole series of angles from a straight line to 90 degrees and yet the seen angle between the lines remains a right angle (Figure 2–13). Accordingly, any ambiguous angle in space tends to be seen as a correspondingly rotated right angle.

There is, however, more to this desire for the "perfection" of form than would appear from the above discussion. In the matter of composition in pictures, it is sometimes found that the simple geometric forms of the rectangle, triangle and circle have aesthetic appeal as such and this factor appears to play an appreciable part in the absence of more notice-

Figure 2–12. *Although the image of the circular dish is elliptical, it is seen as circular. The elliptical image of an elliptical picture frame is also seen as circular.*

48

Figure 2–13. *Although all angles are different in these two views of a cube, they are seen as right angles in both pictures.*

able criteria. Other things being equal, we somewhat prefer to see a rectangle as a tipped square—perhaps just because a square seems a little more complete and perfect, even though if we had free choice of rectangles we might pick some other ratio of sides as specifically the most pleasing.

Things remembered

One of the more vague fields of perception theory deals with the nature of our memories of objects and situations. To the writer's knowledge, little seems to have been published on the subject, perhaps because of the obvious difficulty of the investigations it would involve. Certain general principles, however, seem to be acceptable and to fit into line with introspective facts.

The first of these generalizations would appear to be the fact that remembered shapes tend toward simplified forms just as do the original perceptions. Long ovals and rectangles tend to become longer ones, short ovals tend toward circles and short rectangles toward squares. This is a logical sort of change and to be expected from the lack of care which we use in all of our seeing. It is also fundamental to the way we think. Things tend to be seen, talked about, and remembered in symbols as simple and direct as we can imagine.

On the other hand it appears quite clear that we remember also in terms of language. We would not remember a circle if we called it an oval originally. We might if we had hardly noticed it at all, but not if we had really looked at it. This second generalization appears to apply to nearly all phases of remembered experience. A color, for example, will not be remembered as a red if we would have called it an orange. The class name appears to set the limit, an orange-red may be remembered as a true red and a reddish orange as a true orange, but the class names set the limits of the shift.

This characteristic of memory becomes a criterion of some value in problems of photographic or graphic reproductions. The shapes must be named the same, the colors the same, the relative distances the same, etc. It is as though the reproduction were compared with a verbal description rather than a mental image, although this is probably not the case. Some good experimental work on the subject would be most helpful in a number of different ways.

Associated with these characteristics of simplification and class naming there is a third phenomenon. If an object or thing is particularly well

known to a person, he may not be able to visualize it at all, especially if it is not rigid. The very fact that he is so familiar with all of its appearances makes it quite out of the question to remember how any **one** of them looks. One of the best, if perhaps the most dangerous, of examples is the simple fact that most men are unable to remember the exact appearance of their wives' faces. Asked to do so, they will think for some time and then finally announce that they have it. Almost always what they can remember turns out to be a familiar photograph rather than the person herself. That this is so is not strange. A person's face is never stationary except in sleep and seldom has the same expression for more than brief seconds at a time.

We must not be hasty in assuming that because we cannot visualize very familiar things, the memory is hence rather poor. On the contrary this same man could pick out his own wife from thousands upon thousands of other people. The ability to remember a particular image has been replaced by the ability to recognize almost any possible image—a much more surprising accomplishment. Accordingly, he judges a picture of his wife in considerable measure on the basis of whether or not she **might** look that way, and on whether or not, if so, it is characteristic.

Idealization

These considerations lead us to a still further memory factor and one which, if anything, is even more vague. It can be expressed by the statement that the memory image of a scene as a whole tends to move in quality, if not in detail, toward the description applied to the original when it was seen. If our verbal reaction, whether spoken or not, was that the scene was beautiful, sublime, horrible, quaint or the like, our mental reconstruction of it afterward obligingly moves in this direction. So much so, in fact, that another visit after a considerable lapse of time may be quite surprising.

The changed appearance found on a second visit, or sometimes even a second look, is often ascribed to lack of the emotion of first viewing, increased age, different company or any number of other factors, and there is no doubt that all these can play a part. At the same time a scene thought rather ugly the first time can be found quite charming on a second trip and a picture found ordinary at first glance may be found a work of art if it is hung on the wall for daily viewing. This may be due in part to the mental exaggeration of our first impressions. When these exaggerated impressions are again compared with the facts, the contrast

is so great that it throws our decision in the opposite direction. The effect thus works both ways and seems due to a gradual perfection of the memory image along the lines of the first reaction—resulting in an image which may need complete reevaluation on subsequent direct viewing. The famous phrase "Oh, that the good old days were back again," perhaps illustrates the subject completely.

The effect of this habit of memory is important in many phases of photography and art and even in the evaluation of people and things around us. It is the unconscious operation of setting up standards of judgment for the various qualities a scene may possess. Unless we are to argue that standards of beauty, ugliness, and so forth are inherent in individuals and given from birth, it is necessary that these standards be developed from experience. A possible way in which such standards may develop, based on this self-exaggerating tendency of memory works out somewhat in the following way. Suppose that some little phase of an object seems particularly fitting or appropriate, or agreeable. It is remembered and gradually assumes importance for such relationships in all similar objects. Similar relationships recognized and enjoyed will still further emphasize the attitude. In this way over a long time an ideal of perfection in a certain direction develops. Felt directions, of course, are necessary for all this to happen and these directions may be symmetry, balance or similar factors. The final result, however, is applicable only to that general class of objects and much less closely to others, the whole forming what is known as the individual's taste or preference along that particular line.

The application of this rather involved deduction will be apparent when we come to consider the question of the intention of a photographer in making a picture. It is perhaps enough to say here that the great majority of people who sit for a portrait do not want a reproduction of themselves but either an idealization of their features toward their ideals of beauty for that kind of face or toward an idealization of a kind of character they feel that they possess.

Over and above the personalized ideal, however, there is the class idea, a beautiful woman, stark reality, wonderful feat, brilliant performance, even charming this or that. This, in a rather farfetched sense was the Greek feeling for the ideal, especially in the case of beauty—an impersonal beauty not to be identified with a living person but as an example of how an impossibly beautiful person might look. It is too much to draw a parallel between this and the so-called "glamour" photograph, but it is no exaggeration to say that the people do not look much like the photographic results. One can even say that in some few cases there has

been appreciable movement in a direction similar to the aspirations of the Greeks.

Desire for idealized perception

Accompanying these concepts of ideals of various kinds is a more or less fervent desire to see the best examples of the kinds that have a personal appeal to a particular individual. It seems to be a characteristic of human nature that interest along any line promotes a desire to experience the extreme possibility along that line. We see this in many peculiar manifestations, most of them so familiar to us that we do not recognize their meaning. The person who likes horror in motion pictures attends "Dracula" and "Frankenstein" and likes it even better when both are shown the same evening. The person who likes high speed attends the auto races or the airplane races even though he would not himself dare attempt such speeds.

It would be easy to add other examples and exaggerate the importance of what is, in fact, only a tendency. The tendency results, however, in refining our interests as experience grows. The flower fancier becomes progressively particular about the kind of flowers he likes until he becomes an expert and a connoisseur for this region of experience. The importance of this tendency in the present connection is that it gives us the drive toward progress in the arts. Lovers of beautiful color want to experience ever increasingly beautiful examples, and the same is true, of course, for line, balance, space relations, and all the other attributes of pictures. It is, in short, the basic motive behind a desire to experience the fine arts.

The fact that this basic motive comes from human nature rather than something intrinsic in fine art, however, suggests that we will find it operating in regions which fall short of "fine." We shall encounter some of these also when we consider the intentions of the photographer.

Form adaptation

There is one other rather subtle and totally different characteristic of vision which lies somewhere between the operations of seeing and of remembering. It plays a large part in our evaluations of what we see and so is logically considered here. Stated simply, when we concentrate our attentions actively and closely on objects of a particular type we become

somehow mentally and visually attuned to the properties of this type of object. Suppose as an obvious sort of example, we were required to count coins continuously for a period of four or five hours, or perhaps better, were required to examine each one for some detail like a mint mark or a scratch. For some time after leaving this occupation there would be a tendency to see circular characteristics in all the objects of daily life. In the vernacular you would say that you had been at it so long that you "saw coins all over the place." The effect is even more striking when the objects studied are irregular in their shapes. The number of objects that can show a resemblance to a dandelion after three or four hours spent digging them out of a lawn is a case in point.

Several bases suggest themselves for explanations of this effect, and they throw considerable light on the subject of appreciation of pictures.

There is, first, the kind of explanation that could be derived from the work of Köhler on his "figural after effects." ° In these effects a geometrical pattern carefully viewed for some time changes its form progressively so that when a second figure of similar shape is then viewed it appears much distorted in comparison to the original appearance. It appears that continued viewing of a given pattern will produce a temporary set of that pattern in the mind which for some time afterward will affect the shape of what is seen. A consequence of the effect is a change of the shape of an object in a picture as the shape of the frame is changed. A picture of a tree in a tall narrow frame will look taller and narrower than an identical image in a short, wide frame. Perceived shapes therefore are dependent on other shapes seen either before or during the process of seeing. Long continued association with particular shapes will change the appearance of other shapes accordingly.

Perhaps on a less scientific plane than that of the Köhler effect but along lines that seem just as reasonable, an explanation could be offered based on familiarity with objects. If a person is intensely familiar with the shape, say, of the pen points of fountain pens and he finds them interesting objects, he will be quick to see that leaves from certain trees have strikingly similar points and the leaves will take on an added interest for him because of this fact. Those leaves that tend toward this characteristic will tend to appear more interesting. In similar manner, having noted that some leaves do have this characteristic, he will also be quick to note that other leaves show no such tendencies at all. If his interest in this particular shape is great enough, these leaves may tend

*W. Köhler, *Dynamics in Psychology*, New York: Liveright, 1940. J. J. Gibson, "Adaptation, After-Effect, and Contrast in the Perception of Curved Lines," *Journal of Experimental Psychology*, 16: 1–31, (1933).

to be seen as plain and unattractive. That is, familiarity with and fondness for a particular characteristic not only emphasizes this characteristic wherever it is found, it also by contrast emphasizes differences from it and particularly emphasizes its absence.

It is not too much to say, whatever the explanation, that this tendency of vision or of way of seeing is fundamental to all criticism as applied to pictures. Each person looking at a picture is likely to be seeing something different. That this applies to all phases of the picture will become evident. That it applies to the shapes of the areas as seen by the individual is the first phase we have encountered. It plays, of course, a somewhat secondary role as far as fine art is concerned but it can become vitally important in commercial photography. It is also the fundamental cause of the fact that a worker immersed in one "school" and a deep admirer of works of that school is much more violent in his dislike of the work of other schools than is his less highly trained brother who may be quite indifferent to all of them or like them all about equally well. The two people do not **see**, in the literal sense of the word, the same picture. Whether the cause is an actual distortion of the image seen by one as compared to the other or a concentration on certain types of detail by one as compared to the other would appear to be immaterial. It is what they see that counts. This is perhaps the underlying fact in the Rorshach picture series for personality analysis.

Color and light

The medium by means of which we can see shapes and distances is the light which reaches our eyes from the objects. This light, when it reaches the eye from a point in the scene can differ from any other light in only three ways. It can differ only in quality, intensity and direction. Light is a form of radiant energy, like wireless waves or radiated heat. The energy which it contains may be thought of as vibrating at very high frequencies and in normal white light all possible frequencies to which the eye is sensitive are present. The eye is sensitive to about one octave of these frequencies, that is, the highest frequency visible is just about twice that of the lowest. Lights which are seen as different colors have differing relative amounts of energy at the different frequencies within this octave. They are said to have different spectral energy distributions, or, more simply, to differ in quality. Unfortunately for a simple explanation it is not true that all lights that differ in quality look different since for every color seen there are a very large number of

possible energy distributions which will match it exactly. Happily the reverse is true, however, and if only two lights are visible and they look different, they have different distributions.

Two lights having the same relative energy distributions and hence the same quality may still differ in the total amount of energy involved. This is called a difference in intensity between the two. Visually if they are side by side one looks brighter than the other.

As far as **visible** difference is concerned, the only other way the light may vary is in the direction of arrival at the observer's eye. (The light can be polarized but this difference cannot be seen.) It is obviously this property of direction which makes it possible for the lens of the eye to form images of objects. A little thought will show, however, that direction is not enough. If light from every point of a scene arrived at the eye with exactly the same intensity and quality, the image formed would be completely uniform. We would see only a uniform area containing no traces of any objects. It is only when there are differences in intensity or quality or both in the light coming from different points that it is possible to see objects. Thus a perfectly white figure on an equally white background would be invisible unless there were some intensity differences along the edges of the figure.

In the usual case, of course, there are both intensity and quality differences in the light from different objects, as well as from different points of the same object. These are the differences by which we see and the directional aspect then gives us much information not only about the size and shape of objects but also about some of their other properties as well.

The colors of objects

In scientific usage the word color has been defined as the evaluation by strictly mathematical techniques of the intensity and quality of light with respect to a standardized eye. This definition is very useful in strict scientific writing but will not be followed here because the present intention is purely descriptive. Color, as the word will be used here, will mean the effect on the observer of the intensity and quality characteristics of the light under the actual conditions. This definition includes everything normally called color, including gray and black but possibly not white as we shall see presently.

The color seen when a nonluminous opaque object is viewed is produced by light which has come from some source, fallen on the object

and been reflected to our eyes. It is the result, therefore, of light that has left the light source with a given intensity and quality and that has then been affected by its reflection from the body in question. In general, if the object shows color, it means that the quality of the light has been changed to a new energy distribution. This new energy distribution differs from that of the light source in the following manner. A colored, or "selective" surface as it is more properly called, has the property of reflecting a definite percentage of the light that falls on it but this percentage is different for the different frequencies of light. Accordingly the new distribution is the old one reduced by the appropriate percentages (including zero) at each frequency. Frequencies can be present in the light source that are not reflected (zero per cent) but none can be present after reflection that were not present before unless the object either fluoresces or is a light source itself.

It is very much of an over-simplification to say that the observer sees this effect on the light from the source as the color of the object, yet for daylight and for some other sources this is very nearly true. With some fluorescent lights, some arc lights, and neon, mercury, or sodium lights it is definitely not true.

In the case of transparent objects it is the light transmitted to our eyes that counts, but the action of the object is exactly the same, a certain percentage of the light is transmitted for each frequency. Transparent objects, however, are usually seen by light that has been reflected from other objects, so what we see here is the effect on this reflected light rather than the light directly from the source.

By ordinary daylight the color that we see and ascribe to an object is the intensity and quality of the light from the object as compared to the light striking the object. It follows directly that in order to see the color of the object correctly it is also necessary to see the light from the source. If this requirement is not met, as it very often is not in a photograph, then any peculiarity of the light source will tend to appear as a property of the object. This will become somewhat more clear after considering how we see illumination and light sources.

Perception of object properties

Perhaps the most important fact to understand about vision is the extent to which we have trained ourselves from birth to see objects rather than light. We live in a world in which the illumination falling on objects is changing constantly. Yet we believe that the objects them-

selves have fixed properties which are not affected by these changes. It is these fixed properties that we try to see in ordinary life situations and not their changed appearance due to the light. The artist or the photographer must train himself deliberately if he is to see the total effect.

The net result of this highly developed skill at abstracting the object from its surroundings is to break down any simple relationship that might otherwise exist between the nature of the light reaching the eye and what we see. As a simple example, consider a white tennis ball standing in sunlight. The light reaching our eyes from the ball says the ball is a bright, slightly yellowish color on one side and a dull gray or possibly blue on the other. In ordinary light, however, this is not what we see but a uniformly white ball sitting in sunlight. That is, we separate the illumination from the object and see the object itself. With special attention, of course, it is possible to see the ball as first described. This, however, is not the usual manner of seeing.

This general attitude toward objects and the consequent way of seeing applies to all the visible properties which objects may have. Thus an object with a glossy surface is seen as such because of the nature of the reflections seen in this surface. We are not ordinarily conscious of these reflections, although they can be seen with the greatest of ease if one looks for them. We tend to see only the glossy surface as such if it is the object at which we are looking.

In similar manner we can see the true color of an object with a glossy surface under most conditions (though not all) in spite of the fact that this surface reflects other colors to such a degree that little of the light reaching the eye is the correct color. We have learned simply to look through such reflections.

In an earlier part of this chapter it was noted that we tend to see form and size as constant in spite of conditions. These phenomena were referred to as size and shape constancy. The same term has been applied by many writers to the properties of objects now under consideration. Thus there is brightness (more properly lightness) constancy, and color constancy, and it would be just as logical to speak of glossiness constancy. It is perhaps easier to remember that whenever objects are observed as objects, the whole experience and training of the individual is brought to bear on the problem of seeing the true individual object properties in spite of the conditions. Under familiar everyday conditions the operation is not a conscious one. Under unusual conditions the process is distinctly conscious and may take an appreciable length of time. It is not difficult to devise situations in which perception of the true properties is impossible.

The usual problem which the observer faces is that of separating the

illumination characteristics from those of the illuminated objects. Since this is the usual problem, it is not surprising to find it is the one we are most capable of solving. In daylight or artificial light the separation of the two is almost complete. The observer sees the light sources, the illumination and the objects as separate. The illumination appears to lie on the objects. It is almost as though the objects are seen through the light.

In this process we are greatly aided by a number of interesting properties of the eye. These properties are not the whole cause of our ability to see objects and illumination separately and in some cases they actually make it more difficult. On the whole, however, they are helpful. They belong to a class of properties possessed by nearly all the senses, known as adaptations. The eye is more sensitive to changes in energy than it is to amount of energy itself. Continued action of a steady source of light is less effective in producing a visual response than a sudden change in amount. In fact, it is more accurate to say that the eye is designed to detect changes in light rather than the more common statement that it is sensitive to light. When exposed to a steady source of light, the eye rapidly becomes accustomed or "adapted" to this light and it becomes progressively less bright and less demanding of our attention. If this light changes in intensity, however, we are immediately aware of this and our attention is at once attracted. From the standpoint of evolution this property of the eye has obvious value. A stationary world is not usually a dangerous one. It is only when something moves, changing the brightness pattern that the observer must be aware and alert.

The eye is essentially a device for indicating more or less of the stimulus and not the exact amount. It is the equivalent of what is known in instrumentation as a "null" indicator.

This property of adaptation operates somewhat as follows. We look at a complex scene containing a certain range of intensities. These lie both above and below a sort of average level. The eye adapts itself to something approximating this average in a manner depending on how the scene is viewed. It accepts this level as normal. The whole scene is now seen from the point of view of this intensity level. At a certain distance below it, depending on the actual range present and the absolute level, black is seen. At a certain level above it, usually that of the brightest reflecting object, is seen white. Still brighter areas are seen to give off light because of their effect on other objects and these are seen to be light sources.

In reverse now, when a particular area is giving off light and so affecting other objects, the effect of this is subtracted to see the properties of

objects. The whole procedure is too complex to attempt to describe in detail and sounds somewhat far fetched when the attempt is made. It requires, however, only a slightly artificial set-up to make the whole process conscious and it is then found that this is the type of sequence involved.

In like manner the eye adapts itself to the color of the scene. The mechanism here is somewhat more specialized because of the way in which the eye sees color. In principle, however, the same phenomenon occurs. The "average" of the scene is accepted as normal, and the eye then sees the colors present in terms of this color adaptation level. The result is a decrease in the color changes with illumination, which we should otherwise see.

It is apparent that both of these effects help us to see the true properties of objects. If objects looked different at high illumination intensities than they do at low or if they looked different in artificial light than daylight, then it would be difficult to think of the objects as having fixed properties. We should be inclined to speak of an object as yellow in artificial light and gray in daylight etc.

But adaptation goes still further than this. Suppose there is a relatively large shadowed area in a scene. Looking over the scene as a whole this shadow appears relatively dark and details within it are difficult to see. By fixing our attention wholly within this area we can to a certain extent adapt to the level of the shadow and plainly see detail otherwise obscured.

On the other hand, this function of the eye which makes us see differences as more important than actual values tends to exaggerate certain properties of objects to the point of false seeing. If a light and dark area are presented side by side, for example, the eye tends to adapt to an intermediate level and the lightness of the light part and darkness of the dark are exaggerated. This phenomenon is known as simultaneous **brightness** contrast. A similar phenomenon occurs for color. If two differently colored areas are placed side by side, the eye tends to make them appear as different as possible. This it does by subtracting each color from the other. In more familiar terms each color is moved toward the complementary of the other. If the colors are complementary to start with, they become more so, that is, each becomes more saturated. This effect is called **simultaneous color** contrast.

Both phenomena are a result of the eye acting in every case to produce a maximum difference between areas in the field of view by taking up a sensitivity position which lies between them.

It should be repeated, however, that these effects alone do not explain

the constancy phenomena. We perceive external objects by our ability to separate the object itself from the conditions in which it is found. To do this we make the best use we can of the properties which the eyes possess, as far as we have learned them from our experiences.

We might note also a still further factor which is based on experience and memory. If a change from one situation to another has become familiar through long repeated experience, any change in object appearance between the two comes to be expected and is seldom noticed. Thus there is no doubt that the saturation of object colors increases with the intensity of the illumination but we seldom notice it. A blue in artificial light is about one quarter as bright relative to a red as when they are seen in sunlight, yet it is hard to persuade people that this is so.

Perception of reflectance

One of the most important of the constancies is that of brightness or lightness. It is worth considering it in some detail because it will illustrate many principles that apply to all the others. Further, it is of major importance in the fields of photography and of painting.

When light falls on an opaque object, a certain percentage is reflected. In general the percentage reflected, or the reflectance of the object, varies with the color of the light. This light may then be compared by an observer to the brightness of the light from some other object. A common special case exists for those objects that reflect the light with no change in color. These are usually seen as gray or white and represent a simplification of the general case. The same principles apply to surfaces that are highly colored, but the situation is complicated by the other variables of color.

Suppose we have such a gray or white object which does not change the quality of the light on reflection but which does change its absolute amount. We want to know how this object will appear under different circumstances and what will control its appearance. In particular we want to know when and how we shall be able to see what part of the light is reflected by the object, because we consider this to be one of the important properties of the object.

To test the ability we may set up a simple experiment. Suppose we have a series of cards reflecting different percentages of light. Take one of these and place it at a distance from a window. Then, standing close to the window, select another card which most closely matches the first in apparent reflectance. It will usually be found that the card you chose

has a slightly lower reflectance. However, if we now measure the actual amount of light which is reflected to the eye by the two cards, we will find that the distant card sends much less light to the eye than the nearer one chosen to match it. As before, we have done our best to subtract the illumination from the object property in order to see the actual nature of the object.

The measurements show, however, that our perception of the object reflectance has been a compromise between the amount of light and the percentage of light reflected. That is, our attempt to see the true object property has been partially successful in overcoming the nonuniformity of illumination. We have been able to move part of the way from the illuminated situation to the object characteristic.

This principle is of wide validity and can be used to describe nearly all visual situations. Our attempt to see object properties in spite of existing conditions is nearly always partially successful. The extent of the success is determined by the extent to which we can truly see what the conditions are. Here lies the crux of the matter. To the extent that we can see the situation, including the illumination, its geometrical distribution and the like, we can also see the true object properties. To the extent that we fail to see the situation we also fail to separate one from the other. What we see is then a compromise. In the extreme case where the situation is completely ambiguous, we combine the two completely and see as object properties the characteristics of an object which would send to the eye the same amount, quality and form of light. That is, if the illumination is not perceived as such the variations present are considered to be due to object properties. This is a basic rule for photography and painting.

A numerical example may make this more apparent. Suppose we have a nearly white card which reflects 80 per cent of the light which falls on it. Place this at some distance from a light source and then match it with cards held close to the light source. Suppose it is found that a card reflecting 70 per cent appears to have the same reflectance. Actual measurements now are made of the amount of light reaching the eye from the two cards, and it might be found that the light from the nearer card measures ten times the intensity of that from the distant one. If the cards had been equally illuminated, this difference would have corresponded to a reflectance of 7 per cent for the more distant card. The eye saw it, however, as 70 per cent representing the extent to which the observer could correct for the illumination difference and see its true reflectance of 80 per cent. If instead of one light source near the observer lighting both cards, two light sources had been used, with a separate one shining

on the distant card but giving the same illumination as before, then the perceived reflectance would move toward the 7 per cent value. In the extreme case of the two cards side by side in a box but lighted separately this reflectance would actually appear 7 per cent.

There is a further point involved in situations where the illumination is nonuniform which must be kept in mind and is apt to be rather confusing. We have discussed an observer who is trying to see object properties, in this case the reflectance of a card. Now suppose that instead he tries to see the amount of light reaching his eye, disregarding the card as far as possible. To do this at all requires some training, or perhaps we should say "untraining." It can be done, however, more or less successfully, depending on the individual. Returning to the first part of our example, we assumed that the amount of light from the distant card was one-tenth that from the nearer. A very good observer might be able to see it as perhaps one-half while one with little training might see it as perhaps eight-tenths. For white cards, at least, the constancy effect is exceedingly strong up to ratios of 10 to 1.

There are, therefore, two ways of seeing the distant card, each of them partially corresponding to a physical characteristic of the scene but neither of them exactly corresponding. With an object (card) directed attitude he sees an 80 per cent reflectance as 70 per cent; with a stimulus (light) directed attitude, he sees the amount of light as eight-tenths to one-half as much when it is actually one-tenth. This is a more or less general characteristic of all vision. When two ways of seeing are possible, the tendency is to compromise between the two. The compromise can be shifted toward either extreme by the attitude and intentions of the observer. The important point, often overlooked, is that this compromise perception, except in experimental situations, contains no element of uncertainty to the observer. It is a compromise but it appears to the observer as a definite clear-cut perception carrying great conviction. It is this conviction, in fact, which makes it difficult to realize the facts.

Perception of illumination

We have noted several times that it is necessary for the observer to allow for the illumination in order to see true object properties. Since this is a vital element in all seeing, it may be well to consider it in more detail.

Suppose we have a number of different objects, all of which are painted white, but which are illuminated by a simple light source above

and to one side. Each object will throw shadows on the side away from the light. The amount of light reflected from any given area will depend on its position in relation to the light source. The light which reaches an observer from this scene will vary in amount from that of the area receiving the most light down to the darkest shadow area present. Since the objects are all white, there will be no change in the quality of the light but only in the quantity from point to point.

Now consider a collection of similarly shaped objects illuminated by completely uniform light coming at it from all directions, such as is often obtained from an overcast sky. But imagine that these objects instead of all being white, vary from white to black in such a way that the deepest black reflects the same amount of light as the deepest shadow of the preceding example. Also assume that the white reflects the same amount of light as the brightest white did before.

As far as the light reaching the eye of the observer is concerned, this scene will cover the same brightness range as the preceding example. The difference is that in one case the variable is the light falling on the objects, and in the other it is the light reflected by the objects. The quality of the light is identical whether its intensity is due to reduction by a gray surface or because the area from which it comes is a white in shadow.

To the observer, however, there is a great difference. The first case is seen as white objects in nonuniform illumination, the second is seen as nonuniform reflectances in uniform illumination. Since the two can be made quite similar physically and yet still be seen as very different, it follows that the seen difference cannot be due entirely to the physiology of the eye. Everything indicates that the difference is due simply to experience, and that is the position which will be taken in this book. Any other explanation assumes the metaphysical ability to see the true situation without any reason.

We have to assume then, that what occurs in the first case is direct perception of the illumination, as such. This perception is made possible by shadows, by the way the light falls off on curved surfaces, by different amounts from differently oriented surfaces and the like. Since the illumination is seen separately, it can also be seen that the objects are uniformly white. In the second case the observer perceives the illumination as uniform and accordingly sees the intensity variations as changes in the reflectances of the surfaces. It is important to understand the fact involved here of seeing the illumination as separate from the objects in order to see the objects properly. If the illumination is not seen correctly, then to this extent the objects are not seen correctly. When we come to

consider the viewing of a photograph it will be found that this operation takes place twice. The photograph (or painting) is an object in a certain illumination. The subject shown stands in a second illumination. Unless both illuminations are seen correctly and separately, the properties of the represented objects will be seen incorrectly.

Perception of the source of light

We noted that one of the first perceptions in viewing a new scene was that of the light source itself. This perception again comes from seeing that the objects throw shadows, have less light on one side than the other and so on. The question arises, however, as to how we distinguish between an actual source of light, that is one in which energy is being converted into the form known as light, and the brightest illuminated object in the field of view, since in both cases it is simply light of a certain quality which reaches the eye from a certain direction.

The answer has already been given above. We see a certain area as a light source simply because of its effects on other objects. It is not necessary that energy be converted to light to make an area appear as a source. The requirement is that light appear to be coming from it and falling on other objects. A highly reflecting object, separately illuminated by a hidden light source so that all the light reaching other objects comes from this area, will appear as a source of light.

In general, of course, the light source itself, or if it is itself hidden the immediate area around it, will be the brightest area in a given scene. In many cases, in fact, it is the decrease in brightness with distance from a given area that points to this area as the source. It does not follow, however, that the brightest area is always seen as a source. In pictures it usually is not. The brightest area in a picture aside from minor reflections of the source, is usually the most brightly illuminated area. The light source is usually outside the picture and is inferred rather than seen.

Hence we return again to the fact that a light source is perceived as such primarily by its effects. The effects themselves are perceived as the illumination. The objects themselves are seen after due allowance is made for this illumination.

This brings up the interesting question of the relationship between white, which is often considered the brightest possible object in a scene, and the illumination by which it is seen. The subject is discussed in some detail under the viewing of pictures. It might be noted here that not only can white be seen at a variety of brightnesses in any nonuniform illumi-

nation but that under proper viewing conditions areas of higher brightness than the brightest white are possible. The only requirement is that the illumination be seen as more intense on parts other than those seen as white.

Perception of white

It is convenient to discuss at this point the concept of a **white** object. It has become customary to think of white, gray, and black as a continuous series of reflectances from very high to very low in surfaces, which do not change the quality of the light. This view is in complete accord with our usual experience with opaque reflecting surfaces and is a useful concept. It tends to obscure the fact, however, that the concept of white, as such, has nothing to do with gray in the general case, that is that the two are entirely different concepts and arise through different physical situations.

Perhaps the easiest approach to a general concept of white can be gained by progressively diluting a glass of milk until the water finally becomes completely clear. In the course of this procedure it will be seen that the liquid never does go through a stage which is seen as gray. In fact the only reasonable description of such a series is in terms of degrees of whiteness. The milk gradually becomes less and less white until it finally becomes clear. In other words what we usually call white is the end point of a continuous series that has clear at the other end. It should also be noted that through this series brightness does not change in the same sense as it would if we had two different illuminations falling on two sheets of white paper.

White therefore can change in a manner not associated with changes in brightness and not leading toward the series of grays.

If we consider the matter from the standpoint of physical objects which we call white, we find that a white object is always one that **diffuses** the light. That is, the perception of white is always associated with an object that reflects light about equally in all directions. Looked at somewhat differently, a white object is one that scatters light in all directions without regard to the direction from which the light arrives. As whiteness decreases toward clear, more and more of the light is seen to come through the object (the water in the case of diluted milk). The degree of whiteness represents the percentage of the light diffused by the object. The perception of this object property is independent of the illumination except under unusual circumstances and is independent of

the concept of gray and black. As ordinarily used, however, the word is restricted to diffusing objects which do not change the quality of the light markedly.

Perception of gray and black

It is difficult to describe the nature of the concept that we call gray. We may describe it as the direct perception of the relative effectiveness of a given stimulus in producing the sensation of light. The statement, however, carries little meaning unless the various situations in which gray may be seen are known to the reader.

Gray is a perception which may appear in connection with any area of a scene regardless of the nature of the area, provided some light is visible as coming from or through it to the observer. If no light is seen, the area is black. The requirement that gray appear is that the area be seen as less bright than another.

One of the simplest ways to demonstrate that gray has no physical existence, that is, does not necessarily correspond to any physical reality within the area over which it is seen, is to set up two ordinary lantern slide projectors. Arrange one lantern so that it projects a small area of light on the screen of somewhat lower intensity than the other. This can be done either by placing it further from the screen or by putting a neutral filter in it. Next, arrange the second lantern so that it projects light around this patch but does not add any light to it. This can be done by making a slide with an appropriate opaque patch in the center. It will be found that whatever the relationship of brightness of the two lights as long as the outer area is brighter the central area will appear gray. If the central area is sufficiently bright (the required intensity depends on room conditions) it will appear white without the border and gray with it.

A more elegant and convincing demonstration can be produced by making a series of identical slides in which the central area is quite dark, surrounded by four or five successively lighter borders. A separate mask is then cut for each slide so that the first projects only the central area, the next this area and its adjacent border, the next these two and the second border, and so on. When these are projected in this order, it is found that the first slide projects a dim area of light which may be seen to contain gray if there is enough stray light in the room. The next slide makes this area appear darker gray. The third slide makes it a still darker gray with the first border darker than before and the second

border white. The next slide adds gray to all three and is itself white, and so on. The series is limited only by the intensity of the projector and the skill of the slide maker.

If the same series of slides is run with colored light, it will be found that very much the same series is followed. Surrounding a patch of colored light with a brighter border of exactly the same color will make the central color contain more gray and there will be little, if any, in the border.

Exactly the same phenomenon can be seen with uniform gray papers. If a moderately dark paper is separately illuminated in a dark room so that it is the only area visible, it will appear white. This is true even if under ordinary conditions it would appear black. Introduction of an area that reflects more light, however, will immediately change the former white to a gray, the amount of gray depending on the relative reflectance of the two.

When we were considering the perception of lightness and discussed the so-called lightness constancy effect, we noted that the observer could look for and, at least partially, see either the reflectance of the object or the intensity of the light. It is instructive to consider this phenomenon again in the present connection. Two typical situations will serve as examples.

Suppose we have a card of medium reflectance (a so-called gray card) at a distance from a light source, and a high-reflectance (white) card at a still greater distance. The observer is asked to match each of these cards with other cards held in his hand near the light source. He selects a gray and a nearly white card as noted earlier. Suppose also that the light reaching his eyes from the distant white card is less than that coming from the nearer gray. We now have the following situation. The observer has selected a pair of cards which have about the same relative reflectances as the two distant cards. The one with the lower reflectance he sees as gray compared to the other, just as he sees the distant ones.

Now, however, if he is a moderately well trained observer a further possibility exists. If he is asked to compare the **amount** of light reaching him from the distant cards he may be able to see that the light from the white one is of less intensity than that from the gray. If he can, he can also see that this light contains gray. Perhaps a more familiar example will dispel any feeling of strangeness about such a statement. If you see a shadow lying on a white surface under ordinary circumstances, there is no difficulty in noting that this shadow is gray. The shadow, however, is the illumination and what you are seeing is gray light. (Artists speak of the **volume** of the light in the shadows.)

Hence we have the seeming paradox that gray is the perception of relative brightness or lightness, whichever is being sought by the observer. If he seeks object properties, a gray surface may be seen even though the light be more intense. If he seeks illumination differences, the light may be seen as gray even though the surface is seen to be white.

Gray, then, is the perception of the relative effectiveness of two or more areas with respect to light perception. If reflectance is sought, it is the less efficient reflector that is seen as gray. If light intensity is sought, it is the less effective of the beams reaching the eye.

To anticipate ourselves: it will be found that in a photographic reproduction much confusion is caused by the fact that the print itself contains areas of various reflectances and that these stand in the definite illumination of the print. If they also represent white and gray areas as considered above, it is necessary that the illumination of these areas be very strongly depicted if proper perceptions are to be obtained.

Of black it is necessary to say little at this point. If we can consider gray as the relative effectiveness of the light from an area with respect to an observer, it is sufficient to say that black is the extreme of ineffectiveness. Either no light is perceived from the area, or perhaps more generally, very little light is seen and no area is less effective with respect to the light. The perception, however, is just as positive as that of gray. It is perceived that no effective light is being received from a particular area.

Actually, the maximum intensity that will be seen as black when it is the lowest intensity in a scene depends on the average intensity (adaptation level) for the scene. It is measurable and is known as the "black point." In general the ratio of the adaptation level to the black point is greater at high intensity levels than at low, and the presence of a still lower intensity will make the former black appear a dark gray rather than a black.

The relationship of black to the lightness constancy effect is not well understood although it is known that the constancy effect decreases sharply for surfaces of low reflectance.

Combinations of perceptions

Perception is a reaction of the organism to its environment. What lies outside itself is not a matter of indifference to an individual. The sense of vision is one of the primary ways of finding out. The external world is always exceedingly complex. Neither the eye nor the mind can grasp all the potentialities nor explain the things seen.

It is not surprising, therefore, to find that every view of the world carries with it emotional feeling. The organism does not reason a situation through systematically, it responds emotionally on the basis of experience. A certain area seen under one set of circumstances does not **feel** the same visually as it does in another.

Yet it would be a mistake to assume that this difference is due entirely to vision. Although it may be commonplace to say that the way we feel affects the way things look to us, it is probably nearer the truth than to say that what we see determines the way we feel. All parts of the organism affect the way each part reacts. A sunset may be beautiful in a romantic or idyllic mood or a terrible nuisance if you are trying to use it as a light source for judging colors. The color red may seem hideous during a severe toothache and very pleasant after a good night's sleep. What must not be overlooked, although it cannot be discussed in quantitative terms is the fact of the existence of the observer **as a person**. It is useless to attempt rules for the individual. Rules can apply only to the average observer under average conditions. The essence of the individual is his personalized reactions.

Hence if two people look at a cube we can be sure only that what they feel to be there is different for each. One may feel it friendly, pleasing, well-balanced, and the like, while the other feels it cold, impersonal, and indifferent. Although we have not chosen to treat of such subjects, we must at least remember their existence. Few of the seen properties of objects are purely visual in any strict physical sense.

C H A P T E R

HOW THE CAMERA
SEES
THINGS

Suppose we want to photograph a landscape from a particular point of view. A camera is set up and pointed in this direction. What happens as far as the light which is to make the picture is concerned?

We have first to think of the objects in the scene, then the camera lens and finally the film which is to receive the exposure.

The basic characteristic of objects, except for very shiny ones, is that when light falls on them it is reflected in many different directions. Once it has left the object it travels outward like the surface of an expanding rubber balloon. For smooth matte surfaces this reflection is more or less equal in intensity in all directions. Shiny surfaces do not distribute the light evenly, but reflect more in a single direction than in others.

Thus the light from the sun and the sky falls on the objects in front of the camera and is reflected from each object. However, only a very small fraction of the light so reflected reaches and passes through the lens of our eye or the aperture of the camera. It is only this small part that can be effective either for seeing or for taking pictures. The light which reaches any point of the lens, however, has traveled to it in a straight line from the object. This is the underlying fact of all image formation.

Light reflected by objects

Wherever the camera is located, light from every object or part of an object that can be seen is sending light to the camera lens. The light from each part of the object should be thought of as filling the whole lens. We want to consider what determines how much light will be sent to the lens by a particular object.

When light strikes a surface, it is reflected if the object is opaque and transmitted if it is transparent. Different objects differ in the percentage of the light that they reflect or transmit. This is the property that makes objects when seen in uniform illumination appear lighter or darker than other objects. Objects also differ in the percentage of light of different wavelengths that they reflect or transmit. This is the property that makes them appear of different colors.

It is a somewhat less fully realized fact that both of these properties vary according to the position both of the light source and of the viewer. Objects are relatively rare whose surfaces reflect exactly the same amount and quality of light in all directions. The highlight reflections on the human face, for example, would not be present if skin were perfectly matte and powder would be unnecessary to prevent shiny noses. Neither are the colors of most objects exactly the same when viewed from different directions. Human skin is again an excellent example, for its color varies both when the direction of the light is changed and when it is looked at from different angles.

In the extreme cases, of course, light is reflected only in one direction. These are the familiar shiny surfaces of mirrors, glossy objects and the like. Except for polished metals and some other rather rare surfaces such as some solid dyes, the outer surface reflected light has the same quality as the illumination. Usually the color of the object can be seen only where this outer surface is not reflecting the light directly into the lens. The colored light from the body of the object, however, may be quite well distributed and visible from a wide range of positions.

We have to consider, then, in talking about the reflectance of a surface for picture taking purposes that we refer to the light that it actually sends into the lens. Moving the camera slightly or changing the illumination may change the light from some surfaces by large amounts.

This change in reflected light with direction, in fact, gives nature a large part of the variety which she shows. It is responsible to a considerable extent for the visual solidity of objects under customary illuminations.

It is easier, therefore, to think of objects as sending certain amounts of light into the lens relative to other objects, rather than considering their

reflectances as measured under other conditions. It is this relative **amount of light which will** determine the relative effect on the photographic material. A surface, whatever its reflectance as measured under other circumstances will be darker in the photograph than any object sending more light into the lens.

We shall have to consider in the next chapters what the observer sees when he looks at the finished photograph. Here, however, we do not need to take this into account. **The intensity relations with which photography deals are those in the subject as received by the lens under the existing illumination.**

Image formation

We have to consider next what happens when light from an object passes through the lens. Since light from a single point on the object reaches all parts of the lens surface, we may think of the light as forming a tiny cone with the circular aperture of the lens as its base and the point of the object as its tip. The action of the lens is to form another cone on the other side of the lens. The tip of this second cone forms what is known as the image. This lies at a distance determined by the particular lens, on a straight line passing through the object point and the center of the lens.

A similar line can be drawn for every point of the image. It is sometimes helpful to think of the whole image as "traced out" by moving such a line around the contours of the objects in the scene.

The property of a lens that makes it bring light to a point is known as refraction. Light striking the lens surface is bent in its passage through the glass. For a given lens, the less the angle between the rays striking the **outside edges** of the lens, the **greater** the amount of bending. Accordingly, objects at great distances from the lens are focused **closer** to the lens while nearer objects focus further away. There are limits to these statements, however. After an object is at a considerable distance from the lens, further distance makes so little difference that the image point does not come appreciably closer to the lens (Figure 3–1). This distance of the image is characteristic of the particular lens and is called the "back focal distance." In most cases it is approximately the same as the "focal length" marked on the lens.

As the object point comes closer to the lens, the image point moves away from it. At a distance in front of the lens approximately equal for most lenses to the back focal length the light which enters the lens from

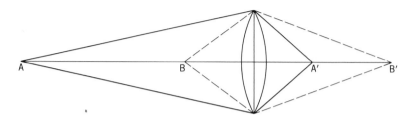

Figure 3–1. *Light from object point A focusses at A', that from B at B'.*

a point leaves it in a parallel bundle, and hence no longer produces an image point behind the lens. From a point still closer the light spreads out instead of converging and hence again no real image is formed. Between this front focal point and great distance there is a unique distance which is of considerable interest. For the usual symmetrical lens there is a distance in front of the lens at which it forms an image at the same distance behind the lens. The importance of this point lies in that (1) here the image is exactly the same size as the object, and (2) the distance of each from the lens (if of simple construction) is twice the focal length.

The three dimensional image formed behind a lens, therefore, is a little difficult to visualize. All objects at great distance (say beyond 50 feet) in the subject lie in the image at a single distance from the lens. As the object distance steadily approaches the lens, the image distance recedes from it at an ever increasing rate, finally forming an image at infinity when the front focal distance is reached and thereafter forming no real image at all. This is illustrated in Figure 3–2.

Image on a surface

Now if we introduce a surface into this image space at any position, it will intercept the light. Light coming from a point in the object comes to a point in the image somewhere behind the lens. It continues on again, however, beyond this point, forming a cone just as it does before reaching the point. When a surface is introduced, therefore, the light from a point in the object may represent a considerable area on this plane or it may be concentrated at a single spot. If the image area for that particular point of the object is large, it is said to be "out of focus" and, if small, "in focus."

A little consideration will show that for the points that are "in" (for a given position of the surface) there is a corresponding imaginary surface

in the object space which has similar geometrical properties. If the intercepting surface is flat and perpendicular to the lens axis as in the usual case, the corresponding surface in the object space is essentially flat and also perpendicular to the lens axis. If the intercepting surface is curved, or is flat but tipped, that of the object space is curved or flat accordingly. We can, accordingly, take out of this image space whatever we please of the image, depending on the manner in which we intercept it with a surface.

In the case we want to consider, this image is intercepted or stopped by a photographic material which has the property of recording the amount of light which falls on it at any point. Usually this material is flat, that is, lies in a plane, but this plane may be at any angle to the straight line through the center of the front and back parts of the lens and may be at any distance behind it. Those points of the scene that happen to form an image point exactly on this surface may, obviously, be represented by a very small part of the image. Those at greater or lesser distances along any particular line will then be represented by areas of various sizes.

We want to consider, then, what is "in" focus and what is "out" for such a plane surface.

Depth of field

It is now necessary to define what we mean by the word "point." It is apparent that the word refers, in common speech at least, to something round and quite small. It is the smallest division of a line, and a line may be thought of as a series of points placed side by side. Lines, how-

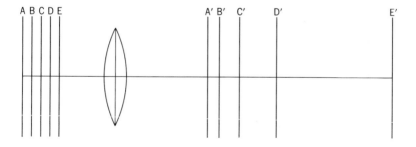

Figure 3–2. *For a series of equally spaced object planes (A—E) the image planes recede at an increasing rate (A'—E').*

ever, come in various widths and so also do points in the present sense. For present purposes a point may be considered as the smallest square part of a reasonably fine line. The question of the size of a point, therefore, resolves itself into that of the width of a "fine" line.

Once we assume a definite width for such a line, however, and say that all lines this width or smaller will be called "fine," then we have defined all distances in any direction in front of the lens at which objects form images producing such lines. The distance from the nearest to the furthest such object is called the depth of field for the image formed on the surface. All objects lying within this range are called in focus and those outside are called out of focus.

Note that the range over which objects are in focus for a given width of line depends on the distance of the objects from the lens. At greater distances objects are in focus over a greater distance.

What, therefore, governs the decision that a line is called fine and what properties of the lens may be used to meet the condition?

If an observer looks at the image light falling on an intercepting plane, he will see lines formed by the lines of the objects in front of the lens. The width of these lines will depend on the extent to which their distance makes them in or out of focus. Their apparent width will also depend, however, on the distance that he stands from this surface. If he is close to it, any given line will appear wider than if he stands farther away. The extent to which a given line appears in focus, therefore, will depend on his viewing distance.

In a similar manner the width of a line will also depend on the actual size of the image at the start. The actual size of the image as a whole formed on the surface must depend on the actual distance this surface lies behind the lens. This follows from the fact that each image point must lie on the straight line from the object point through the center of the lens. The width of the line must also depend on the distance to the place where this particular light will be brought to a sharp focus, that is, on the distance of the lens from this point. It further depends, as we shall see presently, on the actual diameter of the lens, since this governs the angle of the outside of the cone as the light approaches the focus point.

The parts of the image which may be considered to constitute "fine" lines, therefore, are determined by object distance in relation to surface distance, lens focal length and lens diameter as well as the distance from which the light intercepted by the surface is viewed. It is fairly well agreed that when a point source produces an image 0.004 inches in diameter, a series of them would produce a fine line when viewed at a

distance of 12 inches. At greater viewing distances the line could be wider and at shorter distances it would have to be narrower.

At a certain viewing distance, then, and for an image of a certain size relative to the objects, a picture will appear sharp if lines are reproduced as of a certain width **or less**. Since, when lines are exactly in focus, they have minimum width and when the object is either closer to the lens or further away they get wider, there is a range of distances in the object space over which all lines appear "fine" or in focus in the image. This distance is the depth of field for the lens as it is being used. Greater viewing distance of the intercepted image, smaller lens diameter or smaller actual image all increase the range of object distances which are seen to be in focus simultaneously. We shall see later that subsequent magnification or reduction of a photographic image so produced may be used to modify the effective depth of field in various ways.

Photographic images

We come, then, to the matter of the photographic image itself. Photographic film may be considered simply as a material that is sensitive to light in such a way that, after suitable treatment, it indicates the **quantity** of effective light to which each area has been exposed. That is, a properly exposed and developed photographic image is a direct record of the amounts of light exposure at each point of its surface. The amount of response which a particular film gives for a given quantity of light is determined by four principal factors: the **intensity** of the light, the **quality** of the light, the **time** of the exposure, and the manner of **development** by which the originally invisible effect of light on the film is made visible. It does not depend on the extent to which the light is polarized nor, over a considerable angle from the vertical, on the direction in which the light falls on the surface.

The relative intensities of the light at different parts of the image depend primarily on the relative intensities of the subject as seen from the lens. The actual intensity for any given area depends on a number of factors to be considered presently. The quality of the light depends on (a) the quality of the illumination on the scene or on a particular area of the scene, (b) the selective absorption characteristics (color) of the particular area. The effective quality, that is, the quality which is effective as far as the film is concerned will also depend on the sensitivity of the film to the various wavelengths. The time of exposure depends on the technique employed in making the picture and is usually controlled by a

shutter of some sort. The nature of the development can vary rather widely, but usually for a given film used for a particular process is fixed and repeatable, giving a fixed ratio between the amount of exposure and the amount of response.

These effects are considered in later chapters. The balance of this chapter is devoted to the intensities in the lens image and the geometry of the image on the film surface. Both these subjects are of great importance to any photographer who hopes to make full use of the possibilities of photography.

The complete lens image

We considered earlier the position of the image points behind a lens which was imaging a landscape, noting that there were corresponding "in focus" surfaces behind and in front of the lens. If these surfaces are examined for a given lens, it will be found that they can be planes only over a small distance from the lens axis. The image of a plane formed by a very thin lens such as those used for eye glasses tends to lie on a curved surface causing the greater distances to the outer parts of the plane to lie beyond the focus points. In lens design, however, the greater thickness of lenses for light passing through at an angle can be used with other aids to produce a longer focal length for this light. This can be balanced against the distance effect to produce a more or less plane image from a plane surface. There are, obviously, limits to this accomplishment and normally a lens is satisfactory if it is corrected for curvature up to half its focal length away from the axis. No image is formed, of course, when the light path is so oblique that it strikes the side of the lens mounting or "barrel."

The complete image locus of the best focal points of an object plane perpendicular to the lens axis is, therefore, a sort of saucer shaped affair with a circular, fairly flat area in the center, representing the part that has been corrected in lens design. The saucer is usually, although not necessarily, concave toward the lens. The only generalization is that outside of this corrected area the image of a plane tends to deteriorate rather rapidly. The edge of the total image is normally quite abrupt, forming a circle around the lens axis.

The complete set of images for all possible planes in the subject can be thought of as lying roughly within two cones whose axes coincide with that of the lens, the inner one consisting of a series of flat planes that change to curved surfaces in the outer zone.

If we now turn this picture around, so to speak, we will come to some quite useful lens properties. Instead of thinking of planes in the subject space and the images they form, let us consider planes in the image space and the corresponding subject space surfaces. (It is convenient to consider these as surfaces although they have a "thickness" at any point corresponding to the depth of field.)

It is apparent that within the cone over which the lens is corrected for curvature a plane in image space perpendicular to the lens axis is a plane in object space within the boundaries of a similar cone. Outside of this boundary, however, a plane in the image space produces a subject space curvature usually toward the lens. Near the boundary of the flat image region this property permits bringing into focus in a plane objects that are nearer the lens than the corresponding plane, but usually with considerable loss of sharpness in the image.

In this outer region of the lens image lenses of different designs will give markedly different results and perhaps it is in order at this point to say that this is true within the corrected area as well. Lenses represent distinct compromises, sometimes of very large order, among the numerous possibilities open to the designer. The requirement that all parts of a plane in object space lie in a plane in image space over the whole cone of light for all colors is not met by any lens. Lenses of different design will, accordingly, give different results depending on the things considered most important by the designer. This gives lens types a certain individuality which creative workers have been quick to sense, and favorite lenses are the rule rather than the exception among advanced workers. The differences in the central region of the image are usually, though not always, small, but in the outer regions may show up markedly. Some of the varieties of characteristics are discussed after considering tipped planes in the image space.

Tipped image planes

When we come to consider the use of the camera as a tool for producing desired results, we shall find that selection of a particular part of the spatial image is an important variable. While we are considering the complete image, therefore, it seems appropriate to discuss briefly the rather complex relations between positions of the film plane and the surfaces in focus in object space.

At first sight there would appear to be an infinite number of possibilities to consider because the film can be placed at any angle with respect

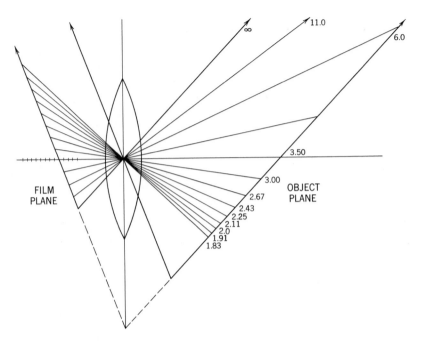

Figure 3–3. *A tipped film plane (FP) corresponds to a tipped object plane (OP).*

to the lens and can be placed at any position on or off the lens axis. In fact, however, there are only two variables involved. They can be considered separately. Once understood for a single camera position all other possibilities can be produced by changing the position of the camera. Remember that the camera can be **rotated** around a horizontal axis as well as pointed in different directions.

Consider first the simplest case of a film plane which is simply tipped at an angle to the lens axis but is still centered on the axis. Suppose the top of the film is tipped toward the lens. The top of the film is now nearer the lens and the bottom farther away than the center which lies on the axis.

We noted earlier that when the image point lies closer to the lens it corresponds to an object point farther from the lens. It also lies on the line connecting the image point with the center of the lens. Accordingly the bottom of the corresponding object surface has become farther from the lens and the top has come closer. It was noted, however, that for a given starting point, movement away from the lens brings the object

point **toward** the lens at a slower rate than movement toward it moves the object point away from the lens (Figures 3–3 and 3–4).

It is also possible to rotate the lens horizontally or vertically about its center. This is the equivalent of moving the film off the lens axis and tipping the film plane at the same time. Since, as we have seen, only the region directly around the axis has been corrected for curvature of the image plane, this, in effect moves the film from the center of this region toward the uncorrected outer field. The so-called "wide angle" lenses have been designed so that they have a larger than normal area of corrected field for their particular focal length. Accordingly, if the film is to be used much off the lens axis for sharp pictures, a wide angle lens becomes necessary. The outer boundary is set by the lens barrel, but there is also a loss in all other corrections near the outer boundary, and a picture in this region takes on the characteristics of the particular lens used (Figures 3–5 through 3–10).

The possibility of using these properties for particular purposes is considered in a later chapter. At the moment we want to consider the various aberrations and distortions which lenses can produce.

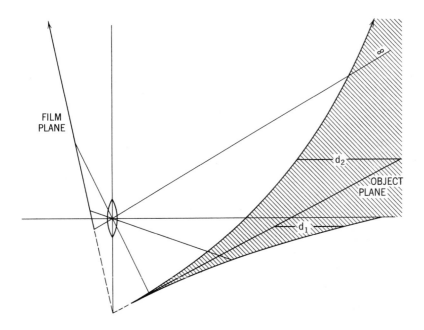

Figure 3–4. *The limits of depth of focus are curved surfaces.*

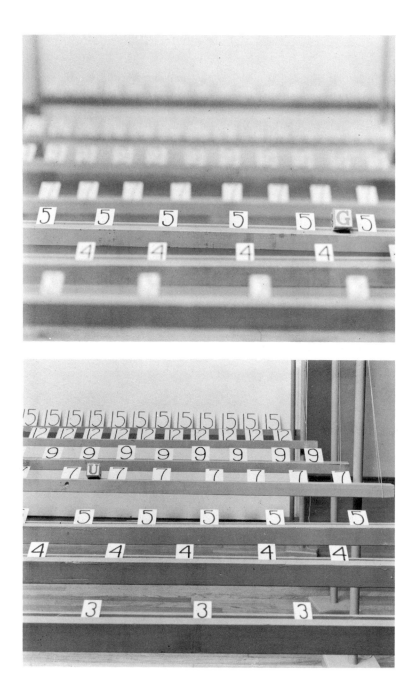

Figure 3–5. *Series of bars at distances shown in feet from camera. Lens and film axes perpendicular to the bars. Effect of lens apertures f/6.3 (G) and f/45. (U).*

Figure 3–6. *Same set-up. Lens and camera same as Fig. 3–5. Right side of film rotated in 20°. (N) Top of film tipped back 20°. (I)*

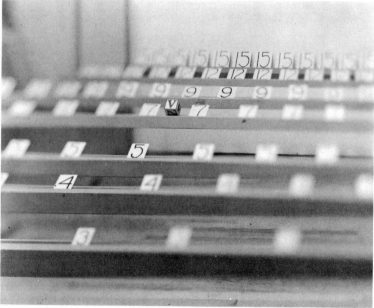

Figure 3–7. *(a) Lens and back of camera normal but camera rotated to left. (W).*
(b) Same camera position but film rotated until parallel with bars. (V)

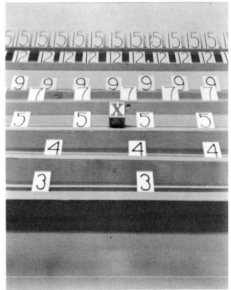

Figure 3–8. *(a) Top of lens tipped forward. Top of film tipped back. All rows same height. (Y) (b) Same as Y but rows adjusted to all be in focus. (X)*

Figure 3–9. *(a) Photograph of set-up and camera. All bars same height. (b) Photograph of bars as adjusted for 3–8b.*

Figure 3–10. *(a)* Showing distortion beyond edge of corrected region of lens. *(K)* *(b)* Same set-up as a. but film moved to best compromise position. *(L)*

Lens aberrations

The image formed by a lens is not always identical with the shape of the object. It is not necessary to consider the subject in any detail, but it is of some interest to note the various ways in which the image may vary with different lenses.

A plane in object space represents a series of points at increasing distances from the front of the lens as the point moves out from the central lens axis. At the same time, in opposition to the usual lens rule that the image will accordingly move toward the lens, it is expected that these points will fall on a plane in image space.

Largely as a result of the necessity to make lenses act in this manner, but also in consequence of inherent characteristics, certain effects enter into the image. Over the central region of the total image in a modern camera lens these effects are all minimized to such an extent that they are seldom visible. In older or cheap photographic lenses or lenses not intended for the purpose at all (spectacle lenses for example) they may be found very easily.

One such aberration is that of **astigmatism.** This aberration has the effect, among others, of accenting lines radial to the lens axis when they are out of focus in one direction from the focal point and lines which lie in circles around the axis when out of focus in the other direction. It is found most noticeably in single lenses, such as those commonly used for spectacles.

Another important aberration is known as **coma.** This has the effect of expanding points off the axis into a peculiar comet shaped figure. Coma is almost never found except in the presence of other aberrations and so cannot be illustrated by itself. The effect is predominantly radial from the lens axis in theory, but in fact a lens with considerable coma gives images which are best described as having poor definition that gets worse as the distance from the axis increases.

For a simple lens the focal length depends on the color of the light which it images. This produces numerous effects which can be partially or wholly corrected in the lens design. These are known as the "chromatic" aberrations. In the final image they may appear as over-all images of different sizes for red, green, and blue light even though all three are sharp, or as image surfaces of different shapes for the different colors. In lenses designed for color work both types of error may usually be neglected. The cheap lenses are liable to have seriously noticeable lateral chromatic errors.

Distortion in the image

In addition to the modification of shapes of small areas by lens aberrations, lenses may also differ in their reproduction of the outlines of large areas. These large discrepancies are usually called distortions. The sides of a large square in object space may bend out (barrel distortion) or bend in (pincushion distortion). In a "rectilinear" lens they are reproduced as straight.

This "justification" of the edges of a square is in strict accord with the classical theory of linear perspective. The result on the appearance of the picture will be discussed in the next section.

It should be noted that this lens correction brings the lens back to the state of a "pinhole" lens in this respect. A sufficiently small, sharp-edged hole in a very thin material will form a fairly good image. This image may be thought of as simply the projection of the small hole onto the film plane by the various points of the scene. It follows that such a lens has no distortion of the type considered. Every line in object space traces out its corresponding projection by means of the straight line through the hole. A corrected lens, therefore, as far as dimensional and directional relations are concerned may be thought of as producing a perfect linear projection of the object areas onto the film plane.

The situation may, perhaps, be illustrated by a homely example. If you were to sit in front of a window having small panes of glass and were to fix your head with an old-fashioned photographer's headrest or a modern psychologist's chin rest and tooth clamp and close one eye, the picture you would see through the pane would be the same geometrically as that given by a corrected lens or a pinhole. If you were to take a grease pencil and trace the outlines of the objects they would be the same as a lens of back focal length equal to your eye distance would produce on a film.

Visual perspective in a plane

The imaginary plane on which the image is traced from the viewpoint of a single stationary eye is called the "projection plane" in the subject of perspective drawing. Considered as a transparent plane between the observer and the scene it has the characteristic that the traced outlines of the subject are identical geometrically with what the eye sees. This is true whatever the position of the plane with respect to the ob-

server and is independent of whether the plane is tilted or not so long as the eye remains fixed.

Brief consideration of the properties of lenses will show that the shape of the image of this projection plane is identical with that of the photographic image behind the lens. It follows that corrected lenses give pictures that, almost by definition, give correct "classical" geometrical perspective. It becomes important, therefore, that we consider perspective carefully.

Assume that such an image on the projection plane has been produced, either by tracing or by photography. Then rather than looking at this image from the correct viewpoint with one eye, imagine it picked up and held at arm's length to be viewed naturally (that is with the line of sight perpendicular to the picture plane). Certain simple characteristics of the image may then be figured out.

1. All straight lines in the object space are straight lines in the image regardless of their position in space and their direction, and regardless of the angle at which the projection plane was tipped. The angles that these lines make with each other and their lengths will vary with the position of the plane but not their straightness.

2. All lines in space that are parallel to each other will either be parallel in this image or will meet at a point. This point may or may not appear within the image but will exist if the lines are continued far enough. It lies at the point in the plane where the line from the camera lens parallel to these lines cuts the projection plane, considered as a pane of glass in front of the lens.

3. Except for certain special cases any curve in object space will be represented by a different curve in the image. The shape of such an image will, again in general, vary with any change in the position of the image plane. Remember we are speaking of its actual shape in the image, not its appearance with one eye at the proper viewpoint; this tends to remain constant.

We may consider at once the important special cases under this third characteristic and then return to the others. It is necessary to describe what we mean by a "curve in object space." Suppose we have a bent rod lying on the ground some feet in front of us. As it lies on the ground it has one curve with respect to the ground, perhaps it is part of a circle. As we are looking at it, from our viewpoint, however, it is seen more nearly from one end of the rod and appears a much shorter curve than it "actually" is.

If we call this shorter curve which we see with one eye at the fixed

viewpoint the "curve in object space" as above, then we want to know the condition under which this curve will be reproduced as the same in the actual image. That is, so that when we pick up the image and look at it we shall see that it is the same curve.

Stated briefly, this condition occurs accurately only when the line from the center of the curve to the eye passes through the center of the projection plane and the plane is itself perpendicular to the line.

The situation is a little easier to visualize with a sphere, although it holds generally for all curves. If we want to see a sphere clearly, we look directly at it. The curve that we see representing its contour against the background is always a circle. Now if we consider a perspective projection plane the only condition in which a sphere is represented by a circle is, as stated above, when the line to the center of the sphere is perpendicular to the projection plane. For all other orientations of the projection plane the image is a more or less distorted egg-shaped figure.

On the other hand it is apparent that as long as the above condition that the plane be perpendicular to the center line is met, the distance from the observer to the projection plane changes only the size of the circle. It will remain a circle with its center on the center line.

We have, then, a dilemma: although an image in true perspective can be substituted (in theory) for the object space for a single fixed eye, yet it can represent curves and angular relations accurately only on the center line when the plane is at right angles to it. This is in fact the case, and we shall see later some situations where it becomes very important. Only objects on the lens axis with the film plane perpendicular are correct. Fortunately, it is also true that such distortions become obvious only at a considerable distance from the lens axis. They are seldom noticeable up to 30 or 40 degrees from the axis unless the subject is unusually critical or lens distortion amplifies the effect.

Visual mental projection

It is rewarding to look at the matter in a somewhat different way. The eyeball rotates around a point about a half inch behind the lens and clear vision results only when the lens axis is directed toward the object at which we are looking. Accordingly in vision all spheres, wherever located, are seen to have circular contour edges or outlines.

When we look at the world, therefore, what we see as long as we do not move our eyes, or move them very little, can be described adequately by the image on a properly placed projection plane. What we see as a

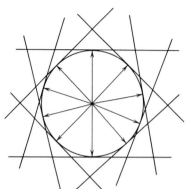

Figure 3–11. *The succession of all planes perpendicular to the line of sight is a sphere.*

mental image, however, for the scene as a whole, cannot be so described. The mental synthesis performed in the art of seeing corresponds to a perspective projection in which the projection plane is always perpendicular to the line of sight for all eye positions (Figure 3–11). Such a projection surface is a sphere with its center at the center of rotation of the eye. Such a spherical projection surface would represent all external spheres as actual circles in its surface.

Plane perspective can now be seen to be limited to areas of the spherical image in which the surface of the sphere is not enough different from that of a plane to matter for the purpose in hand.

A whole series of consequences follow from regarding the matter in this way. It is seen, for example, that if the projection plane is far from the eye, a larger area may be used as though it were flat. This is a special case of the fact that the angle of view is restricted to small angles. A long, but not very high, vista could be represented adequately by a cylinder (as was done in the old panoramas). Subjects consisting wholly of straight lines might not be objectionably distorted even at quite wide angles, etc.

The problem of representing on a flat surface the exact geometry of our mental images, becomes, in fact, identical with that of the mapmakers who are required to represent the surface of the spherical earth on a piece of flat paper. They have little difficulty with small land areas but encounter serious trouble with continents.

It is also true, of course, that for the eye placed at the lens position there is no geometrical difference in the direction of the lines of sight whatever the projection surface may be. It can be argued, therefore, that one is as good as the other because neither of them would be exactly

right from any other viewpoint. The next chapter is devoted largely to a consideration of what we see when we look at photographs. It might be stated here, however, as a simple and not very accurate generalization that the tendency of an observer looking at a photograph is to attribute at least in part to the object shown in the picture, the actual geometrical shape of the image in the picture itself. An egg-shaped projection looks more like an egg than it does a sphere. The fact that it is viewed from one viewpoint with one eye will decrease the tendency but seldom eliminates it, and in any case photographs are not useful if they carry this restriction.

Systems of parallel lines

In somewhat similar fashion it is instructive to consider the factors affecting the angles between lines, particularly those which in object space are parallel to each other. Two special cases are important, one represented by lines which in space are parallel to each other and to a fixed line of sight (case 1), and the other, in which the lines are parallel to each other but perpendicular to the line of sight (case 2). The first case is that of railroad tracks with the observer between them, and the second the front of a building seen from across the street.

Remembering that we are dealing with the projection onto a plane of a spherical image and that optical image size decreases linearly with distance, we have the following situation (Figure 3–12a).

The end of the railroad tracks or any lines parallel to them project on the sphere as a point (the "vanishing point" of perspective drawing). This point coincides with the fixed line of sight chosen for the system. It is the point where the plane touches the sphere.

Lines at right angles to the line of sight are parallel to this plane. They also meet at a point on the sphere, but the projection of this point onto the plane is at infinity. In other words, lines in space parallel to the projection plane remain parallel. Since the system is symmetrical about the line of sight this holds for all such lines regardless of the orientation.

Parallel lines at an intermediate angle (Figure 3–12b) meet at a point on the sphere where the sight line is parallel to them. The projection of this point onto the plane is at a finite distance and often falls inside the image area.

The usual case for the projection plane and the one which gives the most conventional images is the one in which the projection plane is vertical and perpendicular to a viewing direction centered on the hori-

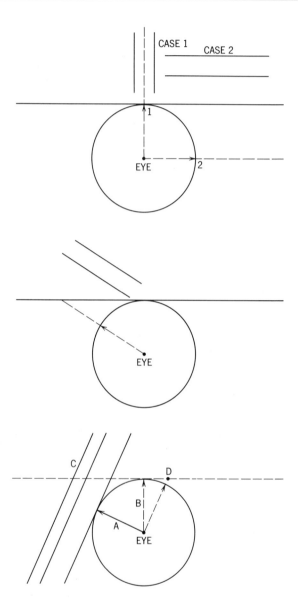

Figure 3–12. *(a) Line of sight parallel to a pair of parallel lines perpendicular (1) and parallel (2) to observer. (b) Parallel lines at an angle to the observer. (c) Three ways of viewing any pair of parallel lines.*

zon. Under those conditions all verticals remain vertical with no conver-
gence from top to bottom, and all horizontals either remain horizontal or
converge toward one part of the image or another depending on their
position and orientation. Thus the vertical sides of a square would re-
main vertical whatever happened to the top and bottom.

Tilted projection planes

If the projection plane is tipped in one way or another, there are two
possibilities that have to be considered. Any tipped plane may be thought
of as touching a projection sphere at one point. The two possibilities
arise when (A) (Figure 3–12c) the fixed line of sight does pass through
this point, and (B) when it does not. The actual total images produced
in the two cases are the same but the first, A, arises when both the fixed
line of sight and its perpendicular projection plane are swung around so
that the plane is parallel to a particular set of lines, C. This corresponds
in photography to simply moving the whole camera so that it points in
the direction A. The situation then becomes that of the preceding sec-
tion. The second case arises when only the projection plane is tipped to
produce the same result. This corresponds to revolving or tilting the film
plane in the camera without changing the central axis, B.

It is seen that in both cases the same image is produced although the
lens points in a different direction for each, and hence each makes dif-
ferent demands on the lens and may select different parts of the field. In
any case, the net result is to make a pair of lines that, if photographed
without correction in the direction B, would have converged toward a
point, photograph as parallel. Cases in which this may be desirable will
be considered later.

It should be noted that the picture photographed along path B, but
with the lines parallel, represents an impossible visual appearance of the
subject. The fact that the lines are parallel indicates a perpendicular line
of sight, but the relative position of objects with respect to the lines cor-
responds to that seen along direction B. In practice, however, this sel-
dom matters, and entirely natural looking pictures can be obtained in
this way provided the lens is capable of meeting the demands (Figure
3–13). Tilting the plane of the film in this manner has come to be called
"correction" of the photograph since it is used to correct unwanted con-
vergences in the picture.

Figure 3–13. *(a) Rectangular picture and other objects photographed from the side. (b) Same with film plane parallel to picture frame. (c) Same objects photographed from the front. Note change of size and position of objects in b.*

Correction and depth of field

If the diagrams of the previous section are compared with those presented earlier under depth of field in tipped planes, it will be found that the requirements in the two cases are in opposite directions.

Suppose two parallel lines make an angle with the line of sight as shown in Figure 3–14. To make the lines parallel on the film would require that it be tipped or rotated to position B. To make the plane of best focus lie along the lines would require that the film have a position such as A. Use of these properties of the image, therefore, always tends to introduce problems either of distortion or of image sharpness.

In solving this problem rotation of the lens is sometimes helpful, especially if it is designed for wide angles of view. As the lens is rotated around a vertical axis through its center, the planes of sharp focus rotate with it, remaining perpendicular to the central lens axis. In theory, therefore, if the lens were rotated until it were perpendicular to the film plane in position B, the focus plane corresponding to the image lines would lie in the film plane. This amounts to having the picture very far off the lens axis, however, and might well be outside the field for which the lens is corrected.

Lens apertures

Most corrected lenses are equipped with variable iris diaphragms by which the size of the opening or aperture of the lens may be varied.

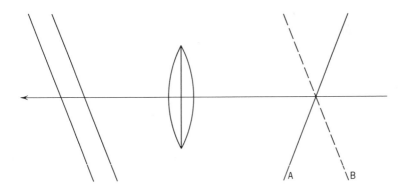

Figure 3–14. *Film position B would correct distortion; A would give best depth of focus.*

Varying the aperture varies the cone of light that the lens picks up from points in the object space. It accordingly changes the amount of illumination in the image. The amount of light picked up and hence the intensity in the image is proportional to the **area** of the diaphragm opening. This is true for any lens and for any point in the image, but holds strictly only if the image is in focus on the film.

If a large, uniformly lighted area, such as a uniform white wall is imaged on the film, the intensity of the image is not uniform over the whole area. With everything else constant the intensity of the image decreases steadily but at an increasing rate as points lie further from the central lens axis. The decrease becomes quite severe for points far off the axis and so sets a limit to the size of the picture unless special techniques are used.

Three factors are involved in this decrease in intensity: the decrease in area of the diaphragm opening as seen from the side, the increase in distance to the film, and the angle at which the light strikes the film. All these factors depend on the angular distance of the point from the lens axis. For this reason they can be expressed for all lenses in terms of the back focal distance as a unit. For a film plane at right angles to the lens axis the per cent of axial illumination is given below for circles around the axis at distances from the axis of zero to two times the back focal distance.

Distance from axis in fractions of back focal distance	$\frac{1}{4}$	$\frac{1}{2}$	$\frac{3}{4}$	1	2
Percentage of axial illumination	87	64	41	23	4

It is seen that at a distance from the axis equal to one focal length the image intensity has decreased very seriously to approximately one-fourth that in the center of the image. If the lens barrel did not interfere, the intensity would be only about 4 per cent at twice this distance. Such a position, however, would be some 63 degrees off the lens axis and beyond the corrections of most lenses. The extreme corners of pictures seldom exceed a distance of one-half the focal length off the axis if the lens is used as recommended. Severe perspective correction procedures as discussed in the previous section, however, do approach these outer regions, and allowance must be made for this effect in calculating exposures.

The intensity of the illumination for any part of the image varies for a given lens not only with the aperture of the lens but also with the magnification of the image. The larger the picture the lower the intensity, in proportion to the area.

For an object at more than eight or ten times the focal length in front of the lens the magnification is proportional to the focal length. This has made it possible to use a quite simple designation for lens apertures. The illumination in a given area of the image under such conditions remains constant if the diameter of the aperture is a fixed fraction of the focal length. That is, if the ratio of the diameter of the aperture to the focal length is constant, the illumination is theoretically the same for all lenses. This has led to the so-called f-stop system for marking the apertures. The symbol f/8 means that the ratio of the aperture diameter to the focal length is 1 to 8. Any lens set at f/8 should give the same image intensity for the same subject if at infinity.

Unfortunately this equality of all lenses is not realized in practice for many reasons. A surface treated lens, for example, may transmit considerably more image forming light than an untreated one, and a camera left to accumulate dust on its lens may transmit less than half what it should. For accurate work, accordingly, it is necessary to test this relationship for any particular lens. Some lenses are actually being calibrated in terms of the measured transmittance of the lens at the different aperture settings.

It should be noted that this f-stop system is correct only for distant objects. When the object is near enough to the lens so that the lens-to-film distance has to be increased to give a sharp image, the illumination on the film decreases. For objects near the camera this decrease can amount to a large error. The error, for the same camera distance, increases with focal length so that with the larger cameras it has to be included in the exposure calculation. It is known as correction for "bellows extension" since it is chiefly of importance with view-type cameras. For a change in object distance from infinity to 40 inches the error is 10 per cent for a 2-inch, 36 per cent for an 8-inch, and 64 per cent for a 16-inch lens.

Since the f/value is a measure of the ratio of the base to height of the cone of light which forms an image point, it follows that all lenses when set at the same f/value will form image points by means of a cone with the same angle at its apex.

It can be shown (see, for example, Hardy and Perrin, p. 464)* that depth of focus in the image space depends almost entirely on the magnification if the true f/value of the lens is at a fixed value. It follows from this that for an **image of a given size** object magnification on the film, the depth of field is entirely independent of focal length and depends only on the aperture setting. For a picture image of a given magnification,

*Arthur C. Hardy and Fred H. Perrin, *The Principles of Optics*, New York: McGraw-Hill, 1932.

therefore, it is not possible to change the depth of field by using a lens of a different focal length.

Changing the f/setting for a picture of a definite size will change the depth of field greatly only if the magnification is small. For pictures comparable in size to the object the depth of field is so small that the f/value does not give an appreciable change in terms of the depth of the objects being photographed. For very small images, however, not only is the depth of field great at all apertures but also increases rapidly as the lens is "stopped down." From both points of view, therefore, there is a great advantage optically in images of small size. Since subsequent enlargement to desired size decreases the depth of field more slowly, this is sometimes the only way in which a particular assignment can be handled. It is, unfortunately, difficult in color photography.

There is a still further advantage in small magnifications which is often overlooked. It will be seen from the above, that for a given depth of field a larger aperture can be used for a small picture than for a large one of the same object. If critically sharp pictures are desired, this may become important because of the change in the inherent definition given by the lens as the aperture is varied.

Most corrected lenses give maximum image sharpness at some f/value approaching their rated maximum opening. Depending on the particular lens design this inherent image sharpness may increase or decrease slightly from maximum opening down to say f/5.6; at smaller openings there will generally be a steady improvement until values around 11 to 16 are reached. At about this point the lens will start acting more or less like a pinhole camera and the quality of the image will get steadily worse all the way to the smallest opening. On the other hand, some lenses at f/4.5 give images of not much better quality than a properly designed pinhole and have much less depth of focus for close work. A small picture size, accordingly, permits operating the lens in its region of maximum sharpness wherever that may be. The minimum useful magnification, of course, is limited by the resolution of both the lens and the photographic material, which are often of similar magnitude.

Illumination on tilted planes

We have considered both the position of the "in focus field" and the perspective of the images when the film plane does not lie perpendicular to the lens axis. There remains to consider the illumination distribution in such a tipped plane. It is beyond the scope of the present work to discuss the matter in detail, but it was pointed out above that image illumi-

nation depends on three factors. Each of these varies across such a tipped plane.

Suppose the film plane is rotated at an angle to the axis. Portions of the image lying off the axis are less intense for that reason as discussed earlier. They are also less bright because the distance to the lens is greater and because the light strikes the film at a still greater angle. On the other hand those portions of the image nearer the lens are more intense than the axial because these factors offset the normal loss due to the angle from the axis. The change in illumination from one side of the image to the other, therefore, has been tremendously increased. If a great tilt is necessary for any reason it may also become necessary to adjust the lighting of the subject to counteract this effect.

Contrast relations in the image

Distinct from the question of general illumination distribution in the image but more important as far as ordinary photography is concerned is the matter of the local variations of intensity caused by light from the subject. In general there are two types of lens effects that can change these relations over those proper to the objects. The first and most widely publicized is that due to the condition of the lens surfaces. The second, not so widely known, is the effect of the definition given by the lens for fine detail.

In the first category come reflections from the glass-air surfaces and scatter of light either from dirt on the lens or from the bellows or lens mount of the camera itself. All of these are called "lens flare," or "flare light."

Both of these causes of scattered light tend to take the general light from the subject and spread it over the whole image plane. The result of this, again in general, is to add light in equal amounts to all parts of the image. Since the image consists of various light intensities, however, it is apparent that a constant amount added to a very small intensity will have a much greater percentage effect than when it is added to a relatively high intensity. Such flare light, therefore, has the result of decreasing the contrast of the image by adding light which is more effective in the shadows than it is in the brighter parts. In some cases this may add to the quality of the result, but it always decreases contrast.

There is a secondary effect of lens surface diffusion which often decreases **apparent** contrast. If there is a light source in the field of view, a dirty lens will tend to spread the image of this source so that it may fill an appreciable part of the picture. If the surfaces are treated and

clean, this will not occur and the light source will be much more sharply imaged on the film. The actual intensity relations in the image may not change greatly, but the appearance of the picture may be remarkably different.

Change of contrast of fine detail with sharpness of focus, on the other hand, is of the essence of the picture. Consider an image so badly out of focus that the entire image plane is uniformly illuminated. Such a condition very nearly exists, for example, if the film is in contact with the rear surface of the lens. All of the light which reaches the lens from the subject is evenly distributed over the film plane and no image, properly speaking, exists. (This is the condition which exists in the image plane when an illuminated condensor is being reimaged.)

As the film plane is placed at greater distances from the lens, the image gradually takes form. This is the equivalent of saying that regions of contrast start to form in accordance with the intensity distributions of the subject. The limiting value which the contrast may attain is that of the subject itself but it approaches this (for fine detail) only when the film lies accurately in the image plane, and when the lens is capable of resolving the fine detail.

Imagine, for example, a black surface on which are marked fine white lines. A certain amount of light reaches the lens from any small part of this line and this light is converged toward the image. The light from the black surface we will assume for the moment is too small to affect the film. The light for the white line then will be distributed over the whole width of the line as it reaches the plane in which the film is placed. If at this position the line is three times the width it would be if it were sharply focused, then the intensity in the plane will be, on the average, one-third of the maximum it can attain. It will have, accordingly, one-third the contrast against the black that it should have.

In assuming that the black gave no exposure, of course, we have set up a rather special case. The fact is that this does not change the relation. A large area is not much changed in area if the film is not exactly at the sharp image point. The edges of the area become less sharply defined, but the size of the area as a whole does not change appreciably. Accordingly, the light that produces the image of a larger area is still distributed over about the same area, and its intensity is much less dependent on sharpness of focus.

It is seen, therefore, that sharpness of focus is important largely because of its effect on the contrast of fine detail and, perhaps to a lesser extent, on the sharpness of edge contours. Examples of this are shown in the accompanying figures (Figure 3–15). We shall see in a later chapter

Figure 3–15. *Flower pots in sharp focus with background in and out of focus. Objects out of focus lose image contrast very rapidly.*

that the apparent contrast of the picture as a whole decreases with decrease in fine detail contrast, over and above the physical decrease we have been discussing.

The so-called "diffusion disks," which produce softness in the image but which operate rather by introducing aberration into corrected lenses than by introducing diffusion, take advantage of this decrease of contrast for fine detail. If a subject is to be photographed in which the fine detail is not considered desirable—perhaps a close-up of a person's face, then loss of sharp focus will have little effect on the general brightness relations although the picture will look less contrasty, but may go so far as to make invisible fine lines of low contrast in the subject. At the same time, such a lens image does not reproduce the fine detail represented by the weave of fine fabrics and the like and so is objectionable if these are to be shown.

Sharpness of image focus, then, is predominantly important when fine detail that has low contrast in the subject has to be shown in the photograph. It may be objectionable if the fine detail is not wanted.

Advantage can also be taken of this fact to subdue the details of an unimportant background. By choosing a depth of field which throws a background very much out of focus, not only are the contour edges of the objects diffused but their contrasts against each other are so decreased that they will cease to demand attention from the observer. This is the so-called "selective focus" technique.

Motion in the subject

Sharpness of image has been seen to depend on a number of optical factors. There is, however, another factor of a slightly different nature that may play an equally important role. This is motion of the image with respect to the film, whether produced by the motion of the subject or by that of the camera while the picture is being made.

It was noted under depth of field that at a given viewing distance a certain small area in a photograph could be considered a point, and a succession of them a fine line. Lens conditions affecting these have been discussed. The same holds for the reproduction of fine detail of objects in motion as well as for the sharpness of reproduction of their contours.

If an image is displaced a certain distance on the film during exposure, the light for any part of the image will be spread over this distance just as in the case of an out-of-focus lens. Contrast of fine detail will decrease, and edge contours lose their sharpness. In addition, since the

motion, in general, will be in a certain direction, the greatest effect will be on lines perpendicular to this direction and much less, if any, on lines parallel to it. For this reason the effect of such motion is usually clearly visible as a directional blurring.

Such blurring can be caused by camera movement during exposure. The amount of image motion that occurs with camera movement depends on the speed of the movement, the time of exposure, and the magnification of the image. (At the same magnification steadiness requirements are independent of focal length.) Since magnification tends to increase with focal length, steadiness requirements are more critical for the longer focal lengths. If subsequent enlargements are to be made all to the same size, the requirements again tend to be the same for all cameras.

Since the amount of image movement at constant magnification depends on the time of exposure as well as the speed, there is a definite maximum exposure time beyond which cameras cannot be held in the hand to obtain critically sharp pictures. For fairly heavy cameras this time can be as great as $\frac{1}{25}$ second (hence well within the range of synchronized flash) and with the lighter ones $\frac{1}{100}$ to $\frac{1}{200}$ second depending on experience. For extremely critical work it is unlikely that any camera can be hand held.

Motion in the subject, of course, follows similar rules. Since the magnification depends on distance of the subject as well as on focal length, they may be considered separately. The subject motion which can be tolerated depends on what might be called the angular velocity of the subject, that is, the angle at the lens through which it moves from the beginning to the end of the exposure. This angle depends on the speed, the direction of the speed, and the distance to the object.

As a rough rule, divide the estimated distance in feet by the estimated speed in miles per hour and then divide the answer by one thousand. Thus for 25 miles per hour at 50 feet the setting is $\frac{2}{1000}$ of a second or $\frac{1}{500}$. This rule gives a large safety factor so that $\frac{1}{400}$ or even more would probably be satisfactory. This is for maximum speed at right angles to the lens axis. For motion at 45 degrees the time can be doubled, and for motion directly toward or away from the lens can be multiplied by 4. If it is desired to show slight motion blurring, the numbers can be multiplied by 3 or 4. This rule assumes subsequent enlargement of small images to normal viewing distance size.

It should be noted that if only a single motion is present in the scene, the photographer has some choice as to whether he will take the blur in the background or on the moving objects. By "following" the motion with the camera the blur will transfer to the background to the extent to

which he has been successful in moving the camera in synchronism with the object.

It is also interesting to note that in the case of a rotating object such as the pendulum of a clock, an automobile wheel, a spinning top, or a dancer the actual speed of the motion depends on the distance from the center of rotation of the point considered. This means that to stop all motion, the exposure must be set for the fastest motion.

For almost all moving objects normally encountered, even when fairly close to the camera, motion can usually be stopped by electronic flash light operating at flash times from a five-thousandth to a ten-thousandth of a second. This is usually the most practical present day solution to the problem where the stopping of all motion is really necessary. Large units are of sufficient intensity to permit the use of small f/values and swing backs where necessary for close work.

Shutters and moving objects

In the discussion to this point it has been assumed that the shutter opened and closed instantly, that is, that there was no moment when the shutter was partially open. The only type of shutter for which this is true is the so-called "focal plane" shutter. In this variety a slit in a black curtain moves across the film at a position slightly in front of it, the lens being open all the time. The time of exposure is controlled by the speed of the curtain and the width of the slit, the time being determined by the time required for the width to pass a given point on the film. Any point on the film accordingly is either being exposed or not being exposed.

The conventional "between the lens" shutter, on the other hand, has to open at the center as a small hole which widens to the full lens diameter and then reverses and closes again. With this type the intensity at any point in the image increases from zero to a maximum which it holds for a determined length of time and then decreases to zero again. It is apparent that "time of exposure" for such a shutter is a somewhat different concept than for the focal plane type. The intention in rating such shutters is the same in both cases. The same total amount of light is supposed to reach a given point in the image in each case but for slit openings narrower than the film it takes longer to do it for the whole picture with the "focal plane" shutter. The only other common kind of shutter is one in which a hole in a metal plate is moved rapidly across the lens. In this case the lens opens at one side and closes at the other. The intensity in the image increases from zero to a maximum and reverses the process to close.

The between-the-lens and focal-plane types of shutters have distinctly different effects on the records of moving objects. Suppose a small, bright square area is moving across the field of view of the camera. With a between-the-lens shutter at the first instant of opening, the square will be in a certain position. This portion will record on the film faintly. The lens then continues to open and the object continues to move. For a period in the middle of the exposure the full intensity acts and the lens then closes in the same manner. The photographic image formed under these circumstances will no longer be a square but will be elongated in the direction of its motion. Furthermore, the beginning and end boundaries of the square will be diffuse: they will start from zero and increase to a maximum exposure and at the other end will reverse. The speed with which the shutter opens and closes will change the distance over which the lead or retreat edges blur. With the focal plane shutter, on the other hand, there will still be blurring of the same edges; but the total elapsed time will be less, and the blur will be shorter.

An interesting difference between the two types may be seen in the case of the wheel of a moving vehicle. If the car is moving so fast that a considerable part of the wheel's diameter moves during exposure, five different kinds of distortion may occur. With the conventional shutter the wheel will simply blur, with the upper part blurring more than the lower because it is moving very much faster. (It is assumed for all these cases that the camera is held still, if it is moved other effects can occur.) The other four depend on the direction of motion of the focal plane shutter with respect to that of the image. The shutter can move up or down or across the film in either direction.

Color relations in the image

We considered somewhat earlier the contrast relations in the image. It is now necessary to look briefly at the relationship between the colors of the objects and those of the corresponding images. We can neglect for the moment the effects of lens aberrations and lens flare and consider only the image from a "perfect" lens.

The light that reaches the lens from any small part of an opaque object is the part that the object reflects toward the lens of all the light which is falling on it. This residual light accordingly consists of that from all the sources of light minus what the object does not so reflect. It is somewhat beyond the range of this book to consider in detail the physics of how this occurs. It is necessary, however, for every photographer to be aware of certain basic facts. The matter is discussed in

considerable detail in the author's "An Introduction to Color," and should be mastered by any photographer who intends to do work which is critical for color.

One important point is that as far as the image is concerned, it does not matter what part of the spectral energy distribution at any point is due to peculiarities of the light source and what part to those of the object. It is true that in vision we are quite successful at seeing the illumination and the object separately—as discussed in the first chapter. The image behind a lens, however, has a single light quality at any given point which can be described completely by stating the amount of energy present at each wavelength. This is the light which will be used to expose the film. Accordingly, if either the color of the light source or its energy distribution is changed, it is exactly equivalent in the image to making the corresponding change in the object. Whatever the observer may see from the photograph, therefore, the record is based on the combination of the light sources and the objects. It follows that if two light sources have the same color but different energy distributions they will in general produce different energy distributions when reflected from an object. In general the appearance of the object will change, but whether it does or not the photographic record will be made from this new energy distribution and may not reproduce the same as before. (We shall see that this is because photographic processes are not perfect in this sense.) Changing the quality of the light source, therefore, is the same as changing to new objects. (This is often true even if the new light source is "corrected" by a color filter.)

A second point which must be borne in mind is the fact that the principal light source may or may not be the most important one for a particular part of a particular object. If part of an object is standing in a shadow formed by the main light source, the light reaching the object is either reflected by other objects or reaches it from a secondary direct source. Such areas, accordingly, may have very different colors than that of the directly lighted part of the object.

A third point of occasional importance is that reflection of the light source from a polished surface (other than that of a metal) will have the energy distribution of the light source itself. That is, such reflections have the color of the light source and are not affected by the color of the object. Metals, on the other hand, reflect selectively from their outer surfaces. The specular reflection of a white light from glazed tile, for example, is white regardless of the color of the tile, whereas reflection of the same source from polished copper is orange.

The quality of light in the image, then, assuming the lens to be per-

fect, is not the selective reflectance of the objects but the energy distribution of the light that reaches the camera lens.

Lens effects on color

We noted that general lens flare, including that from reflections inside the camera, has the effect of distributing the general light from the whole scene over the whole of the film. All flare, however, can be considered as light from the subject or light source which has arrived at the wrong place. Two broad examples will cover all the possibilities. Assume a dirty lens that simply diffuses a certain percentage of the light passing through it. If no light besides that from the subject falls on the lens, a little of the light from all parts of the subject will reach each point of the image. If the sum of all these contributions is colorless, then white light is added to all the colors, but a much higher percentage is added to dark and saturated colors than to unsaturated light ones. The net result is a decrease in the saturation and contrast range of the image as compared to the subject. The same result is obtained if direct light from the source falls on the lens from some angle outside the image cone. Occasionally, however, the subject itself will be so highly colored that the flare from it is colored. In this case this predominant color is added to all parts of the picture but has the greatest effect on dark colors. It also desaturates complementary colors more than it enhances the color of the subject. The net result is seen as a general shift of dark colors toward that of the brighter parts.

It is possible with an uncoated lens to get actual multiple reflection images which focus bright parts of the subject in the image plane. Such flare spots are usually located in the wrong part of the image and colored the same as the spots from which they arise.

With modern coated lenses which are clean, neither general flare nor flare spots are obtained. It should be noted, however, that reflection from the inside of the bellows is not decreased by coating the lens. In the existing methods of coating lenses it will be seen by examination that the lenses take on more or less color. The color that is seen when the lens is viewed is due to a small amount of colored reflection at the surface. Since this light is reflected back toward the objects, it does not reach the image and the image is, to this extent, deficient in this color. Hence a lens which appears blue will lack blue in the image and gray surfaces will tend to appear yellowish, etc. This effect can become quite serious if one lens image is to be compared with another under rather critical con-

ditions. For most purposes it is unimportant. Old lenses often show a yellowing of similar magnitude.

Such color in the lens acts exactly as though the light source had been changed. A colored transmitting medium over the lens is exactly the equivalent of changing the energy distribution of the light source in the same manner. It gives all the same effects as far as the colors of the objects are concerned with one exception; if any of the objects in the scene are fluorescent then a colored medium over the lens and the same one over the light source may give very different results.

There is a further aberration which often occurs in inexpensive lenses. It is known as lateral chromatic aberration, as mentioned earlier. When such a defect is present, the size of the sharp image in the focal plane changes with the color of the light. Thus a picture by red light may be noticeably larger than one by blue even though both may be sharply focused. This means that in the center of the picture the image of a white card on a dark ground may have colorless edges, but as it is moved off the lens axis fringes start to appear at the edges. Fine detail near the edges, therefore, may have the wrong color.

The perfect lens image

A lens image is perfect for photography if, for all parts of the subject (1) points in the object space are reproduced as areas small enough to produce the desired detail; (2) angular relations are those given by lines from all points of the object that pass through the center of the lens; (3) intensity relations are identical with those of the light falling on the lens from corresponding points in the object space; and (4) the energy distributions at these points are the same as those of the light that produces them.

Such an ideal can only be approached, but a modern corrected lens properly coated is close enough for all practical purposes.

The "perfect" photographic result

This lens image discussion permits us to describe a concept which is useful for most theoretical discussions of color photography. We can describe the color photographic result as "perfect" if it meets the following requirement. The photograph, illuminated by the light (including filter if any) used to make the exposure, and the same size and brightness

as the original camera image, should exactly match that image visually, point for point.

While this statement is substantially correct, it may be more readily understood if stated conversely.

The perfect photograph viewed in a particular illumination should match visually, point for point, the camera image which would have been produced had the subject been illuminated (including filters) by the same light source, to the same intensity, etc.

Neglecting scientific niceties, they both say that a perfect photograph would be an exact visual match of the camera image, not of the subject.

This is only one of the possible definitions of a perfect photograph, but it is convenient and is the one which will be used in this book. There are several very important restrictions on this definition, which must be noted immediately, although they will be developed later.

1. The definition does not say that a "perfect" photograph would be satisfactory for purposes other than matching the lens image. It would not necessarily look like the subject.

2. The requirement is that the photograph "visually match," not that it be like it in any other way. In general, the spectral energy distributions of the two will be distinctly different.

3. The definition does not eliminate systematic distortion which is later corrected by photographic manipulation. It simply states loosely that the photographic process is perfect if it does not introduce systematic visual distortion in the final result.

4. The definition defines the photograph as perfect only when it is illuminated by the light used to make the exposure.

5. The definition includes lens defects, that is, any uncorrected lens distortions would be "perfectly" reproduced.

6. The definition definitely does not apply to black-and-white photography where distortion of relative brightness is necessary to compensate for loss of color contrasts.

There are other possible definitions in which the properly lighted and positioned photograph would send light to the eye that would match the light from the corresponding part of the subject seen under the same conditions. The present definition is preferred here because of the difficulty of defining the "same conditions."

C H A P T E R

COLOR

AND FORM

IN PHOTOGRAPHS

A color photograph is a reproduction of a lens image. As such it is itself an object. Sometimes it is intended to be seen as an object. At other times it is a means of creating so complete an illusion that we are aware of only the objects in the photograph. In this latter case it is necessary that the photograph as object disappear as far as possible. It is desirable, therefore, to consider what makes a photograph appear more like an object and what tends to mask this appearance. We shall also find these factors of vital significance in what is seen in the photograph.

The photograph as object

We normally are aware of the existence of an object beyond our reach by the simple fact that we "see it is there." All photographs, to some extent and no matter how produced or displayed, can be located as objects in space and seen to exist as "real." It is only when some restrictions are placed on the observer, such as not permitting him to leave his seat, or forcing him to look through a small hole that he can be made to doubt the existence of the photograph as such.

As an object, a photograph has certain well defined properties. It

usually lies in or on a surface, it has certain dimensions, its surface is shiny or dull, it may be transparent, it may or may not have a border around the outside, etc. Sometimes these properties are difficult to see, and sometimes they force themselves on us so strongly as to be unavoidable. The extent to which they are noticeable, however, is to some extent an indication of our awareness of it as an object.

A photographer always makes a picture for a particular reason. Whatever this reason may be he has to contend with the fact that his final result will be both an object and a reproduction of objects. He cannot carry out his purpose satisfactorily unless he so balances his factors that the observer will tend to see the result as the photographer intends he should. It follows, of course, since different media have different properties, that different media are suitable to different intentions. It follows equally that different media have different limitations.

Extreme types of photographs

With this thought of the restriction of different media in mind it might be well to consider the nature of the different types of photographs before considering their properties.

There are two extreme types of photographs. As examples we can use simple transparencies projected on a screen in a dark room and prints on paper with a white border seen in a normal environment. The first is a completely isolated event taking place in the dark by itself. The second is a perfectly normal object in a normal environment. We can consider all the types in terms of these two. It should be noted, however, that they differ primarily in that the first is the only thing visible to the observer at the time of viewing, while the second is simply one object among many.

We saw earlier that the observer tends to adapt to both the brightness and the color of the scene at which he is looking. The exact level of adaptation is caused by the scene in a rather complex fashion. High brightnesses and large areas predominate in the effect, and the level finally reached is probably often quite different from the average for the scene. The level, however, both for color and brightness is definite for a definite part of the scene. If attention is devoted primarily to a fairly large segment of the scene, adaptation is determined to a considerable extent by this part, but for a small part of the scene it is set more by the surrounding areas.

When a picture is projected in a dark room, it is the only source of

light causing adaptation. It does not cover as large a part of the visual field as does a lighted room so it is seen as surrounded by black. Since this black surround represents an area from which little light reaches the eye, its effect is to permit the eye to reach a somewhat higher brightness sensitivity than if the whole field were filled. The projected areas, accordingly, look somewhat brighter than would be expected. As far as color adaptation is concerned, it is also apparent that any effect must come from the projected area. The eye, therefore, has a strong tendency to color adapt to the picture as though it were the whole scene. It is opposed only by such natural tendency as a black, and hence neutral, surround may have to return it to some resting color adaptation state (presumably daylight). The observer sees the projected picture, accordingly, with eyes adapted to a brightness level somewhat lower compared to the picture than he did or would the original scene. He also sees its color with eyes adapted to the photographed area exclusively except for a bias toward daylight or something close to it. If the picture has large areas of bright strong colors, his adaptation will tend strongly in that direction. This is presumably what also happened in the subject, so the result is an improvement.

On the other hand, when he looks at a paper print in a fully lighted room, the situation is quite otherwise. In the first place the print is usually surrounded by a white border or, if it is not, there is likely to be a white surface nearby. His adaptation level is set, not by the print so much as by an environment in which this white is often the brightest area. In the original subject a white would have been seen with respect to its environment and lighting. In a picture of the scene, however, this white cannot be as light as the border of the print and still retain detail, and may be very much darker. The print, accordingly, will normally look darker than the original subject. Furthermore, color adaptation will tend to be set by the normal environment in which the print is examined rather than by the print itself. The whole subject will be discussed more fully but the appearance in the two cases may be quite different.

Specific types of photographs

It is instructive to consider one by one the major types of photographic reproduction and to weigh their effects on brightness and color adaptation before we go on to other effects produced by any or all of them.

There is, first, the **small photographic print.** This normally subtends a smaller angle at the eye than the original scene and is small in its envi-

ronment. It usually has a white border which separates it somewhat from the surroundings and tends to make it somewhat darker, but otherwise has little effect on the environment as controlling the observer's eyes. If viewed against a black background, without a border, in strong light, however, it may become nearly as effective as a projected picture (with no hands in sight).

If the photographic print is enlarged, then it gradually tends to take over the observer adaptation, usually still under the control of the darkening white border until quite large. A quite large print, say 30 x 40 inches, viewed from a distance of a few feet may so completely fill the field of view that it is more in control of the situation than a projected picture and so may come quite close to producing the same relative adaptation as the scene itself did.

The next logical type to consider is that of a transparency over an illuminator. If the brightness of the illuminator is such that a white in the transparency matches a white beside the illuminator and the whole surface of the illuminator is covered by the transparency, the transparency will look like a print and will act like one. Its effect will depend on its size and on the nature of its surroundings. However, if the illuminator is brighter than this, as is usual, the eye level will tend to be set more and more by the transparency provided it covers the whole surface. The limit is reached by a large transparency in a dark room where it usually is more completely in control than a projected picture. It usually is brighter than it is possible to project and it often subtends a greater angle at the eye. A large transparency completely covering a rather high intensity illuminator is, in fact, probably the ultimate in eye control by a photograph. It still leaves the fact that in the original scene the eye may have been controlled by its environment and so may give the wrong appearance to the picture.

If the whole surface of the illuminator is not covered, the situation changes. Because it is normally brighter than the surround, it usually controls the eye brightness level. This makes the transparency appear darker and tends to hold the color adaptation level to its color. This last effect may be beneficial and may be used to eliminate unsatisfactory surround conditions.

We can consider next the projection of still or motion pictures on a screen in a darkened room. Eye adaptation level, as noted, is set by the picture under influence from a surround which permits partial dark adaptation but otherwise pretty much controls the condition of the eye for brightness and for color. Addition of a projected surround around the screen moves the effect toward that of a print depending on its width and brightness. At first if a low brightness white border of considerable area

is added at a brightness lower than that of a white in the picture, there is a slight apparent enhancement of the highlights, especially if they represent light sources. This is due apparently to acceptance of the border as white and recognition of the relatively higher brightnesses of the lights. At the same time there is a marked movement toward seeing the picture as though it were either a print, or a transparency over a low brightness illuminator. Addition of a border brighter than the picture dulls it to the point where all of its whites appear gray, at the same time making the blacks deeper. Use of a colored border, or course, moves eye adaptation in this direction and the picture tends to appear shifted toward the complementary hues. (We might note here that rear projection on a screen seen in daylight has the characteristics of a transparency over an illuminator.)

One further type of photograph should be mentioned here as it will be discussed again later. This is the **stereoscopic photograph**. At present this may be seen in three forms, each of which is exactly equivalent to one of the above types. It may take the form of the **parallax stereogram**, which normally is a transparency over an illuminator in a light or dark room and acts the same except that it may appear somewhat darker due to its low transmission. It may be **projected** on a nondepolarizing screen and be viewed with polarizing glasses. Again, except for loss of general illumination level, it acts like usual projected pictures. Or again it may be viewed in a small **hand viewer** either with built in light source or held up to a convenient light source for viewing. In some viewers the eye pieces are so made that little light reaches the eyes except through the system. In this case, if sufficient time is allowed, the result is like that of a projected picture in a dark room. If it is used in bright daylight, however, with a built-in low wattage lamp, the daylight eye adaptation may persist long enough to make the pictures look very yellow. Some eye pieces, however, are simply flat lenses with no eye shades, and in these the eye adaptation condition may be set entirely by this outer light. This will happen particularly if the light through the instrument is considerably less intense than that in the room in which it is used.

The appearance of the photograph

Having considered the various types of photographs, we want now to consider more closely the effects these conditions have on the appearance of pictures. In setting up the concept of a perfect reproduction of the camera image it was noted that this implied the light source by

which it was viewed. We will now make the further assumption for present purposes that the illumination quality is the same for all types and that all types when so illuminated produce the same physical stimulus for the eye. This permits us to consider the illumination as a separate variable rather than to discuss it for each type.

The illumination can vary in intensity without changing the quality of the light reaching the eye from any one area of the photograph. This does not mean that the appearance of the photograph does not change. It can be stated quite generally that the appearance of a picture, if considered critically, is constant over only a small range of illumination levels. Most observers are unaware of the fact because it is a purely visual effect and so applies to the appearance of all other objects as well.

In order to describe the effects it is necessary to keep two different factors in mind. There is, first, the absolute level of the illumination, the intensity which can be measured with a light meter. Second, there is the adaptation level of the eye with respect to this absolute level. These have to be considered as independent because it is the **illumination of the photograph** which is measured. The eye adaptation is set by the whole scene and hence may be adapted to high or low brightness levels compared to the photograph. The absolute level of both, however, is also important.

It is difficult to generalize on the change of appearance with conditions because a great deal depends on the actual nature of the picture being viewed. The greatest effects occur, of course, when the photograph is quite small compared to the total field of view.

Suppose the intensity level falling on the photograph is quite low compared to that of the general environment in which it is being viewed, but that the whole level is moderately high, say average daylight. Under these conditions the photograph is a poorly illuminated, and hence dark, object. Whites in the picture will tend to look muddy, details in the shadows will tend to block, and saturated colors will tend to gray over and look dull. Much of this can be offset by the observer unless the lighting difference is extreme, by simply looking directly at the photograph for a sufficient time to force his adaptation in its direction. This again will depend on the size of the photograph. The larger it is the more completely it may be made to set the adaptation level. Holding the print close to the eyes has the same effect.

As the absolute intensity levels decrease from those of daylight, there is a steady exaggeration of the effects just described. At quite low general levels the picture itself may be almost indistinguishable unless lighted to nearly the adaptation level. At extremely low levels, of course, such

as prevail outdoors on a dark night, the subject matter of the picture will be quite indistinguishable, breaking down into perhaps a white area for the lighter parts of the picture and all the rest the peculiar black seen under those conditions. Color disappears, of course, before these very low levels are reached.

When the photograph is brighter than the average to which the eye is adapted, a number of important changes may takes place in its appearance. Again the exact effect depends on the subject matter and the extent to which the photograph controls the eyes. A print lighted to a higher level than the surroundings is perhaps the usual case where a print held in the hand is being studied by an observer. Under these conditions the tendency is very strong to hold it close to a light, or if, possible, to hold it in direct sunlight. This is done so that the observer can "see it better," and this describes the change in appearance. More detail is visible throughout the whole scale, dark colors show their true hues, bright parts of the picture seem brighter and shadows are not so dark. There is, accordingly, some tendency for the print to look too light, so that a print made to look best in full sunlight would usually look too dark under other conditions. This effect depends also on the absolute level. In artificial light with the same ratio of print to background illumination as in sunlight, a lighter print would be required for the same appearance.

A separately lighted photograph or projected picture seen in an otherwise dark room is a special case of the above. Such a photograph, especially if quite large in size, goes a long way toward setting observer adaptation as already noted. In most cases it goes far enough so that the eye condition is determined by the **subject matter of the picture.** This interesting situation has a number of important consequences. To at least a slight extent the effects hold true for all photographs under all conditions of viewing. The first consequence of adaptation to the subject matter is that white, gray, and black do not correspond to definite intensities of light, the identical intensity on the screen being seen as any of the three in different pictures. The picture, therefore, must contain within itself the required brightnesses and areas to make the areas have the desired appearance. This is usually not a troublesome task but it can become very much so. For example, the photography of a light gray object when everything else in the picture is darker can be very troublesome. It may be possible to make such a picture but the usual result when projected simply shows it as a white object. Inclusion of a true white object in an identical picture will immediately make the object appear gray and this is the usual solution. A similar situation exists with respect to black in that a certain amount of the picture area must be

much lighter in order to have a good black appear. In amateur color movies this is quite apparent in underexposed pictures. The maximum density of the film then often appears quite light on the screen and gives the impression the film has been fogged, whereas in other parts of the same film where proper exposure has been given this same density may appear a good black.

A second effect observed when the picture controls adaptation has to do with color rather than brightness. Consider a picture being projected in an otherwise dark room. Imagine that after it has been viewed for some time a transparent light blue or light yellow material is suddenly placed over the projection lens. It is apparent that the change in the appearance of the picture would be seen easily. If it were left over the lens, however, the effect would "wear off" almost at once and the pictures would appear much the same as they did before. It is this fact which makes it possible to project the same pictures with many different types of equipment which actually may give quite different qualities of light. This same fact, however, means that each individual picture also sets the color adaptation state of the eye based on its own colors. Any general over-all color tends to decrease with a corresponding increase in the saturation of complementary colors. For average subject matter this is quite valuable in that pictures can be "off balance" quite badly and still look good, but for some subjects it may introduce quite serious color distortions.

Perhaps we can consider as a third effect that of color in the surroundings on the appearance of the picture. Such effects are due to adaptation also, but have the more common name of simultaneous contrast effects. It may be stated quite generally that any large areas around the picture will shift the over-all color of the picture toward the color complementary to that of the surround. Blue surroundings will tend to make the picture look yellow and vice versa, and so forth. This is particularly true if the surrounding color is due to illumination of a color different from that used to illuminate the picture. A tungsten light projector, for example, will give very yellow looking pictures in a room lighted by daylight and an arc projector may look quite blue in a tungsten lighted room. The effect is decreased, of course, if the picture is brighter than the room and attains the maximum effect (if no room light illuminates the picture) when the two have equal brightnesses. At lower relative levels the saturation of the effect decreases, and the picture tends to be grayed rather than colored.

These effects hold for all possible types of viewing, such as separately lighted reflection prints, projected pictures either on a white screen or

projected through a translucent screen or a transparency seen over an illuminator. An illuminated border if brighter than the picture moves a projected image toward the appearance of a print in a lighted room.

One other effect might be mentioned at this point although it is not very often encountered. When a picture is seen in an otherwise dark room and is quite small, either because of its actual size or its distance, or both, it is entirely possible to light it so brightly that it cannot be seen comfortably or accurately because of the glare it produces. This is because the small area is not capable of completely controlling the adaptation level. It is quite possible to get untolerable glare from pictures projected at 50 foot-candles when daylight may be quite comfortable at 5000. The effect is steeply dependent on the size so that there is an optimal brightness for each size of picture and viewing distance. Too little light makes the picture hard to see and too much makes it hard to look at, so to speak.

Relative appearances of pictures

As might be expected from the preceding discussion, if a picture is seen under conditions in which it affects the state of the observer's eyes it will affect the appearance of the next picture seen. There are two seemingly different situations in which these effects are encountered, although actually they are the same. In a motion picture or any other viewing device in which one picture is replaced suddenly by another, the second is seen, at least briefly, with eyes adjusted to the preceding one. The phenomenon is known as successive contrast. It differs from the simultaneous contrast mentioned above, and which occurs when two pictures are placed side by side, only in the time sequence of events. This time sequence, however, does somewhat modify the final result.

When two pictures are seen side by side in such a way that they are the brightest objects in the field of view—prints under a lamp, over bright illuminators, projected side by side, etc.—the observer looks from one to the other. As he does so the successive contrast discussed above occurs. If the first picture appears pink, the second will appear green, assuming it normal. He now looks back at the first and it may look somewhat less pink than before but now the second looks a little greener. No matter how often he looks back and forth, one will stay pink and the other green. What has occurred is observer adaptation to both pictures so that his eye sensitivity is intermediate between the two both for brightness and for color. Note that one of these has been assumed normal but is being seen as green. If these pictures had been seen **alone** and

studied they would each have been seen as normal. Together neither looks right. In practice this reduces to the amusing generalization that if two pictures which have slightly different over-all color are viewed side by side, brightly lighted, the best color will always be judged as "half way between the two." Stated in another way the eye cannot judge the over-all color of a picture if it is seen under conditions in which the picture can set eye adaptation conditions. One solution of such problems, of course, is to surround the pictures with a brighter border of a color which is supposed to look white. If large enough and not too bright, the true colors can be seen.

Prints, especially with white borders, and seen under normal illumination in a normal environment, can be seen in their true colors with amazing precision. The eye can detect easily a difference of over-all color in two prints comparable to that which can be detected by the best measuring instruments. It can compare them readily and almost as accurately with a mental normal by reference to the surroundings.

Photographs as localized in space

We have seen that photographs are real objects showing properties possessed in common with many other objects. In addition to those mentioned they may also have many other properties. The surface may have a definite texture, or it may be glossy, or the surface may be glossy but the picture itself may have a definite texture not associated with the objects shown. This might be due, for example, to a texture screen. The material of which the photograph is made may obviously be paper or white film base, or the picture may be on a piece of ground glass or a white screen which itself may have texture, etc.

All these obvious possibilities contribute to one of the most important perceptions involved in seeing a picture. They permit the observer to see with greater or less clarity that it is an **image** at which he is looking and not real objects. It will be found shortly that psychologically this is a very important fact and one which accounts for many of the differences between the appearance of a "perfect" photograph and the real objects which it depicts. These factors will be taken up in some detail under their appropriate headings later in this chapter. It might be interesting to note here, however, that at least one investigator has recognized the problem and designed a projection screen that is very difficult for the observer to localize. Adelbert Ames, Jr. (U. S. Pat. 2,542,789) has described a doubly curved screen that causes the eyes of a suitably

located observer to change their relative positions while passing over its surface, as though this surface were at infinity. This eliminates one of the clues to the position of the screen in space. The screen is viewed through a nearer aperture, obviously not in the screen plane. Under these conditions certain types of single projected pictures take on a startlingly three dimensional appearance. The screen has two cylindrical curvatures at right angles to each other and the two radii are different so that the screens are difficult to make. As far as the writer knows, they have not been widely used, due largely, perhaps, to the fact that the number of positions from which the effect is successful are quite limited.

Nearly all other forms of photograph can be localized by one means or another. Even stereoscopic transparencies at wide angles in a viewing device that eliminates all stray light are often seen as localized due to dirt specks, scratches and the like and are quite completely located if the photographic image has visible graininess.

Photographs as representations

Having considered a photograph as an object, we come now to one of its major characteristics, that of the picture as a representation of real objects in real situations. In the preceding chapters we considered the subjects of perspective, image quality, and color and defined a perfect photograph as one that made a perfect copy of the lens image that its surface intercepted. We want now to consider the observer in relation to such a picture. For the moment also we want to assume that the purpose of the photograph is to represent exactly the way the objects looked. That is, we now want to inquire whether or not such a picture is likely to look exactly the way the scene looked in front of the camera.

A photograph is taken from a definite point of view; the scene stands in a definite illumination; shapes, sizes, and distances of objects have certain definite values. We want to know how and whether the observer who was not present when the picture was taken sees these things and others correctly. The photographer was present at the scene and had all sorts of opportunities to know the facts. Any other observer, however, has only the photograph and must gain all his knowledge—and hence what he sees—from what it can tell him. Some of the difficulties he may encounter are elementary and obvious, others are far from it, but they must all be considered systematically to get a well-rounded view of the problem.

Position of the observer

It is difficult to understand some of the apparent anomalies of photographic reproduction unless we realize the visual task a photograph sets for an observer. From a visible two-dimensional object the observer is requested by the photographer to see as though the situation were quite different. He is asked, in fact, to forget that it is a photograph and see through it to the objects. The observer, however, except in certain cases, is usually unwilling to attempt anything of the sort seriously. Perhaps the time when he does so most completely is in motion picture viewing, and by far the least in looking at small reflection prints. We have seen that these represent the extremes in object quality. They also will represent the extremes in any anomalies introduced.

In viewing a reflection print the observer seldom makes any attempt to forget it is a photograph and, in fact, seldom wants to. He thinks of it and looks at it as a photograph of something. He is as ready to answer the question "What do you think of the picture?" as he is "What do you think of the objects shown?" In other words his perception is almost consciously twofold. It is never quite clear to him, however, how much of what he is seeing as a property of an object in the scene is really a property of the photograph as such and how much of what appears to be a photographic property actually belongs to the objects. We shall find that this is the crux of the whole matter. What he sees is a sort of unconscious compromise which has far-reaching effects on his perceptions of the objects in the scene. We shall find this principle operating in nearly every type of perception possible from a photograph.

One of the more obvious examples deals with the position of the observer with respect to a print. Suppose the print is hanging on a wall and he is standing directly in front of it with his eye level in the center of the picture. The picture, in other words, is in a plane vertical and perpendicular to his line of sight.

Now the camera may have had this relation to the subject when the picture was taken and it may not. If it did not, then the observer is required to figure out from the picture what this relationship was. He usually starts with the assumption that the camera was horizontal and the plane of the film vertical and perpendicular to the lens axis. He starts here, unless it is "obviously" wrong, because the great majority of pictures have been so taken in the past. If it had been customary to take all pictures looking down at an angle at 30 degrees, he would have started there. In any case he now almost consciously—and sometimes

not only consciously but laboriously as well—tries to figure out where the camera was. Having been educated by photographs since early childhood, he is very good at the game and usually sees instantly the direction the camera was pointing and "sees" the objects then from this point of view. The only difficulty lies in that he is very often wrong and is almost always influenced by his position with respect to the print. Remember that, in the absence of other indications, he assumes that the objects had the same relation to the camera that the print has to him. If the assumption is incorrect, then to him the objects have accordingly a different shape or position. That is, the objects he perceives are those that would have had the required shape and position to give the reproduction from his assumed point of view. The aim of the present discussion has been to establish the fact that the apparent position of the camera is almost conscious choice on the part of the observer, based on what he thinks he is seeing, and that it is also strongly influenced by his own position with respect to the actual photograph.

Thus far we have considered only the angle of view with respect to the object, that is, the direction in which the camera was pointing and in which we must imagine ourselves to be looking even though we are not. This is not the only factor in position relative to the objects, however. We must also decide how far from the objects the camera was placed and so how far away we must imagine ourselves to be. One element in this is camera perspective, but at the moment we want to consider other, and often more important, factors.

Suppose you are confronted by an object at some distance **but with no indication of distance other than the object.** Your judgment of distance under these circumstances must be based on your judgment of the size of the object. The larger the object is assumed the further away it will appear; the smaller it is taken to be the nearer it will appear. Such situations are relatively rare on the ground, although they are the whole basis for judging distances in the air. In a photograph, however, such situations may almost be said to be the rule rather than the exception. As the magnification is usually unknown to the observer, even the clue of retinal size operates against his correct perception. That is, he is thrown back on two assumptions. First, that the object is of normal size, and second, that it has been photographed so as to occupy a reasonable proportion of the picture.

Let us examine these a little closer with examples.

In either of the pictures of the marble shown, it is apparent that when you think of it you must make some assumption about it. The assump-

Figure 4–1. *There is a tendency to interpret small image size in relation to the picture area as small size in the object and vice versa.*

tion can be either that of observer distance or of size of marble. The final assumption is usually based on experience of average size for the object shown. This means that, in general, each person sees it of a different size.

Because of a second assumption, however, it is possible for the photographer to suggest the true size even in the absence of comparison objects. This rather vague assumption is that the photograph itself is at the average magnification for most of the photographs of its size the observer has seen. Accordingly he expects a large object to more or less fill the picture and a small one to leave a lot of space around it. Figure 4–1 shows the same marble made to appear large and small because of this assumption.

These factors make it necessary, when photographing a subject not likely to be a part of general observer experience, to include some familiar type object of fairly constant size for comparison. Excellent examples are found in the pictures taken by geologists where the formations shown can be 6 inches or 60 feet for all the observer can tell. The usual solution is to include some simple object like a hat, a ruler, a person or the like. Even so, care must be taken to use standard objects. Figure 4–2 is self-explanatory. What is the size of the cube? The large shoe is size 52.

This indeterminacy on the part of the spectator is the basis for a highly developed phase of photography. In motion pictures it is often quite out of the question to photograph the real objects doing what they are supposed to do—an ocean liner in distress in a storm, for example. Such sets are produced in miniature with such precision that it seldom occurs to anyone to even wonder how they were able to make the picture.

In a similar vein the problem of the distance to an object and between objects depends largely on the assumptions made by the observer. In the simple case of an object seen alone with no reference objects it is apparent that distance and size are related to each other. When there are reference objects, however, the position in which the objects are seen relative to each other depends on a whole host of assumptions as to probable size, most likely position, probable relationships and the like.

This phenomenon might fairly be called the perception of place. Things are placed in a scene where it is most likely they should be, without much regard as to where the other indications show it to be certainly. There is, thus, a capricious element introduced in that unfamiliar and illogical scenes are more or less rebuilt to suit the conventional concepts of the observer.

This is a fortunate element for those who have to provide illustrative or entertainment pictures for the public. Backgrounds projected on a screen simplify the problems of pictures in a distant location, and "glass shots," where the whole top part of a spectacle was painted on glass a

Figure 4–2. *The same cube is shown with two different shoes and both shoes are shown together. The larger shoe is size 52.*

few feet in front of the camera, were the stock in trade of the earlier producers and are still used to a great extent even on our present wide screens.

And even this is not the whole story. Portrait photographers have long since discovered that people with long jaws and those with short may be made to conform to the average by simply choosing a point of view which permits the observer to make his own choice. The experienced average, or even perhaps his own preference, is apt to be what the observer sees.

The same effect, of course, is present in all photographs, whether by design or accident. We tend to see things in a reproduction where they ought to be in our experience rather than where they more certainly were by careful analysis of the picture.

Perceived depth

One of the major elements in a photograph is the depth of the scene, that is, the distance from the front to the back. The correct perception of the shape of the objects very often depends on being able to see this dimension in its correct relation to the other dimensions.

We have just discussed a number of factors that tend to affect the picture as a whole. Depth, however, often acts independently of the other two and may be seen as much greater or much less than it should be without affecting the other dimensions. There are good reasons why this should be so. Once the position of the camera and the distance to the scene have been decided, regardless of whether either of them is correct or not, then these angular relations at the eye determine horizontal and vertical apparent distances within any plane at right angles to the camera axis. If the film plane has been tipped, of course, these relative distances may be seen incorrectly but at least they have a physical-visual basis. Distances from front to back, however, have no such simple basis. The distance along any line not at right angles to the axis depends on the angle of that line with respect to the observer. The angle that it appears to make is decided by how far he thinks it is to the other end. This in turn depends on the depth which he is perceiving.

A single lens photograph, as we have noted, is a two-dimensional picture representing objects in three dimensions. Any depth that is seen in the reproduction must be a mental construction by the observer, based on experience in three-dimensional seeing. It will be well at this point to make a distinction that is frequently overlooked. There are two kinds of

depth in a picture. There is the indicated depth produced by the geometry of the image, the placement of objects and the like. This indicated depth permits a studious observer to figure out what the depth may have been. This he can and often does do by a purely logical process—although the correct answer is not always possible of attainment even by this method. The second type of depth is the perceived depth, that seen directly by the observer as depth. This is a new concept for many people and has been treated at some length in my earlier book. A glance at Figure 4–3 will describe what is meant. The depth seen in the two pictures, which are geometrically identical except for the shadows, is what we are calling perceived depth. The indicated depth is more or less the same in both as far as geometry is concerned, although of course the shadows do give some further clues for making estimates. The perceived depth, however, is greatly different. Perceived depth, then, can vary tremendously with little or no change in the geometry of the image. As the perceived depth decides how far it looks from front to back, the relationship of this to the apparent magnitude of the other dimensions will decide the shape of the objects seen.

We can proceed, then, to consider what factors determine the depth that will be seen. They include nearly all of the so-called monocular depth clues for normal vision as discussed in the second chapter. These have been studied extensively for vision by a number of psychologists.[*] Adelbert Ames, Jr.[†] also studied a number of clues for paintings, which are close to our present discussion, and they have been studied for photographs by Gibson[‡] during and after the war.

All perception of depth in a picture starts with the fact brought out in the beginning of the chapter that a photograph is, first of all, perceived as a two-dimensional object. Any depth perceived in the picture has to overcome this obstacle. Accordingly there is a rivalry between the two perceptions and, as noted earlier, a compromise is usually affected between the two. We would expect to find, therefore, and do, that those forms of photographs such as projected pictures in a dark room, which appear the least like real objects, show the greatest depth. The identical pictures seen as reflection prints may give rise to so little depth perception as to distort the objects seriously. It is one of the major facts in the viewing of

[*]Harvey A. Carr, *An Introduction to Space Perception*, New York: Longmans, Green, 1935. Robert S. Woodworth and Harold Schlosberg, *Experimental Psychology*, New York: Henry Holt, 1954.

[†]A. Ames, Jr., Charles Albert Proctor, and Blanche Ames, "Vision and the Technique of Art," *Proceedings of the American Academy of Arts and Science*, 58:1–47, 1923.

[‡]James J. Gibson, *The Perception of the Visual World*, Boston: Houghton, 1950.

Figure 4–3. *More depth is seen in objects which are "contrast" lighted (below) than when they are "flat" lighted (above).*

stereoscopic pictures that the photograph as an object almost disappears. Much of the depth seen, and all of it for objects beyond a certain distance, is due to this disappearance of the photograph as such. This is very convincingly demonstrated by simply mounting two identical pictures in a stereoscope. The increase in perceived depth is sometimes really startling. In fact during the previous vogue of stereoscopic pictures many identical pairs were sold as the real article. The phenomenon is the same as that of the Ames projection screen described earlier. It must be remembered, therefore, that the following discussion applies in quite different degree to the various types of photographs even where the difference is not specifically mentioned.

Perspective

One of the more important factors, although not the only one that makes an individual see depth, is the geometrical perspective of the picture. As already discussed, a lens image falling on a flat film automatically and always, if it is a good lens, produces correct geometrical perspective. Such an image is, in fact, practically a definition of classical geometrical perspective.

This means (for film perpendicular to the lens axis) that parallel lines, except those in a plane perpendicular to the lens axis, will converge to a point somewhere inside or outside of the picture frame. Lines parallel to the lens axis will meet at the point where the axis cuts the picture plane. All other systems of parallels will meet at the point where a line parallel to them from the lens would cut the film plane. It is this convergence that we have learned to interpret and to some extent see as depth. We see it as depth no matter how it is produced. Before discussing this further we must consider the viewing distance of the print.

A picture in correct perspective may be thought of as a window through which we look at the objects or scene. If held at the correct distance from the eye and properly oriented, with the eye placed where the lens had been, it would exactly cover the subject point for point. It could do this, however, for only one distance from the eye, since at greater distances it would be too small, and at shorter too large, to fit. This distance, if there has been no subsequent change in picture size, is usually equal to the back focal distance of the lens. Pictures, however, are ordinarily viewed from a great variety of distances so it becomes necessary to understand what such a change means in terms of the perspective and the represented objects.

The actual size of the image of an object depends directly on its distance from the eye or camera lens. If you have an object at, let us say, 4 feet in front of you and another at 100 feet, and you move 2 feet toward them, the image size of the nearer object will nearly double whereas that of the distant one will hardly change at all.

Now suppose that the eye moves toward the picture from the correct position. All the components of the picture will become larger. As compared to what would happen in the scene itself, the enlargement for distant objects will be proportionately much greater than for those nearby. The photograph, seen from this nearer position, then, is the equivalent of a scene in which the distant objects are in fact nearer. That is, it represents less depth, and less depth is seen.

When the reverse occurs, that is, when the eye is too far from the picture, all parts of the picture decrease in size together. This accentuates distances because there is a greater percentage change for distant objects than for those nearby, just as in the former case.

Accompanying both of these conditions there is, of course, a change in the apparent distance of the observer to the nearest object (when not compared directly with the scene). In some cases this accentuates the effects and in others it makes them less important. The effects can best be understood by means of examples.

Let us take the possibilities in the order discussed. Under each we shall have two cases, one in which the decrease in apparent distance to the nearest object has a large effect, and one in which it has little.

The situations in which the observer views a photograph at too short a distance are relatively rare. Only two are fairly well known, pictures taken with long telephoto lenses, and those greatly enlarged and seen from a short distance, such as photomurals. In some cases the results can be quite ludicrous. One of the best examples the author has seen are telephoto motion pictures of a naval fleet in action. Occasionally there is a picture of a battleship steaming directly at the camera actually taken from a great distance. The loss of depth makes the ship look twice as wide as it is long and much like the proverbial tub. It is often followed by another battleship under full steam at a distance that looks like a few hundred feet. In other cases in which it is obviously far to the nearest object, and hence little size difference shows between similar objects fore and aft, the short viewing distance makes little difference. There is loss of depth but not distortion. A shorter viewing distance, hence, decreases depth and may or may not be important.

A viewing distance greater than that called for by the perspective is perhaps the normal case in photography. A contact print from a negative

made with a 4- or 5-inch lens or shorter is practically impossible to see from the proper distance. The same holds true for practically all pictures up to 4 x 5 inches in size. Even 8 x 10 inch pictures have a usual proper viewing distance of only 10 to 15 inches. It is fortunate, accordingly, that for ordinary subjects which are at a considerable distance (of the order of 10 feet or more) from the camera, the effect is beneficial rather than harmful. The tendency of many of the photographic factors is to cause loss of depth in the reproduction. We have already noted the perception of the picture as an object acting in this direction, and we shall find others. The fact that too great a distance increases depth perception, even though it makes the objects seem to appear further away, tends to offset this effect. It is beneficial, however, only so long as distortion does not occur.

A little thought will show that when the viewing distance is too great, the closer the real objects are to the camera lens, regardless of its focal length, the greater the distortion. This follows from the fact that the objects increase in angular size much more rapidly when they are near the lens than when they are far away. If all objects are far away, not much happens, but if some part of the object is close, its size may be totally disproportionate at the greater viewing distance. The classical example of this, published over and over for many years, is that of a man sitting on a wall—or lying down—with his foot close to a short focal length lens. Viewed properly, there is no distortion although the foot will appear uncomfortably close. From a greater distance, the man is distorted and has a tremendously long leg.

Similar distortions are often seen in automobiles, buildings, and the like when the photographer stands too close. One of the most serious cases of pictures of this type is that of the head and shoulders portrait. Taken with a short focal length lens, such a picture may be so much distorted that an observer could not recognize the person from the photograph at all. This is particularly insidious because, through one of those little twists of fate, the distortion is seldom visible to the photographer if he knows the person very well. Since by far the majority of all photographs taken in the world are of sweethearts and children and are almost invariably taken with short focal length lenses, this is much to be deplored. The proud photographer is often showing his friends a different picture from what he sees. Some improvement, of course, results if the pictures are enlarged, but the natural tendency to look at an enlargement from a greater distance tends to offset the improvement. There is no known substitute for a long camera-to-sitter distance. Portrait photographers for years used lenses of 18- to 24-inch focal length, although

recently there has been a tendency to accept some distortion in favor of the maneuverability of smaller cameras.

An example, which seems to be of a different nature but which on closer inspection is the same, is found in wide angle pictures of small rooms. In fact such a picture must be taken with a short focal length lens and is almost invariably seen at too great a distance—hence the distorted walls and too long room. Seen from the correct distance, the distortion disappears although, for other reasons, the room may still appear to be too large.

We see, therefore, that too short a viewing distance as compared to the correct one decreases depth and produces distortion if the distance to the nearest object appears quite short, whereas too great a distance increases perceived depth and is usually beneficial but may produce serious distortion if the near object is too close to the lens.

We have to consider now a somewhat different phase of geometrical perspective as applied to photography. For the most part, up to now we have been considering pictures taken with a camera which is held level, that is in which the horizon line is in the center of the picture, and the film plane perpendicular to the lens axis. When the camera is tipped, either up or down, the film image continues to obey the same laws as before, but it violates a principle that is often stated as part of the theory of perspective. This statement runs that vertical parallel lines shall remain vertical and parallel regardless of the direction of the line of sight. This is a most interesting concept both historically and theoretically. We know that the fronts and corners of buildings, for example, are vertical and that windows, etc. have parallel sides. When the camera is tipped, these lines show convergence. Our mental attempts to keep the lines perceptually parallel do not, as one might expect, make the top of the building look far away vertically, but tend to make the building tip back away from us. The reason for this is not entirely clear. When we look up at a tall building from nearby, its sides may be seen to converge if one looks for it but even so the building itself appears to tip back. Once noticed it can become rather disturbing (Figure 4–4).

The fact seems to be that vertical convergence either up or down in a vertical plane in front of us is so little a part of our experience that we do not perceive it correctly. When this convergence is accentuated by short focal length lenses and steep camera tilts, it becomes a strange phenomenon and tends to be interpreted or perceived as the more familiar although inappropriate phenomenon of tilt. Whether or not this is the correct explanation, there is some evidence that the prevalence of such pictures from miniature cameras in photography is gradually chang-

Figure 4–4. *Because of the prevalence of small hand-held cameras the present generation is learning to perceive tipped camera pictures as depth.*

ing the perception and that some people are already starting to accept the appearance as height or depth as the case may be.

In this connection if a picture taken up at a tall building is projected on a screen over the observer's head so that he must tip his head to the same angle, the building appears to stand up straight. A similar example is that of a photograph taken down a flight of stairs. If projected so the observer must look down, a normal result is again obtained. The same effect occurs to a lesser extent with a hand-held picture. Based on these facts it would appear that the whole explanation of the distortion usually seen is the earlier noted tendency to compromise between the angle at which the picture is viewed and the assumption as to the camera angle. Such effects may become very important with a high mounted mural.

In photography, as in drawing, however, there is the possibility of correcting this vertical convergence by tilting the plane of the film with respect to the lens axis. If the plane of the film is parallel to the plane of any pair of parallel lines, these lines do not converge in the image.

Figure 4–5. (a) Normal down angle photograph showing convergence of parallels. (b) "Corrected" photograph showing distortions of spheres which is introduced.

In this manner it is possible to avoid the perception of tilted buildings, distorted picture frames and the like. The correction carries with it, however, the consequence that other shapes may become distorted in place of the parallel lines. Figure 4–5 shows an uncorrected and a corrected view of a scene containing parallel lines and spheres. The corrected view, preferred by most people for the parallel lines, gives a vertical elongation of nearly 35 per cent in the spheres. This is, again, an example of the fact that a spherical surface cannot be represented without distortion on a plane, a fact that bothered Mercator and has bothered many others since. The distortion may be shifted in one direction or another, but it cannot be eliminated.

Incidentally, the concept of making the pictures on the inside of a sphere is valid, except that the distortions due to incorrect viewing of distance become intolerable. A cylindrical surface is attainable in practice and is quite satisfactory if viewed from the back focal distance with the picture curved around this as the center. If such a picture is laid out flat, as is the usual case, the distortion becomes extreme.

It can be concluded, accordingly, that geometrical perspective can lead the observer either toward or away from correct perception in photography. Although it is an important factor in producing depth perception, it is an equally powerful agent for producing the wrong perception if viewing conditions are not entirely correct. In what follows it will be found that there are other equally powerful forces at play and that the sum total of these in the hands of a competent photographer permits the production of very nearly the correct impression on the observer. Geometrical perspective nevertheless is a fixed limitation within which the photographer must work.

The "monocular" depth clues

Although perspective itself is a clue or indicator of depth when one eye is closed, it is convenient to group all the other monocular clues under a single heading. As the name implies, monocular clues are those which do not in any way depend on stereoscopic vision or parallax for their effect.

So common is the belief that vision with both eyes is essential in order that depth may be seen that the words of Spindler in his **The Sense of Sight** (page 72), written thirteen years after loss of vision in his left eye, may well be quoted. "The fact is that when a person loses one eye in adult life, he very soon learns to see the world with depth and solidity

just as he did with two eyes, and there is positively no mental feeling of flatness or lack of the third dimension."

Since the ordinary photograph is taken with a single lens and is seen by people who are familiar with the depth of nearby objects given by binocular vision, it is apparent that these single eye clues are of great importance for photography. They are the variables which a photographer, like a painter, may manipulate so that his observers will see depth.

We consider these in some detail in a later section where we discuss the application of principles by a photographer. They were discussed in some detail in Chapter 2, and it is perhaps sufficient here simply to list those that were mentioned. They are: convergence of the objects, overlay or silhouette, shadows, atmospheric perspective, knowledge of object size, motion of known objects in the scene, loss of object detail with distance, and the tendency of brighter objects to appear in front of darker ones.

Surface of the photograph

Before we proceed to consider the last of the factors contributing to depth in photographs, it might be well to consider explicitly a phase of the subject that has been mentioned several times. The general statement may be made that any property of the photograph that draws the attention of the observer to the photograph as an object, will oppose the perception of depth. There are two possible outcomes to this opposition. First, and most often the case, there may be a reduction in the depth perceived. The reduction may be drastic to the point of eliminating all depth or it may be so slight as to be negligible. Second, and somewhat startling when it occurs unambiguously, the surface of the photograph and the objects shown may separate in space, and the represented depth may be perceived through the surface. This latter effect occurs when the depth indications and the surface indications are both very strong. It is aptly described as the "screen door" effect and occurs often with grainy stereoscopic pictures, prints that have been made with a texture screen, and the like.

Brightness contrast

One other effect remains to be discussed: the effect on the perceived depth of the brightness contrast of the picture. Brightness contrasts are

photographically controlled mostly by four factors. (1) The reflectances of the objects in the scene. (2) The nature of the illumination on the scene. (3) The reproduction contrast factor of the photographic process used. (4) The sharpness of the image.

Contrasts due to the first factor appear to have little effect on the perceived depth. It is true, of course, that objects must show some contrast against each other to be seen at all and the clarity with which objects are separated increases with this contrast. Other things being equal, however, changing object reflectance alone does not change the depth seen in a photograph unless its orderly arrangement, or the like, suggests some of the clues mentioned earlier.

Changes in the nature of the illumination, on the other hand, have an enormous effect, both in nature and in photographs. This subject has been treated at some length in my other book and so does not need extensive treatment here. The effect is indicated in Figure 4–6 in which only the lighting was changed. The effect is so well known in photography that the lighting of the lower contrast picture is generally known as "flat lighting." Lights used to produce effects like the second are called "modeling lights" and photographers discuss the "modeling" and the "roundness" of the results. It is not too much to say that this is the photographer's main variable as far as depth is concerned, often greatly exceeding the effect of the perspective. This is particularly true of portraits, in which the proportions of the face and head of a sitter unknown to the observer may thus be greatly modified.

Comparison of contrast and perspective as depth producing factors leads to the interesting concept noted earlier. Perspective always indicates depth but it does not always produce the perception of depth. That is, the observer knows the depth is there but he doesn't see it as such. Objects accordingly may be seen as quite distorted even though the relative dimensions can be estimated quite accurately. This is one of the methods by which a photographer can produce a picture as distinct from a record, as we shall see later.

The third method of varying the contrast, that of manipulating the photographic process requires more detailed treatment, both here and in later chapters. It is difficult to give an adequate measure of the contrast that an observer sees in a photograph. The subjective impression depends basically on the range of brightnesses that the observer sees. This perceived range can vary with the subject matter, the photographic process, and the conditions under which the photograph is viewed. The contrast also depends to some extent on the rate of change of brightnesses within the range, whether produced photographically or otherwise. These are, in fact, the major photographic variables at the disposal of

Figure 4–6. White objects in "flat" and "modeling" light showing change in depth of picture and "roundness" of objects.

the black-and-white photographer in order to produce the effect he desires.

The point of the present discussion is the fact that, however produced, decreased contrast leads to a decreased perception of depth in the scene, and within limits increased contrast leads to increased perception of depth.

Let's consider this first for black-and-white photography. Suppose we have a given subject in moderately contrasty lighting and suppose the process is one which gives moderate size reflection prints. The contrast of these prints can be changed in three basically different ways. The range of brightnesses can be changed as can the rate of change of brightnesses relative to the subject (often called "gradient" or, less accurately "gamma"). The sharpness also can be changed. Assuming for the moment no difficulty in filling the range with the subject, the total range depends on the deepest black that the paper can produce. This limit is usually set by the amount of diffuse surface light which the paper reflects. A matte surface paper, in general, will reflect the most light and a very shiny or glossy surface, held so that it reflects a black surface will show the least. The range of contrasts which can be so produced is very large. Under controlled viewing conditions the ratio of light reflected from white to that from black can vary from as low as 20 to 1 for matte papers to as high as 500 or 1000 to 1 for a really high gloss surface. Such extremes are seldom encountered in practice but can exist.

Unfortunately for a simple presentation of the subject it is usually not possible to utilize anything like this range of contrast in the paper without extensive modification of either the subject contrast or the gradient of the picture. It is, accordingly, not strictly correct to say that the range **alone** produces the whole effect seen. General experience indicates, however, that for depth perception range is the more important variable and almost any glossy print with good blacks produces more depth than a similar picture with a matte surface. (To the contrast effect is also added, to a certain extent, an increased awareness of the matte print as an object.)

The gradient of a picture can be changed by suitable choice of paper emulsion and by extent of development of the negative. In this manner contrasts that are different in two scenes may be made to come out alike. That is, a relatively flat lighted scene may be increased in contrast or a contrasty one reduced. Papers that produce this effect are called "hard" and "soft," the names originating largely from the change in depth perception produced from the same negative. In general, from the same negative only one or two of the contrast grades will give pleasing pictures because of loss of either highlight or shadow detail. Again it is difficult to generalize because of the effect of subject matter, but the im-

pression one gets from working with the materials is that the gradient in a print is far less important for depth perception than is brightness range.

Another phase of this relationship also should be noted at this point. As the gradient is increased, one of the most noticeable effects is that the sharpness of the image increases. In fact, the increase in edge gradient seems to be more easily seen for small changes than the change in the relative brightnesses of the areas.

This is the reverse of the fourth effect noted that changes contrast, namely, the sharpness of the picture itself. It is well established that the perceived brightness contrast of a picture depends heavily on the sharpness of reproduction of sharp edges in the objects. This effect, based on the Mach line phenomenon may be stated as follows.° Any area in a picture or scene will appear to have more contrast with adjacent areas if its boundaries are sharp than if they are diffuse. Thus a dark area on a lighter surround looks very much darker if its edges are sharp, and a light area on a darker surround looks very much lighter. The net result in a picture is a very great decrease in apparent contrast when a picture is not sharp and an increase when it is. The effect is illustrated by the spots of Figure 4–7 and the pictures of Figure 4–8. There is considerable loss in this effect by half-tone reproduction. In photography the effect can be so large that areas may be moved in apparent brightness by amounts approaching one quarter of the full scale for reflection prints. It is, in fact, comparable in magnitude to the effects which can be produced readily by changes in scale and gradient.

Exceedingly sharp pictures, accordingly, can have a lower gradient to fill the scale and can compress more detail into the range available. This may be the origin of this school of photography.

It is a more or less commonly accepted notion that, except for special effects, the most satisfactory print is the one which just fills the scale of the photographic material. In fact, the writer has heard one photographer go so far as to say that the aim of the photographer is to produce the greatest possible contrast without loss of detail in either highlights or shadows. It is certain that for the most realistic reproduction possible in this medium a glossy print with good blacks is by far the most successful.

When we come to color photography, matters are somewhat different. In this medium, as we shall see, it is possible to reduce the brightness contrast to zero and still have a semblance of a picture. What remains is the combination of saturation and hue that was inherent in the scene from the start, but which has now become important from the absence of the overriding impression of brightness differences. All illumination

*See Ralph M. Evans, *Sharpness and Contrast in Projected Pictures*, unpublished.

Figure 4–7. *The dots in each set differ only in their edge gradients. The center of each dot had the same reflectance in the original photograph.*

Figure 4–8. *These pictures differ only in the fact that the contrast of fine detail is higher in one than the other. Large areas have the same contrast.*

144

nonuniformities disappear and brightness differences aside from those of the various printing media also are brought to a minimum. Depth as a true perception also effectively disappears. There is no better way of showing that depth perception in photography is largely a matter of brightness differences—or perhaps better of sensed illumination differences—than this method of bringing all parts of the scene to the same reflectance. All other clues except perspective become unimportant, and this becomes an indicator of depth rather than a factor which produces depth perception. The perception present is that of a flat, colored surface carrying depth indications.

THE PERCEPTION
OF LIGHT AND COLOR
IN PHOTOGRAPHS

The preceding chapter dealt with the perception of form and depth in photographs. It was noted that the properties of the photograph as an object are often at variance with the properties of the objects shown. Each affects the other and the observer sees either a compromise between the two or an occasional split perception in which the latter is more or less seen **through** the former. When we come to a careful consideration of the reproduction of the light and color phases of a subject, we find that the same relationships exist and often cause even more striking effects. From the conflicting indications presented in a picture the observer uses all his past experience in an attempt to see what he believes the picture to represent. The result is nearly always a compromise but satisfies him unless called in question by another observer or by comparison (mental or actual) with the scene itself.

Illumination perception

As we have noted perception of the illumination falling on a scene is one of the basic parts of all vision. The correct perception of object properties depends very heavily on how correctly the observer sees the nature of the illumination. To the extent that he is in error he will likely be in error also concerning the object properties. In nature such effects

and errors are not often important because situations are usually so complex that other clues straighten matters out. In photography they play a dominant role.

Following the reasoning of the previous chapter, a photograph is simultaneously object and reproduction of objects. In the same manner illumination in photography is always presented doubly. There is always the effect of the illumination of the photograph and in the photograph. In many forms of photographs, such as projected pictures, one does not often think of the projection light as an illuminant of the image, but in the broader sense it is just as much so as that for a reflection print. The main difference lies in that the object at which one looks is a projection screen whose properties appear to be modified simultaneously by the light and the system forming the colors, whereas with the reflection print the object which modifies the light is the object seen. The perceptual effects are the same in kind, however, and we shall have to note only a few exceptions, mostly of magnitude, if we discuss only the case of the reflection print.

Illumination can vary in intensity, quality (spectral energy distribution), uniformity over the scene, and geometrical nature. That is, it can be bright or dim, of any energy distribution as well as color, it may or may not light all parts of the scene in the same way, and it may proceed from any number of large or small sources in any location. Each of these has an effect both on and in the print.

First we must realize that the light which reaches the eye of an observer from any small area of the print at any one time is of a single quality and a single intensity. Yet this single area may represent a whole series of different things which it is up to the observer to separate out and see correctly. Thus a particular spot on a glossy print may represent simultaneously, part of another object (such as a wall reflecting in the print surface), the glossy surface itself, a reflection in an object surface in the picture, and the surface of that object itself. Thus there is not and cannot be, except under very special conditions, any simple relationship between the actual properties of an object's surface and the light that will reach an observer's eye from a photograph of that surface. This fact alone shows that correct perception of an object property is a complex operation and may not lead to simple photographic relationships.

Geometry of the illumination

One of the photographer's main controls in the studio is the placement and intensity of the lights by which he illuminates the scene. It is not

ordinarily understood, however, outside the profession, what factors can
be varied in this manner. We have already noted that perceived depth in
the scene can be varied, simply by modifying the contrast of the lighting.
Such lighting usually casts single, clearly defined shadows which indicate
the position of an apparently single light source. This in turn indicates
the shape and relative positions of the objects.

Light sources, however, can vary in many other ways than simple
position. Perhaps the chief factors are their size, shape, uniformity,
number, and distribution.

The manipulation of the lights in a studio is a highly developed art,
but there are a number of general principles and many "rules of thumb"
that have been developed over the years. The same variables, to a some-
what limited extent, are also available to the photographer working out-
doors. Here, however, he must watch and wait for his conditions unless
he is working with relatively small objects at fairly close range.

The photographer's problem is to so arrange his lighting that the
photograph will induce the desired perception in the observer. This de-
sired perception may be that of the object's "real" properties or it may
be something quite different. In either case the apparent object proper-
ties will depend on whether the illumination as such is seen by the
observer. To the extent that it is not seen its effects will be seen as object
properties. This is a fundamental principle, applicable to all photo-
graphic lighting of all kinds. We want to consider it for the various kinds
of lighting mentioned above.

The two major effects by which illumination is perceived are surface
reflections and shadows. Each of them is about equally dependent on the
geometry of the lighting. But it is the perceived nature of the surface
that is most likely to be affected by the geometry.

There are not many basic varieties of surface. They can all be thought
of as ranging from rough to smooth and at the same time from glossy to
matte. That is, surfaces differ in their roughness independently of their
gloss. Surfaces of the four indicated extreme types are shown in Figure
5–1. Surfaces of the rough shiny type are perhaps the least frequently
encountered, but they are far from being rare and are often difficult to
photograph convincingly.

When light falls on a smooth, shiny surface, it is possible to see in
the surface a direct reflection of the source of light. This property of
image reflection is characteristic of a shiny surface. The only way a shiny
surface may be seen at all as shiny is to see something reflected in it. In
daily life it is nearly impossible to place such a surface so that it does
not reflect something. In a photograph, however, unless the surface is

Figure 5–1. *Two lightings of objects showing the four basic extreme surfaces. Rough matte, rough glossy, smooth matte and smooth glossy.*

Figure 5–2. *The appearance of a glossy surface may depend rather heavily on the size and shape of the light source that illuminates it.*

properly oriented it is not seen as glossy. Usually, especially if the surface is curved, at least one of the light sources will be reflected. A typical case would be the eyeballs of a person sitting for a portrait.

Although clear image reflection of anything in a surface will give the appearance of gloss, we want to consider here chiefly the light source.

In the perception of size and distance the observer's assumptions about the size of an object tend to control his perception of its distance. In an exactly similar manner the assumptions he makes about the light source determine, or at least strongly affect, his perception of the surface in which he sees it reflected.

Thus a piece of wood or metal with a so-called "satin" finish has the characteristic, like satin, of reflecting light in a characteristic manner. The reflection of a small light source, rather than being sharp, grades outward from a bright spot in the center. If this grading of the light source is imitated by the light source itself, then when it is reflected from a high gloss surface, the observer will tend to see a satin finish (Figure 5–2).

The principle involved in the example above is quite general. Whenever a reflection is produced characteristic of a kind of surface, that kind

of surface will be seen unless other and stronger indications contradict it. A high gloss surface in completely diffuse illumination (uniform light from all directions) can be made to appear completely matte surfaced. If one attempts to make such a picture, however, he soon finds that reflection of the light source is only one of the indications of surface. It is often difficult to prevent reflection of other objects from indicating the true surface. It is interesting that in some cases the simple removal of highlights by painting them out in the final picture is sufficient to change the surface appearance from glossy to matte. A pair of pictures, in one of which this has been done and the other not, are shown in Figure 5–3.

It is possible to go in the other direction also, in many cases, making a shiny object appear more shiny by decreasing the size of the light source. The Western Union light source offers some interesting possibilities along these lines. Visually in the subject itself the effect is often enormous, giving a sense of glossiness beyond anything normally observed. In a photograph, however, and particularly in a reproduction of a photograph, an interesting limitation is soon encountered, which applies to some extent to the photography of all glossy surfaces. In order for the reflected light source to appear small it must so photograph. If the surface is curved, however, the image actually being photographed may be at a considerable distance from the object. For close-ups of the objects this position may be beyond the depth of field available. If sufficiently small apertures are used, it may be beyond the resolution of the lens. In the case of the Western Union source the size may be smaller than can be resolved by the photographic material.

Glossiness perception, therefore, relates to reflections seen as caused by the surface. The whole perception, however, involves the nature of the source of light as seen from other indications as well. In this larger way of seeing the picture shadows play a predominant part. The extent to which perception of illumination is dependent on shadows has been discussed extensively in my earlier book. It is important here, however, to consider the matter from a somewhat more photographic point of view.

The edge gradient of a shadow, its position, its brightness relative to other parts of the field, and its relation to other shadows cast by other objects are the main characteristics by which we distinguish one kind of source from another. For the photographer all these factors may be varied more or less at will. The size of a source in connection with its distance determines the edge gradient. The distance from the object alone determines the angles which the shadows make with each other and with the object. The brightnesses of the shadows, of course, are determined by light reflected from other objects, coming from other sources of lesser

Figure 5–3. *These pictures are identical except that the light source reflections have been painted out in one. Note the changed appearance of the entire surface.*

brightness, etc. Brightness of a shadow is more an indication of the nature of the scene as a whole than of the principal light source.

It is important to note, however, that the apparent brightness of a shadow will depend also on its edge gradient. A shadow with a sharp edge will, in general, be seen as much darker than one with a gradual edge. This effect is quite large. A set lighted with a small light source at a distance, or a focussed small spotlight, may appear to have three or four times the contrast that it would have if lighted by a large source such as a skylight in the same position. That is, if the actual light in the shadows is the same in both cases, there will appear to be three or four times as much light in the shadows from the diffuse source. This is the reason why carbon arc spotlights are called "hard lights" and the light from a skylight is called "soft." A picture made with arc lights will appear more contrasty and sharper than one made by diffuse light with the same intensity ratios. Note that it is the geometry of the source that produces the effect and not, for example, the fact that it happens to be a carbon arc.

Matte surfaces

Matte or dull surfaces may be defined as reflecting light in all directions at each point of the surface. It follows that the representation of such a surface is far less dependent on the nature of the light source. Under any illumination a matte surface looks matte, the danger is that a shiny surface may appear matte, not a matte surface shiny. This does not mean, however, that in photographing a matte surface the photographer need have no concern over the placement of his lights. With matte surfaces it is the shape of the object which must be brought out with some care. In the case of a glossy surface the shape is usually evident from the nature of the reflections. In a matte surface, however, we are dependent on the gradation of brightness of the surface to indicate shape.

A perfect white sphere photographed in completely diffuse illumination will, in general, be seen as a flat white disk. To make it look like a sphere it is necessary that the light be quite directional. While matte surfaces reflect light in all directions, they do not reflect equal amounts in all directions. It is on this property that we rely to give the impression of roundness (a reference again, of course, to experience). Lighted directly from the front by a single light source a sphere is seen to fall off in brightness rapidly as the contour edge of the reproduction is approached. While this is sufficient indication that the surface is curved,

it is often not sufficient to make it look spherical. To do this it is usually necessary to light it from the side so that the crescent shaped decrease in brightness on the shadow side is clearly visible.

In its most important application this is the major problem of portrait photography. The roundness of a person's face with its semi-matte surface must be brought out in a portrait if a face is not to appear flattened and distorted.

A further case of some importance is that of a rough matte surface. If the degree of roughness is not very great, that is, if the individual projections from the surface are relatively low, the amount of change in reflected light will not be great. With a sphere the outer portions may actually become parallel to the line of sight of the camera. Under these conditions no light is reflected toward the lens. If the surface is simply rough, however, without sharp edges, no such great change in brightness occurs. Such a surface may still be made to show large brightness differences and hence good surface contour by using a small light source shining along the surface of the object. A pair of such pictures photographed by front light and by side light are shown in Figure 5–4.

In extreme cases very fine texture can be brought out in this manner. Figure 5–5 shows the surface of a piece of wallpaper brought out in the same fashion.

This general approach is the technique by which it is possible for the photographer to show the **texture** of objects to his observers. Texture as appreciated in daily life involves seeing the surface from many angles with different kinds of illumination and, usually, an exploratory survey with the fingers to find out how it feels. To get an equivalent experience by way of vision alone from a single point of view without change of illumination the texture must be exaggerated. The correct ratio of side to front lighting is the chief means toward this end, although size of source is also an important variable.

Again, however, it is often necessary for the observer to know that the dark areas he is seeing are actually shadows. For this to be well established the light source must be well established. This may call for the presence of some recognizable object throwing a well defined shadow from the same light source.

We might conclude, then, that the problem in glossy surfaces, whether rough or smooth, is to see that they reflect something convincingly (if a light source, it may have to be small). In matte surfaces the problem is to so arrange the geometry of the lighting that the **shape** of the object is observed correctly and this may involve clearly defining the light source by shadows, reflections from glossy surfaces, and the like.

Figure 5–4. *Wrinkled cloth photographed by lighting from one side and by direct front lighting.*

155

Figure 5–5. *Wallpaper with a fine surface texture that is not visible by front lighting but may be made visible by side lighting.*

Transparency

While considering the surface properties of objects and the requirements for their correct perception, it is interesting to consider transparent objects. In order to see that a thing is transparent it is necessary that something be seen through it. This is strictly analogous to seeing a shiny surface because something is reflected in it. A little thought will show, however, that the two cases have more than analogous relationship. Unless the location of the secondary objects are clearly defined by the conditions of the scene the observer may not be able to tell whether he is looking at a mirror surface or a transparent one. Even worse, if the secondary object is completely indefinite as to position and especially if it is not sharply reflected or transmitted, it may very well be seen as part of the pattern of the surface of the object itself.

Reflection and transmission, therefore, are characteristics which the photographer must deliberately design his set to portray. Examples of the three cases mentioned above are shown in Figure 5–6.

Surface reflections

There is another phase of surface reflections which we have not as yet considered. It was noted earlier that a given area on a print might represent four distinct types of information. One of these was reflections of other objects in the surface of the represented object.

Figure 5–6. *(a) A mirror reflecting unrelated objects may be seen as a framed picture. (b) A mirror reflecting white paper is seen as a white surface. (c) When both the mirror and the objects are shown, the scene is interpretable.*

The condition under which such a reflection will be seen to be that of another object, of course, is first that the true surface be clearly indicated and second, that the second object be fairly well defined. The first condition requires that at least some part of the surface, no matter how small, appears in its true color. The second is most easily met by having the second object also visible directly in the picture.

If these conditions are not met, there is then a strong tendency to see the characteristics of the reflected object as part of the surface of the reflecting object.

Suppose, for example, that a clean mirror in a frame is reflecting a uniformly illuminated sheet of white paper in such a way that this reflection fills the whole mirror, and the paper itself is not visible in the picture. It is apparent that the observer would, necessarily, see a piece of white paper in a frame.

This general principle holds for all reflections and leads to some interesting consequences.

In the photography of shiny surfaced, colored objects, for example, if these are lighted by completely diffuse light there will be a heavy loss in color saturation of the surface. This occurs because the white light everywhere reflecting from the shiny surface is taken as a property of the surface with consequent loss of the perception of a saturated color reflecting white light.° In similar vein if one colored surface more or less uniformly reflects another colored surface, especially if this is not visible in the picture, there will be a strong tendency to see the mixture color of the two as the color of the surface visible. Again the requirement is that the situation be clearly defined in the picture. The observer is then in position to obtain the true perceptions of the object properties.

Illumination level

Thus far we have been concerned mostly with the geometry of the illumination in a scene. The effects, for the most part, have been fairly straightforward and could be stated rather easily. We come now to the question of the intensity of the illumination, and here the situation is quite different. Whereas the geometry of illumination is readily seen as such, the intensity of illumination is often inferred rather than seen even in the original subject. That is, intensity is perceived because of secondary rather than primary effects.

We have, as always, two intensities to deal with and must keep them

° See color plate in Ralph M. Evans, *An Introduction to Color*, New York: Wiley, 1948.

quite separate. There is first the intensity of the illumination which it is desired the photograph will show. (This may or may not be the same as when the picture was made.) There is second the intensity under which the photograph will be viewed. The ideal result would be to have the picture appear just as the photographer wants it to under all illumination conditions. This is obviously impossible, even for transparencies, hence the viewing problem becomes a question of satisfactory range of conditions.

In order for the picture observer to have the desired perception of the intensity of the light of the original scene it is necessary that the photograph show the intensity effects the observer would have seen. This follows, of course, from the fact that the actual intensity at which he is really looking is that of the photograph at the moment. It is therefore fortunate that it is secondary effects which produce the proper perception rather than primary ones. Let us look for a moment at how the observer's perception changes when viewing a scene lighted to various intensities.

Suppose we start at the high intensity end of the scale. The highest light intensity illumination with which man is normally familiar is probably tropical sunlight. This reaches intensity levels variously reported at 12 to 15 thousand foot-candles. It is interesting to note that travellers are quite unanimous in their reference to the startlingly saturated colors seen under these conditions. There seems little doubt that high intensity and lack of a shadow lighting haze are the predominant causes of this effect, although there is good evidence that saturation does depend on absolute intensity.

At somewhat lower intensities, such as we have in the temperate zones, colors are not overbearingly brilliant yet we are fully conscious of the change in saturation from clear sky summer sunshine to the "gray" days of winter. This change includes both intensity (often dropping to 100 foot-candles on a rainy day) and the shift from purely directional light when the skies are clear, to diffuse light when the sky is overcast. It is significant that in England some American color movies are said to be unacceptable because their colors of natural scenes are too saturated. The gray skies and foggy days of England do not show such saturated colors.

At the next lower levels of illumination we encounter artificial light, and under this we can consider all levels down to, say, 1 foot-candle. This range is characterized by a steadily decreasing ratio of intensities which represent "darkest white" and "brightest black." Suppose that at 100 foot-candles the dimmest area that will be seen as white in the ab-

sence of a brighter area is 100 times that which will just be seen as black in the absence of a darker area. Then it will be found that at, say, 2 foot-candles this ratio has decreased perhaps to 20 to 1.

Expressed in other words, the total brightness scale of perception decreases steadily with the intensity of the illumination. As a matter of fact this decrease starts at the highest levels where the ratio may be several thousand to one, and continues on to the extremes of dark adaptation where a ratio of two to one in sufficient area may separate white from black.

It is, perhaps, unnecessary to point out that as far as the camera is concerned the ratio of intensities reaching the lens from two objects in a scene is entirely independent of the intensity of the illumination. Given the correct exposure time, the total exposure ratios of the two objects will be the same. For perfect photographic materials the results would be the same at all levels, and yet the photographer who took the picture has seen widely different effects.

For color photography the situation is further complicated by the fact that at levels much below 1/2 foot-candle color itself tends to disappear, leaving only brightness differences of a color usually described by artists as a dark blue. Yet a properly exposed color photograph made under these conditions, suitably correcting for the color of the illumination—which in fact on a moonless night outdoors is a deep blue (from the sky)—will have the normal colors usually seen.

We have, then, two problems. First, to represent correctly the range from perceived white to perceived black, and second to represent the colors as perceived rather than as present physically.

It is apparent that the same statements with regard to the original scene apply equally to the photograph itself. We are faced, then, with the fact that unless the viewing conditions for the photograph are known, there is no unique solution to our problem. In practice, however, the problem is not as critical as this discussion would indicate. Probably because we are quite accustomed to the change in objects with illumination level we apply this knowledge equally to real objects and to reproductions of them. A really good color photograph is appreciated as such at both low and high intensity levels, although its true beauty cannot be appreciated except at daylight intensity.

Perhaps the only safe generalization which can be made is that a picture of a normal subject must be seen to contain a good white and a good black at all normal levels of illumination. If the blacks tend to gray when held in direct sunlight and the shadows tend to lose detail at twilight or in dim artificial light, a fairly satisfactory compromise has probably been reached. If a print is to be made for salon judging, or exhibition in a

particular spot, it is a wise photographer who sets up a duplicate of the conditions with fair precision and makes his prints accordingly.

Brightness range

Just as in the case of the painter, the photographer is confronted by one very definite limitation. Regardless of his particular medium, whether projected pictures or hand-held prints, his pictures are limited in the range of brightness that they can actually produce.

An actual scene can have an intensity range in the light from the different areas as high as 1000 to 1. This seldom occurs and ranges of the order of 2 or 300 to 1 are more common. Under ordinary circumstances even this lower range is at the very limit of the brightnesses of the medium. That is, the white of a photograph is only rarely, and then only in carefully arranged situations, 300 times the brightness of the black. Actually this probably occurs only in the two cases of a transparency over a bright illuminator or a glossy print separately lighted in a dark room, although a glossy print held in direct sunlight may approach this range.

Accordingly the photographer often has to decide whether highlights or shadows are more important, whether he will sacrifice contrast to get the needed detail range, whether to light the shadows to decrease the contrast, etc. In any case what he actually does is to compress the scale of the subject so that it fits his medium, exactly as does the painter, except that the photographer, especially in the studio, may make the change in the subject rather than in the photograph.

A more serious difficulty arises when the contrast of the subject is low. We have noted earlier that the range of intensities from white to black in normal vision varies with the intensity of the illumination and that, except for rather rare circumstances (usually artificially arranged), something very close to a white and a black is visible at all times.

If we make a photograph that under normal viewing conditions does not contain a fairly good white or a fairly good black, it will tend to look too dark in the first case and washed out in the second. This is not by any means an infallible rule but if it is violated there must be good reason clearly evident in the picture—very high key subject, night shot, etc. Accordingly, the photographer frequently has the problem of stretching his brightness scale as well as compressing it.

This stretching and compressing is done by raising or lowering the contrast of the photographic process until the required result is obtained. Because what will be seen as black and what white in the final picture

depends rather heavily on the way in which the result will be viewed, it is necessary that this stretching and compressing be done with respect to a particular viewing condition. In color photography, as we shall see in a later chapter, a change in contrast may be made in two ways, one of which changes the color saturation and the other does not. Hence this factor also must be taken into account.

Brightness higher than white

One of the fascinating problems in photography is the portrayal of the illumination of the objects. As noted frequently throughout the book, proper perception of object properties is often entirely dependent on proper perception of the illumination.

A major factor in this problem is the handling of what may be called "brightnesses higher than white."

Suppose we have a scene in which sunlight is illuminating the back of, say, a white rose. The perception is that of a white rose illuminated from behind. The front of the rose is still white but the outer edges that reflect the rear illumination are brighter. Now consider a reproduction of this phenomenon. Suppose first that we have a reflection print and that this print, as in the usual case, has white borders. It is apparent that white, as far as the observer is concerned, is represented by the intensity of the border. He knows the paper on which the print is made is white and he knows that the border is supposed to represent this white. Furthermore he knows that nothing in the print can actually be any brighter. Now what happens to the rose? The rose itself is white and so should be like the border, but the reflected rear illumination must be brighter if the perception of illumination is to be satisfactory.

This is a problem with which artists have struggled for centuries. It is, perhaps, not too much of a simplification of the problem to say that for reflection prints only one solution has been found. Simultaneous brightness contrast is capable of raising the brightness of a white area above that of the same surface seen as an extended area. Accordingly, if the rose is portrayed on a dark background, that is, if a considerable amount of black lies between the flower and the border and particularly if this black surrounds it, a fairly satisfactory result may be achieved. This is not by far the only way in which it may be accomplished, especially in color, but it is sufficient to indicate that in a reflection print such a subject sets a real problem. In fact it not only sets a problem, but also sets a limitation on reflection print processes (Figures 5–7, 5–8, and 5–9).

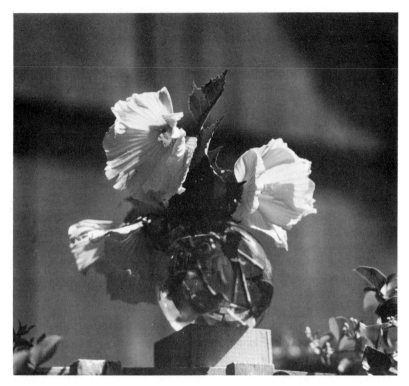

Figure 5–7. *Photograph of back lighted hibiscus plant. Note that non-illuminated white is represented by gray.*

Reflection print photography is not a favorable medium for subjects that contain directly visible light sources, strong contrast illuminations that show white objects in shadow, highlighted areas of strong color saturation and the like. It is only by carefully managed techniques that such subjects can be handled with any success in this medium. More favorable subject matter for reflection media is the depiction of object characteristics in whatever mood may be desired, or the subtle interplay of light on objects whose surface characteristics are not important in themselves.

If the brightness of the illumination is to be portrayed without loss of the perception of white objects, it is necessary that a different medium, or at least a different mode of viewing, be employed.

In the projection of pictures in a darkened room the eye is not presented with a surface which all the viewer's experience says is white.

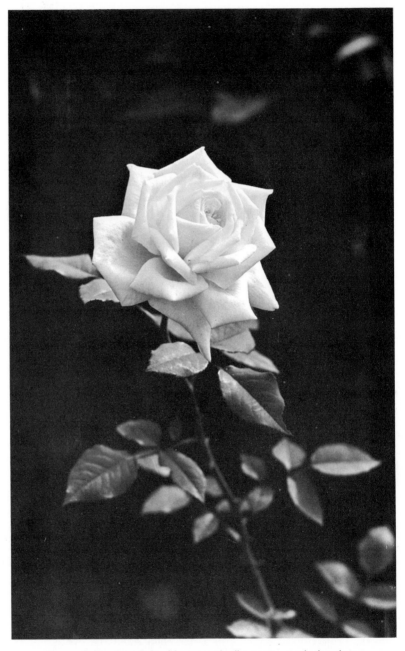

Figure 5–8. *Rose lighted by rear-side illumination and placed on black background. A fairly satisfactory solution of the problem.*

Figure 5–9. *Showing effect of black and light gray backgrounds on two otherwise identical photographs of a rose. (Rose reflectances are matched.)*

It is true that the screen is itself white but this is not presented in perception as a white surface (although it would be if a white border were projected around the picture). For this reason one is as free as in everyday life to decide what is white in the scene and what is simply higher intensity. This sounds like quite a trick to do and it is so in fact, but it is a trick we have been using over our whole perceiving lifetimes. It becomes reasonable only when we recollect that what we have trained ourselves to see is object properties. In the case of the reflection print we have an object (the print) in uniform illumination and we look for its properties as a matter of habit. Everything on its surface is either equal in brightness or darker than the border. In the projected picture in a darkened room, however, we are free to look not at the properties of the photograph but of the objects represented. Thus an intensity less than the maximum can well appear to be a white surface with no particular contradiction involved.

This phenomenon, in fact, gives a peculiar charm to the projected picture and accounts, at least in part, for its present amazing popularity. The effect can be imitated, of course, by separately illuminating a reflection print to an intensity considerably above the surroundings, and is almost always present when a transparency is viewed over a bright illuminator. The effect has given rise to considerable confusion in the subject of color. It is not unusual to encounter a person who maintains stoutly that transmitted light is different in kind from reflected light.

It is a fact often overlooked or not realized, however, that a reflection print lighted far above the surrounding illumination looks like a transparency, and a transparency illuminated so that its brightest portion is no brighter than a white in the immediate neighborhood looks like a reflection print.

In consequence of all this it would seem that if the desire is to reproduce a strong perception of illumination and yet maintain the object characteristics, the logical medium is that of projected pictures in a darkened room. Equally it would appear that factual presentation of object properties (with little emphasis on illumination as such) or decoration pure and simple are in the proper sphere of the reflection print as a medium. Unfortunately photographers in both spheres attempt the realm of the other and hence the urge to illuminate prints above the surroundings because it gives the prints more "brilliance" etc. The net result for the most part is the production of prints that will not stand the "light of day" and that are muddy and ill considered in uniform illumination.

These facts have led also to a rather discouraging situation. A slide

enthusiast who normally looks at his pictures projected in a darkened room soon learns that strongly backlighted subjects are especially attractive. As we have seen, it is the possibility of brightnesses higher than white, among other effects, that give this medium its special appeal. When such a worker decides that he would like to have reflection prints of some of his best pictures he is very apt to select ones that simply cannot be printed to give the effect that he sees on the screen.

We have considered, then, the effect of illumination intensity as it relates to white and black. The same considerations hold, in somewhat more technical fashion, for the effect of illumination on the saturation of the colors. A highly pure but very dark color will have its saturation greatly increased by isolation and separate illumination. The case is exactly the same as for white and black. Absence of a brightness which sets the condition of seeing permits the eye to see the true purity of the colors. If a lesser intensity may be seen as white because no known reference white is visible, so may colors be seen as more saturated because no reference color is visible.

Hue shift with intensity

If a relatively small area of a large scene is reduced in intensity there will be a change not only in brightness (and usually in saturation) but there will also be a shift in the hue.° This effect is most noticeable in the yellows and reds. Yellow colors will tend to shift toward green, and orange areas will likewise shift toward red. The effect is observable in nature but is not often seen by inexperienced observers.

In color photography these shifts are not always well reproduced. The somewhat lesser brightness range of the reflection print tends to decrease the effect. In subtractive processes at least, saturations increase into the shadows rather than decrease, and the hues shift with density in a manner characteristic of the particular product.

It is also true that the actual brightness ratio of a shadow in a photograph must be considerably less than that in an original scene. It follows that if this intensity hue shift is physiological, as it appears to be, the effect will be considerably less in a photograph than in the original scene. This appears to be the case, because we find artists who are particularly sensitive in such matters actually painting hue shifts into their pictures to show shadows. If the same eye effect were produced by the picture

*D. M. Purdy, "Bezold-Brücke Phenomenon and Contours for Constant Hue," *American Journal of Psychology,* 49: 313–315, 1937.

as the scene, they would have to paint meticulously the same **psychophysi-cal** color for shadows as highlights. Photography tends to err in this respect, therefore, because the shadows as well as the highlights are determined by the physics of the light reaching the lens and not by what the photographer sees. The photographer may have to counteract the effect by the use of colored shadow illumination, just as the painters shift their reds to orange in the highlights and their blues to purple in the shadows if they want a naturalistic picture.

Uniformity of illumination

We come now to the perception of uniformity of illumination and must proceed at a somewhat different level of difficulty. As cannot be repeated too often, the observer looking at a photographic reproduction sees both the photograph as object and the objects of which it is an intended reproduction. The properties of the objects, however, can be separated from the illumination only to the extent that the illumination itself exists as a separate perception. We want to consider a little more closely, there-fore, the matter of the separation of object properties and illumination.

When we look at a natural scene our whole visual training is brought to bear on the problem of separating the properties of objects from the environment in which they are seen. After all, it is objects—animate or inanimate—with which we have to deal in life. Illumination is important to us but only in extreme cases is it necessary that we have to take any action toward it. Objects on the other hand are the very basis of our daily activities. For this reason we have become highly skilled at seeing object properties under even highly adverse circumstances.

An ordinary case, frequently encountered, is that of a uniformly reflec-ting surface seen in nonuniform lighting. Such a case, for example, is the ordinary living room wall lighted from a window during the daytime. We see the wall as having uniform characteristics. Its reflectance does not seem to change as it lies further and further from the window. We see it as uniform with respect to the fraction of light it reflects, although we can see with ease that it is less brightly lighted further from the window. This is a basic, fundamental characteristic of our vision as it has developed from early childhood. We look to see objects, eliminating, as far as the situation and our knowledge permits, anything that inter-feres with our pursuit.

Now let us consider a photograph of this same wall. We see a wall,

perhaps with a pattern that indicates its continuity. We are not acutely aware, however, as we would be if in the original room, of the window through which the light is coming, and hence of the nonuniform illumination. Furthermore, we are aware of the picture before us as an object. We want to see the characteristics of the wall as portrayed, but our whole experience tends to make us see the reflectances of the picture as an object. The reflectance of the picture decreases with distance from the window. Intellectually we tell ourselves that this is due to decreased illumination, but still we tend to see the change in reflectance rather than the change in lighting.

In nature the perception of object reflectance in spite of variation in illumination is a dominant factor. The perceived reflectance (lightness) of an object tends to be independent of the illumination. In photography the effect works in reverse. The tendency to perceive the true reflectance of the print rather than that of the portrayed object tends to make all shadows or regions of decreased illumination appear darker than they would have in the original scene. This follows from the fact that decreased illumination always sends less light to the camera from an area of the same reflectance. This in turn produces a lower reflectance in the print for this area and the same tendency to see true reflectance makes the area appear darker.

The net result for photography is that any area in shadow or in a region of decreased illumination tends to look much darker in a print than in the original scene. Photographers have long been aware of this and have adopted many rule-of-thumb methods to circumvent it. Thus all isolated backgrounds on which the illumination is not apparent must be lighted to nearly the same intensity as the foreground. All lighting contrast must be reduced far below what would be indicated visually for the effect desired. The set must be lighted to a uniformity which far exceeds that at which the eye would be satisfied on the set, and so on. It is to aid in seeing such relationship that motion picture photographers especially have adopted dark viewing glasses through which they look at their lighting, the lowered intensity tending to destroy their perception of object reflectances in favor of illumination changes.[*]

This division of perception between depicted object properties and the properties of the photograph as such is one of the basic problems of all photographic reproduction. It is interesting to see how this particular phenomenon, the perception of object reflectance, varies with the particular type of photographic medium.

[*] See Ralph M. Evans and J. Klute, "Brightness Constancy in Photographic Reproductions," Journal of the Optical Society of America, 34: 533–540 (1944).

Work by the author indicates that for a photograph of objects in non-uniform illumination true object reflectance is perceived least accurately in the case of a reflection black-and-white print under ordinary conditions. For the same subject projection of a black-and-white transparency distinctly improves the perception. Somewhat better than this is a color reflection print; still better is a stereoscopic black-and-white picture; this is followed by a projected color picture, and a stereoscopic color pair is usually very close to the appearance of the original as far as this characteristic is concerned.[°]

It will be noted by those familiar with the various media that this series (which may vary with the subject matter) is essentially the order in which the photographs increase in apparent realism. This is perhaps the clue to the whole matter. To the extent to which objects standing in a definite well defined illumination appear to be in front of the observer, all his training is brought to bear on the perception of the true object properties. To the extent that realism is not present he tends to see the characteristics of the photograph instead and attributes them to the objects. The situation is exactly paralleled in everyday life. If he cannot see that an object is nonuniformly illuminated, he sees the object as having a nonuniform reflectance. The world does not make itself seen correctly. What we see is our own, it is not necessarily shared by others or by the objects themselves.

Uniform illumination

It is interesting in this connection to consider a simplified form of the general question discussed above, which has lead to much information on the subject of photographic reproduction. Although in nonuniform lighting a surface may be perceived as lighter than another when in fact it reflects less light, no such situation exists for completely uniform lighting. Under these conditions the reflectances of surfaces bear a relatively simple, although not unique, relationship to the brightnesses observed. In particular this simplification permits a study of perfection in photographic reproduction. Because in the scene itself brightness depends on intensity and this on reflectance, and the reflectances of the photograph depend on intensity, a straightforward solution of the problem is possible. The fact that print reflectance tends to be seen rather than depicted object reflectance now becomes a help in that the two are now simply related.

[°]See Ralph M. Evans, "Visual Processes and Color Photography," *Journal of the Optical Society of America,* 33: 579–614 (1943).

This subject is known as Tone Reproduction Theory and has been developed and extended by the late Loyd A. Jones and his associates. A thoroughgoing treatment will be found in Mees', **Theory of the Photographic Process.** By means of statistical techniques it has, in fact, been possible to go considerably beyond the uniform illumination stage and consider such matters as optimum print exposure, best negative characteristics and the like. The fact remains, however, that the basic postulate of this science is that a reflectance in a print will look like the same reflectance in the object.

Color reproduction

The three main visual color variables are hue, saturation, and lightness. We have already discussed lightness, and brightness relations. The lightness was associated with perception of reflectance, and brightness with the relative amount of light. It might be expected that similar pairs of relations connect, for example, selectivity and hue, or saturation and purity, but no such relationships have been found. Although hue and saturation are each very complex, there are only a few situations where it does not seem likely that the perceived color could be calculated if we knew enough about all the relations involved. These are the situations where the color at a given point in a scene is obviously a result of two causes (or more), and the observer has some choice in the matter of how he will see it.

As before, we shall want to consider the final photograph both as object and as reproduction. In hue and saturation, however, the viewing conditions and the color adaptation properties of the eye play a very important role. It might be well, then, to start with a discussion of the problem of making a picture under one color of light and looking at the result under another.

Color of illumination

It has been noted as one property of the eye that after a short time under a given illumination that is not too highly colored, the eye tends to adapt to this light and accept it as white. Normal sunlight, for example, mixed with some blue skylight is more or less accepted as the standard colorless light source. Most objects do not look greatly different under yellow incadescent light or under blue skylight. A great part of this is due to color adaptation of the eye which simply changes the eye

sensitivity relations so that the source looks white. Actually it appears to be some brightness less than that of a white which becomes colorless. This accounts for the fact that the color of the light source is nearly always visible to a critical observer. White paper in incandescent light is quite obviously yellowish and in blue skylight obviously bluish, although these facts are not ordinarily noticed by untrained observers.

The eye thus shifts its sensitivities with the illuminant, tending to keep the apparent color of objects nearly constant. Photographic materials, however, are fixed in their sensitivity relations. They are so adjusted that when a nonselective surface is illuminated by light having a certain quality the reproduction will consist of the three dyes in amounts that produce the most neutral result possible by the process. This is known as the illumination for which the film is "balanced." A perfect process according to one standard would reproduce all intensities of this light by colorless deposits.

If the illumination on the nonselective surface departs in any color direction from this standard illuminant, the result will depart in the same direction. Thus a film balanced for daylight will reproduce gray as blue in blue skylight and very yellow in incandescent light. To make film act in the same manner as the eye requires a different film for each illuminant. In practice two are usually found sufficient.

There is often some confusion at this point. A hasty consideration of the problem sometimes appears to indicate that all a color process has to do is to record the color of the light reaching the film, and the eye should take care of the rest of it. In other words "why doesn't the eye adapt to the picture and correct for changes in illumination?" Perhaps the best simple answer is that the eye tends to see a nonselective gray as gray under all illuminations. A photographic print is an object under a given illumination. An area of this print will appear gray only if it is gray, so to speak. Hence illumination color in the scene must be corrected so the print will be gray.

The matter is not quite this simple, however, since there is, in fact, something to be said for the other point of view. Let us consider the various ways in which a photograph may be viewed and how these affect this relationship.

Adaptation to the photograph

When we look at a natural scene under a certain illumination, our eyes are filled from all directions by light from objects so illuminated. Color

adaptation to this illuminant accordingly proceeds as far as it can go, modified only by the predominant color of the objects themselves. When a photograph is viewed, however, it normally occupies only a relatively small part of the total field of view. Therefore any color adaptation which the picture itself produces is very much less than that produced by the original scene.

It is equally apparent that what lies **around** the photograph will often be more important than the photograph itself as far as it affects the observer's eyes. The least effect from the surround occurs when the picture is completely surrounded by black or nearly black areas. Such a situation is that normally found in the projection of motion pictures or slides in a dark room. Under these conditions it is found that (a) the color of the projection light is not very important, (b) the color balance of the film may vary considerably without being noticeable, and (c) the subject matter of the picture itself is capable of producing adaptation in the same direction as that produced by the original scene.

It must always be kept in mind, however, that color adaptation of the eye affects only the perception of hue and saturation; it does not affect the relative brightnesses of objects. The relative brightness of one colored object with respect to another is determined by the energy distribution of the light source; it is independent of observer color adaptation for all practical purposes. Hence although the color of the projection light is not very important for hue, an incadescent projection lamp will make reds four times as bright with respect to a blue as in the same picture projected by an arc lamp with daylight color such as is used in large theaters.

Effects (a) and (b) above make projection color photography less critical and hence more nearly perfect, each person adjusting his own eyesight to make the pictures look more realistic. This holds, however, in the form stated, only for stationary pictures, held on the screen for relatively long times. As soon as one picture is made to follow another in rapid succession the adaptation condition from one picture is carried along to the next. Although the observer is still not sensitive to the color of the projection light, he becomes quite sensitive to changes in color balance of successive scenes. Hence motion pictures have the requirement that grays be reproduced as the same color in all scenes; even though this may not be what would be called gray if held in the hand. This is a first approximation requirement modified by what follows.

Effect (c), the effect of subject matter, has interesting consequences in two directions. In the first place it makes possible in some cases the reproduction of colors produced in the scene by adaptation to pre-

dominant **object** color. Thus shadows and neutral areas in a scene predominantly bright green, as foliage, are very often seen as pale magenta or purple. The beauty of such a scene is often enhanced by these colors. They are usually due to eye adaptation to the green of the foliage. If examined through a hole in a large gray card, they no longer appear purple. At least an appreciable tendency exists to see such colors as these purples in projected pictures, especially if the screen is fairly large, close, and bright. They are not, of course, actually present in the photograph.

The second effect due to this adaptation to scene color is to make observers very critical of the colors of sequences of scenes in a motion picture. It was just noted that successive scenes have to have the same **color balance**. This must be modified for best results, however, if the scenes show strongly predominant object colors. Thus a short neutral gray scene following a relatively long sequence of pictures predominantly strong green will be seen at first as pink. To look neutral it would have to be printed slightly greenish.

Other types of viewing situations follow the same pattern. The more the photograph becomes apparent as an object and the smaller part it becomes of what is viewed, the less the photograph as such affects the observer's adaptation. At the other extreme, of course, is the small reflection print with white border. For such prints there is very little adaptation. About the only effect is that two slightly different balances of the same scene placed side by side will magnify their differences somewhat. As we have seen, in motion pictures and transparencies over an illuminator this effect is so strong that "something half-way between" always looks best even if both are wrong in the same direction. The effect with prints is often reduced to a mere suggestion. The print is a definite object with definite object color and is seen as such under all usual illuminations.

Reproduction of colored illumination

The fact that a reflection print is seen as a real object standing in the prevailing illumination raises an interesting point concerning the reproduction of light source color. We noted that to reproduce a neutral area it was necessary that the print reproduce this as gray, and similarly for white. In the original scene, however, if the illumination is a yellowish incandescent light, whites will appear slightly yellowish. If a print is made reproducing these as white and this is viewed in daylight, they

will appear colorless and not yellowish. They must, accordingly, be reproduced as yellowish. On the other hand, a gray of somewhat lesser reflectance must be reproduced as neutral and this would require a distortion of color processes not ordinarily possible.

A similar situation is involved in a daylight picture that is to be viewed by artificial light. The whites of the print will appear yellowish even though they represent areas that did not so appear. In this case, however, the experience of the observer comes to the rescue. A white object always so appears under this light and so he accepts it as a reproduction of an object which would appear white in daylight.

The principle involved is one of very general validity in all reproduction processes. The requirement for satisfactory reproduction of a scene is that the photograph, under the condition of viewing, shows the proper hue and saturation differences **from the adaptation state of the observers.**

It should be noted that strictly this calls for a different treatment of pictures for each different condition of viewing. This is so, in general, but the differences involved, fortunately, are usually quite small. In fact the differences involved in this present discussion are not ordinarily noticed as such by nonexperts. It is a fact, however, that to obtain the highest realism such corrections must be made, and if made may be visible as greater realism by everyone.

Energy distribution of the light source

These adaptation effects do not take into account one quite important factor.

Two light sources can look exactly alike and yet be quite different in the amounts of energy they contain in different parts of the spectrum. When two such lights separately illuminate the same objects, the colors seen will, in general, be different except for nonselective neutral areas.

Two such light sources will, in general, not reproduce as the same color by any known photographic process, but the film can be so balanced that they do so reproduce by the use of filters or films of modified sensitivity. After such correction is made, however, the illuminated objects will still show differing colors to the two films, just as they do to the eye. This is a little understood point by most users of color photography. It is considered in more detail in a later chapter. At the moment we want to consider the effect of these facts on the viewing of color photographs.

A color photograph is itself a colored object. It is not only colored, but colored with dye deposits that, by their very nature, are particularly sensitive to the energy distribution of the light by which they are seen. Accordingly, to a critical observer, color photographs change their colors when moved from one illumination to another of different quality. The more different the energy distribution the more different the reproduction colors will appear. Perhaps more important because it rules out corrections based on experience, the colors will usually change in a different color direction than would the real object under the same circumstances. For a really critical observer a color photograph may be satisfactory only under an illumination of a single color and single energy distribution.

Summary of color adaptation effects

Eye adaptation for color in any real situation results in a condition of the eye in which nonselective surfaces of medium reflectance are seen as neutral gray, provided the scene is not highly colored. If the subject matter is predominantly of a single color, the nonselective neutrals will tend toward a complementary color, and some surface of the hue of the predominant color will be seen as gray.

Color adaptation depends only on the visual color of the light. Two matching illuminants with different energy distributions produce the same color adaptation. Selective surfaces seen under two such illuminants, however, usually differ in color.

Photographic film has a different receptor mechanism than the eye. It will, in general, reproduce visually matching lights of different energy distributions as different, but it may be so corrected that they photograph alike. After this correction is made, the object color changes due to the illuminant still persist just as they do to the eye.

A photograph is a colored object. In general its colors also will change if viewed under two illuminants of different color or two with the same color but different energy distributions. Again, in general, these color shifts will not be in the same color direction as would occur with the real objects.

In practice these effects are not often troublesome as is attested by the widespread popularity of color photography. That they exist is attested by the dissatisfaction of the critical users who attempt to record some color phenomenon exactly.

Critical nature of print viewing

A subject closely allied to those of adaptation and lightness constancy is the attitude of the observer when viewing prints. When we look at a natural scene we are ordinarily looking for or at objects or people. We use the colors that we see, for the most part, to aid us in this operation. Only occasionally do we look carefully at the actual colors in front of us. When we do we are often surprised at what we see. Normally we assume that if we looked, objects would have the colors that we assume them to have.

When we make a color photograph of this scene we make the logical assumption that the photograph will more or less match these assumed object colors. The act of viewing a photograph is of quite a different nature from that of the scene. The photograph is a new object. In spite of ourselves we look at it critically. We want to know how the color reproduction came out—whether or not it is a good color photograph—what it looks like. Hence any color we did not realize was present in the original scene will come to us as a surprise. Such colors as the blue of a shadow illuminated by blue sky, a surface lighted by reflection from a colored object, a person with a deep sun-tan to which we have grown accustomed—all may strike us as strange. A less often noticed but very striking example is the color of spring foliage as compared to that of late summer. The difference between fairly accurate pictures taken at the two times is usually blamed on the process variability. The change in nature is so gradual that we become accustomed to it from day to day and cannot remember in September how saturated and bright the greens were in May and June.

As a matter of fact, the same change in attitude between viewing the scene and the photograph is responsible for many of the differences in appearance between photographs and real objects. Unskilled photographers usually make the assumption that objects and people always look the way they think of them. When they make a picture of a person, they may go so far as to get the person to smile and not "make faces." They do not go the next step of looking at him critically to see what the smile looks like. They see this first in the photograph after it is finished. There is an interesting fact in this connection which is responsible for a good many disagreements about photographs of people. If one stops to think of it, it is not quite polite in present day society to look at another person critically to see how he actually looks. Such a perusal is too intimate for the ordinary social relations. However, there is no such con-

tact in looking at a photograph and often it is in the photograph that the person is critically viewed for the first time.

No color photographic process can reproduce a scene so that the print will look exactly as the scene did when photographed. Ignorance of basic principles, however, will make the print seem even less like the scene than it really is.

The consistency principle

There is a general rule governing acceptability of photographic reproductions. It has been called the "consistency principle" by the present writer.

1. All objects and parts of the scene must be reproduced as they might have appeared at the time.

2. And, no part of the scene may be reproduced more poorly (or better) than any other.

There are many ramifications to both parts of the statement, and of course, many exceptions. On the whole, however, they represent the most reliable guide to acceptable color fidelity available at the present time.

Under the first heading there is a derived idea which is of some importance. The chief criterion of color reproduction as far as hue is concerned appears to be color names. A person will be satisfied with a color reproduction of an object if he would name the color the same from both the object and its reproduction. This implies that the more critical a person is about color the larger his color vocabulary and there is some basis for this in fact. If we look at the range of tolerances that this rule implies we find an amazing spread between individuals. Thus the Thorndike-Lorge Word Counts show 3 color names, white, red, and black in the 500 most frequently used words in the English language, 14 in the first 1000, and only about 150 which occur once or more in a million words.° A recent survey of 17 popular words shows a total of less than 100 words and phrases used at least once.

The Inter-Society Color Council in collaboration with the National Bureau of Standards attempted to divide all possible colors into the minimum number of categories that would be satisfactory for ordinary use (actually for the use of druggists in the U. S. Pharmacopoeia).†

°Edward L. Thorndike, and Irving Lorge, *The Teacher's Word Book of 30,000 Words*, New York: Bureau of Publications, Teachers College, Columbia University, 1944.

†K. L. Kelly and D. B. Judd, *The ISCC-NBS Method of Designating Colors and a Dictionary of Color Names*, Washington, D. C.: National Bureau of Standards, 1955.

They finally arrived at 267 color names. Of these the number of hue ranges is 17, the balance are modifications of saturation and lightness. This may be contrasted with the number of hues commonly accepted as just distinguishable in the spectrum which is 150 to 300, depending on intensity.

As opposed to these relatively small figures we have the Maerz and Paul Color Dictionary with approximately 7000 color names.° A reasonable estimate of the colors readily distinguishable by any normal, untrained individual if the colors can be placed side by side is of the order of a million, and the best estimate of the total number of colors which can be just distinguished under the best possible conditions is about 10 million.†

We see, therefore, that this criterion for color reproduction is, for most people, one that leads to fairly large tolerances, and experience indicates that this is indeed the fact. The process of seeing is one of trying to see object properties correctly in spite of the situation, and we try to help the reproduction just as we normally try to discount the situation to see the real object.

In this operation we are greatly assisted by the facts which lead to the second part of the principle. The eye acts like a "null" instrument. That is, it does not usually indicate absolute values of what it sees but only departures from a momentarily fixed reference point. For color this reference point is the momentary color adaptation point. All colors are seen with respect to this adaptation quite independently of the physical stimulus in absolute terms.

In an entirely analogous manner the colors of a reproduction are, to a large extent, seen with reference to each other and, particularly, with respect to the color representing gray. One requirement for good reproduction is that in this inner comparison the colors shall stand in their normal relationships to each other. It is difficult to state the exact meaning of "normal relationship." One cynic has phrased the rule to say that "the reproduction of all colors must be equally bad." As a matter of fact this is true. It is just as serious a defect in a process to have one range of colors reproduce better than the others as the reverse.

Perhaps the whole principle can be summarized by such statements as the following.

1. Hues shall not depart from those seen in the original object by an amount requiring a new name designation.

°A. Maerz and M. Rea Paul, *A Dictionary of Color*, Second Edition, New York: McGraw-Hill, 1950.

†D. B. Judd, *Color in Business, Science, and Industry*, New York, John Wiley & Sons, Inc., 1952, p. 171.

2. Saturations shall all be approximately the same fraction of the saturations of the original.

3. Brightnesses shall fall at the same fraction of the distance from black to white that they did in the scene.

The magnitude of the reproduction errors that can be tolerated when these rules are followed is astonishing. In fact it may be said quite fairly that if it were not for the facts behind these rules the development of color photography for the general public would have been delayed for many years.

If we look at the matter from a slightly different point of view we find a hint that perhaps this matter of consistency touches on a broader problem. We shall see in a later chapter, when we come to consider why people want photographs, that one of their aims is often simply a pleasing picture. One of the basic attributes of a work of art appears to be that it has a basic unity. The picture as a whole exists as a unit despite conflict of forces and the like.

Strangely enough in realistic pictures, and even in some cases for nonobjective work, the feeling of unity is supplied in part by the same consistency principle. Hence we may perhaps imagine that part of the acceptance of a poor but consistent reproduction may be due to simple aesthetic reactions based on the unity so produced. The idea cannot be pursued far, but it is of some interest in connection with the subject matter of the remainder of this chapter.

Color balance of pictures

We have now discussed at some length the various factors that determine the acceptability of photographs as reproductions and the various factors that must be considered in making the picture look like the scene itself. We have not considered, except in passing, any of the factors that tend to make the photograph pleasing as an object, or the extent to which the photographer creatively contributes to his subject in making a picture. This section and those immediately following are intended to fill this gap and act as an introduction to similar material in later chapters.

Perhaps the simplest of what may be called the color photographer's controls comes from his ability to shift the color balance of his pictures at will. In reversal processes in which the product is a positive transparency this can be done by the use of filters over the lens. In other

processes in which a print must be made from the film exposed in the camera, the color balance can be shifted during this operation.

It may come as a surprise to some readers that the most pleasing color balance for a picture is not always that at which a gray in the subject is a gray in the print. This requirement is what might be called the "physical norm" for the print. A short visit to an art gallery will convince even the most skeptical that very few artists indeed actually paint this way. The color balance of a picture is a powerful contributor to the "mood" or "feeling" of the picture, and it may require only a slight adjustment in just the right direction to make the difference between just a photograph and a revealing and appealing picture that goes far beyond the subject in expressiveness. While many other controls are available, this one is perhaps simultaneously the most difficult and the most rewarding. It is difficult to suggest examples to illustrate the point (a pair of pictures was published in my previous book). It may well be that it takes a study of the finer works of art by a person sensitive to the suggestiveness of color to master the subject.

An interesting side problem comes up in the mass production of color prints for the casual photographer. If it be admitted that exact neutral balance seldom gives the most pleasing picture that can be obtained, is there a better **average** balance for such a program? It must be remembered that the subject matter for such a program is everything in the world, with minor exceptions. The question is whether there is a preferred average balance that depends simply on the fact that it is a picture. The writer believes that there is, and that it lies slightly in the yellow-orange direction from neutral. Some processes, of course, have color distortions which make it desirable to shift the neutral point to get other colors to come out most favorably. It is believed, however, that even in a "perfect" process the bias would still persist. The effect, of course, is small compared to the shift desirable in many single pictures.

Contributions of the photographer

The preceding section describes a case in which the photographer with his controls has made a direct contribution to the observer's pleasure in the picture by deliberately departing from the most exact reproduction he can obtain.

It does not seem to be generally realized that he nearly always makes such a contribution if his pictures are considered successful. The manner in which the contribution is made and the nature of the contribution will

vary from subject to subject and from photographer to photographer but its existence can hardly be denied by one experienced in the subject.

There seem to be two general schools of thought in the matter of beauty in photography. One school, and it is quite widespread, holds, apparently with Ruskin, that all beauty lies in nature. To this school it is the primary aim (and the greatest success of a photographer) to see this beauty and "capture" it with his camera. Much of the finest work which has been done has been produced by men who have followed this philosophy, at least verbally.

The other school admits all but the premise of the belief. They do not believe that all beauty lies in nature. In fact they believe that their destiny is to **create** beauty out of nature's forms and circumstances.

It must be apparent to the careful reader that the present writer is forced into the second group by what he feels to be the nature of the photographic process. It has been emphasized that a photograph made from an unmodified scene and viewed, say, as a reflection print does not look like the scene. It does not because it is not the natural scene; it is a piece of paper. However much it may remind the photographer of the scene, to the naive observer it is a different scene. It is different to the extent that his perceptions are modified by the fact he is looking at a new object which represents something he has never seen.

It would appear to follow that such beauty as the photograph possesses is not strictly that of the original scene as it was. It must be either that of the new scene that has been created, of the photograph as object, or both. In fact we know that the simple act of looking at a section of nature through a picture frame with one eye will change its appearance markedly. Objects will appear of different dimensions and distances, the relative importance of objects will change, colors will be modified in their appearance, and so forth. It would seem that the skill of the photographer is devoted, not to recognizing the beautiful scene and then photographing it but to the discovery (and arrangement and lighting if necessary) of a scene which **when photographed** will result in a beautiful picture. Perhaps this is an extreme point of view but the writer likes to feel that the proper definition of an expert photographer is a person who can see nature the way it will look in a photograph, and so can see a beautiful photograph directly.

C H A P T E R

HOW

COLOR PHOTOGRAPHY

WORKS

Basic principles

It has been known for years (and amply demonstrated) that to explain most of the color vision properties of the eye it is necessary to assume the existence of only three types of receptors. It is not at all certain that these describe the actual nature of the visual process. What is certain is that most visual color effects can be predicted if such an assumption is made. The nature of the three receptors that must be assumed is as follows. One receptor is assumed to have a slight sensitivity to deep blue which becomes greater as the light is changed toward blue-green and then diminishes toward green. The second has its maximum sensitivity in the green, diminishing toward blue and toward red; and the third similarly has its maximum sensitivity in the red. The nature of the sensitivity distributions of these three receptors is assumed not to change under any conditions, but the actual responsiveness of each may vary under different circumstances (color adaptation). In a normal situation each receptor gives a definite response, and the ratios of responses of the different receptors to any given stimulus determines (at least to the first order) the color that is seen. Millions of such receptor systems in each eye build up the visual image which is transmitted to the brain. It is worth repeating that there is no evidence that the eyes are so

constructed, the point is that a model so constructed (with refinements here omitted for clarity) would work the way the eye does.

The processes of color photography represent exactly such a model. Records are made of the amount of red, of green, and of blue light reaching the camera from each point or area of the scene. Just how this is done in each process need not concern us for the moment. Every known process of color photography has this or a modified version of it as the first step in making the final picture. Modern color photography is sometimes called "three-color" photography for this reason. Earlier processes tried omitting the blue record because of the difficulty of handling three. The use of four records has often been suggested. Basically, three records are necessary and have been found sufficient for processes to date. It remains to be determined whether more may be gained or lost by four.

A photographic material responds to light in such a way that a picture can be obtained that reflects or transmits in its various areas the same relative amounts of light as do the objects in the scene. This can be done whether white light is used or whether the light is restricted to one color region of the spectrum. The records, therefore, are literal in the sense that they can be used as though they were the light coming from the objects. If they are transparencies, light can be transmitted by them and if they are reflection records, light can be reflected from them. Three-color records, then, can be thought of as the scene itself divided into its relative reflections to red light, to green light, and to blue.

The basic problem of color photography is to recombine these records in such a way that the result will be satisfactory to the observer and not too expensive or inconvenient for the use intended.

One of the first techniques attempted, and perhaps the most obvious one, is simply to project the pictures through the corresponding red, green, and blue filters onto a white screen in a dark room. This technique does in fact work excellently as far as appearance of the picture is concerned. Unfortunately, except for certain unusual applications it has three restrictions, which have prevented its commercial use. In the first place it is apparent that the three pictures must be lined up with each other ("registered") to high precision. This has prevented motion picture theater application except in a decidedly modified form. Second, it calls for three projectors that match, and it uses three films for each "subject." This makes the process expensive. Third, it is not possible to produce reflection prints that have satisfactory white areas by this technique. The combination of the three difficulties restricts its use to still projected pictures, and the need for special equipment both in projectors and cameras has not permitted even this field to develop except for special applications.

In distinction to these "additive processes" are the so-called "subtractive" ones. In principle, these subtractive processes are identical with the preceding ones. In the additive processes a **red** beam of light is decreased as demanded by the subject, from full intensity down to zero by the action of a black-and-white record picture. In the subtractive pictures the amount of red light in a **white** beam of light is decreased from full intensity down to zero by means of a **dye** image which absorbs red light. The concept is actually the same in both cases. It does not matter whether a silver image decreases the amount of red light in a mixture which makes white, or red is taken out of a beam of white light. In both cases red light is taken out of white light and the result is the same.

In the subtractive pictures, in which the record picture does its subtracting from white light rather than red, there is one vitally important difference. In additive processes the red, green, and blue light beams must be separate and can be combined only after passing through the three record pictures. The subtractive dye pictures on the other hand act on white light to produce their effect, and each works on a different **part** of the white light. Hence they are placed **on top of each other** and a single beam of white light passing through all three produces the finished picture. Subtractive records, accordingly, can be placed together in register and the result handled like a single piece of film in standard black-and-white projectors. The fact that white in the picture is represented by **no deposit** in all three layers means that this multiple film can be laid on a sheet of white paper and seen as a reflection print. Subtractive processes, accordingly, hold the promise of doing everything that additive ones will not do according to the list above.

The actual colors of dyes that absorb red, green, and blue light respectively, to the eye, are cyan (blue-green), magenta, and yellow, but the colors themselves are artifacts in the practical case. It is the fact that they control the amounts of red, green, and blue in white light that matters.

Subtractive processes have been known for many years and many techniques have been used, such as transferring the three records to a permanent support and cementing three thin film records together. Several commercial applications of these principles have been successful, both for still photographs and for professional motion pictures (notably by Technicolor). It was not until manufacturers learned how to coat the red, green, and blue emulsions on top of each other on a single support **before exposure** and then to convert them to dye images of the required colors **after exposure**, however, that the method became generally successful. It was then possible to use an ordinary camera to expose the

pictures by white light, and the final result could be projected by white light in an ordinary projector. Satisfactory reflection prints were slower in coming, but are now available in many different forms.

It is characteristic of subtractive processes, because they are dependent on dye images, that they have certain definite peculiarities due to the dyes that are available or can be made. Thus no dyes are known that absorb only in the red region of white light and not at all in the other two regions. Such absorptions in the blue and green of the cyan dye, for example, are called "dye impurities" and have the effect of darkening blues and greens as well as slightly shifting the hues of greens and some other colors. It is often assumed that if these impurities (the word has nothing to do with chemical purity) were not present the process would then be perfect, and such theoretical dyes are called "perfect dyes." Perfect dyes would make a subtractive process act exactly like an additive one. Additive processes, however, are also imperfect in many ways, and so the term is purely relative. Nevertheless many techniques have been devised to correct for these impurities and we shall discuss a few of them as we go along. The fact is that the range of colors that can be produced by subtractive dyes is as large or larger than that producible by an additive system, but the results are different.

Artists who are accustomed to oil paints or water colors will realize that any set of colorants will have its own mixture peculiarities. One of the things a painter has to learn is the mixture characteristics of the paints he intends to use. Color photographs are made by the mixture of just three dyes, and the gamut of colors a process can produce is the total range given by these in all possible proportions except for a limit on the maximum amount of each that may be used. The series of colors so formed bear the characteristic stamp of the three dyes used in the process. A trained artist familiar with the processes can recognize the process from a glance at a picture. If the dyes were perfect, this would not be possible to the same extent, and one of the aims of research in this field is to reduce this effect.

Any set of three dyes that absorb roughly the red, green, and blue regions can be so adjusted in concentration that they will produce a neutral gray for a given illuminant. One of the requirements of a color process is that it photograph a gray as gray and do this for the whole series of grays from black to white. Suitable manipulation of a process would do this for any such set of dyes, but there are two further requirements that greatly limit the choice.

There are a very large number of energy distributions of light that will look gray to the eye under a given illumination. If the quality of

the illumination is changed, however, most of them will change color. There is only one gray that cannot be made to change with illumination quality. This is the kind which absorbs or reflects equally for all colors. The choice of dye sets, accordingly, is limited to those that will produce grays which are "stable," that is, to those not sensitive to illuminant quality changes. No present processes are known that do not change at all with the illuminant, and there are considerable differences in this respect between processes. Some of them, however, approach the ideal quite closely, and we may expect further improvement.

The second requirement has to do with the maximum range of colors that can be produced by mixture of the dyes. It is apparent that if each of the three colors is of low saturation (muddy or pale) at fairly high concentrations, it will be easy enough to meet the first requirement, but the total range of colors for a given set of maximum concentrations will be small. The fewer the dye "impurities" the greater the range' but the more difficult it is to meet the first requirement.

It is also true that the individual colors of color photographs have more tendency to change color with illuminants than do the colors of everyday life. This is a basic characteristic of a picture made by mixing only three dyes, each of high saturation. Perfect dyes would probably make this characteristic worse. Ordinarily, however, the hue shifts due to this cause are not large enough to be serious except with certain rather extreme types of light source. The original fluorescent lights, for example, before the advent of the DeLuxe types, were sufficiently extreme that they could not be used satisfactorily with most processes.

A similar characteristic of dye sets is that as the total amount of dye present in any color increases, as it does in the shadowed areas, the visual saturation of the color increases. This is opposite to what an artist sees and what he paints. A colored object that shades into dark on one side shows decreasing saturation visually toward the darker parts whereas in a color process the purity and saturation tend to increase. To the artist this is sometimes objectionable, and in any case it gives a characteristic appearance to the pictures. Hues tend to shift somewhat also, but this is often masked by other effects.

One further difference from the mixture systems to which artists are accustomed might be noted. An artists often uses a particular pigment for its appearance characteristics other than color. Thus he may choose either an opaque or a transparent color for a particular area and does this because he wants that quality there. In color processes, obviously, the characteristics in this respect are the same in all parts of the picture. All areas may be made to appear transparent or opaque, but not to differ

from place to place with the subject matter in the same picture. Whether or not this is desirable, it is a characteristic of all processes.

Components of the picture

Having established in a general way how a color process produces a picture, we want now to consider several aspects of such a picture without regard to any particular subject matter. In particular we want to consider the nature of the picture variables that are related to hue, saturation, and brightness.

Consider first the most important single variable as far as the picture is concerned, the reproduction of the relative brightnesses of the subject. Although the various parts of the picture have various colors, the brightnesses may be considered as independent. Blue may be light or dark, for example. A high brightness is represented in the picture by a small amount of dye and a low brightness by a large amount. Except for very saturated or very light colors there will, in general, be at least some of all three dyes present in every area. Since the three dyes together in a certain ratio produce gray, we may think of any color containing all three as a certain amount of gray plus an excess of one or two of the dyes in the ratio required to produce the proper hue and saturation. A large part but not all of the brightness differences in the picture are due to the varying amounts of this underlying gray. The dyes themselves taken singly also vary in brightness with concentration. This is particularly apparent when they are present in pairs, blue (magenta plus cyan) darkening most rapidly with concentration, green (cyan plus yellow) next, and red (magenta plus yellow) the least. Thus, while the brightness of each area is produced by the ratios and amounts of the records produced by red, green and blue light, from the photographic standpoint it may be thought of as made up of a gray plus a certain amount in excess of one or two of the dyes.

If the whole process worked exactly so that it made a "perfect" reproduction of the subject colors, then the brightnesses of the different areas would be exactly the same as those of an equally perfect black-and-white picture.

The photographic variables that correspond to hue and to saturation are quite complex if considered closely. To a good first approximation, however, hue is determined by the ratio to each other of the two dyes in excess over the gray. If there is only one dye, of course, its hue is that

of the dye itself. A lot of cyan and a little yellow makes a bluish green whereas a lot of yellow and a little cyan makes a greenish yellow. Saturation, on the other hand, corresponds roughly to the amount of excess of the dyes over the gray and particularly on the amount of the one present in greatest amount.

A fourth major component of a photograph is its detail. Photographs differ markedly in the way that the details of the image to which it was exposed are recorded. At first sight this might seem to stand in simple relation to the reproduction of the brightness scale. This, however, is not the case. The recording of fine detail, edge contour, edge gradient and the like depends as much on the nature of the particular photographic medium as it does on its tone scale. It is probably better to consider them as separate properties. It is shown in a later section that fine detail and tone scale may be treated in subsequent steps so that they become well defined independent variables.

The effect on the picture of edge sharpness and of detail reproduction is not independent of the large area contrasts of the picture. Edge effects and fine detail contrast affect the visual contrast of the whole picture. Increasing the sharpness increases the contrast. Conversely a change in the physical contrast of large areas changes the apparent sharpness in the same direction. Thus a sharper picture must have less physical large area contrast to appear of the same visual contrast as one with less sharpness.

We might mention in passing that highlight and shadow quality in a picture also tend to differ from one condition or process to another—again more or less independently of the picture contrast or sharpness of the middle tones. Thus the sharpness of detail in highlights or shadows can be higher or lower than in the middle tones, etc. These parts of the picture also can be modified independently by subsequent operations.

Finally we have as a component of major importance, the characteristics of the picture as an object: size, dimensions, surface, edges, weight, stiffness, size and proportion of borders, color of the paper, and so on. As noted earlier, all these items enter into the appearance of a photograph whether the observer is looking at it "as a whole" or simply "at the objects" it represents. These variables also, of course, are under the control of the photographer and often do much to make or break the result.

Tone scale, hue and saturation characteristics, nature of the detail rendering, highlight and shadow quality, and the physical make-up or "format" of the picture are the main variables of a color process con-

sidered independently of the way in which the subject of the picture is handled by the photographer. All of them may be modified within limits to produce the exact result wanted.

It is apparent that there will be great differences among the various types of photographic color processes in both the ease with which such changes can be made and the total available range of the changes. To learn something of these it will be necessary to consider the various kinds of subtractive processes that may be encountered. Additive methods will not be considered because (a) they are adequately treated in other works, (b) to date they have not been important to the ordinary worker, and (c) the problem of combining the three images is a mechanical-optical one rather than photographic.

Dye-forming processes

In the processes in which the finished picture consists of dye images in the same film that was exposed in the camera it is apparent that the dyes must either have been present before exposure or have been introduced into the film afterward. Both methods are known, but the latter method is gradually being superceded by the former.

To simplify the discussion we shall not attempt to describe all the possible ways that have been tried to produce images by these two approaches. Basically the two most successful approaches have been (a) to bleach out existing dyes and (b) to form the dyes in the film, these two results are accomplished somewhat as follows.

When photographic emulsions are exposed to light, the silver compounds that they contain are altered by the light. The amount of altered material is roughly proportional to the total amount of light that has fallen on a given area. This alteration makes it possible to reduce the silver compounds to metallic silver by treatment with solutions that do not affect the unexposed material. The total amount of silver formed, however, does depend on the solutions used, on their temperature, the time over which they are allowed to act, and on the movement or "agitation" of the solution over the emulsion. That is, the light modifies the silver compounds in such a way that gradual reduction to metallic silver is possible and the operation can be stopped at a desired point.

This metallic silver record of the light is the familiar black-and-white "negative" of the ordinary camera. The formation of such a silver negative is the basic operation characteristic of all present day processes with one exception, to be considered presently. It is the fundamental process

of all photography as we know it today. Its unique position comes from the enormous multiplication involved. The initial modification due to light is so slight that even if it is actual metallic silver, it is totally invisible. The amount of silver finally produced may represent a multiplication of as high as 100 million times. Hence these processes have high light efficiency and very "fast" film can be made with their use. No other type of photographic process known at the present time approaches this efficiency.

The operation of reducing the silver compounds to silver is known as "development" of the image, and the material causing the change is called the "developing agent." The result, of course, is due to a chemical reaction in which the silver compounds are "reduced" and the developing agent is simultaneously "oxidized." We do not need to consider this any closer. The result is always reduced silver and oxidized developer plus other products of the reaction that so far no one has been able to use to operate a color process, although they often modify the result profoundly.

In the dye bleaching processes the developed silver image is used as a basis for bleaching the dye near each grain of silver. The chemistry of the process need not concern us, but we need to note that dye is destroyed in proportion to the amount of silver developed. Where a lot of light has reached the film during exposure much silver has been formed, and this produces a maximum of bleaching. This means that at this point there is a minimum of dye. Where there has been no light exposure the full amount of dye originally present is left. The final dye image is, accordingly, a "positive" with respect to the original light. That is, the dye image will be light where the scene was light and dark where the scene was dark. This is the opposite of the "negative" originally developed as silver. The silver, however, is removed after or during the dye bleaching and the final dye image is left as pure dye. Processes using this type of approach are those covered by the patents of Gaspar and Christensen.

The second method of producing a dye image is at present more widely used (Kodachrome, Ektachrome, Anscochrome, etc.). It consists of the formation of dye as part of the development operation. During reduction of the silver compounds, oxidized developing agent is formed in direct proportion to the amount of silver reduced. This oxidized developer is a quite reactive compound, and by having a suitable chemical agent present it will immediately react or "couple" with this material to form a dye. By the choice of suitable developing agents and couplers, dyes of the proper color and having the desired characteristics

may be formed. One requirement is that this dye must be insoluble, and when this requirement is met the dye is formed inside the gelatin of the emulsion and becomes a permanent part of the film.

Two ways of having this coupler present during development have been used, both leading to similar results but requiring quite different handling steps. The first of these is to have the couplers present in the developing solution during development (Kodachrome). This requires water soluble coupling agents. The second method consists in putting the couplers in the emulsion during manufacture (Ektachrome, Anscochrome). This latter method requires couplers that are insoluble and inert photographically, but it leads to a real simplification of final handling. In modern multiple-layer coatings in which the red, green, and blue sensitive emulsions are coated on top of each other and only a single film exposed in the camera, each layer must produce a dye image of a different color. In the method involving couplers in the developing solution this means that each layer must be developed separately. In the second method, however, these couplers are already present in their proper layers and development in a single solution then produces the required colors simultaneously. Obviously from the standpoint of final handling, even if not from that of manufacturing, the latter method is greatly superior. For this reason only the latter type of process has reached the market for the photographer who desires to develop his own pictures.

There is a third method of producing a dye image, which may become important in some applications. This is the so-called diazotype process in which the dyes are produced by the action of light on light sensitive compounds. These afterward combine with each other in the presence of an alkali, usually ammonia gas, to produce a dye. In this type of process, of which Ozalid is the current example, the amount of material modified is roughly equivalent to the amount of dye formed. The processes are, accordingly, not very sensitive. They also are sensitive only to a single color of light and so cannot be used for exposure to natural objects. However, color pictures can be produced by this means.

Reversal processes

Taking the first two of the above methods of arriving at a final dye image, namely, dye bleaching and dye formation by coupling, let us now consider how we can arrive at a satisfactory color picture. Particularly,

we want to consider what the film, the exposure, and the processing are like.

Consider first a modern multilayer film. Fundamentally such a film consists of a plastic material called the film base, one side of which is coated by a series of three emulsion layers, sometimes coated directly on each other and sometimes separated for one reason or another by layers not containing light sensitive materials. The three light sensitive layers are for the purpose of producing the red, green, and blue light records that we noted are required by all processes. The inert layers are either to isolate the others chemically or to absorb light of certain colors. In camera film the red record is usually on the bottom (next to the film base), the green in the middle, and the blue on top. The top emulsion is sensitive only to blue light, the second to blue and green, and the bottom to blue and red. White light entering through the top layer exposes it to blue light. Any blue light not absorbed in the top layer is stopped by a blue absorbing (yellow) interlayer. Thus only green and red light passes through to the second layer which is sensitive to and absorbs green light. The red light passes on through to expose the bottom layer. This, in essence, is the nature of all present day multilayer camera films. In some the order of the red and green sensitive layers may be reversed, but the three separate records are always formed. It has been a dream for many years that some day all three of these emulsions might be mixed and yet retain their individual identities. This would require only a single coating operation and will undoubtedly be accomplished.

Before going on to consider the step of producing the dye image from these exposures, we might consider briefly the requirements of such images. We noted earlier that the final picture should transmit red, green, and blue light in the same ratios that are present in the original scene, so that white light passing through the finished picture would in fact result in the same ratios for each area as were present in the original scene. It is somewhat easier to consider this requirement if we take specific examples. Suppose the light from a red object contains only red light with no green and no blue. This light strikes the film and passes through to the bottom layer without exposing the other two. The bottom layer, however, will control the amount of red in the white light which is later to be passed through the film. That white light is to be changed to red. Obviously the bottom layer must **pass** a lot of red light and the top two must absorb green and blue heavily. This means that where the **most** light exposes the bottom layer, the **least** dye must be formed; and where no light strikes the upper two, the **most** dye must result. This means that

positive images are required to imitate the original scene. Similar considerations hold for all other colors, and we find that the requirement is a positive image in each layer exactly recording the relative brightnesses of the blue, green, and red parts of the light from the scene. This has been considered in some detail because it is always the positive which is wanted, and in some cases we shall find that the camera film produces a color negative and then has to be "printed" to get the final result.

Returning to the exposed camera film, we found that red light gave exposure only to the bottom layer. If this is developed in a developing solution that produces silver only, we obtain a heavy deposit of silver in the bottom layer and none in the other two. That is, it produces a negative. If the camera film is to be used as the final picture, however, this is not what we want. There are three ways of proceeding to the desired result. These three ways of proceeding correspond to three kinds of film.

In the first type of film mentioned, the bottom layer is coated containing the maximum desired amount of red absorbing dye, the middle with green absorbing, and the top with blue absorbing. After development of the exposure to silver, dye is then bleached according to the amount of silver present. All the silver is then removed leaving the three required dye images. In description this is one of the simplest of the "reversal" processes, so-called because the original tone scale developed to silver is reversed in the final result, light areas taking the place of dark, etc. Unfortunately, this approach has a number of difficulties that have precluded any great commercial success in this form. Among others is the fact that it is difficult to expose all the way through a layer by blue light, for example, when that layer contains a very large amount of blue absorbing material.

The first really successful color film for the general photographer produced in this country made use of a dye coupling system in which the couplers are introduced in separate developing solutions. In this process the exposed film is first developed to the silver negative image in all three layers. Use is then made of the fact that there was originally a constant amount of silver compound per unit area. When a lot of silver has been reduced to metal, there is very little unaltered material left; when no silver has been produced, there is the original amount, etc. This residual material is still sensitive to the color of the exposing light. Accordingly it is possible to re-expose the top layer to blue light and develop it with a solution that will produce a blue light absorbing dye, the red layer to red light followed by formation of a red light absorbing dye, and so on. In this way, after removal of all the silver, the required positive image remains.

The third technique involves a film more difficult to manufacture. In this material the coupling compounds that will later form the dyes are mixed with the proper emulsions in the required amounts before coating. The exposed film is then developed to silver first in a developer solution which does **not** react with the couplers. The remaining material is then exposed to white light and developed in a developer which does form dyes in all three layers at once. The silver is then removed as before.

All of these methods lead to transparency films which can be projected by white light in a darkened room or viewed over an illuminator. The film projected is the same as that exposed in the camera with 16mm, or 8mm, 35mm slides or sheet film.

Often what is wanted, however, is not the single film that was exposed to the subject but either a copy ("duplicate") of it, or one or more reflection photographs rather than a transparency.

Theoretically there is no reason why reflection material cannot be made for exposure directly in the camera, but the fact that such images are reversed right to left and the frequent desire for more than one copy have retarded this development.

For these uses a series of processes and techniques have been developed by which both multiple copies of the original transparencies and reflection photographs may be made. The operations broadly are known as "printing" processes, the original transparency being "printed" to get the final result.

Also, when the final goal is a reflection photograph there is no need for the camera original to be satisfactory as a projected picture. Because there is considerable photographic advantage in developing the original to a negative rather than reversing it, there have gradually evolved the negative-positive color processes in which both the negative and the positive are in color but the first is printed onto the second to get the desired final picture.

We shall consider first "duplicating" and then negative-positive processes.

Duplicating processes

It is apparent that if a photographic material can be exposed to a natural subject and result directly in a color reproduction, the same thing can be done a second time with the first picture as the subject. When the identical process is used twice in this way, however, it is difficult to get a satisfactory result. There are many reasons for this,

all adding up to the fact that compared to the subject the first result has departed so far from the original that the same change cannot be tolerated a second time on the same subject.

There are many ways of offsetting these changes. They are the result of a combination of causes, and each cause can be offset to some extent. One of the causes is the unwanted dye absorptions described earlier, the so-called dye impurities. The effect of these impurities is quite large, and they result in loss of saturation of all the colors accompanied by some shifting of the hues. (We might note here that for nearly all processes loss of saturation of the colors is the major color defect.) This type of loss of saturation can be offset to a very large extent by simply increasing the contrast of all three of the dye images but retaining the proper dye ratio to keep grays gray.

Such an increase in contrast in the process is customary in nearly all processes because up to a certain point the resulting increase in saturation is more important than the resulting distortion of the brightness scale of the subject. There is, however, a definite limit to this increase beyond which the appearance of the picture as a whole suffers seriously. When an original photogaph with such enhanced contrast is copied by the same process unmodified, the contrast increase occurs twice and is nearly always beyond the acceptable limit.

The gain resulting from the increased contrast, however, can be retained by a process known as "masking." Although the technical details of this as well as other similar operations are outside the intended scope of this work, the use of masks is so important to the photographer who really wants to master his medium that both here and later it is necessary to consider in some detail just what can be done by their use.

The present problem is to copy an original transparency by the same process without having the brightness contrast of the second picture higher than the first, even though it is a film that increases contrasts.

We noted earlier that the brightnesses of the various areas of a picture are independent of hue and saturation. A given deposit already consists of a certain amount of neutral formed by all three dyes, the hue and saturation coming from the excess of one or two of them above this gray. The hue and saturation of such an area, accordingly, will not be changed if a neutral gray area of silver is placed over it. Only its brightness relative to the rest of the picture will be decreased. Accordingly we can change the relative brightness of any area we please simply by adding silver density to darken it, or by adding density to all other areas and not to that one if we want to lighten it. If we want to keep the brightness contrast from increasing during duplicating all we have to do

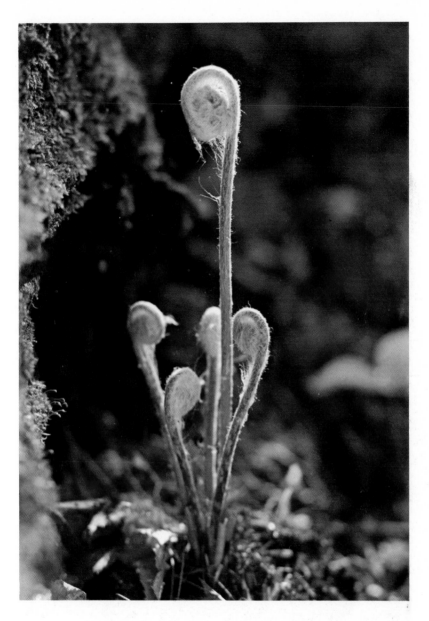

1. May 2, 7½″ lens at f/8 for 1/5 sec. Back lighted Cinnamon fern.
All color photos by J. Klute with Ektar lenses on 4″x5″ Ektachrome.

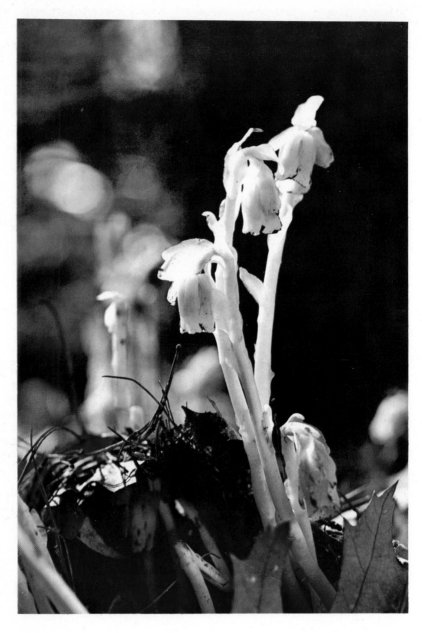

2. Aug. 12, 8½″ lens at f/11 for ½ sec. 3:30 P.M. *Indian pipes.*

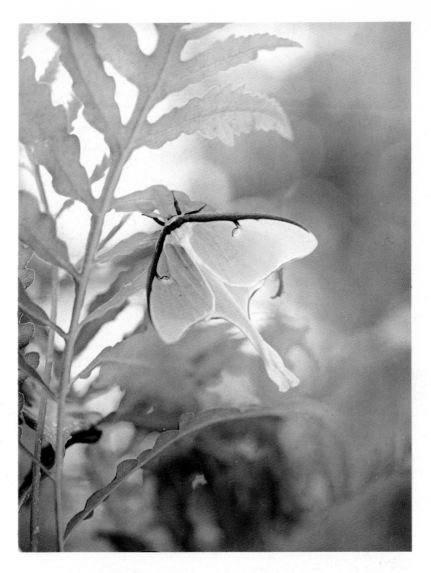

3. May 30, $8\frac{1}{2}''$ lens at f/11 for 1 sec. Dull day. Just emerged Luna moth.

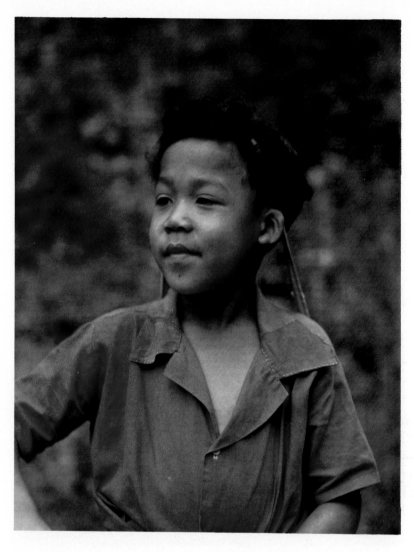

4. Mar. 15, 10″ lens at f/8 for 1/10 sec. Overcast day. Jamaica school boy.

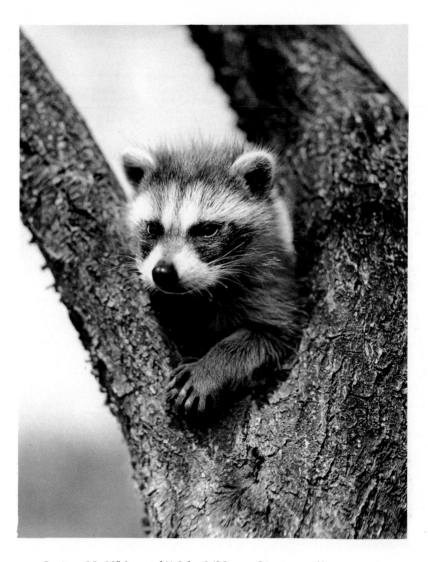

5. June 15, 10″ lens at f/6.3 for 1/25 sec. Direct sun. Young racoon.

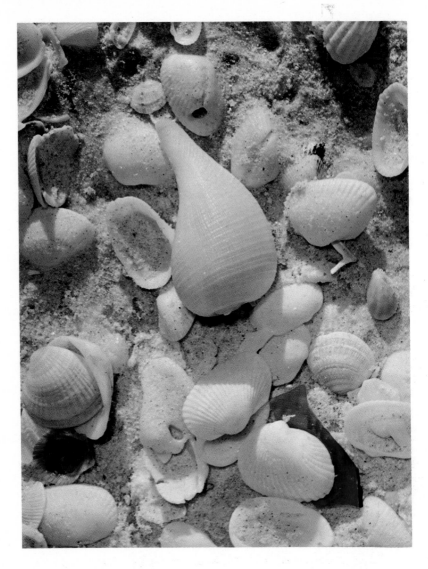

6. Dec. 30, 10″ lens at f/32 for ½ sec. 17″ bellows extension. Florida.

(Above) Sep. 20, 10" lens at f/11 for 3 sec. Under water, through surface.
7. *(Below) July 4, 8½" lens at f/45 for 1 sec. Bright sun, dark sky, Cape Cod.*

8. Aug. 27, 10″ lens at f/11 for 2 sec. At noon in deep woods.

Oct. 31, 14″ lens at f/6.3 for 1/5 sec. 3 P.M. Bright sunshine.
9. Aug. 20, 10″ lens at f/45 for ½ sec. 9 A.M. Steep frontal slope.

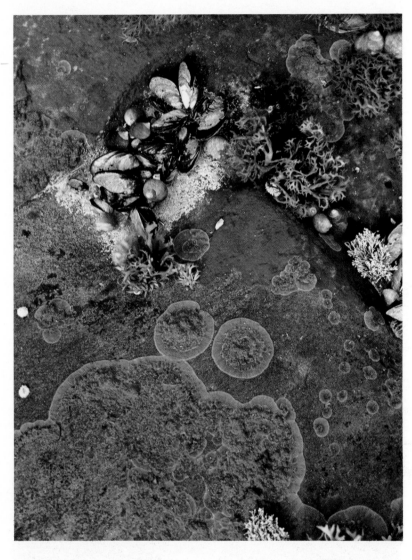

10. Sept. 14, $7\frac{1}{2}''$ lens at f/16 for 1/5 sec. New England tide pool.

11. *Same house and leaves photographed with and against the sun.*

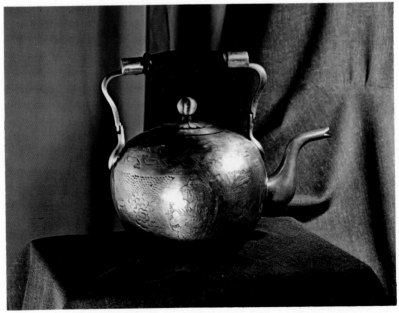

12. *Polished metals need diffuse rather than directional lighting.*

13. *Many objects change color when lighting direction only is changed.*

14. *The background is always important to the subject of a picture.*

15. Two pairs of pictures in which the only variable used is depth of focus (f/45 on left f/8 on right). The ability to see the possibility of such pictures is part of the art of photography.

16. *Natural light varies greatly. Made two days apart in Nova Scotia.*

is decrease it first by the amount required to offset the later increase. How this may be done remains to be considered.

When a black-and-white negative material is exposed in a camera to neutral gray surfaces, the result after development is a series of densities of silver corresponding inversely to the brightnesses of the subject. The brightest area in the subject will produce the greatest amount of silver and darkest area the least amount. The relationship of the relative brightnesses in this negative to those in the subject, however, can be modified extensively by the amount of development and the choice of the film used. That is the ratio of the amount of light transmitted by two areas of the negative may be made the same (inversely) as that of the corresponding areas in the subject or it may be less, or more than the subject. This relationship over most of the range of the material is known technically as "gamma" (γ) but we shall call it "photographic contrast" here.

In this same black-and-white material, exposure to two areas of the subject having different colors again results in two areas of silver. The amount of silver formed now depends, however, not only on the brightness of each area but also on the color of each. The ordinary "panchromatic" film is sensitive to all colors of light but its sensitivity varies with the color in a manner different from that of the eye. Accordingly with a particular film a green area that looked the same brightness as a blue might photograph considerably lighter in the negative. This effect can be corrected by the use of a piece of colored transparent material ("filter") over the lens when the picture is made. This changes the relative amount of exposure produced by the different colors so that the result becomes similar to that seen. Use of any colored filter will alter this relative brightness relation, and by suitable choice the relation can be altered in any way desired.

The degree of development, then, controls the photographic contrast of this black-and-white negative, and the film sensitivity combined with the use of a filter controls the relative brightnesses of colored areas.

Returning now to the problem of reducing the brightness contrast of a color positive without changing the hue or saturation of its areas, we find that the problem is quite simple. The positive has a certain photographic contrast produced by the process, and its areas have definite colors. If we place this transparency in contact with a piece of black-and-white negative material and expose or print it with light passing through an appropriate filter, we will get on development a negative image in silver of the same size as the transparency. The brightness contrast of this negative will depend on the degree of development, and

the relative brightnesses of the colored areas will depend on the color of the filter used as well. If we want to record the brightnesses inversely, as they appear to the eye, then the filter, the film and the light source must combine to act like the eye in this respect.

Having made such a negative, or "mask" we can now place it over the original transparency. To understand the effect of this consider first a series of gray areas of different brightnesses in the scene. If the photographic contrast of the negative is such that it has inversely, but exactly, duplicated the original brightnesses of the transparency, the two will add up to exactly the same brightness for all areas regardless of their original brightnesses. In other words the contrasts between gray areas will have been eliminated completely. However, if the photographic contrast of the negative is lower than this, then brightnesses in the positive (starting at the dark end of the scale) will increase faster than they decrease in the negative. Accordingly the sum of the two will still be a positive but with **decreased** contrast. By this technique then the brightness contrast can be decreased all the way to zero. It can be reversed by still higher negative contrasts.

Consider now the effect of such a mask on colored areas. If the light source, filter, and masking material is properly chosen, it is possible to make the mask exactly (again inversely) duplicate the brightness contrasts of the colored areas as well as the grays. When this is done, the mask **does not change** the relative brightnesses of any two areas of the **same** brightness in the original regardless of their color or saturation. A mask that does change the brightness contrasts of a color picture but is independent of the hues is known as a "white light" mask. It is useful anywhere that visual brightness contrasts **alone** are to be modified.

Masks made in a similar way may be used to alter the brightness relations between colors also. It is only necessary to change the color of the light by which they are exposed. Suppose, for example, that the reds in a picture are too light compared to the other colors. By exposing the mask by red light and developing to a low contrast it is possible to put as much density as desired over the reds. Having the reds too light is the exact equivalent of having all colors but red too dark, density is added to the reds until all colors are equally dark, then the duplicate is printed lighter so that black is taken out of all the colors.

It is hardly necessary to point out that this technique also permits changing of the natural order of the color brightnesses to nearly anything desired.

One application of this of practical importance is the correction of brightness distortion introduced by the impurities of the dyes. The red

absorbing dye always absorbs a considerable amount of green and blue; the green absorbing dye nearly always absorbs blue; and the blue absorber tends to absorb some green and no red. The net result is that reproduced colors darken progressively from red to blue. A certain amount of this is reasonable since it is an order to which we are accustomed. Because it adds to the natural order and intensifies it, however, the effect cannot be tolerated twice on the same subject. This darkening of the blues and greens can be offset by the use of a low contrast mask (about 30 per cent of full photographic contrast) exposed to red or orange light and placed over the original. Unfortunately this mask must be made separately from the contrast reducing mask described above, and the two used over each other if much change in brightness contrast of the whole picture is desired. Masks add but exposures of masks do not.

This rather lengthy discussion of masks is important because of the enormous flexibility which masks give in the handling of color photographs. We shall return to them later when we discuss some of their creative possibilities. At the moment we want to note mostly that by their use satisfactory copies of photographs can usually be made by the same or a similar process.

Negative-positive processes

We saw earlier that the direct action of light on emulsions was to make them developable to silver images with reversed brightness scales, or negatives. Also the products of development can be used to form dyes, and these dyes may be in separate layers appropriately sensitized.

It is obviously possible to produce in this way a colored dye negative, just as we have been considering dye positives. The properties of such a negative are the same as a similar positive, that is, each dye image controls its own portion of the white light more or less independently of the others. If the emulsion that was sensitized to red light forms a negative in red absorbing dye, then the red light transmitted by the film as a whole will be inversely proportional to that from the subject. The only difference between it and a positive will be this inverse relationship. The same holds for green and for blue light.

Now if this negative is printed by white light onto a similar negative material, the scale is again inverted and we have a positive in each emulsion exactly corresponding to those made by reversal processes. The only difference lies in the fact that we have printed a color process back onto itself, and we again encounter the difficulties mentioned in the previous

section. For this reason some form of masking, at least to decrease the effect of dye impurities, is desirable.

We shall consider this in a moment, but at the risk of confusing the subject it might be well to note one point. The colors seen in such a colored negative are approximately complementary in hue to the colors of the subject. This follows from the fact that a saturated color consists of a lot of light of one or two of the three colors and relatively little of the others. In the negative the large quantities of light are represented by large absorptions and the small amount by low absorption. Hence the negative transmits the opposite color as far as white light is concerned. When this is printed, of course, a reversal happens again and we then get the correct color.

Color negatives then are inverted in the brightness scale and of roughly complementary colors. Saturations, however, representing the **magnitude** of the differences in the three emulsions come in the same order in the negative as in the positive.

Returning to the need for masking, we encounter a new development in color negative work (Ektacolor, Kodacolor) which is of great importance but somewhat complex to explain. It has been found possible in a negative material where the appearance of the transparency does not matter, to make the dyes act nearly as though they had perfect transmissions. This development, known as colored couplers, operates as follows for the red absorbing dye. The others operate in a similar manner.

The red absorbing dye itself has impurities in both the green and blue. It should transmit both without absorption, but it does absorb appreciable amounts of each. In a process in which a dye forming coupler is present in the emulsion this compound is normally colorless and forms dye only with oxidized developer. It has been found possible, however, to give these compounds a color, that is, to make them absorb colored light, in such a way that this color **disappears** when the final dye is formed. The coupler is, accordingly, made to have the same absorption for blue and for green light as does the maximum impurity of the red absorbing dye after it is formed. Since the coupler is uniformly distributed through the emulsion before exposure, this emulsion starts off by having a uniform (orange) color throughout. As red absorbing dye is formed, however, and in exactly the same amount, this orange dye disappears. However, the blue and green absorptions of the red absorbing dye exactly match that of the orange dye that has disappeared. Hence as far as green and blue light is concerned nothing has happened. This means that the red absorber is acting as a perfect dye controlling only

red light. We have described the ideal case, of course, and in operation the effect is not as perfect as this but the principle is exactly the same.

When such material is printed it is only necessary to use light containing more green and more blue than would be used ordinarily to make a correct print.

By the use of these colored couplers the awkward and expensive operation of making and using a separate mask during printing is eliminated entirely, and the chief obstacle to negative-positive processes, that of the need for masking, is overcome.

This is a fortunate outcome because for many reasons negative-positive processes are superior to those involving printing a positive onto a positive. We might note just two advantages which by themselves would be sufficient. In our discussion of positive processes we treated the brightness scale reproduction as though it were perfect. As a matter of fact, it always breaks down at both ends of the scale, in extreme highlights and extreme shadows. When a positive is printed onto a positive this effect tends to be accentuated. In negative-positive there tends to be a compensating action and a much better tone scale results. Again, in all photographic exposures there tends to be a spreading of the fine detail of the image, especially in heavily exposed parts of the picture. In positive to positive work this spreading takes place twice in the **same** direction, tending to hurt the quality of detail in the highlights, whereas in negative-positive printing the effect occurs in **opposite** directions and tends to compensate. Hence the photographic quality of negative-positive is distinctly superior to either reversal or positive to positive printing. It seems likely that all professional work in the future for which quality is important will tend toward negative-positive processes.

Separation negative printing processes

Up to this point we have considered only color processes in which the red, green and blue records are in different emulsions coated on the same film. This form of record is so convenient for most operations that it is rapidly displacing the older form in which the records are on separate films. For some processes, however, such separate records are necessary, and we want now to consider this group.

There are two general ways in which such separate records are obtained. They may be exposed directly to the subject through red, green, and blue filters, or they may be obtained in the same manner from a

color photograph. In both cases they are called "separation" negatives, or positives, as the case may be. Cameras exist which will expose the three films simultaneously through a single lens and the negatives so produced are often called "one-shot" negatives to distinguish them from sets made one after the other on still life subjects.

Separation negatives are just the same as the records of multilayer film except that the ability to get at each of them greatly increases the flexibility of handling. Thus it is possible to modify their transmissions locally by "retouching" and so to change colors, modify lines, and so forth. It is also possible to modify the contrast of the individual records separately, occasionally a very useful operation.

Reflection print processes

Up until fairly recently all reflection print processes required separation negatives for their operation. Multilayer printing papers have been one of the most difficult accomplishments of all research on color photography.

There are many possible variations of color printing processes, but they are all basically the same. Just as in multilayer films the final image consists of the usual three dyes, one absorbing red, one green, and one blue. The differences come in the way in which the dyes are combined to form a picture. We need to consider only two general types to understand them all for present purposes.

In one of the oldest workable processes (Carbro) the final picture is made up of three layers of pigment having the required three absorptions. In order to make the picture, a positive paper print the size of the final picture is made from each of the three separation negatives. The silver in each is then bleached in contact with a "tissue" of gelatin containing the appropriate pigment. This bleaching operation hardens the gelatin of the pigment containing tissue in proportion to the amount of silver in the print. The pigment tissue is now transferred, in two operations, to a carrier layer from which the soft gelatin is washed away. This leaves various thicknesses of the pigment in proportion to the original record. The three images are then transferred on top of each other in register on white paper to make the final picture. The process has the merit that where the picture represents a white surface there is no pigment present over the white paper. Considerable technical skill is required to operate the process and such prints are made for the most part by specialists in this field. Up until fairly recently they were gen-

erally considered the best prints that could be made, although they are made almost exclusively from direct or one-shot negatives. A good deal of their excellence has derived from the quality of workmanship required to handle the process.

A somewhat more recent process (Dye Transfer) although itself only a modification of an older process (Wash-Off Relief) is easier to handle and at its best gives equally good results.

In this process a somewhat similar operation takes place. Each separation negative is printed onto a silver halide film which is the size of the final picture. The exposure is through the base of the film and the image is developed to silver in a developer whose oxidation products harden gelatin. The soft parts of the gelatin, which lie close to the surface because the hardening is next to the base, are washed off with hot water. The final result is three films consisting of different thicknesses of gelatin in proportion to the silver of each color record.

The three films (called "matrices") are now soaked in the appropriate dye solutions. Each of them takes up its dye in proportion to the thickness of gelatin present. A piece of paper coated with a gelatin layer containing a substance with a strong affinity ("mordant") for the dyes is now placed on a board and the three matrices are rolled into contact with it one at a time. Because of the mordant in the paper, the dyes transfer completely and quickly. The final picture consists of the three dyes together in the gelatin layer. As many prints as needed, within limits, can be made from the same matrices.

As ordinarily operated, the negatives used for this process are silver images in separate pieces of film. A more recent version of the process, however, makes the three separate negatives unnecessary. Pictures are made on a multilayer color negative film (Ektacolor, Kodacolor). This film contains colored couplers and so needs no further masking. The matrices are each made directly by red, green or blue light on a special matrix film sensitive to all colors (Panchromatic Matrix Film). In this way the operations of masking and making separation negatives are avoided. Quality is distinctly improved by the decrease in number of photographic steps involved.

As mentioned earlier, these processes afford maximum freedom to creative workers in color photography. Each step of the process is available for manipulation and control and the final picture can be hand tailored to the taste of the individual worker.

It should also be noted that the masking operation discussed earlier corrects only for the characteristics of the dyes in the original color photograph. If it is also desired to modify the results because of the dye system

of the final print, this can be done by the use of separate masks over the separation negatives. For some purposes this is an important possibility, but the details are not of importance in a general survey. We shall see later some of the directions such masking permits in creative work.

Exposure and exposure calculation

The effect of light on film depends on both the time and the intensity of the exposure. For ordinary purposes in black-and-white film the two are interchangeable, the product of the time and the intensity being the important variable. Some effect is produced even in black and white by changing the time of exposure but the effect is small compared to the control in printing.

In color films three separate emulsions are involved, or at least the film is always exposed to three colors of light for the separate components of the image. Any difference in the exposure-time responses of the different emulsions shows up as a shift in color balance of the final picture. Accordingly, for precise work, the time of exposure in color photography must be kept close to manufacturer's recommendations or color correction filters may need to be applied.

Within this restriction it is still necessary to determine the proper exposure for the subject at hand. This is done in exactly the same manner for color photography that it is for black and white. Exposure meters of many kinds are available and have been discussed in many books. There are two general methods by which meters can be used. The light falling on the subject may be measured or the light reflected toward the lens. The light reflected from the average subject has been determined to be about 17 to 18 per cent of the light falling on it if bright areas such as the sky are excluded. Cards that have this reflectance on the gray side and five times this value on the other side are available. If such a card is placed in the light from the principal source at the scene, a reading from the gray side gives the reflected light reading as it would be obtained from an average scene. A reading from the white side is five times this value and may be used for low intensities or to calculate the value of the light falling on the set, which incidence meters read directly. The reading from the white side is 85 per cent of the incident intensity. Thus all of these methods really read the same thing; some fraction of the incident light.

A reading of the whole set is used by some photographers. This has the advantage that a lower reading is obtained for scenes having mostly dark subjects and so the meter indicates a higher exposure.

While it is true that for dark objects a somewhat higher exposure is required than for lighter ones, neither method indicates the required exposure correctly. The incident light meter tends to underexposure for scenes with dark objects and the reflected light reading for the whole set leads to overexposure. The proper exposure is between the two but usually somewhat nearer the incident light reading as measured on a white or gray card.

There is another technique for determining exposure with a meter, which is used with success by some photographers but which requires much experience and skill. A reading of the meter taken by the light reflected from the brightest area in the scene is a measure of the maximum exposure the picture can be given without overexposure. We noted earlier, however, that the brightest neutral area tends to look white in a projected picture, and will see later that full exposure for a colored area greatly decreases its saturation. These reasons, and the fact that the meter does not respond to color as does the film, make this technique one not to be recommended for any but the expert.

As a matter of fact, unless a person is to go into the subject in some detail, daylight exposures can be made with entire success by means of charts showing exposures for various described daylight conditions, and simple tables are available giving exposures for simple home and studio lighting set-ups. The same is true for flash bulbs of all kinds in which exposure guide numbers are supplied for simple exposure calculation. The precision is usually as good or better than it is with the use of a meter and just about as easy.

It is also important to note that the best exposure—perhaps we might say as distinct from the "correct" exposure—will depend very heavily on the subject matter and the photographer's intentions as well as on the process used. The reproduction characteristics of color pictures vary rapidly with exposure, and in a complex manner. For this reason, unless great skill has been developed in the use of a particular product, serious workers usually give a series of exposures around a normal value and select the best result. The "best" exposure may differ by a factor of two or more on either side of the "correct" one.

It should be noted here (as it is elsewhere) that in color processes in which the camera film is the finished product (reversal processes) the exposure is much more critical than it is in black-and-white or color negative-positive processes in which a print is to be made. The reason is not, as often stated, that color processes are more critical to exposure; they are not, or only slightly so. Reversal black-and-white pictures are equally critical. The reason is that in reversal processes the camera exposure also determines the printing exposure, so to speak. In negative-

positive processes the negative merely has to record the scene. The negative is then printed and careful exposure corrections can be applied. In reversal processes no such correction step occurs (at least in color). The camera exposure has to be as precise as is the printing exposure in negative-positive processes, and this is quite critical. The camera exposure would be very much more critical, of course, if reflection prints were to be made in the camera. Projecting the picture in a dark room considerably increases the exposure tolerance. Satisfactory results for most purposes in color are obtained if exposure is within the range from one-half to two times the correct value.

Another prevalent misunderstanding is that the latitude of color film is much shorter than black-and-white and hence contrast in the subject must be held to a low value. This is no more true for color than it is for black-and-white. In black-and-white printing, contrast grades are available in the printing paper. Therefore there is control in this respect, which is lacking in color with its single contrast. In the color print processes some contrast control is possible but it is ordinarily less than in black-and-white.

The statement is often made that the maximum contrast usable in color is 4 to 1, and this is interpreted to mean that the ratio of the highest to the lowest **reflected light intensity** can be only 4 to 1. This is nonsense. The reflected light contrast that all color films will handle when properly exposed is of the order of 200 to 1. What the statement actually means is that the **lighting** contrast should not exceed 4 to 1 if detail is to be shown in the shadows. If the **reflectance** range of the subject (ratio of highest to lowest reflectance) is 50 to 1, an unusually high ratio since 30 to 1 is more usual, then if the ratio of the most brightly lighted part to the most dimly lighted is 4 to·1, this can take up the 200 to 1 latitude. The fact that most scenes are 30 to 1 or much less permits an error in exposure without overexposing the light areas or underexposing the shadows.

Hence, at least in the studio, gray or white card readings in the most brightly lighted and most dimly lighted regions ordinarily should not exceed 4 to 1 except for subjects of restricted reflectance range (all subjects light or all dark etc.). If special effects are wanted or if loss of shadow detail is part of the intention, lighting contrast can be anything obtainable.

Two exposure factors sometimes overlooked but which often become quite important should be mentioned while we are discussing exposure. The first of these is correction for bellows extension, and the second, the temperature coefficients of shutters and films.

The f/ratings for lenses hold only when the lens is at the focal length distance from the film. This means that they are correct only for quite distant subjects where a setting of infinity (∞) would be appropriate. At any closer subject distances more exposure must be given. This reaches a value of four times at a magnification of unity; with the picture the same size as the object. The rule is that the exposure must be increased by the ratio of the square of the actual lens-to-film distance to the square of the focal length, again for ordinary type lenses. When magnification is unity the distance is twice the focal length. The correction is often important because an increase in the lens to film distance of only 40 per cent doubles the required exposure. For a 10-inch lens this occurs when the objects are approximately 3 feet in front of the camera. This distance varies proportionately for all focal lengths. Thus for a 2-inch lens the distance is 7 inches etc.

It is not often realized that most shutters have a fairly large temperature sensitivity. It is not possible to make any definite statements, of course, because every shutter is different. Most of them, however, appear to slow down appreciably at low temperatures. At temperatures normally encountered during the winter months in the northern sections of the country it is probable that most shutters give more than the rated exposure. This effect increases at lower temperatures with many shutters giving twice the exposure by the time a temperature of 0° F is reached. It is perhaps fortunate and also probably the reason so little has been written on the subject, that almost all film also slows down, and often by about the same amount at such temperatures. The combination tends to make winter exposures come out about the same as for the summer months. The photographer should keep the matter in mind, however, because of the possibility of a shutter or film which does not behave in this manner. Motor (not spring) driven motion picture cameras may not change their exposure at all, especially if synchronized for sound.

Hand colored photographs

It is appropriate to end this chapter with a brief discussion of hand colored photographs. There are some things which present-day color photography will not accomplish and a number of things it will never be able to do. It is instructive to consider these.

Because of the nature of color processes, exact reproduction of all colors both for saturation and for hue simply is not possible. Thus if the requirement of a photograph is that it match, say, a piece of fabric when

the two are placed side by side, this cannot generally be done without handwork of some kind.

Professional and commercial photographers occasionally meet another type of problem which cannot be solved readily without handwork. Sometimes after the picture is finished it is found desirable to change the color of some object to something quite different from that photographed. Thus in a fashion picture it may be decided after the picture is finished that the model's dress should have been, say, green instead of pink. This can be accomplished with fair ease by hand coloring, but taking the whole picture over again may be an expensive operation.

There are several methods of hand coloring, each leading to quite different results. Perhaps the most obvious is the use of water colors on a finished black-and-white print. By this technique some very attractive results have been obtained. It suffers from the defect, however, that the black-and-white print already, to a first approximation at least, represents the brightnesses of the subject. Hence a dark color is represented by a lot of black regardless of whether it was a very saturated color or a very weak one. If one attempts to put a dark, very saturated color on top of this black, the area becomes so dark that the color hardly shows at all. To get away from this in part brown prints called "sepias" are often used. These prints have higher reflection in the red than in the green and blue and hence pure reds and browns can be produced more easily. At best, however, the colorist has to fight constantly to keep the picture from becoming dark and "muddy."

Another technique rather widely used is the application of oil paints similar to those used by painters. For the most part the paints used are quite transparent and are applied as a very thin coating, often with a tuft of cotton around a pointed stick. When so applied, the same situation holds for them as for water colors. The darkness of the print limits the purity of the colors that can be obtained. Some operators, however, work with colors that are more opaque and apply them with a brush. By this technique the blacks may be partially or wholly covered so that pure dark colors as well as lighter ones may be obtained. Since these paints, however, tend also to cover up the edges of objects, they tend to destroy the photographic appearance of the picture and considerable skill as an artist is required to prevent loss of picture quality. In the hands of a competent artist very beautiful results can be obtained, but the average quality produced by any of these techniques is regrettably low.

An almost complete solution of the hand coloring problem is on the market (Flexichrome) and has found some use. In this technique, rather than starting with a black-and-white print, use is made of the fact that a

Dye Transfer matrix has different thicknesses of gelatin representing different densities. Where the subject is dark, a lot of gelatin is present and where it is light there is very little.

The procedure is to make a special stripping matrix film, usually from an ordinary black-and-white negative or sometimes from a white light negative made from a color transparency. This matrix is then dyed with a special neutral gray dye and stripped off onto a final paper support. At this point it looks much like a silver black-and-white print. It differs from it, however, in the fact that over any desired area the gray dye can be removed. Coloring consists in applying an excess of dye of the desired color and moving this about with a brush. The dye penetrates the matrix and displaces some of the gray dye. A blotter is then applied to remove the excess dye, which contains this displaced gray. This process can be repeated at will until as much gray has been removed as desired. The fact that it is a matrix that is being dyed means that a given area can hold only so much color and no more. Successive applications simply remove more gray. In the case of an area like a face the modeling will be taken care of by the matrix. The operator has to be concerned only with overlap at the edges of objects and the brightness of the area being colored. If it is decided that an area is the wrong color, this also can be displaced with the correct one. With this technique it is possible to make hand colored pictures that can hardly be distinguished from direct color photographs even by an expert, and yet have the colors those desired, the precision depending only on the time spent on the picture. For high precision work the time and skill required is considerable, and it is not likely that, for ordinary purposes, the method will compete with direct photography. For some special uses, however, it greatly extends the possibilities in colored pictures, solving many problems that cannot be solved directly.

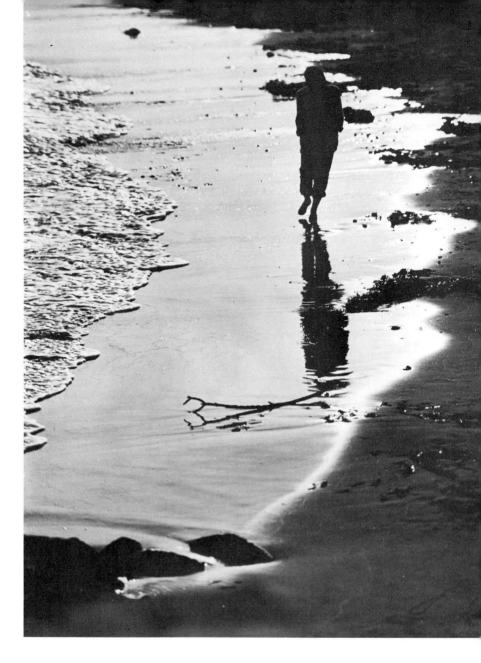

Figure 7-1. Consider the change in meaning of the above picture using the following titles. 1. Morning splendor 2. Despair 3. The Call of the Sea 4. Treasures of the Sea 5. Indecision 6. Shining Gold.

C H A P T E R

SUBJECT
AND INTENTION
IN PHOTOGRAPHY

The literature of photography, and particularly that part appearing in newspapers and magazines, consists largely of articles on the mechanics, optics, and chemistry of photography rather than on the pictures produced. Nearly every magazine, however, and an occasional book, carries an article or two dealing with the pictures themselves. In these articles a wide variety of terms and expressions are used in no consistent manner. Many of the terms are borrowed from the field of painting, others are more related to photography itself.

Consider such terms as: "the subject of the picture," "the ideas expressed," "the feeling conveyed," "importance," "expression," and others of a similar nature. Basically, of course, the topic is aesthetics as applied to photography. Yet it can and should be discussed at a practical, everyday level, because aesthetics in some form or other is important in the making of any picture—with the possible exception of some made for scientific purposes alone.

A basic underlying principle in aesthetics is that everything about a picture should aid the purpose of the picture. The final result should be a unity to which everything contributes in its own way. It is not likely that a photographer will produce such a result without a fairly clear-cut concept of what it is he is trying to do. At least we certainly cannot say that a photograph is a good job from the photographer's point of view unless it succeeds, at least in part, in the direction he intended.

We shall see shortly that this intended unity is practically the same

thing as the "subject" of the picture. Before we go on to consider this, however, it is best to take up some points suggested by these remarks.

The statement was just made that it is necessary for the photographer to know what he is doing to produce a satisfactory result and that his purpose plays a large part in the final picture. Experienced photographers will realize that this statement is in apparent conflict with two undeniable facts. First, some photographers work by making many pictures and then selecting the one they like best. Second, many photographs are used successfully for purposes for which they could not possibly have been intended.

In the first place, to answer, the making of many pictures of the same or similar subjects does not necessarily mean that the photographer is not clear in his intentions. A tendency to motion in a subject, uncertainty as to exposure, the fleeting character of the expression on a person's face are all good reasons for making more than one. Furthermore all the pictures may be serious attempts to do the best he can. No true artist ever feels that he has really accomplished the best that he can do.

On the other hand, there is a serious and distinguished group of photographers who both preach and practise the rather indiscriminate making of large numbers of pictures. They recommend that this should be followed by a painstaking and **creative** study of the results, pointing out the exciting and interesting pictures that can be obtained in this manner, especially with the miniature cameras.

From any rational semantic standpoint such an approach can hardly be considered as directed toward an art of **making** pictures. It has to be an art of something else, perhaps an art of studying photographs. Certainly the people accustomed to such a procedure should be outstanding in their ability to see inherent possibilities in pictures. Such a study, however, does not even lead to an art of criticism because all that can be criticized about such a picture, in terms of the photographer, is his selection of the picture that he shows.

What this school of thought does point up, in no uncertain terms, is a very real difference between photography and painting that is not often recognized. It is not necessary to have more than a slight inclination to make a photograph in order to do so. In other words an intention in the sense in which a painter might use the term is not necessary. The photographer does not even have to look at what he is shooting! The painter must at least look at his canvas. On the other hand he can have just as sharply defined ideas as any painter, and he can carry them through just as successfully.

These two extreme attitudes on the part of the photographer lead to a dimension in photography that is missing in painting. The intention

of the photographer can vary from that of playing with the camera, to its casual use on a subject, to a serious intense desire to produce a definite picture. Perhaps someone will some day carry through the implications of this situation for photography as a medium. The purpose of this book, however, is to try to aid those who are attempting seriously to create photographs. Because the writer does not see how useful rules of procedure leading to an increased percentage of successful pictures can be found by either indiscriminate or casual photography, these ideas are not considered further except in passing. It is assumed that a photographer who wants to make better pictures will make them deliberately, however much he may enjoy and be stimulated by other approaches.

The second point that appeared to be in conflict with our statement about aesthetics in photography was the evident fact that many pictures are very successfully used for purposes for which they were never intended. This is a more serious difficulty, although it is largely a logical rather than a practical one. The logical point of view can be expressed as follows. If the photographer is successful in carrying through so that he produces a unity according to a specific purpose, how can the picture ever be used in a context to which that purpose is not relevant? There seem to be a number of answers to this question, some of them bringing up important points which we shall consider later. One apparently correct answer is that many pictures cannot be so used without having the apparent intention of the picture change (Figure 7–1). A photographer cannot wholly realize his intentions within the frame of the picture. The picture must also be seen amid appropriate surroundings. Removal of the picture to wholly different surroundings, however, does not necessarily destroy the picture. The apparent intention and even the meaning of the picture may change, but the picture may remain enjoyable if the workmanship is sound.

We have to distinguish in this connection two extreme ways in which a photograph may be used. A picture may be displayed by itself in a minimum of context and expected to stand on its own feet. Or it may be used as part of a literary work to serve as illustration of the text. It is apparent that the two uses make quite different demands on the photograph, particularly as regards the photographer's intentions. The intentions may be exceedingly important where the photograph is to stand by itself and of no particular interest when it is used simply as illustration.

We can return now to our original intention of studying some of the terms used by writers in discussing various aspects of finished photographs. We shall start by considering the word **subject** as used in the phrase "the subject of a picture."

The subject of a picture

There are at least six broad notions that are often meant by the phrase "the subject of a picture." We can list them first and then discuss them in some detail. Each is characterized by a single word for ease of reference but the notions are larger than the single words imply.

1. Objects—The objects, persons, or things which constitute the main center of interest in the final picture.

2. Situations—The general situation or location in which the recognizable objects in the picture will be seen.

3. Events—The event or events which are shown to be occurring in the scene displayed.

4. Emotions—The emotions or other interactions between the people or objects which are displayed because of the events taking place.

5. Comments—The photographer's displayed opinion or attitude on any or all of the above.

6. Idea—The idea which the photographer is trying to express.

This list is not exhaustive unless the words are very broadly construed, but it is apparent if they are so construed that the entire list is made up of two broad notions. These may be called "subject matter" and "idea." The meaning of the term "subject matter" is fairly apparent, but the term "idea" comes from aesthetics and is not so readily defined.

In aesthetics it is more or less of an axiom that all pictures express ideas. To many people such a statement sounds abstract and not very meaningful. An attempt to discover the meaning of a particular picture is apt to meet with failure unless the person is experienced in the use of the concept. Such a failure, however, is more often due to looking for too deep a meaning rather than inability to see it.

Consider a picture of a single object on a white background such as might appear in a catalog. Figure 7–2 will serve as an example. The "idea" behind this picture and which it expresses adequately is, "this is the way this object appears from this point of view." The "this" has to be explained by the context in which it is printed. The subject matter of the picture is the object shown and the idea is to show how it looks.

Every picture of any possible kind, whether realistic or nonobjective, if it is presented as a picture, necessarily contains both subject matter and idea. The subject matter is usually quite apparent; the idea is often hopelessly elusive or trivial.

Whether elusive or trivial, the fact remains that every picture must contain or at least represent an idea from the very fact that it is shown

Figure 7–2. *Catalog photograph.*

as a picture. At minimum there is the showing of it. In the extreme case, and we suspect not infrequently, the purpose of the idea has been to puzzle the observer. This is most easily done with a nonobjective presentation in which no recognizable objects are visible. In this extreme case the picture itself becomes the subject matter for what it is worth in terms of the visual reactions of the observer.

Thus a clear sheet of white paper, if presented as a picture, has as its subject matter either white or white paper. There is no way of telling which without some literary support such as a title or some text. There is also no way of deducing the idea without support of a similar kind.

When such a picture is presented along with a title or text, the idea behind the picture then becomes simple again no matter how complex the thought behind the words. The idea behind the picture is then to illustrate the text. It becomes identical in idea to that of the picture for the catalog, that is, "it looks like this."

Both the subject matter and the idea can, however, on occasion become exceedingly complex. The extent of the possibility is limited only by the character of the medium and the skill of the photographer. But it is a serious mistake to assume that complexity is a measure of the value of a picture. It may be quite the reverse if it is not required by the intentions of the photographer.

With these thoughts in mind it is instructive to consider some of the various kinds of subject matter and ideas that photographs can display. We shall find it necessary also to consider each of these in terms of the use to which the photograph will be directed. An illustration is quite different from a picture to be seen by itself.

Subject matter

The subject matter of a picture can consist of nearly any visible thing in the world. When this is multiplied by the possible situations and people, the number can well be considered infinite. It can be assumed, for example, that almost none of the two or three billion pictures taken annually in this country are identical. It does not follow, however, that the number of types of subject is very large, or not worth attempting to consider.

The number of concrete ideas that can be conveyed by pictures is, in fact, rather limited. For the most part these ideas can be conveyed by a relatively small number of types of subject matter. The first four definitions given for the word "subject" cover nearly all of them, if broadly interpreted. This will be apparent if we consider a few examples under each. It should be remembered that in discussing subject matter before ideas we are not implying that subject matter can appear alone. Many types of ideas can be expressed by very similar subject matter. It is convenient, therefore, to be quite clear about what is included under subject matter before we discuss the more elusive concept of ideas.

The first class of subject matter is concerned with straightforward articles, objects, or people representing the center of interest of the final picture. We have already considered an example in the case of a simple object for a catalog. The object shown, however, was relatively simple in its properties. The picture made complex description unnecessary. Often the object to be illustrated in this kind of picture is one which cannot be described adequately in words. Such an object might be the sea shell shown in Figure 7–3. Again the object may be so complex that even if a word description were attempted the mind would fail to form an adequate concept of it without a picture. Any landscape is such an object, as shown in Figure 7–4.

Such a use of pictures greatly extends the possibilities of communication and is exceedingly valuable in its own right. It is the only use that many make of photography. In this category come, for example, most of the snapshots of people comprising some 85 per cent of all pictures

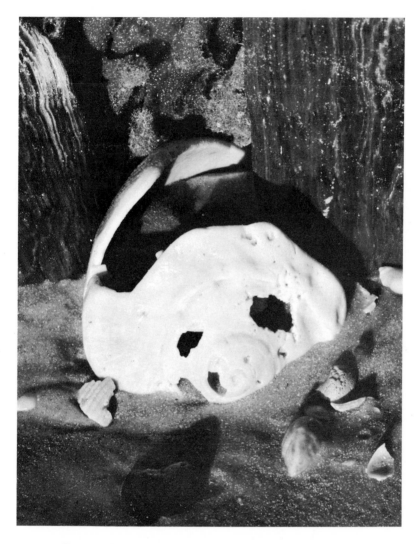

Figure 7–3. *Objects too complex to describe easily by words.*

made. In this respect, although photography goes considerably beyond speech or written language, it does have definite limitations. When the object becomes sufficiently complex, the problem may exceed the limitations of a single picture. In this case the possibilities may be greatly extended by using a number of photographs. Such an object is illustrated

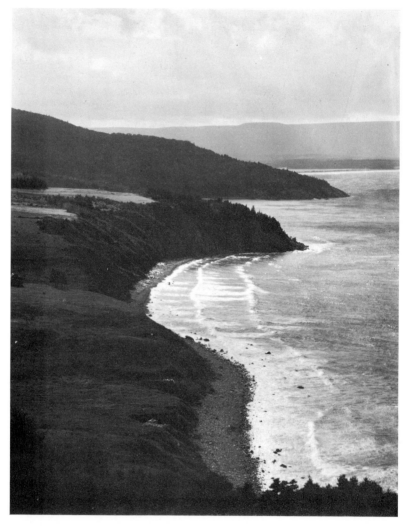

Figure 7–4. *The concept of any landscape is difficult to describe in words, particularly as its appearance changes with lighting.*

in Figure 7–5. The eventual limitation, of course, lies in the fact that a straight single exposure picture can only show what can be made visible and, eventually, we have to have recourse to drawings and the like.

In all of the above cases the subject matter involved is an object that is to be shown, for whatever reason, by means of a photograph. The

Figure 7–5. *More than one picture may be necessary to give an adequate description of an object.*

Figure 7–6. An "abstract" picture made of kelp under water with the aid of a mirror.

word object is to be very broadly interpreted. We have mentioned people as objects in this sense. The term also includes regular abstract patterns such as that of Figure 7–6, regardless of how they are made. The subject matter is the pattern, not the objects from which it happens to be made. In fact most abstractions and nonobjective pictures come under this heading. Thus Figure 7–7 is an abstraction, although obviously made from real objects, and the subject matter is the abstraction itself. Figure 7–8 shows another type of abstraction made from real objects and Figure 7–9 shows a nonobjective picture made in a similar fashion, in which the photograph itself is the object to be considered. This is not to say that all abstractions come under this heading but that a large number of them do.

The second heading under subject is concerned with situations as distinct from objects. This is, in a sense, a simple extension from objects to the situation as a whole. Portrayal of a situation, however, differs fundamentally from that of objects and, as we shall see, often requires a quite different approach. Basically, in the portrayal of a situation, the subject matter is space, occupied in a particular manner by particular objects. Thus most landscapes such as Figure 7–10 come under this heading, as do photographs of interior decorations like Figure 7–11 or illumination installations such as Figure 7–12.

Many abstract pictures partake of this same nature such as Figure 7–13 in which the objects are trivial compared to the real subject matter which is occupied space. A similar picture, which would logically be classed in the same manner, would be that of a large number of people at a particular place for a particular reason.

Pictures often, of course, combine the object with the situation in which it is placed. The subject matter is then a particular object in a

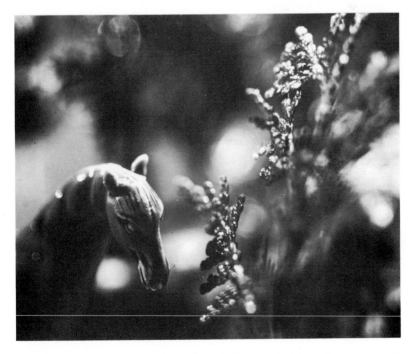

Figure 7–7. *An abstraction obviously made from real objects that are not the subject of the picture.*

Figure 7–8. An abstraction produced from the plants and shells of a tidal pool.

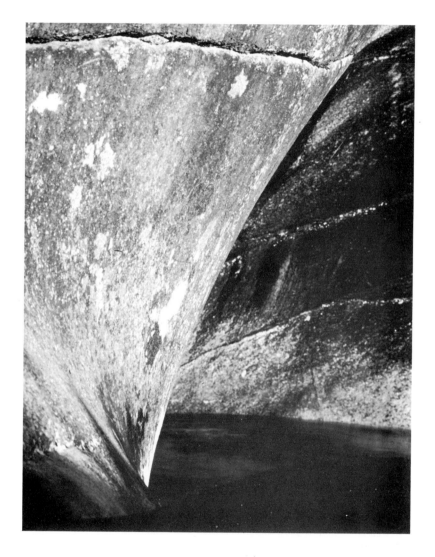

Figure 7–9. *An abstraction produced from an essentially uninterpretable subject: water flowing past a strange rock formation.*

Figure 7–10. *In a landscape the primary subject matter is occupied space.*

particular situation. An example would be a snapshot of a person at an historical spot.

The third heading discussed logically extended the first two in having something going on in the occupied space. The subject matter then includes what is going on, and becomes a photograph of an event of some kind. The usual case, of course, is that of photographic reporting, whether done casually or professionally. The most successful medium for this kind of subject matter is the motion picture as exemplified by theater newsreels. In still photography almost any picture of a sporting event, a wedding, a picnic, is an example of this kind of subject. Figure 7–14 comes under this heading as do pictures of Old Faithful Geyser in action, Bobby sliding down a hill, or a group of friends arriving or leaving. These are all pictorial reporting. Even in such pictures, however, widely different ideas can be expressed. Careful consideration of how to convey the idea may be necessary to the success of the picture.

The fourth heading called "emotion" covers pictures having a definite "human angle," particularly those in which the emotions of people are

to be shown. This group covers a rather large part of the pictures carried in magazines and newspapers. They run the gamut from joy to grief with the emphasis currently somewhat on grief, perhaps because it is easier and perhaps because it is more rewarding.

It should be noted, in passing, that many photographers appear to believe that human emotions are the only subject important enough to warrant serious photography. That it is an important type of subject matter is certainly true. It is also true, however, that this type of photograph is particularly liable to misinterpretation and often has to rely heavily on an explanatory text. Properly used it may well represent the peak of the power which a photograph may deliver.

It is no accident that the greater part of the footage of professional motion picture film is devoted to this type of subject matter. At the same time the photographer has to realize that in this case he is again aided by a powerful literary text. It is problematical how much of the effect is due to sight and how much to hearing. Although it is true that the

Figure 7–11. *An interior photograph is a picture of a situation.*

Figure 7–12.　*A photograph of a lighting installation portrays illuminated space.*

photographer can make a great contribution, it is also true that the radio can be nearly if not equally as tense as television or the motion picture. The difference is perhaps one of kind rather than degree. In any case a motion picture with no sound and no titles cannot easily convey complex ideas. Such a picture is so difficult, in fact, that it was only attempted a few times, even in silent picture days.

There is an extension of the concept of this heading that should also be mentioned here. The subject matter of a picture can be a definite abstract concept. Thus beauty, as such, can be the subject of a picture and both the subject matter and the idea are then the same, with the objects playing a wholly secondary role (Figure 7–15). Other broad concepts like texture, tranquillity, action, austerity, will suggest themselves to the reader. They represent an important class of pictures.

We see, then, that, broadly interpreted, the four categories of object, situation, event, and emotion cover the greater part of all photographic subject matter. The naively held view that all photographs are of simple objects or objects in situations is incorrect. It is at the base of much of

Figure 7–13. *Abstract photograph of objects in space.*

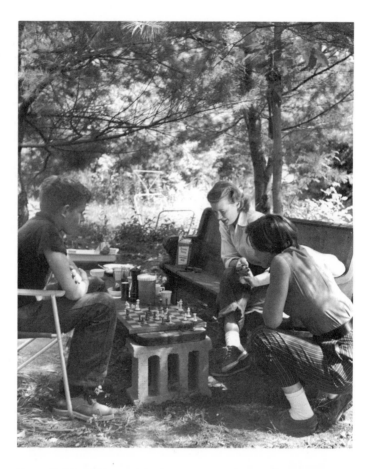

Figure 7–14. *A photograph of an event portrays something going on in occupied space.*

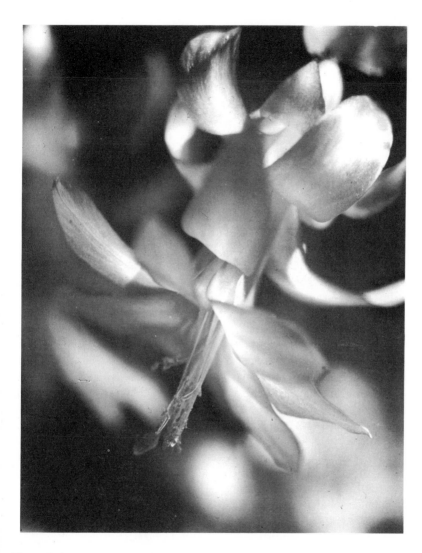

Figure 7–15. *Beauty, as such, can be the subject of a picture almost independently of the objects.*

the erroneous belief that photography is not a medium suitable to the expression of ideas. The four types of subject matter can now be used as we go on to discuss the kinds of ideas that can be expressed.

The "idea" in photography

Up to this point it has been sufficient to consider that the subject matter and the idea behind the picture constituted the whole picture. In a sense this is true but it involves a use of the word idea that is a little broader than that of everyday speech. Thus in common speech we might ask the question "What is the idea of this picture?" and the answer in about every case could be "to show what ____ looks like." In a certain sense, of course, this is necessarily a possible answer for any picture at all. If a picture is shown, there must have been a desire to show it, or at least a desire for the photographer to see it himself. Often, however, such an answer is too superficial.

Just as an example, consider again the simple object to illustrate a catalog entry. The photographer who makes such pictures is expected in most cases not only to describe the article but also to show it as attractive, desirable, useful, etc. These are all ideas which photography is entirely capable of portraying. They can be classed under the general heading of a comment by the photographer on the objects. Such comment often amounts to little more than direct exaggeration of some characteristics of the objects. Thus Figure 7–16 is a straightforward descriptive picture of a cameo brooch (above) while below it shows it as having high relief. The exaggeration, in this case, calls attention to this fact. It does this in exactly the same manner a salesman might use in trying to sell it. He might well hold it up to a light in such a way that exactly the same effect is produced. The photographer is saying, "Look at the high relief and the fine modeling." It is a comment by the photographer beyond the bounds of simple description.

We have to say, then, that the idea of a photograph may include not only the desire or intention of the photographer but also his attitude toward the subject matter. The distinction is important because his attitude often shows quite clearly even if that is not directly part of his intention.

Photography, like writing or speaking, is in one sense a means of communication, a way of saying something. The idea is what is being said. It is helpful for this reason to consider some analogies between photography and speech.

Figure 7–16. *Photograph of cameo brooch showing design only (a) and exaggerating the relief (b).*

231

One of the basic units of speech is the noun. The noun stands for an object or a situation, in fact for all the things we described as subject matter earlier. Thus the four nouns "tool, landscape, game, and fear" fall in the four groups of the previous section. In many cases, in fact, the noun standing for the subject matter is used as the title of the picture.

Nouns alone, without assistance, however, are not very descriptive. They state at best that an object belongs to a certain class of objects. We can refine the statement some by saying "hammer" rather than "tool" but it still says only that the object belongs to the class of objects called hammers.

To go beyond this simple classification it is necessary to use the noun in some sort of context. We put it in a sentence. We say, "This hammer is "_____," or "This hammer can _____" etc. It is apparent that if we want to say very much we have to put it in many sentences.

It is here that the power of photography becomes most apparent. The photographer can describe some aspects of the hammer in a way which is both easier and more satisfying than the use of words. He can say quite simply, "This is the way the hammer looks from this position, with this kind of lighting and so on."

Such a description, given by means of a photograph, is nearly always more clear-cut and more specific than is possible by the use of words. It is important to realize, however, that this description may be less complete in important details and even less truthful as a whole than could be done in words. Thus it may omit much that it appears to show and be misleading in many other ways. All of this it does, none the less, in a manner which carries great conviction.

The simple fact is that a photograph goes one step beyond speech and offers to an observer a more or less complete mental image. If the description were in words, he would have to build up such a mental image for himself. The photograph takes care of this for him. We must note again, however, that what he sees comes nearly as much from his own experience as would a mental picture constructed from words. The analogy is close in many details. Much photography can be described as the production of a complex noun.

In speech if we want to go beyond simple description we modify the noun in other ways. One way to do this is by the use of adjectives such as "beautiful" or "useful." The ideas conveyed by such words are not necessary for simple description. They are a comment on the object by the speaker. We saw earlier that such ideas can be conveyed by photography. Such comments are almost impossible for a photographer to

avoid. They are often in addition to the main idea he is trying to convey and give it, so to speak, a distinctive flavor.

In speech, again, it is possible quite easily to go on from such commenting adjectives to more elaborate ideas. We could, for example, go on to eulogize a particular hammer. This is easy in speech but we are now getting into a region difficult for photography. A particular result done with the aid of the hammer could easily be shown and the whole idea suggested but the total concept of praise would be hard to show. In speech we could easily go much further. We could give a complete oration on what the hammer as a tool has meant for mankind and for civilization. At most, such thoughts can be only vaguely suggested by a picture.

By comparing photography with speech in this manner it becomes apparent that photography is very strong in some directions and tends to be weaker in others. For some types of description it cannot be equalled by words, readily describing some things that cannot be done by words at all. There are, of course, other types of description, for which photography is practically worthless. It cannot show directly boxes within boxes, or compare weights, for example. Photography, then, is the most powerful medium known for the communication of visual description.

When we consider the ideas that a photograph can state clearly, however, we find that they are somewhat limited. Fairly specific general ideas can be expressed clearly. Fairly simple thoughts can be expressed very powerfully. But complex ideas in the sense of consisting of many parts can be conveyed only with difficulty. In other words, combining this with our conclusions above, the subject matter of a picture may contain any number of object details with very little restriction. The number of details possible in the idea that is being expressed is rather severely limited.

It is necessary to consider this statement further so that it will not be misunderstood. The statement that the idea cannot contain many details refers only to the specific statement of the picture. Thus the broad idea "useful" is a simple idea that can be conveyed. The observer may proceed to think of thousands of ideas related to this concept and the train of thought may include an endless number of ideas. These have not been stated by the picture. The idea stated has suggested them. They are unique to that observer and would not be seen by other observers.

It is again an oversimplification to say that the number of ideas that can be stated is limited to one or two. The number of ideas in the same

picture may be quite numerous. But each idea can contain only a few details, and there must be one main idea behind the whole.

We have discussed this matter of the idea in pictures for the simplest case, that of a principal object. When we consider it in terms of the more complex subject matters of situations, events and emotions, however, we find that the same statements apply. Thus a photograph of a landscape can describe the scene in great detail or not, as desired. The subject matter can have any degree of complexity. The thought conveyed by the landscape, the idea, however, cannot contain complex detail in the statement; it must be relatively simple. The observer's reaction need not be simple but the statement must be. Thus, for example, a landscape may present a very delicately shaded mood felt strongly by the observer. This may lead the viewer into all sorts of bypaths of emotion. These bypaths have been **produced** by the picture—not conveyed. The thought conveyed was simply the mood itself. In a similar manner the same statements hold for photographs of events and of emotions. Specific examples are encountered later.

In breaking down all subject matter into four groups for discussion the **subject** appears to be simple, which it is far from the author's intention to claim. The intention is rather to point out how different in nature the possibilities are for what can be handled as subject matter and as idea. Subject matter can vary from very simple to immensely complex detail. Idea can vary only in the nature of the thought, not much in the details of this thought.

We noted that more than one idea can be conveyed by the same picture. Mention also was made of the attitude of the photographer. Often this attitude, this comment by the photographer, is the only idea it is desired to express. This need not be the case, however, and it is worth noting that no matter what the intended idea may be, the attitude of the photographer is nearly always apparent in the picture. It is almost impossible for him not to show his attitude. He chose the subject matter, the treatment, the things excluded. All of it adds up to his attitude. If, for example, he tries his utmost to present an unbiased, noncommenting picture, the attitude he displays, if successful, is a desire to present an unbiased noncommenting picture.

With this we can leave for the moment the concept of the idea in pictures. Our efforts so far to understand the term "subject of a picture" have led us to include under it both subject matter as given in the first four headings and the idea, including both the fifth and the sixth. The statement that this constitutes the whole of what is meant by subject, however, is too academic and too restrictive. It does not give sufficient

importance to other aspects of pictures which are harder to define. In particular it does not allow an apparent place for the degree to which the photographer's feelings and aspirations show through over and above any simple idea he may be trying to express.

It will have to suffice here to say that the basic concepts we have not discussed are those of **importance** and **expressiveness**, both lying in the field of aesthetics and well outside the scope of this work.

It seems more useful to turn to the question of why photographs are made. It is hoped that such a consideration will at least make clearer the concept of **importance within a field** if not of importance as a basic concept.

Intentions in photography

The first part of the word "photography" is derived from the Greek word meaning "light" and the latter part from the Greek verb meaning "to write or to describe." Many words have the ending "graph" and in their original meanings nearly all indicated an act which involved writing or describing. At about the time the word photography was coined, however, the use of the ending "graph" had started to change toward a broader concept although the word itself probably came from "lithograph" already in use. Thus **telegraph** was used to mean what we today would call semaphore signallings, and meant the sending of information by signals or signs. When the sending of messages over wires became practical, the word was attached to it. No writing was done but information was sent to a distance. Today the ending is being used in an even broader sense to include almost any mode of sending or recording information. In a very real sense the ending "graph" now means a process of **communication**.

The meaning of the word photography has kept pace with the change. It now includes, at least in the popular mind, any technique by which a photosensitive material made from silver halide is made to produce a reasonably permanent image, despite its earlier restriction to paper pictures made by Fox Talbot's Talbotype or Calotype Process. These images may be a record of the position of a spot of light at a particular time, photomicrographs, microphotographs, camera pictures or any one of thousands of other phenomena. They may be used for an equally large variety of purposes.

We want now to consider some of these forms and uses. In particular, we want to see why people make the pictures they do and what it is they

hope to get. Since some restriction of the subject is obviously necessary, we shall restrict ourselves to photographs produced by lens images of real objects. This will permit us to cover the tremendous range of magnifications and subjects without becoming involved in X-rays, electron microscopes, gamma rays, and the like, none of which are as yet of importance in color photography, however important they may be in their own right. We shall restrict ourselves, too, to the questions of why the pictures are made and what is expected.

Records

It is no exaggeration to say that from the standpoint of numbers alone nearly all the pictures made during any given year are made for the apparently simple purpose of recording something. At least that is what the photographer will tell you if you ask him. In one sense that is all that the photographic material in a camera ever does. It records the light intensities and colors of light in the optical image that falls on its surface.

However, we want to go a little deeper than this. We want to consider what the photographer **actually** hopes he will get—if necessary, what his **subconscious** desires are with respect to the picture he "takes."

There is one class of photographers who make record pictures as a serious business. This, of course, is the large group of news photographers. The pictures they make are intended to record events. They are intended as substitutes for the presence of the reader at the event, as a record for history if the event is important, as records in the life of a person for files, and so on.

In such pictures there is seldom an attempt at making the picture attractive as such. Often, however, they have the assignment of photographing a scene or person to convey the fact that the subject is beautiful —Washington cherry blossoms, beautiful star of stage and screen, etc. More often the problem is to so photograph a scene that the reader has the best possible view of what occurred. Airplane views of fires or floods, high window views of parades with a few close-ups of special sections, celebrities getting on or off trains or boats, a crash at a race, the scene of an automobile accident or a fatal shooting, to name only a few.

Few people realize the skill, knowledge, and daring necessary to get such pictures. As we have noted earlier the production of a picture which will actually look exactly like the scene in front of the camera is difficult if not actually impossible. The best that can be done is to so select the point of view, including both angle and distance, the lighting and the

magnification that the observer will see the result with as little chance of error as possible.

It is obvious that the news photographer seldom has the opportunity to do very much along these lines. Too often he has just one chance to get the picture from where he is and is lucky if he gets that. On other occasions, of course, he can take his time. To the first fact is due the enormous distortion and failure to present the scene clearly which are found in many news photos. To the latter is due the many excellent pictures that establish news photography as just less than one of the fine arts.

There are other groups of people who are really interested in trying to record. One group, of whom much has been heard recently, are the so-called "documentary" photographers. They undertake to record for the present and future generations all phases of some social situation, or all facets of some part of our civilization. Since such a record obviously involves a multitude of pictures and aims at as lifelike a presentation as possible, it is not surprising that the favored medium is motion pictures. Here the aim is to record in such a way that the observer can inject himself into the situation and for the moment feel himself as part of this phase of our world. To help him to do so—or to try to make him—all the arts of the motion picture are brought to bear. Great effort is usually put into producing an "atmosphere" in which the subject is presented.

Perhaps the writer will be forgiven the statement that to the extent this is accomplished the picture often fails as a record, whatever it may gain as a "document." It is doubtful if the medium of motion pictures can convey an atmosphere to an audience sitting in comfortable seats in a theater which is at any great variance with that of comfort. They can be inspired to horror, fright, gaiety, romance, but these are versions much affected by the comfortable and secure position from which they are seen. The daily drudgery of subsistence farming, for example, can be portrayed and an atmosphere of despair, frustration, and blind groping can be produced. Perish the thought, it has a little tendency to look romantic. If the photographer can make the people look real enough for the audience to identify itself with one of them, more good is accomplished without the atmosphere. It may be objected that both are records but it seems necessary to insist that a picture is a record only if the observer sees it as he would have if he had been there. For this all the art of true representation must be used, and it should be noted that to make the picture look to the observer as the scene looked to the photographer when he arrived, he may have to use supplementary lighting, make-up, directed acting, and all the art of the Hollywood cinematographer. The

aim is an honest record that looks like the scene "in the flesh." Fortunately his aim is made easier by the greater appearance of reality of color photography but the production of such pictures is not simple at best.

While we have considered here only the form of documentary photography in which a record is desired, much photography that goes under this name has the intention of teaching or of propaganda. These purposes come under other headings and so need not be considered here.

Thus far we have dealt largely with scenes and events. A considerable number of record pictures, however, are intended to look as much as possible like real objects. Much of this work is done by the so-called Commercial and Industrial photographers who may be called on to photograph anything from a whole city down to its buildings, statues, machinery, instruments, and art objects.

For these photographers each separate picture is likely to be a unique problem. Take, for example, the problem of photographing a high building in a congested business area to make it look like the building. But this is nothing compared to what they are sometimes expected to do. A case was recently reported of a photographer asked to photograph a mural painting so obscured by large columns that only about two-thirds of it could be seen from one point of view at any time—and the columns were not to show in the picture, only the mural. By cleverly making a number of pictures from different points of view and making use of principles of optics we have discussed earlier, he produced the exact picture desired, the wall with the whole mural but no columns! This is skill of a high order, yet it is not an unusually difficult subject as such assignments go.

Photography of art objects is a difficult problem of quite a different kind (we are here thinking of three-dimensional objects, paintings are considered in a later section under reproduction). An art object practically by definition is one in which nothing can be changed, except perhaps by the original artist, without changing its aesthetic value. When asked to photograph such an object, therefore, the photographer is faced with the necessity of as nearly reproducing the **exact** appearance as possible. As we have seen, this involves the whole gamut of visual differences between objects and photographs. Depth must be seen in its correct relationship to the other dimensions; reflectances and colors must be seen in their true relation to each other, the size of the object must be conveyed correctly, the texture of the surface and its nature must be shown clearly. Beyond all these, however, he is faced with two problems on which he may require competent advice unless he is himself a student

of art. These problems are camera position with respect to the object, and direction and nature of the main source of light.

The observer looking at the object sees it with two eyes and, furthermore, is usually free either to turn it in his hands or to walk around it. The photographer usually has his choice of, at most, two positions. From these, with single eye views, he must record the exact appearance of the object. Needless to say, there are many objects for which this is an impossibility and for many other objects it gives only a rough indication, of extreme value to artists and art students but giving the naive observer little idea of its true appearance. In spite of long experience in photography the writer has often been startled by the actual appearance of such objects when they have first become familiar through photographs. The largest errors have usually been those of size and shape, particularly the former.

All of the errors of perception of such photographs are worse for black-and-white pictures than they are for colored ones, and particularly for those of shape, as a result of loss in the third dimension. It is to be regretted that the high cost of color plates for the various graphic arts processes has almost prohibited their use in this field. It can be expected that this situation will be remedied in the foreseeable future, much to the advantage of this branch of art. It is also safe to predict, however, that the reawakening of a very old branch of photography, coupled with color, will be even more important in this connection.

Stereoscopic photography, once on everyone's parlor table for the entertainment and enlightenment of children and guests, finally gave way to the phonograph and radio. The coming of color materials that can be exposed like black-and-white films in any camera is bringing back this most realistic of all photographic processes.

With stereoscopic color pictures an art object is so real that the urge to walk around it becomes very great. It lacks only this to make it a more or less exact record and this can be supplied by stereo motion pictures. It will be recalled that in stereo pictures even reflectances are seen correctly so that almost the natural lighting can be retained. Such a process represents, if properly handled, the nearest approach to true record photography of which present day science has knowledge. It is as good or better if properly made than seeing the object itself in a glassed-in wall case in a museum.

It is interesting to note, on a somewhat lower plane, that salesmen are using color stereo processes to sell everything from store window dummies to corsets and hardware. The sense of seeing the real objects is great

enough so that the purchaser can buy what he wants directly from the picture with some feeling of assurance.

This is enough to say about record photography at this point, although we shall refer to its problems throughout the text. Record photography is at once the most difficult and the most challenging of all photographic problems. Snapshot and portrait photography have not been included under this heading for reasons which become apparent in the balance of the chapter.

Descriptions

Closely allied to record photography and often indistinguishable from it is description by means of pictures. This includes the simple description of simple objects and processes, more complex descriptions of people and situations and the "story telling" picture in which a particular point is put across by means of the positions and attitudes of the subjects and usually a key title.

In the description of an article we are not so much concerned with accuracy of perception as we are in the true record picture. The intention is to explain to someone what a particular thing or place is like, not necessarily to make him see it exactly as it is.

We here encounter the so-called "illustration" field. Illustrations for advertising, for magazine and newspaper articles, for text and other books have become a highly specialized field. The pictures made divide roughly into three categories. At one extreme is the matter-of-fact **text book type of illustration** which, if well done, supplements the text in extraordinary fashion. The intention is factual, descriptive, and educational. Ordinarily accuracy is of less consequence than is illustration of the point with which it is associated in the text. Depth perception is often important, as are texture and similar properties. In the last analysis making such pictures becomes a problem of obtaining the proper lighting, arrangement, and point of view to bring out the point desired. This again is a field in which the commercial and industrial photographers excel.

Quite different from this type of photograph are the **advertising pictures, made largely for catalog use.** These have the added requirement, which makes them quite different photographically, that the pictures should show the objects to be attractive as well as describe them with fair accuracy.

This requirement of making the object attractive introduces a wholly

new phase of photography into this discussion. There has been much controversy at times as to what the photographer contributes to a picture. It has been maintained or assumed by many that a photograph always looks the way the subject did in front of the camera. This is not true, as has been shown earlier, but a visit to an illustrator's studio while this type of picture is being made is a very convincing demonstration. The aim is to produce an attractive picture of the required objects. An attractive picture contributes its attractiveness to the objects. Thus anything that will contribute to attractiveness is used. Some of these factors, of course, are in the subject matter. For example, an attractive girl makes a bathing suit look better. Even here though, the requirement is a girl who looks attractive **in a photograph** rather than in real life. The two are not necessarily the same, as Hollywood discovered early in its history.

Furthermore, the arrangement of the objects in the studio is of no importance as such; it is the way they are perceived in the picture that counts, and the two are often very different. The art of this type of picture, and it is a highly specialized one, comes in so arranging the objects that in the picture their arrangment will be so attractive that the objects will look better.

Attractiveness of objects is enhanced by the color scheme in which they are placed, by the objects with which they are associated, by the shape of the finished picture, particularly by the lighting with its ability to bring out the attractive features and by many other factors.

It is probably unnecessary to point out that the same skill that will make a good article look attractive will also enhance the appearance of a poor one. Cheap silver and glassware can be made to look just as attractive and desirable as solid sterling and hand-cut crystal. The burden of justification is on the advertiser, not the photographer.

One step beyond the picture which makes a particular object look desirable lies the **eye-catching advertising picture.** This lies at the other extreme from the factual descriptive type. Here the picture has nothing directly to do with the object, as such. The best example, of course, is the perfume advertisement in which the bottle, on which great expense has been lavished to make it attractive, is usually shown factually, like an art object, but the background or accompanying pictures are intended to catch the eye of the reader. In addition such pictures may be intended to create in the observer awareness of a mood or sentiment which it is hoped he, or rather she, would like to attain. The subject matter is usually associated with the name of the perfume. Hence by indirection the perfume is desirable. Other examples of the type are readily visible

in any magazine. The matter of catching the eye of the reader is, of course, fundamental to all advertising. One technique used consistently is to find constantly novel types of pictures. This can be done through new poses, new types of models, unusual photographic techniques, unusual color combinations and in a host of other ways. Such a constant search for novelty and new ways of varying the same thing pictorially produces a photographic gold mine for the expressive worker who is trying to express his feelings through photography. It is not too much to say that *Vogue Magazine*, long the leader in the field of photographic novelty, has been the training manual for many of our most promising original workers.

We turn now from advertising and illustration to a number of other fields which come under this same heading of description.

Perhaps the most important single type of picture in which description is the intention is the **portrait photograph**. Among those who make their livings by making pictures, it is likely that there are more portrait photographers in the country than any other kind. This has to be modified of course by the fact that a photographer in a small town is expected to be able to make any kind of picture. After all, the public believes that all that is needed is the proper equipment, and that all one then has to do is point it at the subject.

In portrait work the aim of the photographer is to describe attractively. The average person having a picture made of himself does not want an exact likeness and neither do his friends, unless he or she is unusually attractive. What is wanted is a recognizable likeness as attractive as the facts of the situation permit with as much of the personality of the individual in evidence as possible. This is often quite a difficult assignment. Fortunately, attractiveness is in part a matter of the mode of the moment. Then too, there are styles in portraits just as there are in clothes and automobiles and the photographer is free to exploit these fads. He is, on occasion, fortunate if the fad of the moment is soft focus. On the other hand, the serious portrait photographer for whom making portraits is his sole life work, tends to rely less on fads than on a thorough knowledge of lighting and human nature. The face, like any other complex object, is very easily changed in appearance with lighting. Much of the individual's personality can be expressed in this manner. Sharp decisive lighting and soft well-modulated lighting go with different types of individuals.

Above all a portrait photographer must be a good actor in the sense that he can get to know his audience quickly and play up to it accordingly. The proper expression is the greater part of the success of any

portrait. The skilled painter can study his subject over many long hours and, if good enough, can then make a likeness with the most character-istic expression. The portrait photographer has only a short time not only to discover this expression but also to call it forth honestly and sincerely.

The failure of the great majority of portraits lies simply in the fact that they look exactly like what they are, a picture of a self-conscious person sitting for a photograph. The more successful photographers, and especially those permitted only a short time with their subjects, have cultivated the art of calling forth a particular kind of expression, often that of mild amusement but sometimes a true dignity. This is far superior to the rigid, tolerant look which befits a man who believes it is really not quite proper to want to have his portrait made, or the too eager look of one who feels he photographs nicely. Mild amusement or dignity are desirable attitudes for any person and the pictures, aided by skill along other lines, are successful.

In addition to serious attempts to portray people attractively within the limits of their actual appearance, photographers are often requested to go the limit and to use all their art to make the person appear as attractive as is humanly possible. This type of photography has come to be called "glamour pictures" because everything possible is done to add glamour to the person so displayed. The face is usually made up—as are other parts if they show—the background and position stress the type of personality being suggested, and costumes of appropriate sorts are the rule. This type of photography is not far from that of the creative type discussed in a later section. The intention, at least, is often in the direc-tion of art rather than science.

There remain two broad types of descriptive picture that can be con-sidered, with profit briefly. These are **entertainment** and **propaganda** pictures.

Entertainment pictures, of course, include the whole gamut of the pro-fessional motion picture industry. Drama, comedy, travelogues, cartoons, short subjects of all kinds—one and all are designed for the entertain-ment, intellectually or emotionally, of the movie-going and television public. The group technical skill that goes into their production has no parallel in any other phase of photography. The motion picture produc-tion groups are the miracle workers of the present age. They illustrate in large measure what can be done with photography, given sufficient finances to attract the skilled workers. The urge, however, is to entertain at the level of motion picture audiences. It is the rare picture, usually produced "on a shoestring" that has honest artistic aspirations. Oc-

casionally though, the combination of story, actors, director, and photographer in a regular production produces a masterpiece which can be compared with the best in the fine arts.

In a similar way the pictures of the *National Geographic Magazine* and *Holiday* can be considered as intellectual entertainment, "armchair traveling" although their educational value is not lessened on this account. *Life Magazine*, of course, is a mixture of record and descriptive pictures of all types, and its recent excursions into publication of the works of single photographers makes it cover, if only sketchily, the whole range of possible types of still photography that can appear on the printed page.

Propaganda pictures are of such variety that it is difficult to point to examples. The emotions are easily aroused through pictures of emotional subjects, and the medium of photography has been thoroughly exploited in this direction. Either as motion pictures or in association with the written word the appeal can be tremendous. In former times it reached the people as no other medium could. More recently, however, radio and television have rather taken over this phase of our culture and photography is coming to play a powerful supporting role rather than the main part, except as it is used for television.

Snapshots and home movies

The pictures made by photographers for whom picture making is a vocation have been fairly easy to classify. They are made for the most part with clearly defined ends in view. No such statements can be made about the pictures taken by the casual photographer. Yet this group makes close to two billion single photographs each year and uses as much motion picture film as the whole professional industry.

The casual photographer on the average knows nothing about photography and cares less. Any success he has with his pictures is due as much to the manufacturer's skill as to his own. It is interesting to consider the reasons why he makes so many pictures. There is, of course, no single reason. We shall simply examine a few.

The urge to own a camera is universal and so strong that few families do not have at least one, and many families have upwards of a dozen in various states of repair. It is evident that photography touches on a fundamental human desire.

It does not take a very deep analysis to show that one of the urges is the desire to retain pleasant experiences. Life to most people is a sort of

mad progression. The need to clutch some moments of it and to retain them against the inevitable change is strong indeed. We can consider, then, the first reason to be that of retaining a given moment, of stopping a section of time to relive at our leisure. A high percentage of casual photographs are made on vacations, at picnics, at home gatherings for birthdays, holidays and celebrations, at weddings and the like. The desire is to assist the memory and bring back some part of the feelings that were part of the occasion. If this were the only reason, all such pictures could be considered simple records. Below the surface, however, there are other notions and it is these we want to discuss.

Over 85 per cent of casual pictures are of people, some 10 per cent are pictures of scenic or famous places, and the balance is a complete chaos of subjects. Why so many **people** if the purpose is simply to record a pleasant time? They are for the most part pictures of one person, not groups, and the people are not as a rule engaged in an activity.

Two explanations present themselves for these facts although there are doubtless many more. First, at least half the pictures are of young children and old people. These were clearly produced because of the desire to retain a record for future reference. The children will grow up and old folks will die.

The second explanation is that pictures tend to ward off that human characteristic, loneliness. People cannot always be present when we want to see them. They may live in far cities, or it just may not be possible at the time. In any case, possession of a photograph of the person makes him seem nearer and more real. In cases of long separation between people who are very close to each other the photograph may almost become a substitute person, in which are seen many of the person's characteristics, far beyond the photographic record.

This special case, however, is part of a far more general reason for making pictures. It is exemplified by the very verb used for the operation in popular speech, "to take." In a very real sense we can feel that we are "taking" the person or the scene away with us when we make the picture. It is as though through photography we could transplace objects and scenes at will. We can take a view back to our friends from vacation, can show a friend off to other people, can take a new boat to work with us, can take the children along on a long business trip. It is somehow the urge to have everything that is connected with us available at all times. In a sense it could be considered pseudo-possession of the subjects and yet it is not quite that. It is a sort of completion of our little world by being able to include in a small compass at least token representation of things we like.

Not all pictures, however, are made with such serious motives. The making of pictures, particularly of people, has become a sort of minor amusement. People make pictures because the act of making them is fun. Part of this, of course, is the sort of intimate relationship it establishes between "taker" and "takee." Partly it is the fun of hearing the camera click and the enjoyable suspense as to how the pictures will look—enjoyed by both parties. Part of the enjoyment goes a little deeper. By a simple act we can stop time and change and freeze a little moment of it to keep for ourselves.

Whatever the reasons, the use of photography in this manner continues to increase and the advent of color photography has put manufacturers to a real test in trying to produce good pictures from the truly casual exposures which are made.

In this connection it might be noted that the term casual applies for the most part only to the way in which the pictures are made. Once exposed, the imaginations of both photographer and sitter see a far more attractive picture than they are likely to get. The odds are pretty much against the success of such a photographer, as will be seen by a quick survey of the earlier chapters. He knows nothing of lighting, except perhaps to put the person in the sun, he has no way of lighting his shadows, he pays little attention to exposure, he does not look to see what expression the person has or try to call forth a characteristic one. Interestingly enough, he does not seem to care a great deal about these failures in his results. He **knows** what the person looks like and reads it into the photograph. His main demand is one that we have met before and shall again, he wants his final result to be **attractive** if it is a print and **realistic** if it is a movie. These demands are far more insistent than accuracy in the perceived result. It is for this reason that prints, for example, have been more successful with wide white borders. It is the reason that a pleasing color balance is more important than an accurate one. It explains why sharpness is most important in home movies. His urge to **take** the picture changes when he starts to show them to other people. For this purpose he wants the pictures pleasing to look at.

Reproductions

There is one type of subject that color photography is, in theory, able to duplicate exactly. This is the so-called "flat copy." There is no theoretical reason why a perfect color process should not make an exact reproduction of another color photograph. In fact existing processes cannot

do this, and the failure is an indication of the present status of color photography. A photograph of a person or natural scene by modern color processes is wholly satisfying except to the most critical if it has been properly handled in all the steps. The same process handled with equal skill, however, may be quite unsatisfactory as a copy of a photograph.

The departures from exact reproduction are similar in the two cases. The difference lies in the fact that the drop in quality obtained in an exposure to an original scene is acceptable provided the consistency principle has been met reasonably well and it is a fairly attractive picture. The actual loss is so great, however, that it usually cannot be incurred again successfully no matter how well the second picture is made. We have seen that there are techniques by which such copies or reproductions can be made. For the most part these techniques are neither simple to understand nor easy to do.

Wonder is often expressed that such reproductions cannot be made when the processes look so satisfactory in a direct photograph. The fact is that originals are satisfactory, although quite different from the scene itself. When we try to make a reproduction of a print, however, it not only has had its quality dropped twice but it is compared with the original subject.

In making such reproductions no visual problems are involved so long as the material being copied is the same kind of a photograph as is being made from it. When the original material is of an entirely different nature, new problems are encountered. These will be dealt with later, but it is pertinent to this section to note that color is not the only characteristic of such objects. In water-color paintings, for example, the texture of the paper used is often an important part of the effect. While it may be possible to indicate this texture by special lighting, the main requirement of uniform intensity over the surface must be maintained. Even then it is unlikely that a glossy surfaced photographic print will look anything like the original. In other words, a reproduction must reproduce all of the characteristics of the object if it is to appear the same.

Scientific photographs

The reasons for making scientific pictures are as varied as all the sciences and all their branches.

In many scientific fields, such as astronomy and spectroscopy of all kinds, it is the position of part of the image that matters and little else. This requires accurate knowledge of the dimensional characteristics of

the materials and little more. Color may enter into this in some subjects but usually in a secondary manner as a means of locating the right part of the image.

In other uses shape and perhaps fine detail are the important points, again with color in the role of identification. Many such cases arise in photomicrography. Here there are likely to be problems of best viewing conditions, but again these, like color, are apt to be minor.

It is not until we meet situations in which the intention is to photograph some sort of event that is to be interpreted from the picture that serious perceptual problems arise.

Suppose, for example, that an explosion or other rapid phenomenon is to be photographed with an exposure of $\frac{1}{10000}$ of a second. The resulting picture may not look like anything previously encountered in our experience. Interpretation may then have to rely on deductions from careful placement of the light source, from multiple exposures taken from different angles, from hypotheses as to what is supposed is happening and the like. It is probable that in such a situation, as in so many others, stereoscopic photography would help, or perhaps high-speed photography if the illumination problems can be solved. If the intention in making such pictures is to understand completely the nature of the event which is occurring, unusual precautions may be necessary to prevent reading some preconceived notion into the pictures. The more unusual the event the greater the danger.

Where colors are important in scientific pictures, the problems are of two kinds. If the role of color in the pictures is simply to differentiate areas that might otherwise be of the same brightness and so escape detection, little difficulty is encountered. The same freedom exists, as already noted, when the purpose of the color is simply to differentiate different kinds of things. Every different color in the subject is recorded as a different color in the photograph with minor exceptions. If it does not matter that the color in the photograph does not match that of the subject, most processes are adequate and satisfactory.

On the other hand if it is necessary that colors in the photograph exactly match those in the subject so that subsequent identification is possible or that other real objects may be compared to it for color, then no known process of direct color photography will even begin to do the job. All known processes have the characteristic that a certain color is produced when a given energy distribution strikes the film. This color, in general, is more or less different than that seen when the same light strikes the eye. For every color the process can produce there are a very large number of energy distributions that will produce this color, just

as there are for the eye. In general those that match for the eye do not exactly match for the film, and vice versa. Exact matching of natural colors by color photography therefore should not be considered seriously at the present time.

This does not mean that color photography is useless, even in those cases where exact matching would be desirable. Reproduction of fine gradations of colors, of the relative saturation of colors in different parts, associated with the realism which color contributes, may in many cases be all that is necessary for the purpose. Exact reproduction is not often necessary even where at first sight it may so appear. Very often the problem may be solved by comparisons of photographs in which the color errors are the same. There is also the matter of degree of precision required. If it is required only that the film distinguish between, say, a blue and green, nearly any process will make the distinction. If it is required to distinguish accurately between a yellow and a yellow-green which are just noticeably different, no present dye process will work.

It is perhaps not necessary to point out that in the present state of color photography, in which the manufacture of the material is in itself little short of a technical miracle, it cannot be expected that two pictures of the same object taken at different times will come out alike. This precludes some scientific applications that might otherwise be feasible. Thus it is not valid to assume that a difference in color between two photographs taken at an interval of a week or in two widely separated locations is due to the objects photographed. Photography can be used for this purpose with the aid of suitable color charts photographed next to the objects. Then it is the different variations between the chart and the object in each picture that give the desired information. But even when used in this manner unless there is a color in the chart that nearly matches the objects, serious photographic errors may be encountered.

To summarize this section, color photography is of inestimable value to the scientist as a means of recognizing color identities within one picture or for differentiating different areas where the exact color does not matter. It cannot be used for color matching purposes, or for the recording or exact description of colors.

Expressive pictures

At almost the opposite pole from scientific uses of color photography lies its use as an expressive medium for the photographer. To many a person photography has become a worth-while, entertaining, and re-

warding hobby. The appeal is different to different people. For some it is the appeal of the fine high precision workmanship that goes into many of the better cameras and accessories. It is the love of owning and using fine instruments. To these people the photographs are proofs of the remarkable quality that they are able to produce through knowledge of how to use their high quality equipment. The pride and joy of fine workmanship is evident in many of their pictures.

For others less mechanically minded the interest may lie in the quality of their lenses or their ability to squeeze the last bit of quality out of their developers and photographic materials. There are the thousands of people who develop their own pictures, who are experts on the latest formulae for fine grain development. Their pictures, too, show their love for fine photographic quality and their subjects are chosen appropriately. Color photography will now reach this group and we can expect eventually that many pictures of high technical quality will result. Many of their results will be more appropriate to the field of optics than to photography.

For still others the most important phase is neither the mechanical equipment nor the photographic quality although both may be considered important. They want to show other people things as they see them. A willow tree swinging in the wind may mean something important to them. They want others to see it as they do, and they try to make a picture that will make the tree say to everyone the same thing it says to them. It does not matter whether the thought is freedom, grace, grandeur, solitude or beauty. Their intention is to capture the scene at a moment when things are so perfect that the picture will say to others what it says to them. These are the true photographic impressionists.

Their aim is not necessarily to have the **objects** say what they want them to express. The objects may be completely secondary to the picture. Their aim is that the whole picture imply forcefully just the shade of meaning they want expressed. The subject matter may be sorrow, despair, joy, loneliness, strength, age, mysticism or anything else.

The number of such pictures honestly carried through to a successful conclusion is regrettably small. All the problems of visual perception are here met in aggravated form, and photography is a strict and exacting medium for this sort of work. The aim, of course, is the same as that of many of the painters and the medium is more severe. The photographic process with rather strict laws and rules compares with painting much as the sonnet compares with other rhymed verse. Art must be produced within the compass of the limitations.

The pictures for our photographic salons come from all three of these groups, perhaps principally from the second and, to some extent, the third. Work of exceedingly high technical excellence is being produced in black and white and will presently be produced in color. Work comparable to that of the great painters is rare but possible.

Creative pictures

We have, finally, in photography as in painting, the creative worker who is less interested in simply expressing his feelings than he is in creating pictures around emotionally felt central ideas. The picture is the end in itself, whatever the content.

The possible subjects for this type of worker are again infinite just as they are for other workers. Both the pictures and the subject matter may range from trivial to important and the techniques employed may cover an equally wide range. As in painting many of the works produced by this group are technical exercises not intended as important in themselves but important in their study of the subject. Again as in painting, still life subjects predominate in such technical exercises, but the important pictures can have about any subject matter.

For this group, arrangement of the subject, its lighting, the color harmony of the parts, the nature and relationship of the shapes are often more important than the objects photographed.

This also is the group who make nonobjective pictures, who attempt to destroy, at least in part, the realism or the recognizability of the objects in favor of the picture as such. It is the group that works with "solarization" with "posterizing" with "derivation" techniques to attain their desired ends. They take low power photomicrographs to move into a world of pattern and design not familiar in everyday life; they move the camera in a carefully predetermined fashion during the exposure; they photograph moving objects with long exposure times and so on.

In this connection an interesting point of view has developed concerning the relationship of both black-and-white and color photography to realism. A black-and-white photograph abstracts the brightness relations from the subject to the exclusion of the other color attributes. Because it abstracts, it cannot look exactly like the objects photographed. It is possible in this medium, therefore, to present an interesting type of picture. By using a starkly realistic approach, pictures can be produced that say to the observer, "This is a starkly realistic way of looking at life."

A picture of a barn door or anything else can thus be presented that is interesting and important because it proposes an interesting and important way of seeing.

When this approach is used in straight color photography, however, the result is no longer an abstraction from the subject, it is a close approach to reproduction of the objects. A realistic picture of a barn door does not say "This is a way of seeing"; it tends to say "This is a barn door" and the observer's reaction is likely to be "So what?"

The corresponding color abstraction has been worked out in the "derivation" techniques but it remains to learn whether or not important pictures can be made in this manner.

In many fields such as decorative pictures and commercial pattern design, creative color photographers are already doing work in the field of the hand artist. Whether true art can be attained along these lines remains to be determined.

C H A P T E R

WHAT THIS
PERMITS US
TO DO

In the earlier chapters we considered a number of effects that govern what the observer sees when he looks at a photograph. The emphasis there was on the nature of the visual processes involved, and the intention was to gain some concept of the nature of a photograph in terms of the objects it represents.

We want now in this and the following chapter to reconsider these same effects, not from the standpoint of the observer now but of the photographer making a picture. He wants to make a photograph that will be seen in a certain way by the observers. How can he use these effects to offset or amplify what the observer would otherwise see?

Rather than to refer to previous chapters constantly, the effects are redescribed briefly from the standpoint of the photographer, and in many cases illustrative examples are given showing how they might be used deliberately. It will be apparent that every effect has a multitude of possible uses, the ones shown are simply intended as an aid to understanding how the effect might be used. It is emphatically not suggested that in every case the modified picture is the more desirable of the particular pair. The effects are tools and not rules for the photographer.

Subject and objects

In order to make an interesting picture a photographer must have or develop an idea. That idea we call the "subject" of the photograph. It

253

is true that the original idea with which the photographer sets out may be simply that he is going to make a photograph around certain objects. Or he may simply put his camera under his arm or over his shoulder and go out looking for ideas. At any rate once he settles on a more or less definite course of action his ideas start to develop and continue to do so until his final picture is completed. In the course of this activity the direction of his thinking may change many times—in fact this may be a necessary requirement if he is to make a good picture.

When a painter starts to make a painting which may take him weeks or months to finish, he generally plans pretty carefully just how he is to proceed. He may make a number of preliminary sketches, may even make fairly complete wash drawings or the like until he is quite satisfied that he knows how to start. From then on he constantly changes and modifies his ideas as new concepts and ways of accomplishing his end suggest themselves or are worked out, and as new relationships suggest themselves.

The problem with most photography is that it is not difficult enough. The ease with which a shutter may be "clicked" and the more or less mechanical nature of our processes does not make the photographer hesitate long enough before he makes the exposure. Nevertheless he has at his disposal a better technique for improving the result than does the best artist. Because of the fact that he can make a picture so easily, he can try one, see how it appears and then go back and do it better. It is the failure to study a result and then do it over and over until it is perfect that gives us so much second-rate photography. Even a second-rate idea can become important if it is executed flawlessly from the aesthetic point of view. Technical perfection will not by itself accomplish this result, but if the subject demands it, such perfection also becomes an aesthetic requirement. What is needed is a perfect unity of purpose in a picture that in itself is a perfect unity.

The purpose of the photographer's controls, however, should be to help him so to handle the image of the **objects**, human or otherwise, composing his picture, that the **subject** is successfully portrayed.

Every photograph—even a nonobjective one—is produced by the light from objects. Objects are, accordingly, the stock in trade of photographers in a sense that they are not in other fields of art. The photographer is working with a drawing or drafting instrument that is essentially perfect. He may modify it as he will, but this perfection in some degree persists. Accordingly a large share of his art consists in dominating this phase so as to make it do the bidding of his subject. This control comes

largely through choice or manipulation of the objects and their environment.

Every object has a large number of properties. Each has size; shape; position; surface; angle of view; transparency or opacity; outline shape; fine or coarse detail; to say nothing of color, which may be surface, depth, dichroic or complex. These variables modified by lighting, the lens, and subsequent photographic handling produce the end result. No rules can be laid down for the placement and treatment of objects. They must so exist in a given situation that in the final picture they support and further the subject of the picture. It is the subject, and only the subject, from which procedures may be devised, and then only with respect to the final picture itself. In the making of a picture, the end justifies the means. There is no requirement that a photograph must look like the objects unless the objects happen to be the subject of the picture. Even in this case, as we have seen earlier, the object reproduction often must actually be distorted if the photograph is to give a true impression of the distorted object.

We shall proceed, then, on the assumption that the photographer must himself solve the problems in accordance with his subject, and discuss the positional factors involved and what the lighting and the subsequent steps permit him to do. It is true, of course, that the subsequent treatment will modify the arrangement he should have had, but such interactions of effect cannot be discussed except in connection with specific problems. Handling of such interactions is known as experience and cannot be supplied by a book.

Position of the camera

Perhaps the simplest of the variables a photographer may use, and yet in many cases by far the most important, is the position of the camera with respect to the objects. We have noted that an observer viewing a finished photograph has to make an almost conscious assumption as to the direction in which the scene is being shown. If this decision were always correct, there would be little problem involved. Actually the very strong tendency toward seeing the camera angle as the same as that of the observer's position with respect to the picture can and does produce large apparent changes in the shapes and positions of the objects.

There is a basic rule that holds for most of the effects discussed in this and other chapters. **Any deviation between the observer's assumptions,**

Figure 8–1. *Horizontal surfaces usually appear higher at the back if the camera is tipped down toward them.*

conscious or unconscious, and the true facts of the picture will be seen as modified properties of the objects. The large number of such variables and the magnitude of the effects permits the photographer wide latitude in obtaining the result he wants.

There are not many general rules for the effects that can be produced by the direction of the camera. There are no effects, of any kind of course, that are not affected by many other factors as well. A good case in point is that of objects laid out on the floor and photographed by a camera tipped down toward them. Almost every time the picture, when viewed will appear to show the objects as lying on a tilted surface higher at the back than the front (Figure 8–1). This can be considered as a compromise by the observer between the actual surface shown and the surface of the print. The actual apparent tilt, however, as will be shown presently, can be modified all the way from flat to vertical and to negative values by changing the depth factors in the scene. Even so, in order to have it appear as it was photographed, factors have to be introduced that oppose the normal tendency for tilt.

Figure 8–2. The true slope of a surface can seldom be seen in a direct frontal view. Both pictures are of the same steep slope.

257

The degree of tilt seen, on the other hand, will be determined by the experiences of the observer and the nature of the subject. Thus if the surface photographed is actually tilted, it may become very difficult for the photographer to show the correct tilt. The variables he may use in this connection are discussed later. The problem may be illustrated by the difficulty of photographing a steep hill from the front so that it appears to slope correctly (Figure 8–2). It might be added that this problem also exists in stereoscopic photography, although not to the same extent. In photographs seen in a viewer the surface plane of the photograph is far less apparent and so produces less effect. For nearby tilted surfaces, of course, the tilt is likely to be seen more correctly than for distant ones.

In addition to effects on the plane where objects are resting, there are large effects on the objects themselves. A downward angle tends to move the tops of objects forward, and an upward angle moves them backward relative to their bases. Even in symmetrical objects if the top and bottom are not of the same size, then relative sizes may appear different in the two cases. In this sort of effect perspective also plays a large part. The two effects work together toward making the top appear larger on a downward view and the base larger on an upward one. Large, unsymmetrical, and unfamiliar objects can be modified very extensively in this manner.

It is not only camera tilt that can be used in this manner. With the camera horizontal, the height from the floor or ground may often produce a large effect. The usual eye level for viewing photographs and for natural scenes is some 5 to 6 feet from the ground. If the camera is placed very low or very high, the height and again the shape of objects will be modified considerably. The tendency is toward an appearance of greater height from a low position but is often countered by other factors. These often result in apparent greater width at the base relative to the top (Figure 8–3).

Equally important in what the observer sees is the matter of the assumed distance from the camera to the objects. While this appearance is often determined by the assumed size of the objects, there is a rather little known and understood factor which may be considered at this point.

It was noted earlier that in perception there is a phenomenon that may be described by saying that the eye appears to work at variable magnification. The little or large group of objects at which our attention is directed seems to fill the whole field of view. Cornish, in the book already mentioned,° points out that some of the larger constellations may

° Vaughn Cornish, *Scenery and the Sense of Sight*, Cambridge Univ. 1935.

Figure 8–3. *Three views of the same pitcher from different positions. Camera position can change apparent shape of unknown objects.*

fill an angle as high as 70 degrees while the full moon is about $\frac{1}{2}$ degree, and yet often there does not seem to be this large difference between them. The moon alone or the moon and a nearby star may often equally fill the field of our attention. Cornish has called it the "aesthetic factor" in vision. The eye tends to produce a unity out of a grouping and to see this as a whole that appears to fill the field of vision, more or less excluding other parts of the field. Photography, to produce anything like a similar impression, must reflect a similar change in included angle.

If a distant grouping of, say buildings or trees, is the subject of a picture, the inclusion of areas outside of this grouping may produce a vastly different effect on the observer. As Cornish notes, this is the major defect of the ordinary fixed focal length camera. Nearly every photographer has had the experience of photographing a distant landscape which appeared interesting at the time, only to find that the picture was hopelessly uninteresting (Figure 8–4). Much of this is because the included angle of such a picture is appropriate for people standing at relatively short distances from the camera. For distant objects the angle is appropriate only for subjects that present a large angular unity. Such a subject, for example, might be the Grand Canyon or a large building filling the picture.

There are two ways in which this effect can be modified by the photographer. The important factor is the angle of view included by the borders of the picture. This may be modified in two ways. The first and most obvious of these is by simply cutting off the edges of a picture that includes too much. "Cropping" of a picture, as this is called, is perhaps the simplest and most important single operation at the disposal of the photographer in producing his final result. It is regrettable that cost considerations make it necessary for the full area of casual photographs to be printed when done commercially. It is not too much to say that any such picture can be improved by cropping. Often such a photograph will contain as many as four or five separate pictures—which if isolated and enlarged to reasonable size would represent among them what the observer saw and enjoyed but which together are lost to the observer because he tends to see the whole picture as a unity formed by the border, not its separate parts. For creative photography, of course, it is these pictures within pictures that must be adequately balanced by the artist photographer so that they are suitably adjusted to the unity of the whole. It is the whole picture as a unity that will tend to fill the observer's field of view and not the smaller components.

Direct control of the angle of subject matter included is, of course, available in more flexible cameras by change in focal length of the lens

Figure 8–4. *The relationship of the hayrack and the farm buildings interested the photographer but are interesting to the viewer only in the close-up view.*

or by change in size of the film for cameras of fixed focal length. For a fixed size of film the angle of view decreases with increasing focal length, and for fixed focal length decreases with size of film. Subsequent magnification or reduction, if possible, will then produce the effect of combinations not actually available to the photographer. Thus magnification

of a small area in a picture is exactly equivalent to the use of a correspondingly longer focal length lens at the same camera position. Because nearby objects change in size more rapidly than distant ones as camera position is changed, in a series of such pictures all would be somewhat different from each other. To get the correct included angle **from a given position**, therefore, focal length, size of film, subsequent magnification and size of final picture are the only variables. Definite limits are set, of course by the photographic process being used, but it is far better to include only what is wanted, even if it means a quite small final picture.

To the extent that the perspective viewpoint rule holds there is still a further limitation that the focal length of the lens times the subsequent magnification should equal the viewing distance of the print. From a given camera position this rule determines the size of the final print. Except in the extremes, such as murals and the like, this is not very important.

Arrangement of the objects

In a very real sense the art of arrangement of objects is the basic art upon which the photographer must rely for his results. It seems to be little understood, however, that it is the arrangment as it appears in the result that matters and not the arrangement in front of the camera. The two can be and often are very different. Before considering examples of this and how they may be used, however, it might be well to look at the matter from a rather broad point of view.

The word arrangement suggests immediately the movement of objects into desired positions. Often, however, the photographer neither wants to move the objects nor has it within his power to do so. The obvious situation in which this is true occurs in landscape and nature photography. It occurs just as often in any outdoor photography in which the photographer works with objects in their natural state, so to speak. It may be a street scene, a house, a human activity or what not. In all of these cases, however, the photographer arranges his objects just as truly and should do so just as carefully as he would with smaller objects in the studio. He produces these arrangements by the position of his camera with respect to the scene. Because the operation is often done with little thought, it is well to consider what he is able to do by this means even though the subject overlaps that of the preceding and following sections.

There are three general directions in which a camera may be moved and each produces a different type of effect. The simplest of these are

the horizontal and vertical movements. Displacement of the camera horizontally to the left moves all the objects in the rear to the left relative to those in front. Raising the camera raises all the rear objects with respect to those in front. A combination of the two movements does both, and for restricted camera positions these are the basic elements by which successful composition is obtained. For distant objects the required motions are greater but the principles remain the same. They add up to the fact that in this sort of photography one of the important requirements is the selection of the spot from which the picture is to be made.

The third movement is that of the camera toward or away from the objects. The effect of this movement can also be stated very simply. Movement of the camera toward the objects increases the **size** of the nearer ones more rapidly than that of the more distant ones. In fact it increases the size of the front of an object faster than it does the back. For very distant objects the effect is small for small movements and for very near objects the effect can become very large.

With a given focal length lens, movement of the camera also changes the angle of included view when the camera is focussed on nearby objects. For distant objects this angle is constant. As nearer objects are focussed this angle decreases, slowly at first and then more and more rapidly, reaching a value of approximately one-half the original angle when the image is the same size as the object. In this position the object is approximately two focal lengths away from the lens.

The three movements together, accordingly, represent the variables by which the photographer controls the basic compositional elements of his picture. Since compositional rules will not be considered in the present book, it might be noted that these controls are by no means as feeble as they may appear. It is probably true that a competent photographer given unlimited choice of camera position can produce a picture with pleasing composition from any group of objects placed in any position. The ability to "see" the position from which the objects will give the desired result represents a large part of the skill of the outdoor photographer.

Once the spot for the camera has been chosen the surface pattern formed by the outlines of the objects has been established. Except for optical stretching to increase the separation of objects in some direction or modification of the outlines through sharpness of focus, the relative positions of objects cannot be changed further. Use of long or short focal length lenses simply selects a smaller or larger part of the scene in the same sense as would a smaller or larger piece of film.

In the studio, of course, the variables work in the same manner, but there is usually freedom to move the individual objects. Even under these conditions, however, the same variables and to the same extent must be used in the photography of a **single** object. Many photographs of art objects fail miserably through neglect of just these factors.

These remarks have dealt primarily with the determination of the surface arrangement of areas in the final picture. Pictures are not frequently seen as mere surfaces but rather in some sort of compromise depth between that of the actual scene and this surface. Such factors will be considered in the next few sections and are just as truly part of the problem of picture composition as the arrangement of surface areas. They are varied, however, by different means.

Before considering these possibilities it is appropriate first to examine some of the freedom that the photographer has in modifying the apparent, as distinct from the actual, position and nature of objects in a scene.

Role of logical probability

The extent to which the perception of a scene from a photograph may differ from the actual scene is beyond the belief of those for whom it has not been a direct experience. It is perhaps for this reason that such differences are not used by photographers to a greater extent even where they might solve difficult problems for them. The basic principle involved is that **objects will appear to have such properties and to be so located as is most logical from the standpoint of the observer's experience** as it applies to the picture at hand.

There is first the question of the size of isolated objects. This was discussed in some detail earlier under the perception of form in photographs. Like all the effects there described, this effect can often aid the photographer.

Because the observer is dependent on what is visible in the picture for what he sees, he often has to refer to general experience for decisions. With a single object, shown by itself, there are three major variables from which he may draw conclusions. The first of these is his experience with objects of the type represented. Most lemons fall within a certain size range, adults fall within another range, and so on. Each observer tends to adopt a certain size as representative of the class of each object. In the absence of other criteria this is the size he will tend to see from a picture of an object of that class. If the object is actually much smaller

Figure 8–5. *Photograph of a large and small shell together and the small one separately. The high magnification makes the small one seem too large.*

or much larger and it is desired that this fact be evident, it is necessary for the photographer to show enough normal objects so that these will control the size seen, rather than the object itself (Figure 8–5).

A second factor from which the observer may draw conclusions is the relative space in the picture occupied by the object. If the class of objects to which this belongs is not very definite, then this factor may control the appearance. Consider, for example, a glass drinking vessel. This may vary from a diminutive liqueur glass to a jumbo brandy snifter without the basic design being essentially different. A large glass, photographed so that it fills a small part of the picture, will tend to be seen as small. Filling the picture from border to border, it will tend to be seen as larger. This is particularly true of small pictures.

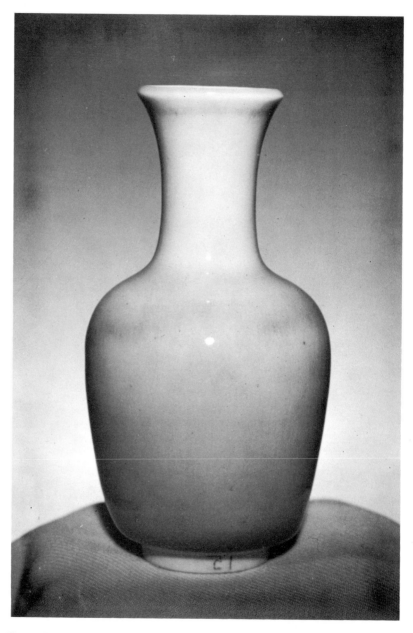

Figure 8–6. *Presenting an object in its true natural size will produce a strong tendency for this size to be accepted as correct.*

If the picture is large enough so that the actual image size approaches that of a possible size of the object, there will be a strong tendency to accept this image size as the true one. This is the third factor (Figure 8–6).

By the physical size of the image, therefore, both relative to the borders and on an absolute scale, the photographer can influence the perceived size of the object. Examples of this are seen daily in advertisements and the subject does not need elaboration. For the photographer who wants the **true** size apparent it may often pose a real problem and for the others it is a convenient possibility.

In a very similar manner to that of size perception the position of objects in a picture is also controlled by what may be called the most probable position as indicated by experience. That this factor is often stronger than the assumption of size is shown by Figure 8–7. It is more likely that the objects will be in the position seen than that their size

Figure 8–7. *The oversize cigarette seen as standing on the table is actually nearly 8 feet in front of the table, glued to a sheet of glass.*

be normal in comparison to the other objects. This assumption is aided, of course, by the fact that in normal seeing there would be a difference in the images seen with the two eyes. The combination of clues makes it more probable that the objects are the wrong **size** than in the wrong position.

The possibilities which these facts open up for the photographer are tremendous. Within the depth of field of his lens he can vary the relative sizes of objects over wide ranges. Whole groups of small objects can be photographed to appear larger, large objects to appear small and their relative positions, within limits, whatever he wishes. We shall see presently in the discussion of lenses that definite limitations are met if the objects are to be sharp, but this is one of the few actual restrictions.

A fourth experience factor is available to the photographer, often presenting puzzling problems when the intention is correct representation. If a picture is made which is anomalous in its indication of a true situation, then the perception of form reverts strongly to simple forms. Ellipses tend to be tipped circles, obtuse and acute angles tend toward right angles, etc. This effect can be used deliberately and in fact, must sometimes be used to obtain the effect desired.

It is interesting in this connection that an angle may be perceived as 90 degrees even when this means that the plane on which it appears to lie must also appear to be tipped up on one corner with respect to the rest of the scene (Figure 8-8).

It may sometimes be necessary to offset this effect. If the camera is tipped downward, for example, the tendency of horizontal planes to appear tipped upward may sometimes be offset by using obtuse angles in place of right angles. This reversion to simple forms is particularly strong for ellipses which, when isolated, tend strongly to be seen as circles in any view except that in a plane obviously perpendicular to the lens axis. This property again permits the photographer to help define the position of a surface when other factors operate in the other direction. In a simple subject, of course, this factor will also control the apparent angle of the line of sight of the camera.

In theory, at least, it is possible to insist that all the perceptions from a photograph are referred to the experience of the observer. In practice, however, certain of these factors are of such general validity, or such common experience, that it is convenient to consider them rather as rules for reproduction. This is particularly true of factors relating to geometrical and aerial perspective. Recent generations have been educated to the use of such perspectives in paintings and photographs and have learned to interpret such pictures in terms of nature. It is convenient for

Figure 8–8. *Hat rack photographed in three different corners in which the walls make different angles with each other.* (a) *90°.* (b) *130°.* (c) *50°.*

this reason to treat them separately. The photographer should bear in mind that they are just as much appeals to experience as to the use of an oval to represent a circle. The experience referred to may be that of geometrical perspective as a convention of representation.

Assumption of constant size

One of the means that the photographer may use to vary the depth which will be seen in a photograph is the so-called assumption of constant size of objects. When a group of objects that appear geometrically identical are seen under circumstances in which depth is not strongly indicated by other factors, the observer assumes that the objects are all the same size. From this assumption (he is usually not aware of it) he tries to see the distance which they indicate. If there are no conflicting factors, such as overlap of a smaller in front of a larger one, or straight lines connecting them, etc. the smaller ones will be seen as farther away. The actual perceived distance, of course, will depend on many other factors in the situation as a whole.

If such graded objects are available to the photographer, his arrangement of them can produce amazing changes in the depth seen. This effect is so strong, in fact, in ambiguous situations, that the objects do not have to be geometrically identical. Objects that could be described by the same class name, such as sea shells, or shoes, or buttons, if there is no direct indication of size will work nearly as well.

By this means the photographer can often suggest a greater or a lesser depth even though other clues are present. In the extreme case of isolated objects, even though they are completely dissimilar, mere placement of the small objects at the rear and the large ones in front may greatly increase the depth seen.

Perhaps of more importance to the photographer, especially in this latter case, is the fact that not all of the size difference will be taken as depth. As always the observer will compromise in what he sees. If the larger of two objects of different size is placed at the rear, it will tend to look larger than if in front, and vice versa.

This effect can easily be offset or increased by the introduction of other effects such as convergence or the opposite. In fact, when the situation is ambiguous with respect to depth, both depth and apparent size are at the disposal of the photographer.

We shall see presently that this effect is one which can be combined with or opposed to other similar factors to produce a variety of effects. One such effect, for example, is produced when objects that are actually

Figure 8–9. *Two photographs of same (miniature) table with face for size comparison in one.*

all of the same size are arranged in a depth which is produced strongly by other factors such as convergence and the like. We noted earlier that apparent position is then controlled by logical probability. The position so decided then also determines the apparent size of the object.

There is a limitation to this procedure, however, if the object itself is one that in common experience never varies outside of a small size range. Such an object, for example, is the human face. If a portrait is so arranged that other objects are smaller than they should be, regardless of the indicated depth, the face will win out and the other objects will be seen as miniatures (Figure 8–9).

In the opposite direction, however, if the objects are, in fact, very large compared to the face, we can enter the realm of fantasy and see the person as a doll or as a very small person. This always occurs if the depth perception as determined by the object is strong enough. Perhaps the best example is a motion picture made some years ago in which all objects were many times their normal size. In this case (even on the set it is told) the actors looked like midgets. Presumably the same thing could be done with small objects if the space could be made real enough to the observer.

(It is interesting to note that many of these effects are nearly as strong in looking at the real objects as at the finished photograph. We are dealing with the nature of all vision—a photograph is only a particular way of looking at the subject by means of a new object.)

Here is seen a generalization of considerable use to photographers whether they want a picture that looks more like the objects or less. Exaggeration of effects which oppose the direction in which a picture fails will make it look more like the object. Exaggeration in the opposite direction will make it look less as it is and perhaps more as the photographer or his customer wants it.

Convergence

The present generation, as we noted earlier, is trained from birth on geometrical linear perspective as the nearest convention of representation to what the eye actually sees. One of the most obvious and best known facts about this convention is that all parallel lines in any plane at an angle to the observer converge to a point on the "horizon." This means that any rectangular arrangement of objects on any plane at an angle to the observer appears to converge away from the observer.

This has become such a well founded element of experience that simple convergence of objects that appear to lie in a plane is sufficient to pro-

duce the appearance of depth. It does not matter a great deal what converges, the objects can be very different in character. It is the convergence itself that produces the effect. If there is also present the assumption of constant size, this adds or subtracts from the effect depending on how the objects are arranged. (See Figures 8–10 through 8–13.)

The photographer can use this effect in many different ways, particularly to control the apparent size and relative side to side to depth dimensions. An object seen in a space of apparent great depth will, in general, appear longer from front to back than when seen the same size in an apparently shallow depth.

By change of apparent total size as discussed earlier the frontal dimension may be varied so that it appears normal or distorted as desired. This effect is well known, of course, to photographers of motor cars who are sometimes asked to make them look somewhat longer than usual.

It should be noted, however, that convergence is accepted as meaning depth more readily in the horizontal plane than in the vertical. Until nearly the present generation any architectural photographer found it necessary to have any vertical parallels in fact parallel in the picture.

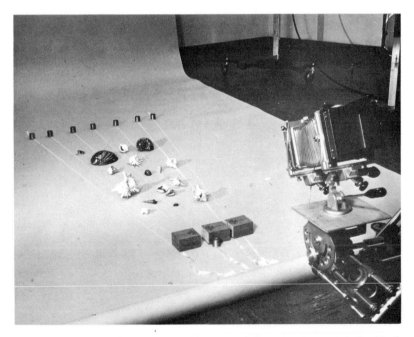

Figure 8–10. *In the following six pictures sea shells were photographed with the camera as shown here. Only the shells were moved to produce all the effects.*

Figure 8–11. *(Above) The shells have been graded for size and converged to a point. (Below) The shells are presented in random arrangement.*

Figure 8–12. *(Above) The shells have been graded for size with no convergence. (Below) The shells are graded and convergent with converging lines and graded strips.*

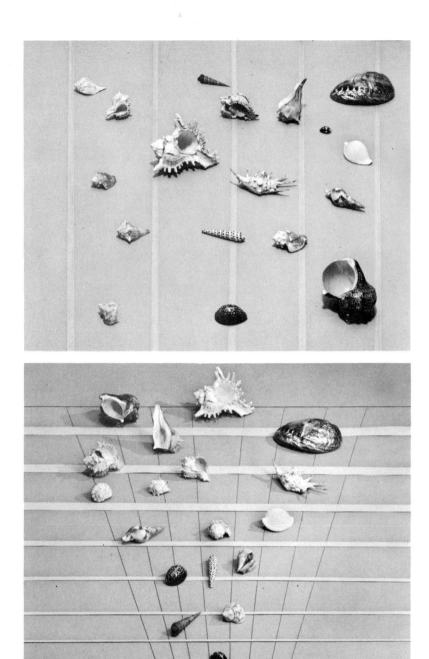

Figure 8–13. *(Above) The shells are random but nonconverging lines have been added to produce vertical appearance. (Below) All clues have been reversed producing the effect of looking up at a ceiling ("negative depth").*

276

This was because we do not ordinarily see the upward and downward convergence when we look up or down at buildings. Nor do we see in fact the horizontal convergence except under unusual circumstances, but we have learned to accept it from pictures.

No better proof that this is, in fact, a convention that we have learned can be found than that we are now beginning to accept vertical convergence as meaning height. The prevalence of the miniature, or at least hand-held, camera over the last fifty years and the tremendous growth of popular photography have taught us that high buildings converge if we look up at them. Although it is not yet as strong as the horizontal effect, it is now possible for a photographer to give added height to an object seen as above eye level by simply introducing vertical convergence. Its use is limited, however, by its relative novelty (Figure 8–14).

Downward convergence is, perhaps, even less acceptable and soon breaks into distortion rather than depth. It is vital to all such pictures that the position and direction of the line of sight be made amply clear from the picture. As noted, in the absence of other indications the observer will assume either that the camera was horizontal or pointed in the direction toward which he sees the print.

There is an interesting limitation on the use of convergence to mean depth and it can occasionally be useful to the photographer. Convergence due to a tipped camera or a swing back is apparent to an observer

Figure 8–14. *Height can sometimes be added by tilting the camera upward.*

Figure 8–15. Correction of a tilted camera by tipping the film plane only changes the general shape of an object that does not appear to have parallel lines. *(left) Tipped camera (right) corrected.*

Figure 8–16. Where the subject is known to have parallel lines correction removes the obvious convergence.

Figure 8–17. *Two pictures of same child that have been lengthened and widened in printing. Neither picture is correct.*

only if he assumes that there were parallel lines in the objects. This assumption is easy if there are buildings or motor cars and the like present. That is, he has to recognize the object and know that it always has a certain kind of shape. If he cannot recognize the object or the immediate space in which it is located, or if it is an object that can have almost any shape, then he does not see the convergence. This is shown interestingly in pictures of objects like as trees. A tree can have nearly any relationship of height to width but always grows nearly straight up from the ground. It is almost impossible to make a picture in which convergence is seen, or, what amounts to the same thing, in which an isolated tree appears to tip. The change in size of the parts of the tree that would show convergence in a building is simply taken as shape of a vertical tree. In Figures 8–15 and 8–16, normal and tilted pictures are shown of a building and a tree with the same tilt used for each.

For objects like trees, therefore, the proportions may be changed almost at will by the photographer: A face is such an object also and can be changed over the range of normal experience without distortion for any observer who does not know the model (Figure 8–17).

The ways in which convergence may be modified and situations where it may be helpful are considered below. It must be remembered, however, that although convergence is a powerful factor in seeing depth, it by no means is the only one. The final result will be a combination of all factors.

Experience

It has been noted many times earlier but cannot be repeated too often that what an observer sees is what he thinks he is looking at. In this he relies on the average of his visual experiences and the operation is essentially unconscious. We rely so strongly on visual experience, in fact, that knowledge of the true situation does not always change what we see.

In this lies one of the most powerful tools for the photographer. If the picture he produces looks like a certain situation, that is what will be seen regardless of whether or not the viewer can figure out that it was in fact quite different. In other words it is what the picture looks like that will be seen and not what was in front of the camera. This is shown in Figure 8–18, which shows two views of the same set-up with only the camera moved. Although the side view explains the situation, it does not change the appearance of the front view appreciably.

Figure 8–18. (Above) Side view of objects on a checkerboard. (Below) Front view of same with nothing moved but camera. Note distance from sphere to pyramid.

Figure 8–19. *Three views of same objects: (top) from left side; (center) from quarter left side; (bottom) from directly in front. Camera at same height for all three pictures.*

It is important to the photographer that the visual experiences of most people of the same culture are essentially the same. They will vary in degree, of course, in different parts of the same country. They probably will not change basically, except perhaps in countries where geometrical perspective is not the accepted convention of representation. Because of this fact the photographer can be quite sure that in broad detail others will see the objects in a picture much as he sees them himself. The moment he tries to become subtle, however, or sees something in his own pictures with difficulty, he can be quite certain that there will be few who will see it the same way.

The fact that what we see in a photograph is determined as much by our past visual experience as by the objects themselves is, perhaps, the most fundamental principle behind the making of a **good** photograph. It is not what was there, but what the photographer makes us see that counts. (See Figures 8–19, 8–20, 8–21, and 8–22.)

It is perhaps not overstressing the fact to point out that unless the photographer shows us something within the realm of our experience, we see either the wrong things or nothing. We sometimes forget how easy it is to make a photograph that is not interpretable at all in terms of objects. It is so easy, in fact, that nonobjective abstract art is a legitimate field for the photographer. In such work, of course, it is the **photograph** that we are supposed to see and not the objects. But between these extremes it is not infrequent for an amateur to make a picture that he can interpret because he saw the objects but which few other people will happen to see that way.

Figure 8–20. *A flat paper "cube" shown in two views with other objects. It is not necessary that a picture "make sense" to be seen in depth.*

Figure 8–21. *Vanishing points do not need to be consistent. The string, the cube, and the camera all have different ones.*

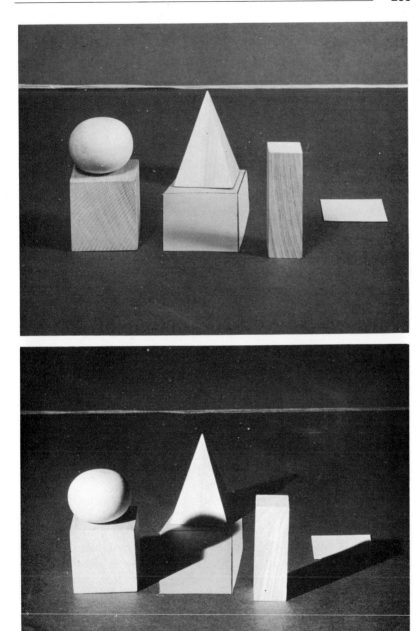

Figure 8–22. *Strong enough clues to the real situation will tend to make it be seen correctly, but for many the feeling for a cube will make the shadows in the lower picture "just seem the wrong shape."*

Lighting

There has probably been more written on the subject of lighting than on any other phase of photography. For this reason we do not devote much space to it here. As a matter of fact only a few actual principles are involved but their interrelations are so complex that they cannot be reduced to simple rules. It may be well, therefore, to look again at the principles and to consider a few of their applications. But the photographer must remember always that he is the master, that there is no right way to light anything, there is only the way that best suits his purpose. I speak, of course, only of the serious photographer. Unless the photographer is serious he needs only light, not lighting.

The subject of lighting can be divided broadly into that of daylight and artificial light. The division is convenient, not because the two are different in principle but rather because the geometry of the illumination is usually quite different in the two types. Daylight is usually considered the norm for lighting, but it should be remembered that under proper circumstances everything that is said about either one holds true for the other also. Lighting deals with the light that is reaching the principal object or objects under consideration. It does not matter where it originated nor how much it has been modified after leaving the primary source. If the light reaches the object in relatively appreciable amounts, it is part of the illumination and must be considered as such.

As a considerable part of the light reaching any object comes by reflection from nearby objects, this part of the lighting is of the same nature in both daylight and artificial. The first principle of lighting, therefore, is that lighting consists of all the light striking the principal subject. The nature of the principal light source often makes less difference than the nature of the nearby objects.

A second general principle that might well be mentioned here is that the nature of the reflections in the surface of an object, particularly if it has a high gloss surface, may be more important than the light from the principal sources. These reflections will be determined in large measure by the light falling on the reflected objects rather than the principal one. This is, of course, a variant of the first principle. For diffusely reflecting principal objects these secondary objects act simply as secondary light sources.

Perhaps both principles can be summarized by saying that lighting is not so much the art of placement of primary light sources as it is the control of all the light within the volume of the picture space.

At this point we should realize, however, that if there were no psycho-

logical effects in the viewing of pictures, there would be no such thing as a problem of lighting. If the nature and distribution of the illumination were immediately apparent to the person viewing a photograph, any lighting would be interpretable. The subject of lighting would then reduce to a matter of ease of seeing and aesthetics, just as it does for lighting the factory or the home. The fact is, however, that accurate perception of the illumination almost never occurs from photographs, with the result that large modifications have to be made to get the desired perceptions from an observer. This is also one of the facts that leaves the photographer free to get the effect he desires.

Daylight or "natural" light

One of the major difficulties in considering daylight as lighting for a photograph lies in that it is often thought of in the singular whereas in fact it should be thought of in the plural. There is no such thing as either a daylight or a natural light. Daylight is nearly as variable as studio lighting except in one respect. Small multiple sources of similar source **brightnesses** are not often encountered in nature but are the general rule in the studio.

Beyond this difference in the number of principal sources, the major difference between the two lies in the **size** of the major secondary light source in daylight—the sky. This cannot, with ease, be duplicated in the studio.

In daylight we are dealing with one principal source, the sun; a very important secondary source, the sky, which may reach an illumination intensity as high as one-fourth that of direct sunlight, and secondary reflected light from objects in the picture volume.

The intensity of the sun varies over a tremendous range as far as its effectiveness as a light source is concerned. From a maximum of some 12,000 foot-candles it can decrease during midday hours to as low as a few hundred—and still cast visible shadows. It subtends an angle at the object of one-half a degree, and this does not vary except momentarily during the passing of a sharp-edged cloud. At such a time—and often at other times—it is the edge of the cloud that is the effective principal source and not the sun itself. Such an illuminated cloud edge can subtend a much larger angle than the sun and be of quite various shapes.

At other times, of course, the sun may be obscured by clouds so that it does not throw shadows at all, and we are then dealing with the sky as the principal source.

During all these modifications, of course, the color of the sun may vary over a considerable range. Color problems will be deferred to a later section, and only intensity and geometrical effects considered here.

The sky as a light source is almost beyond description. It is often called a lighted hemisphere sending light to an object equally from all directions above the horizon. This is seldom true even on the clearest days with no clouds in the sky. In the first place a location lighted by the whole sky is extremely unusual—and ceases to be such if there is an observer present unless the object is above his head. In the second place even at noon in the tropics the sky is almost never uniformly bright, but varies both from zenith to horizon and, ordinarily, with orientation even with the sun overhead. It is, of course, always brightest near the sun, acting to shade off the sun's otherwise sharp edge.

When the sky is acting as a secondary source, that is, when the sun is shining, the distribution of the clouds will usually determine the nature of the sky as a light source. A single, bright cloud anywhere in the sky may send as much light to the subject as all the rest of the visible sky. This bright area may vary from very small to very large and have a wide range of brightnesses.

With the sun obscured by nearby objects such as houses and trees, the sky becomes the principal source unless sunlight reflected from nearby objects is brighter. The sky when acting as such a principal source may be a sunlighted cloud, a heavy overcast, a patch of blue or a combination of these and, of course, have any area. In a large area it may be mottled white, blue and gray, or at sunset or late afternoon may be of various shades of red.

Without unduly elaborating the subject it seems apparent that if the photographer is willing to wait and watch for his conditions an exceedingly wide range of lightings is available to him. In addition, of course, by the use of reflectors or flash bulbs and the like and by screening off direct sunlight or reflected light he can vary the conditions over a still wider range (Figures 8–23 and 8–24).

None of the principles involved, however, and none of the operations, differ essentially from the use of artificial lighting in a studio—that is, the conditions that must be met to get the desired effect are dictated by the same visual phenomena. Some of the effects, of course, are much simpler to obtain in daylight and conversely, some are much simpler in the studio.

One notable effect is nearly always present in daylight and is beyond the means of most photographers in the studio. That is uniformity of lighting, particularly from front to back of the scene. The principal

Figure 8–23. *Rockport Harbor, Massachusetts, in two different lightings.*

Figure 8–24. *The same harbor in two more lightings.*

and secondary sources are so far from the subject in daylight that in the absence of clouds there is no change in intensity over the whole of the scene. This uniformity is very difficult to produce on a large set indoors and is only attempted by the largest studios.

Artificial lighting

The wide range of possible lightings in nature is the source book of ideas for lighting in the studio. Whether or not it is desired to simulate daylight the photographer need never be at a loss for conditions to try if he will only think of the different ways the subject could be found to be lighted outdoors. Perhaps with this in mind it might be worthwhile to consider just how he can produce similar effects and what they can do for him.

The amateur should note that nearly all the effects can be produced with the simplest sorts of equipment. It is a common complaint of the amateur that he is limited in what he can do by lack of equipment and space. This comes largely from a misunderstanding of the reason the large studios have so much equipment of such large size. The major differences between the amateur working at home and the professional with a large studio are the **size of the set** that can be handled and the **length of the exposure** that must be given. Within these restrictions the amateur with ingenuity can do anything that can be done by the professional. Perhaps an exception should be made for results obtained by electronic flash, but so many types of these are now available that they no longer need to be considered beyond the reach of the serious amateur.

Establishment of the Illumination

When an object or area is seen out-of-doors, there is never any doubt in the observer's mind about the nature of the lighting. He is in the environment and usually himself illuminated in the same way as what is before him. Under these conditions he sees the lighting as wholly separate from the objects and so can see object properties almost wholly independently from the illumination.

If a picture is made from such a scene, or if any picture is made in a studio, the observer has only the picture from which to see the illumination as separate. This is a major difference between a scene and a

Figure 8–25. *The same small vase illuminated by broad general lighting (above) and by two small light sources (below).*

photograph and is responsible as we have seen for many of the perceived differences between the two.

We have here, then, one of the most powerful tools at the disposal of the photographer to produce effects that he wants. If he wants realism, however, and wants the picture to look like the scene, he may have to go to extraordinary lengths to make the observer aware of the lighting. To the extent that he cannot do so he will have to use supplementary lighting to show the object properties.

There are two major effects of lighting by which the observer becomes aware of its existence. These are shadows (including shading) and reflections of the light sources (highlights) in shiny objects (Figure 8–25).

The size, position, and nature of the edge of both the shadows and the highlights, or "catch lights" as they are sometimes called, work together to define for the observer the position of the lights. To the extent that they are clearly visible and unambiguous the observer will be aware of the lighting and able to allow for it if he is interested in the objects. They are also important compositional elements in the picture.

Oddly enough one can almost say that to the extent that shadows and highlights are **not** seen as illumination they become **more** important for the composition. We are so accustomed to looking for object properties through shadows that we are hardly aware of them when we are fully conscious of the light source. We do become strongly aware of them in a picture when the lighting is ambiguous.

Full awareness of the illumination, then, can be produced by strongly directional light and well marked shadows and highlights. The photographer then encounters the phenomenon of lightness constancy. As we have seen, shadows ordinarily look darker, sometimes very much darker in a picture than they do to the photographer when he makes the exposure. Accordingly, for good realism it is necessary that he add light to the shadows until the expected loss is compensated (Figure 8–26). The amount of expected loss will depend on the kind of final photograph he is making. He will have to add a great deal if the final picture is to be a reflection print, much less for a projection transparency and hardly any for a color stereo.

This additional light can be provided in a number of different ways. The major problem is to get light into the shadows without spoiling the main lighting effect intended. One technique, used by studios on large sets is to use many lights high overhead to produce a more or less uniform diffuse down light such as would be produced by the sky. On a smaller scale this can be done by simply reflecting light from a large overhead diffuse reflector such as a ceiling or crumpled metallic foil. This works well for sets of moderate size but is quite inefficient, especially if the

Figure 8–26. *Successive pictures of same subject without flash fill light (above) and with the required flash (below) to make it look as it did to the photographer without the flash.*

Figure 8–27. *Fill light is necessary for any nonuniformly lighted subject if the picture is to appear as the subject did to the photographer.*

fill light has to be, say, half the intensity of the main source, as is often necessary for reflection prints (Figure 8–27).

Another perhaps more common method for shallow sets or close-up shots is to add light to the set from the position of the camera. This can be done by fairly large sources placed on either side of the camera (preferably both) by a flash bulb at the camera, by a ring of lights around the lens, etc. By placing the light near the camera any shadows produced tend to lie directly behind the objects and so do not interfere with the shadows from the main lighting. However, unless the light were to be actually projected through the camera lens, some of these shadows would still be visible, hence it is desirable to use large sources so that their edges will shade off gradually and they will not be noticed. In fact such shadows may become quite desirable in that they tend to produce a

dark edge next to any contour line and so accentuate the contrast at such an edge without looking like a shadow. Such large sources at the camera are conveniently white diffusing surfaces illuminated by lights directed toward them. In sunlight or wherever the principal illumination covers a sufficient area simple diffuse reflectors, so held that they reflect this source toward the object may be sufficient. The important point is that the shadows must be filled in unless darker shadows are actually wanted (Figure 8–28).

In addition to this shadow fill light it is often necessary to use supplementary lighting in other parts of the set. If the lighting is nonuniform over the set, the eye will tend to exaggerate this nonuniformity, but it will compensate for it partly on a **continuous** surface. Thus a nonuniformly lighted table top will be seen as such in a picture but will be considerably exaggerated. If this is not desirable, the lighting will have to be made more uniform, by additional lights if necessary. The insidious part of this effect is that it is not visible to the photographer unless he is a professional who has learned to see it. Lightness constancy is so powerful that a nonuniformly lighted table cloth or wall looks uniform unless the lighting is actually "spotty." Untrained workers may have to actually measure different parts with a meter to find the nonuniformity.

The extreme effect of nonuniformity occurs when there is present in the picture a **separate** plane not continuous with the main lighted areas. This will appear to the eye to have just as much light falling on it as does the rest of the set and yet it may photograph black. In general any such plane will require supplementary lighting and the amount will have to be measured to get it right. To the uninitiated it is unbelievable how little light can fall on a background and still have it look well lighted on the set. It is possible to learn to see such nonuniformities and any good professional has learned it. Nevertheless there are some aids that can be used. Looking at the set through a dark neutral glass will make nonuniformities more apparent, tipping the head to one side, looking at it in a small mirror or through a hole in a card all help. The final test, however, is measurement of a reflecting card held in various parts of the scene. Any lighting difference higher than 2 to 1 is likely to be seen in the pictures even though it is invisible in the set.

It might well be repeated here that this is a purely visual effect and cannot be fully corrected by subsequent manipulation of the photographic process. It can be decreased by decreasing photographic contrast (gamma) but only at the expense of object detail contrast and color saturation.

Figure 8-28. *Three degrees of fill light on same subject.*

In the case of large natural sets in which the photographer cannot change the lighting he may face a dilemma for which many ingenious solutions have been proposed. Only if the lighting is uniform does he have no problem.

The obvious solution of using a large flash at the camera works well for shallow sets or for situations in which all of the interest is in the foreground. If the set is very narrow, then the falling off in intensity of the flash from foreground to background can be minimized by use of a suitable reflector. At best, however, such lights do not carry very far if they cover an appreciable angle. Any falling off from front to back will be exaggerated just like any lighting nonuniformity. On isolated objects it will look like a change in surface reflectance of the objects.

One solution, and the one most often employed, is to hide flash lamps at various points through the set, arranged to fire in synchronism with the camera. If the normal illumination of the scene is to be shown also, however, and that is what we are assuming here, then it may be difficult to balance the intensity of these fill lights against the others. In this case it should be remembered that the film doesn't care whether it gets all of its exposure at once or not. An exposure appropriate to the existing illumination can be given and then another greater or less exposure be given for the flashes. If necessary it can be done in any number of steps to get the desired effect.

The ultimate in this approach is the so-called "painting with light" technique in which the normal lighting is first photographed at the required exposure, and then these lights are turned completely off. Next, while the camera lens is open, a person dressed in black walks through the set, illuminating the various areas as he goes with a light source held in his hand. This light must be shielded from the camera and he has to stand to one side of the illuminated objects as he goes. It is apparent that this technique requires some little skill and no mean amount of forethought, but by its use almost any conceivable kind of illumination can be produced on a set of any reasonable size. It requires only that no object moves over the time necessary. The interested reader will do well to read Charles Abel's **Commercial Lighting°** where many exceedingly ingenious solutions for problems of this sort actually encountered in commercial practice are described and illustrated.

The principle of long-time exposure and moving light sources is the one that frees the amateur most completely from limitations of equipment. At least for stationary sets he can imitate almost any kind of light source or sources with a single lamp It is necessary only that he hold it

°Charles Abel, *Commercial Photographic Lighting*, New York: Greenberg, 1948.

in the various places and move it over the area of the light sources he has in mind for the time that will imitate the intensities desired. In this way he can, in fact, with a little practice imitate nearly hemispherical diffuse lighting of a small set-up with a single light bulb!

This discussion has been based on the needs of a photographer who wants maximum realism of object characteristics. It should hardly be necessary to point out that this is simply a point of departure for a photograph. Complete anomaly or even conflict of lighting does no harm if it gives the effect the photographer wants. There is no **right** lighting except for a purpose.

Description of surfaces

Lighting from which the observer will see the illumination as separate from the objects is necessary if the relative lightnesses of the various surfaces are to seen correctly. If this were the only requirement, then completely diffuse, completely uniform lighting would seem to be the best. That this is not true is apparent immediately if one considers a glossy and a matte surfaced sphere placed side by side. Because the two would each be reflecting light in all directions, there would be nothing by which they could be distinguished. Although their true percentage reflectances might show, the **nature** of the reflection would not be visible.

A second characteristic of the objects that the lighting must show, accordingly, is the character of the surfaces of the various objects. Surfaces vary in **roughness** and in degree of **gloss**, aside from their general curvature or flatness, which are discussed under shape.

To show the roughness of a surface the main lighting must fall along the surface at a flat angle. Completely diffuse light will often wipe out any evidence of roughness not large enough to be considered shape. The requirement, therefore, is a quite directional lighting from a direction that will show the roughness of the most important surfaces to best advantage. This requirement is not at variance with the need for fill light for the shadows except in one respect. Because in all photographs there is a loss of realism, it is necessary that the lighting exaggerate any property of the objects to which attention is to be called. This can usually be done best by **not** using much of any fill light. Accordingly some compromise may be necessary or it may be decided that surface texture is more important than relative surface lightness or the brightness of shadows. Often such texture is the very basis for the picture in the first place. In extreme cases it may be necessary for this purpose to use a

single small source and to be at some pains to keep any other light from being reflected into the darker areas. With grazing incidence light and no fill it is possible to make textures clearly visible that are not seen at all in ordinary light.

Roughness of the surface of some materials is directional in character, that is the surface may be rough in one direction along the surface but quite smooth in some other direction. If the surface is also curved, this characteristic will be apparent in the picture from the shape of the highlights as we shall consider presently. If the surface is flat, however, and strongly directional, the photographer may have some difficulty showing its true nature. If shiny enough the reflections of other objects in its surface may be sufficient. If the striations are coarse enough, he may be able to light it at right angles and make them visible. If there are two objects which the observer will know are identical, it may be possible to show each lighted differently so that the observer carries each impression over the other. In the last analysis it will be found that there are some subjects which cannot be shown by still photography. These are the objects that we can understand only by picking them up and turning them around in our hands, watching the changes in the reflection of a light source in their surfaces. The nature of such objects can be shown in photography by the same technique, that is by turning it to various positions in front of a motion picture camera. If that is the only way it can be seen in the hand, it is the only way it can be shown by photography.

A similar situation holds with respect to the gloss possessed by the surface of an object. Occasionally what would normally be called the gloss of an object is seen to be different from different angles and similar considerations apply. Glossiness and roughness differ only in the size of the areas involved. A matte surface has a very fine roughness and a glossy surface has a fine smoothness. If the roughness is large enough to be seen clearly, the surface can be either glossy or matte.

The description of roughness of a surface, then, is a special case of description of shape and can be emphasized primarily by the use of lighting that is quite directional and falls along a surface.

The description of glossiness, on the other hand, depends more on the size, shape, and distance of the light source and on the extent to which the illumination is seen from the photograph. It depends also as we have seen earlier, on reflection in the surface, or lack of it, of nearby objects that are in position to produce mirror reflections.

With these variables the photographer can make the surface of any single glossy object pretty much anything he desires (Figure 8–29). If the light source is effectively large and shades off gradually at the

Figure 8–29. *Two pictures showing change of apparent surface texture by change in lighting.*

301

Figure 8–30. In the lower picture the central object at the rear is seen as matte surfaced because it would have appeared shiny otherwise in this lighting. See object in same position above.

edges and no mirror reflections of other objects are permitted, the surface will appear semi-matte or "satiny." With the same light source but with other sharp edge sources or good mirror reflections it will often appear like a burnished surface, etc. The exact appearance, as always, is a compromise and cannot be predicted without knowing all the factors. In general, the larger the light source and the fewer the reflections the more matte the surface will look. At the extreme of complete hemispherical diffuse illumination the glossy surface will appear completely matte.

A matte surface, on the other hand, remains so in all lightings but to emphasize this characteristic it is necessary to show by the sharp shadow or the presence of glossy objects that it would have appeared glossy if it were. That is, the perception of a matte surface is based on the lack of reflections and not on any directly perceivable property (Figure 8–30).

It will be appreciated that, as it is necessary in general to exaggerate surface properties to have them seen properly, it is quite possible to put together a collection of objects whose surface properties can all be shown only with great difficulty. In fact it is not very difficult to put together objects whose characteristics cannot all be shown in the same picture if shape is also considered. It is in the handling of such arrangements that the skill of the professional photographer shows clearly.

Establishment of shapes

The problem of so lighting objects that their shapes will show clearly has been touched on a number of times earlier. It is, in fact, essentially the same problem as showing the roughness of surfaces but on a larger scale. Two major problems have to be solved, as far as lighting is concerned. One is to show clearly any curvature that any surfaces may have and the second is to so light the whole that all parts visible may be seen clearly. There is, in addition, the requirement that the depth of the scene and hence the object will be seen clearly, but for this lighting is only one element and we shall consider it separately.

To show the curvature of surfaces it is usually necessary that a light be so placed that a somewhat crescent-shaped edge is seen on the il-luminated surface as the light passes into shadow. In keeping with the usual fact that all nonuniformities of lighting are exaggerated in photo-graphs, it is desirable that this shading from light into shadow be more gradual than would be the case from a single small light. For this reason it is often desirable to use a rather large light source (usually produced by diffusers in front of a bank of lights) rather longer in the vertical than in the horizontal position. The width of this light source, if used close to the object, permits the light to shine around the curve, thus giving a more gradual shading off. The added height increases the range of sur-faces it can handle and also gives more light for the same width. Such lights are often called modeling lights and are used, among other things, for close-up portrait work.

A modeling light like that described will, of course, tend to give en-larged source reflections in high gloss surfaces. If a high gloss curved surface is an important element of the object, it may not be possible to use it for this reason. If necessary, however, as in a case where there is also, say, a spherical matte surface to be shown, it is possible to put cross bars in front of such a light so that its reflection in the glossy surface looks like that of a window. Ingenuity is the keynote of good

color photography, and ways can be found to solve nearly any problem. It is necessary only that the photographer either understands what he is doing or has developed the ability to see the scene as the final result will appear.

The second requirement, that enough light be provided so that all the elements of the shape are clearly visible, is essentially the same as that for fill light in establishing the illumination. There must be enough contrast to give clear shape but not so much that shadow details are obscured. In some cases it may actually be necessary to use two crossed lights so that there are shadows thrown by the second light by parts of the object that are wholly within the shadow of the first. The second light should be of lower intensity than the first so that the first shadow is still visible, and in general a fill light will still be necessary although of lower intensity. In extreme cases, even these measures may have to be discarded in favor of simply experimenting with various objects until the best compromise is found. There are many objects that cannot be described by a single stationary view, whatever the lighting. Motion pictures, a series of different views, or the photographer's concept of the best compromise are then the only possibilities.

Even with a single quite simple object, it is apparent that in choosing the direction and contrast of his lighting and in the size of the sources, the photographer is deciding what is important and what is not. The result of his lighting expresses an opinion that the act of making the picture has forced him to give about the object. It is well for the photographer to realize this and to make his fairly obvious opinion one that he wants people to see.

Depth and lighting

In all lighting the perceived depth from front to back in a scene will depend heavily on the contrast of the lighting. Lighting is not by far the only factor that affects seen depth, but in a scene of fixed geometry it is the major factor. Fortunately it depends on the photographic contrast also. That is, regardless of the lighting an increase or decrease of photographic contrast (gamma) will increase or decrease the seen depth accordingly (Figure 8–31). Lighting is such an important factor, however, that scenes lighted either by completely diffuse or completely front light are called "flat" lighted scenes (Figures 8–32 and 8–33).

Since perceived depth is important for correct appearance of shape, it is necessary that all factors, including the lighting be satisfactory. It

Figure 8–31. *A change in photographic contrast (gamma) alone will change the depth perceived in a picture.*

Figure 8–32. *Apparent depth can be changed easily by the position of the light source.*

Figure 8–33. *The nature of the light source, whether "flat" or "contrasty" can have a great effect on perceived depth.*

is fortunate, however, that this requirement is not in conflict with those discussed earlier. Depth is affected primarily by the over-all lighting contrast, modeling by the size and positions of the light sources, and surface reflectances (lightnesses), by the perception of illumination, which depends on proper shadows and properly balanced fill lighting.

Lighting and sharpness

There is one factor that does run counter to some of these requirements and which in some cases the photographer should keep in mind. If maximum **sharpness** is wanted in the picture, a considerable amount can be added by the use of a **small** source for the main light. In fact it is difficult to obtain the impression of sharpness from incandescent lights and reflectors that can be obtained by use of a focused arc light. This is particularly important for motion pictures but may sometimes become important for still photography as well. The effect is due to the sharpness of shadow edges. The sharp edges increase the apparent but not the actual contrast.

Lenses

The subject of lenses has been treated rather extensively earlier and there are a number of good books on the subject. (See Bibliography— Optics and General.) Perhaps what needs to be said at this point is that the differences between most modern lenses from reputable manufacturers are not large in terms of the effects we have been discussing. Neither is the lens design as such an important variable by which the photographer can modify his results. Lenses differ in that some are less sharp than others and some makes are designed to be soft in their results. An expensive lens advertised for its sharpness will give all the detail required for any but the most exacting work. This is particularly true if the lens has coated surfaces to minimize lens flare due to surface reflections. In fact the advent of the coated lens has eliminated the major differences that previously existed between lenses of different designs. To the user the most noticeable difference was this lens flare and coating greatly decreases this difference.

In what follows, therefore, we discuss only the two major variables that lenses place at the disposal of the photographer, depth of focus and perspective. For the photographer who wants to experiment with distorted lens images the discussion presented earlier should suggest appropriate directions. These include the use of "soft focus" attachments or "diffusers," which can vary all the way from a finger print on the lens to the most expensive device for upsetting the corrections that have been introduced into the lens at such cost. The successful use of diffusers is either an art or a fad and can follow no laws other than those of common sense. Sharp pictures are not always the best by any means, but the correct loss of sharpness is a matter for individual discretion based on the subject and the intention (Figure 8–34).

Depth of field

One of the most powerful tools available to the photographer is the variable depth of field that can be produced by changing the aperture of his lens. Yet, because few photographers use cameras in which the lens image is visible, it is little used or appreciated. It has become even more important with the advent of color photography and we shall consider it again. At the moment we want to consider it in terms of emphasis in the subject.

Emphasis of one subject out of a group or of one part of a subject over others is one of the photographer's most important tools for the expres-

Figure 8–34. *The same scene without and with a diffusion disk. Note loss of apparent contrast due to loss of fine detail.*

sion of his ideas. Although much can be done by lighting to bring forward one object over the others, the darkness that is necessary for the subordinate subjects does not always lead to the type of thought the photographer wants expressed. By variable depth of field, however, accompanied by careful arrangement of subject or of camera position it is possible to have the main object stand out in a manner impossible by lighting—and without sacrifice of the brightness of the rest of the picture (Figure 8–35).

Although tables and charts of depth of field are abundantly available and indicated on the mountings of many shutters, it may be worthwhile to consider briefly just what is involved in such results. Before doing so we might notice one of the few rules that exist for photographic composition. It may be stated as follows. **No part of a picture may be out of focus if it raises in the observer the desire to see more detail in the out-of-focus objects.** We are accustomed to using our eyes to see objects and when we want to see and cannot the frustration is an unpleasant experience. Granted there may be exceptions where this is the result the photographer desires, but he should realize what he is doing. Also, this rule does not mean that important objects may not be out of focus. For example, if an object is in clear focus and well defined in the foreground, another identical object may repeat out of focus in the background if it is sufficiently obvious that they are identical. On the whole, however, it is better that the out-of-focus objects be so far out that they are hardly if at all recognizable and enter the picture as areas of brightness or color that ·play their parts in the composition as areas and not objects.

This requirement means that we not only have to consider the depth of focus for acceptable sharpness but also the distance from the back focus point to loss of recognizable detail of various sizes. In practice, of course, one does not look it up in a table but experiments with the subject by looking at the image as he works, either on a ground glass or in a reflex finder.

Just as important as this sharpness separation between foreground and background objects is the nature of the out-of-focus images themselves. We have noted that the basic fact is loss of detail in the out-of-focus objects, but there is also a greater or less fusion of the light from adjacent objects into a continuously varying pattern of light and shade and of different colors. Any single bright area will become greatly enlarged and tend toward a circular shape for the ordinary lens. In fact a single small spot very much out of focus can throw an image of the diaphragm onto the film. As such this effect may be undesirable, but some modification of the appearance of the out-of-focus parts can be produced by

Figure 8–35. *Two subjects, each photographed with maximum depth of field (right) and with the depth restricted to the desired objects (left).*

Figure 8–36. Left, a normal lens diaphragm showing circular patterns from out of focus point sources in the subject. Right, the same scene with a star aperture held in front of the lens.

modifications of the aperture shape. This can be done by mounting small apertures in front of the lens when the picture is made (Figures 8–36 and 8–37).

In addition to the change in nature of the out-of-focus images, and equally important for the effect produced, is the change in contrast of the out-of-focus background. Even for objects slightly out of focus, a contrast difference is introduced due to the loss of sharpness. It is this effect as much as the loss of recognizable detail that makes the foreground object "stand out" from the picture. Its higher contrast produces more depth perception in the foreground than in the background. In the extreme the background becomes a flat colored surface behind the object. The same effect is produced if the background itself is changed in the same manner (Figure 8–38).

Needless to say, this sort of effect is one that the photographer must build up for himself on the ground glass of his camera. It would be quite futile to attempt to predict the result from the appearance of the subject itself. It is this very fact, however, that greatly out-of-focus images cease entirely to represent objects, that makes these effects so useful as picture compositional elements. It makes control of background color composition a rather straightforward matter.

Figure 8–37. *Above, a normal lens diaphragm with out-of-focus background. Below, the same subjects with slits over diaphragm produced by holding the fingers across the front of the lens. Note horizontal feeling of background.*

313

Figure 8–38. *The same effect as an out-of-focus background is produced if the background is changed to one that does not contain detail.*

Focal length and perspective

The photographer is usually working with objects that lie in depth and trying to produce from this volume of space a two-dimensional picture with the properties he wants. In this problem he is faced by the fact that the focal length of his lens relative to the size of his film is one of his most important variables because it determines the size of the principal objects relative to the picture as a whole. The possibility of enlarging part of the picture effectively makes the size of the film he is using variable also, and only a clear understanding of the principles involved permits him to use these variables intelligently.

The first principle involved should be memorized by all photographers. **The geometry of the image aside from sharpness is wholly, completely, and finally determined by the position of the camera.** The picture can be made on any size film by a lens of any focal length. It can be subsequently enlarged, reduced, squeezed, stretched, diffused or anything else. Except by the use of distortion that is different for different parts of the picture, the relationship of the objects in the picture to each other cannot be changed once camera position has been fixed. From this point on for optically undistorted pictures the only variables are **magnification** and **included angle of view.** These two variables affect very strongly what the observer will see when he looks at the picture, that is, the perception that the geometry of the picture will produce, but do not affect that geometry.

The selection of the proper focal length lens for a picture, then, is a matter of practical expediency and is determined by the nature of the equipment with which he is working.

Without going into why the angle of view and magnification are important, let us assume that they are and see how the photographer can meet the requirements.

Because magnification often can be varied at later stages but maximum angle of view then can only be decreased, it is apparent that the first requirement is that the photographer include a sufficient angle in his original exposure. This included angle, of course, is determined by the relationship of the film size to the focal length. With constant film size, included angle increases with decreasing focal length. With constant focal length, included angle increases with increasing film size. As under ordinary conditions neither of these variables are continuous, it is apparent that the photographer who must make a camera image that can be used without cropping must use camera position (distance from subject) in addition, to get just the included objects that he wants. That is, unless he happens to have a continuously variable focal length lens such as

is available for motion picture work, he must select the nearest angle of view to what he needs and do the best he can with it. For the photographer who works with a single size film and single focal length lens, of course, there is no way of changing the included angle of view. His camera is suitable only for subjects for which this angle is appropriate.

The photographer who cannnot vary subsequent magnification, of course, is left with the size of his camera as the principal variable. If he needs a larger picture for a given angle of view from a given position, he can only use a larger camera.

Incidentally, it is perhaps clearer from the preceding discussion than from any other way of looking at the subject why it is that professional photographers frequently complain about the amount of equipment that they need. Changing the film size, the focal length and the camera position do not produce wholly interchangeable results, and the critical professional must use all these over quite wide ranges.

Although the matter of magnification will be considered presently under presentation of the picture, it might be worthwhile here for a moment to consider the interrelation of included angle of view and position (distance) of camera to what the observer will see from the final picture.

Suppose we have a series of similar objects arranged in depth, perhaps a group of trees in either formal or random arrangement but with the more distant ones clearly visible. Suppose also that the ground in front of the group is clear and level so that the photographer has a wide choice of camera locations. Once he has chosen the direction along which he wants to show them he then has three variables left as far as the geometrical (as opposed to photographic) nature of his picture is concerned. He can vary the distance from camera to nearest tree, the focal length of his lens, and the effective size of his film. (We are assuming that he wants all the trees in sharp focus.)

This distance of the camera from the nearest tree will determine completely the arrangement of the trees with respect to each other. That is, the **perspective** of the picture will be determined by the distance of the camera and nothing else. From any one position the included angle of view, that is the number of trees included and the relation of their heights to the height of the picture, will be determined by the relationship between the focal length of the lens and the size of the film. The actual size of the picture, of course, will depend on the area of film used.

The effect of these variables on the observer will vary with his distance from the picture, but for present purposes let us assume that we are dealing with an illustration in a book or magazine and so can assume

viewing distance as constant. The general effects of the variables, though heavily affected by many others such as arrangement and lighting etc., can then be stated as follows. If each of the other two variables is fixed, then:

1. The **greater** the distance to the first tree, the **less** the depth will appear to the trees behind it.

2. The **greater** the included angle the **greater** the depth.

3. The **larger** the picture the **less** the depth.

According to the theory of perspective, the **correct** depth, as it would have been seen from the position of the camera looking at the subject with one eye and with the head stationary, is shown when the assumed viewing distance of the final picture is equal to the distance of the film from the lens in the camera (assuming a simple lens and no subsequent magnification). The depth which is actually seen, however, depends on so many factors, as we have noted, that this theoretical condition is of almost purely academic interest. Even the above generalizations, which are based only in part on the theory, are valid only for a single subject, and, depending on the subject, may actually pass through maxima or even reverse their direction. They are, however, sufficiently general in application to act as satisfactory guides to the photographer as to what to look for on his ground glass. They also help in suggesting ways around difficulties. Thus if he must make his picture from too great a distance for good perspective, a larger included angle (shorter focal length) and a smaller picture will increase the apparent depth. If he must be too close so that depth is exaggerated, the longest focal length and the largest picture may be the best he can do. If he cannot change position, included angle or size of picture, however, as often happens in commercial work, then he must resort to nongeometrical variables such as lighting, photographic contrast, surface texture and the like. It should be repeated, however, that almost none of these variables are really interchangeable. One can be offset against another, but in the final analysis it is the artistic balance of all of them that determines the success or failure of a picture.

Method of exposure

We have considered some of the factors that the photographer can use to solve the problem of getting the effect he wants. Thus far they have been quite general in nature and applicable to nearly any method of

making his pictures. The photographer, however, has available to him a great many ways of making pictures—what are often known as the "kinds of photography." Thus he can make still pictures in black and white or color, stereoscopic pictures in either, and motion pictures in any combination of these. He can keep his camera still or move it during the single or multiple exposures. He can also arrange to have his film at any angle to either the optical axis of the lens or the line of sight through the center of the film and the lens.

All the principles involved in such choices have been considered earlier but it is worthwhile to consider them again from the standpoint of the photographer making his decision and of the effects in relation to each other.

"Kind of photography"

There is, perhaps, not much to say about the photographer's choice of color over black and white, stereo over single lens, or still over motion pictures. For the most part such choice will be decided either by the circumstances, or by the reason he is making the picture, or both. It may, however, be of some interest to compare the methods in respect to certain kinds of photographic problems. For some kinds of problem, at least, the methods are not as sharply different as often supposed.

Consider, for example, the problem of making the observer aware of true depth from front to back in a given scene. It is often assumed that stereo photography is the medium par excellence for this problem, as it often is. It is not always the best medium, however. For distances up to 15 or so feet from the camera, depth, as a fact, can be demonstrated stereoscopically with great ease, but the depth so shown may be rather badly distorted, usually in the direction of exaggeration. As we have seen earlier, such depths can also be shown rather easily by single lens photography if lighting and lenses are properly used, and especially if the "monocular clues" to depth are present and properly handled. These monocular clues are just as powerful in many cases in making us see depth as the single clue of "binocular disparity" that is given by stereoscopic photography. The most important difference between stereo and still photographs at the present time comes in the way in which they are customarily viewed and not in the fact that one is a single and the other a double lens picture. Two identical pictures viewed in the same manner, or a single slide viewed similarly with both eyes, gives nearly as convincing an effect.

The real problem in making people see depth in pictures is that of producing maximum realism in the pictures. The increase in realism obtained by going from black and white to color photography is often as great and sometimes greater than that in going from single lens to stereo. In like manner there is often as great a gain in going from reflection prints to pictures projected in a dark room or slides seen in a viewer. Realism and hence depth is gained to the extent that the picture disappears as such.

This does not mean, of course, that there are not subjects that are far better in stereo than in single lens pictures. Just as a subject which had the same brightness in all of its parts would disappear in black and white but show up correctly in color, so it is possible to have a subject that is almost or quite uninterpretable from a single lens image that is reproduced satisfactorily by stereo photography. In like manner there are distant subjects that are uninterpretable in stereo color still pictures which can be shown by single lens motion pictures with a moving camera. But these are the extreme cases and not the rule. The basic principle is that there must be sufficient realism for the problem at hand. The maximum realism at present available in photography is wide screen, stereo, color motion pictures made with a moving camera. For the great majority of purposes single lens still pictures in color are ample, as is black and white if properly viewed.

What has been said with respect to depth holds true for many other photographic problems also. Suppose the problem is to portray a three-dimensional work of art such as a vase, a complex medal, a piece of sculpture or the like. For any one view of the object its apparent properties will depend on how the lighting, camera position and so on have been handled. All of the properties of the object, however, will not be visible from a single position. The photographer then must have recourse to multiple views of the object. In using multiple views he is faced with the necessity of making the observer see the continuity of these views since otherwise it may be hard to see them in any way except as separate objects. Such continuity, of course, can most easily be obtained by making a motion picture in which either the object revolves or the camera moves around the object. However, although this simple solution may succeed admirably in giving the observer a correct first impression of the object, it does not, because of the necessary manner of its presentation, allow the observer to study the object as he almost certainly would want to do in the case of an art object. From this point of view a successful series of still reflection prints would be the most desirable. The object, however, let's say the medal, may be encrusted with precious stones or

unusual enamels. To show the properties, say of an opal, it will be necessary for him to use either stereo color photography or a series of pictures very closely spaced because the colors appear in depth in the stone and change rapidly with direction of viewing, position of the light etc. Furthermore, some properties of surfaces as well as of gem stones, such as that of luster, are the result of appearing different to each eye simultaneously. For them stereo photography in a series must be used, but this still permits study. There are some properties of many such medals, however, that can be shown only by motion pictures. One such property is the "sparkle" of a diamond. Sparkle is due to the fact that slight movements of the stone or observer change greatly the amount of light that it reflects toward the eye. This variation takes place in time and hence can be shown only by motion pictures. If the sparkle is necessary to describe the piece, it may be necessary either to give up the possibility of studying the pictures or to use both a series and the motion picture. We have probably reached absurdity at this point but it is well for the photographer to realize what compromises are produced by the medium that he either must or wants to use.

A problem similar to that of depth in space and three-dimensional object characteristics is that of motion in the subject when this motion is part of what should be shown. Here the problem is whether it is necessary to actually show this motion or whether it is sufficient to suggest it. If it is necessary to show it, there is of course no other method than motion pictures. Even here, however, there are many cases where simply pointing a motion picture camera at the object and following its motion is not sufficient. It is necessary that the pictures establish the space in which the object is moving as well as the object itself in order to produce the desired effect.

Take, for example, a racing car driving around a race track. If the camera is pointed accurately at some point on the car and accurately follows it in a picture nearly filled by the car, the motion is suggested but not seen directly. It is necessary to cut in establishing long shots and the like until the observer sees the space as well as the moving car. A still camera can also suggest the motion of the car alone by following the car with a relatively long exposure, letting the background blur into horizontal streaks. Establishing long shots in this case explain the close-up but do not give the observer the same sense of motion.

In the case of a relatively stationary object of which parts are moving, there has been much controversy over the years as to how such motion can best be described by still photography. Painters like Faure (dog wagging his tail) and photographers such as Mili (girl jumping rope)

have tried to show it by multiple images in the various positions. Still others have tried to suggest it by letting the moving part blur. In this latter case, however, because this is the natural result of a too long exposure, there is always the suspicion on the part of the observer that this is what the photographer got, and then persuaded himself that people would see it as motion. On the other hand the sculptors as well as the painters have found another solution to the problem. In effect they have said, quite correctly, that the portrayal of motion itself is quite outside their medium. What they can and do portray with great success is **potential movement.** This solution is just as available to the photographer. It involves taking the picture just as the motion is at the starting point rather than later, but of course it does not work for machinery and the like. It is really successful only in the motion of animate beings. When successfully handled, however, it may be the maximum true movement that can be suggested by a still picture.

Film and lens angle

We have considered a number of factors that the photographer may use but so far have assumed the usual arrangement of lens axis and film perpendicular to each other and the lens axis centered on the film. A number of quite useful effects can be produced by changing this relationship, but they are rather severely limited by the size of the corrected field of the lens and the maximum depth of focus of that field. The so-called "view" cameras are designed to take advantage of these effects. In such cameras the film, within a certain range, can assume any angle with respect to the camera bed, and the lens cannot only do the same but can also be raised and lowered and sometimes also moved sideways. It is apparent from a little thought that many of the possible combinations are the equivalent of each other and that some of them can be produced by simply tipping or rotating the camera. Perhaps the easiest way to consider the matter is in terms of the effects produced, especially as the simple optical effects have been considered earlier.

The multiplicity of positions of the view camera elements makes it possible to do just three things. If these three are understood, it is apparent in any given case how the camera should be set. These three are as follows.

(a) It permits distortion of the geometrical perspective given by the lens. This distortion moves the **apparent** observer point to a different

position than that occupied by the camera, but in so doing modifies the relative dimensions of the objects.

(b) It permits the depth of field given by the lens to be used **perpendicular to any plane** in the subject. Again it does this at the expense of the relative dimensions of objects.

(c) It permits the use at all times of that part of the lens image desired, whether it be the axial part for best definition, or some other part. To the extent that the field is large enough it permits the plane of best focus to coincide with the film plane.

It is apparent from (a) and (b) and to some extent from (c) that manipulation of the relative positions of lens and film is not a subject about which hard and fast rules may be stated. Certain basic principles may be stated, but the success or failure of the result will be determined by whether more has been gained than lost by the change from the usually accepted relationship. Perhaps the situation can be described best by considering actual cases. We can consider the effects under the same headings (a), (b), (c).

(a) Let us assume that it is necessary that a picture be taken with the camera pointed downward at a rather steep angle, and that the subject contains lines that are obviously parallel to each other. We saw earlier that these lines will converge in the picture and that such convergence is not acceptable to many people. The result is shown in Figure 8–39. By tilting the plane of the film so that it is parallel to these lines the convergence is eliminated.

In correcting this convergence the apparent position of the camera has now been moved downward toward the center of the objects and yet the geometry of the objects shows that the camera is still above, so that there is some ambiguity about the position. This ambiguity, however, is not as serious as the very real distortion that has taken place in the shapes of the objects.

Actual measurement of the height and width of the spherical balloon and balls will show more than 15 per cent exaggeration of the vertical dimension. That it does not ordinarily appear this great is due both to the "shape constancy" of the obviously spherical objects and to our long familiarity with the slight distortions of all perspective pictures.

Incidentally it is of real interest to note that it is shape constancy again that makes us object to the distortion we see in the uncorrected picture. We know that the lines of the rack should be parallel, and we have not been made conscious of the convergence up and down by customary photographs, so we see the distorted image and not the depth it indi-

Figure 8–39. *Left, subject photographed with camera tipped down and no correction for convergence. Right, same camera position with convergence corrected.*

cates. This also arises in part from our assumption of camera position as we shall see later. We tend to assume that the camera line of sight is the same as ours when looking at the picture. When this is not correct, we tend to see a distorted picture.

This type of conflict arises, however, only when we think we know the "true" nature of the objects. As noted earlier, the face of an unknown person, or of a tree etc. which can have any proportions within limits can be distorted within these limits without producing the appearance of a distorted picture. Advantage may be taken of this fact either to change the proportion of objects deliberately or to offset distortions due to other effects such as those resulting from the shape of the picture itself.

(b) The effects under **(a)** are produced by changing the angle of the film in relation to the line of sight of the camera when the picture is made and the axis of the lens passes through the center of the film. Changing this angle, however, also changes other factors in a way which is occasionally useful. We noted that the image formed by a lens is three-dimensional and that the position of the film plane selects out of that image whatever falls on its surface. For each point in the image space so

selected by the film there corresponds a point in object space. The sum of all these points determines a surface in object space that is continuous but not, in general, a plane. Because no image is formed at a point closer to the lens than its focal length by an object at any distance, all points of the film must be at least this far from the lens. Points at this distance will focus all objects from infinity down to 50 or 100 feet or closer. Film points farther from the lens will focus closer objects the farther they are from the lens, but at twice the focal length film points will focus objects at twice the focal length from the lens.

A little thought will show that if the **lower** part of the film plane is held in position at the focal length distance and the **upper** part is tipped back **away** from the lens, objects **below** the axis of the lens will be in focus nearer the camera and those **above** the axis will be in focus **further away**. The nearer objects will also be rendered **larger** in proportion to the distant ones than they would be by untipped film, and their vertical dimensions will be exaggerated compared to their horizontal. For subjects for which these distortions are not objectionable this tipping of the film plane, then, gives us a technique for changing the position of the surface of best focus in the subject. Since the photographer is often limited by the maximum depth of field that he can produce with his lens, especially when working with objects relatively near the lens as in a studio, it is often convenient to be able to place this surface through the subject at the most useful points. On subjects for which it can be used it also allows him to use a larger aperture on his lens and hence less light or less time of exposure.

In considering these facts and determining the exact shape of the surface of best focus through the subject space for any given film position, it is necessary to remember one fact about lenses. Modern lenses are designed so that they have what is known as a "flat field." That is, the image of a plane in the subject space at right angles to the lens axis is a plane in image space also at right angles to the lens axis. The fact that the corners of the film are farther from the lens than the center has been taken care of in the design of the lens. Strictly speaking, therefore, it is the distance from the film to the **plane** of the lens that must be considered and not to the lens itself. For some conditions this makes a large difference in the position of best focus. Also, although the subject is almost academic for telephoto lenses, here it is the effective position of the lens, not its real position, that matters. In some they may be very different.

(c) These considerations bring us to the question of what can be gained by tilting the lens or moving it up or down or sideways. Since

lenses are corrected to have flat fields, it is apparent that tilting the lens will tilt all the focal planes of the subject. That is, for any position along the lens axis a plane in the image field perpendicular to the axis will correspond to a plane perpendicular to the axis in the object field. But unless the film is perpendicular to the axis also, we have the same situation considered under (b) namely, the film at an angle with respect to the lens axis. If the film is perpendicular to the axis and this axis passes through the center of the film, we then have simply tipped the camera. We come out then that except for one possibility to be considered presently the only motion of the lens that is not the same as tipping the film is one in which the lens axis is moved **away** from the center of the film. The other motions are the equivalent of tipping the film or the camera or both.

Moving the lens axis away from the center of the film is the same as moving the film into an outer area of the lens image without tipping it. Such a movement cannot take the film outside the area for which the lens image is corrected without introducing distortion, and hence this movement is really useful only for the so-called wide angle lenses, which are corrected for flat fields over a wider angle than most ordinary lenses.

The usefulness of such a movement can be illustrated by an example. Under (b) we discussed tipping the plane of the film to tip the surface of best focus and so make optimum use of the depth of focus of the lens. Under (a) we discussed the correction of parallel lines by tipping the film so that its plane was parallel to the plane of the lines. These two directions of tilt are **opposite** to each other. Suppose we want to take a view looking up at a building. We do not want convergence of parallel vertical lines. Accordingly we tip the film until it is vertical. Vertical parallels are now parallel on the film. Our surface of best focus now, however, has tipped the other way and intersects the plane of the building front at a sharp angle. We can now do one of two things. First we can stop down the lens. If this gives us enough depth of field for the whole building, we can proceed. We can also tip the lens in such a direction that its axis approaches being perpendicular to both building and film. When it is perpendicular the plane of best focus again coincides with the film plane if the film is still within the corrected area of the image. Any movement in this direction, however, helps so that a compromise is usually possible. Incidentally, keeping the film vertical and the lens axis perpendicular is the equivalent of setting the camera horizontal and just raising the lens without tipping, so the way in which it is actually done is just a matter of convenience and range of adjustment of the camera.

Choice of sensitive material

Although many of the concepts considered in this book apply to photography in black and white as well as to color, in this section we shall consider color photographic materials only. In addition, because the materials on the market are changing rapidly at this time and doubtless will for some time in the future, it seems reasonable to consider primarily the properties for which one should look for any particular application.

Color materials, like those for black and white, fall into two broad categories. These two are the **reversal products** and **negative-positive products**. No products exist on the market today that, for other than very highly specialized uses, can be used both ways, so these are exclusive categories and any material purchased is intended for one or the other use only.

In the **reversal products** the film used in the camera is the one in which the final "positive" image is formed and for many purposes is the first and final picture made. Although theoretically the material can be a paper base material for viewing by reflected light, this is little used because unless a camera image is reversed right to left in making the picture, it must be viewed through the back of the material. Viewed from the front all lettering and the like is reversed in the ordinary camera image. Some copying cameras have what is known as a reversing prism in front of the lens and in these cameras paper reversal material may be exposed directly. Because of this fact, most reversal material is transparent film intended to be viewed by projection or over an illuminator, or copied by a reflection print process. As 8 and 16mm motion pictures, as 35mm and other size transparencies, and as sheet film, these were the first color products successful commercially and still represent a great part of the entire material used today.

For projection purposes or viewing over an illuminator the properties that the film should possess are fairly obvious. The purpose of almost all photography of this sort is to make a picture that will produce in the observer the effect wanted by the photographer—in most cases the most realistic portrayal of the scene that he can make. For this, first, the **definition** must be adquate to record as fine detail as the photographer wants to show. Materials differ considerably in this respect, and the tendency is toward poorer definition in the faster films. However, we should note that the sharpest of the materials is as good or better than the sharpness of the image given by most lenses so that for materials used and processed as directed this factor should be of importance only for the most critical work. Although sharpness differences between ma-

terials can be seen when pictures are made with any good lens, the difference is not important for what might be called ordinary purposes. If the image is to be copied at rather high magnification, however, as in some reflection print work, then this factor may be the deciding one in what material to use. A number of the materials that are entirely satisfactory for the use directly intended by the manufacturer show considerable loss of definition if used for reflection print enlargements of four times (the dimensions) or larger. The best may go as high as thirty or more times if exposed to a really sharp image, depending, of course, on the distance from which it is to be seen.

Similarly, if a picture is to be projected at great magnification and viewed from a relatively short distance, differences in definition will show up. This is true of 8mm pictures in which the best obtainable lens and material is still marginal for critical definition.

The second requirement which the film must meet for satisfactory realism is that the pictures must not be too **grainy** for the purpose at hand. Here again graininess tends to run with speed of the material and most, although not all faster materials, are more grainy than the slower ones. Graininess again, like definition, is not ordinarily objectionable when the material is used for the purpose for which it was designed. This is not always true, either, because some materials are made to meet the demand of the photographer who would rather have film speed than the best image. This is not always foolish on his part; often he must have the speed and take the graininess to have any picture at all. Graininess is important for enlargements of all kinds, both motion pictures and still reflection prints. People differ very widely, however, in the amount of graininess they will tolerate. In motion pictures it is seen as a moving scintillation of areas of uniform density. Some people never see it at all, and in scenes where the action is gripping and exciting it is safe to say no one does. In reflection prints it is seen as a more or less fine, often sharp, mottle in uniform areas. Except for the relatively poor definition of many enlarging lenses, it would set a pretty definite limit to enlargements from any picture. For the finer grain materials this limit is usually set by other factors. For stereoscopic pictures graininess has a rather unusual and somewhat difficult to understand appearance in that it usually appears as a grainy mesh screen through which the objects in depth are seen. To many people this effect is very annoying but others seem indifferent to it. For those who are critical in this respect the finest grain materials available are just satisfactory at ordinary viewing magnifications. In spite of some statements in the literature all color processes at present available or known do have graininess, although for

the same size grain the visual contrast is lower than in black and white materials.

A third requirement that may decide the choice of film and process is the so-called "scale" of the material. All color materials have a minimum density below which nothing can be recorded, and a maximum density above which no detail is produced. Between these two extremes there is a continuous but not usually uniform grading of densities corresponding to the range in the subject when the picture is made. In reversal materials particularly, this scale tends to crowd the visual steps together as they approach either the maximum or the minimum density end. This crowding tends to be more extreme in reversal processes than in negative-positive ones and so may decide the kind of color product chosen for a particular job.

Aside from this crowding, which is usually referred to as part of the "curve shape" of the reproduction, there are three other ways in which reversal products may differ from each other in respect to scale. They are quite apparent but not often understood.

1. They can differ in the rate at which they pass from minimum to maximum for the same subject. This is often called photographic contrast, or just contrast or "gamma."

2. They can vary in the difference between maximum and minimum density. This usually depends almost wholly on the maximum density since they differ little in minimum.

3. The combination of the maximum and minimum densities and nothing else except curve shape (which does not vary widely) determines the length of the scale of the material. This concept is often misunderstood. It can be described by saying that the length of scale will determine the number of steps that can be seen on the material if successive areas of the film are given, say, double the exposure of each previous step and the film is then examined by an adequately bright light. Perhaps a simple analogy is easier. Think of a person walking up a hill. Suppose he does not change the length of his step along the ground. The number of steps he must take to reach the top of the hill will depend on both the steepness of the slope (gamma) and the height of the hill (maximum density). If it is a low hill, he will take more steps to reach the top if the ascent is gradual than he will if it is steep. If it is a very high hill he will have to take more steps for both slopes but again will take more for a gradual slope than for a steep one. In just the same way a photographic material with a high maximum density and low photographic contrast will record more exposure steps than will one with a low maximum density and a steep slope.

In the negative-positive processes the same variables exist but to a different degree. A color print made from a color negative is, in one sense, a "copy" of the original negative. That is the finished print is the second color step and not the first, as in reversal products. For this reason, as noted when discussing the copying of color originals, there is a tendency to lose color quality. Most negative materials, for this reason, now contain "masks" to offset this loss.

There is, however, an important difference as far as the brightness scale is concerned between copying a color positive by a reversal film and printing a negative to make a positive. We noted in the former case that shadow and highlight details tend to be crowded in such pictures and that this is exaggerated by copying. In negative-positive processes the copying (printing) process tends to offset this crowding rather than making it worse. It is largely for this reason that when it is desired to have more than one copy of a picture the negative-positive processes are or will be superior.

Graininess and definition in negative-positive materials can be considered as having the same effects as in reversal, bearing in mind that the finished picture is the second photographic step rather than the first so that graininess tends to increase and sharpness decrease.

These variables are characteristic of the film as it is manufactured only if the materials are handled in the process for which they were designed. Forcing the process to increase speed nearly always changes them. In reversal processes, forcing the first development by time or temperature usually increases contrast and graininess and may decrease maximum density (which sometimes offsets the contrast increase but shortens the scale) and decrease definition. Forcing the development of a negative material increases graininess, may decrease sharpness, and may first increase and then decrease contrast or just decrease it, depending on the material. In both cases there will be more or less shift in color balance and degeneration of color quality.

Materials in general are designed for the highest contrast and speed and lowest graininess consistent with the use for which they are intended. For special other purposes, of course, something may be gained by forcing the development and taking the distortions—they are often better than no picture at all, but sometimes not much better.

Keeping properties

The keeping properties of the different materials are not enough different so that this is an important element in their choice. There are three

kinds of keeping which have to be considered: the keeping properties before exposure, after exposure but before processing and the dye images after processing. In general color films should be kept cool and moderately dry at all times, before, during and after. Actually the basic stability of color film is as good or better than black and white emulsions, but the color films, so to speak, have a built-in comparison device in that the slightest difference in keeping in the three different emulsions in each film shows up as a shift in color balance. Again as a broad generalization, the faster films keep somewhat more poorly than the slower ones and the latent image before processing is more sensitive to heat and humidity than is the film before exposure. The final dye images of nearly all films and papers have reached a high degree of stability but, like pictures printed in ink, or any other colored medium, can be faded by enough exposure to light or heat. They are entirely satisfactory for most purposes but cannot be left for months exposed to summer sunlight or left on illuminators for thousands of hours any more than a colored picture from a magazine or book could be so treated. Some of the products are also sensitive to chemical fumes such as hydrogen sulfide and can be bleached by strong oxidizing agents such as acid permanganate. Both heat and light effects also depend on humidity, being worse at high humidities.

Presentation of transparencies

We need to consider, finally, the control that the photographer may have over his picture if he may choose the manner in which it is shown. We shall consider here only transparencies, leaving prints to be considered at the end of the next chapter. It is realized, of course, that the photographer does not often have adequate control over the conditions under which his pictures will be shown. This brief section is intended to help just in case he does.

There are two extremes of viewing conditions for transparencies. Brightly lighted from behind and isolated in a dark room the effect is that of the objects themselves in miniature, whereas the photograph as an object is practically invisible. If this effect aids the subject, there is no better way in which it can be accomplished by present-day photography. Motion pictures, being larger, would give the same effect if it were possible to get higher screen brightnesses. At the present time the average transparency illuminator is of the order of twenty to thirty times as bright as the usual projected picture.

The other extreme is that of a rear illuminated transparency in a lighted room with the intensity of the illuminator less than that of the surroundings. Under these conditions the transparency can hardly be distinguished from a reflection print except by the nature of its surface.

Between these extremes there is a continuous variation from one to the other. The useful extremes, however, can be exceeded. If the intensity of the light is too high in the darkened room, the picture may glare so much that it cannot be appreciated. If the illuminator in the lighted room is too dim, all the colors will appear to contain large amounts of gray, and the picture will look like a very "muddy" print.

The nature of the desirable condition, of course, will vary with the subject. The dark surrounds favor object presentation and the representation of light sources. It is the only condition under which compelling reproduction of illumination as distinct from objects can be presented.

The other extreme, of course, has the advantage of reflection prints in that the picture as an object is visible and the unification of objects and picture can be accomplished more readily. The major point is that there is a **best** condition for every picture, and a given picture may be very critical to its environment.

Colored filters

There are available on the market several sets of lightly tinted filters suitable for modifying the color balance of reversal pictures at the time they are made.

There are several uses for such filters. They represent valuable tools for the photographer, but he must know what he is doing in order to use them.

Perhaps first among the uses is that of bringing materials back to a neutral balance. The tolerances necessary for the manufacture of color materials are large enough so that for very critical use it is often necessary that a slight correction be made. In products in the professional lines the manufacturer sometimes includes a statement with the film suggesting such a correction. However, because film changes in various directions as it is kept, depending on the conditions, it is not possible at the time of shipment to predict the required corrections very accurately. For high precision use of color film, therefore, it is necessary to test what correction is most desirable. Such a test, of course, implies a high degree of repeatability in processing and so will be of no significance unless processing is highly controlled.

For most purposes the relatively small range of color balance produced by manufacturing tolerances and processing variability will not require correction. For really high precision reproduction, however, such corrections must be made.

A second use for such filters occurs when it is desirable to emphasize a certain color aspect of a scene. Such a use is beset by two great difficulties but they can be overcome by careful study of the problem. We have noted earlier that artists seldom paint a scene in such a way that a neutral is reproduced as a neutral. Some color aspect of the scene is usually exaggerated, and this exaggeration tends to establish a mood for the picture.

The two difficulties inherent in the use of filters for this purpose are, first, the decision as to what direction, colorwise, would enhance the result; the second, the fact that the photographer is already adapted to the color of the scene.

The first problem is one that the photographer alone can decide for himself. For some, yellow always adds a certain glow and warmth. For others, magenta or orange are preferred for the same sort of effect. There are no rules and each person must decide the problem for himself.

The second problem is most troublesome. When the photographer is making a picture of, say, a sunset with warm interesting shades of pink and the deeper magenta, he may feel that more of the same color would make the effect more vivid and better carry across to the observer the emotional reaction that he has had in the scene itself. He must remember in these circumstances that he has color adapted to the scene before him. To him there is less color in the scene than will record on the film. If anything, the film will tend to give more color than he can see, rather than less. Hence he should, in nearly every case, assume that the film will exaggerate the color effect he sees, rather than presenting it as less. It is only when the scene appears to have almost no color, but he feels that a color bias would help that he is fairly free to use a filter to help him toward that end. In fact in many cases a better sunset picture may be obtained by the use of a pale green filter over the lens.

It is amazing what a yellow filter will do to enliven a fairly drab scene —just as many photographers have found that late afternoon and early morning shots are among their best—but it is an effect that should be used with discretion and not overdone. Incidentally, a filter that leans toward the orange is required rather than a pure yellow.

An apparent exception to this rule occurs in pictures taken in the shade on a day when the sky is quite blue. Due apparently to eye adaptation such subjects do not look blue to the photographer. If he will analyze his

feelings, he will find that the shade looks quite "cool," but it is unusual if it looks blue. Experience has shown, however, that a photograph under such conditions will tend to appear quite blue. There is available generally a light orange filter, known as a "shade filter" that will tend to offset this effect. It is the equivalent of rebalancing the film for the light source used.

Effect of colored filters

Perhaps it is well to point out the effect of the use of such color transmitting media when the picture is made.

If for any reason the film is not well balanced for the light source used, a normal picture results from the proper use of a correction filter. That is, its main effect is to correct the relative speeds of the three emulsions so that a neutral results from exposure to a neutral surface.

However, if the intention is to introduce a distortion of the colors for artistic reasons, certain reactions must be kept in mind. In all subtractive color processes the saturations of the colors increase with the density of the deposits in the film. In normal viewing of objects if the illumination decreases across a uniformly colored surface, the saturation decreases continuously with the illumination. In color photographs, however, such a decrease in illumination, since it produces darker deposits in the film, results in increasing saturations up to a certain point, beyond which saturation again decreases.

Accordingly if a colored filter is used over the lens when a reversal picture is exposed, the result is not the same as would be seen in the camera finder. In the finder the main effect of the filter would be seen in the lightest parts of the picture with the effect decreasing into the shadows.

In the photograph the effect of such a filter would depend on the exposure given. If the exposure were full so that a white in the subject resulted in clear base in the picture, there would be no effect of the filter in these lightest areas. At densities higher than this, however, the filter would begin to take effect and at still higher densities would show maximum effect. Accordingly, a yellow filter over the lens when making, say, a flat lighted snow scene would not add yellow to the highlights on the snow but would add yellow to the middle tones. The effect is rather that of yellow snow rather than yellow illumination. The same is true, of course, of late afternoon sun (filters and light sources are interchangeable if there is only one light source). If the film is underexposed, how-

ever, the full value of the filter may take its effect and the result may be surprisingly yellow. In the long run only experience will suggest what to do to get the effect desired.

In this same connection it might be well to speak of colored light sources in the scene. Although we almost always have two light sources in pictures made in daylight, it may be desired occasionally to introduce deliberately a colored lighting effect. It must be remembered when this is done that, contrary to the way it appears to the eye, the most brightly lighted areas from this source will have the least color added and the maximum effect will come at some lesser lightness where it may or may not have been clearly visible to the eye. The light source itself, if it is visible in the picture, may reproduce as having no color at all!

C H A P T E R

CONTROL

IN

PRINTING

Probably the most flexible of all strictly photographic processes are those in which a final print is made by way of separation negatives. The possibilities for variation and control in the intermediate steps is so great as to put them nearly on a par with the photographer's controls in making the picture. Because the picture must be made with the end result in view, it is important that the photographer realize the variety of end effects into which he may work. Conversely, too, the end result can be varied so greatly that close coordination of picture taking and printing can produce results that are entirely beyond the possibilities of a direct photograph. Hence we shall go into the matter here in some detail from the standpoint of achievable results. Technical details are omitted where they do not contribute to understanding the nature of the freedom a particular operation gives. Methods for control of the more usual type of photograph will be considered first, followed by consideration of a broader approach.

Picture contrast

One of the very important variables in color photography and especially in reflection prints is the contrast of the picture. Many photog-

raphers make it a rule that every picture should contain a good black and a good white. Although there are many obvious exceptions to any such fixed statement, it does express a simple fact. Unless the picture does extend from white to black or "fill the scale of the paper" there is a strong tendency for the picture to look either too dark (no white) or washed out (no black). Too much contrast leads to washed-out highlights or blocked shadows or both. Excellent pictures can be made and are made quite regularly in which neither appears black or white. The rule illustrates that far more skill is required if white and black are not present.

To adjust the picture to the scale of the print requires that contrast be under the control of the photographer. This is required even though the photographer be skillful at handling his objects and lighting, and the process is under accurate control. If more than one paper surface is used, this change alone is enough to require contrast changes.

In color photography changes in photographic contrast involve all three records. They are said to have the same contrast when the three can be made to produce a neutral scale all the way from white to black by a change of color balance only. If one of the records is of higher contrast than the others, this cannot be done. Since having one record more or less contrasty than the others is a fairly frequent occurrence, it is worthwhile to consider the effects. Also some useful results can be obtained by deliberately introducing such a change.

Suppose the contrast of the blue-absorbing yellow image is higher than that of the other two. For convenience, suppose also that the color balance can be shifted freely in the process without changing the contrast of any of the records. We then have three possible picture situations. If the yellow is in excess throughout the scale, then the fact that the contrast is higher means that necessarily there will be less excess in the highlights than in the darker parts of the picture. If the balance is shifted far toward the blue by taking out yellow, so that there is too little everywhere in the scale, then there will necessarily be a greater deficiency in the highlights than in the shadows. At an intermediate balance there will be an excess in the darker part and a deficiency in the highlights with one point in the density scale at which a true neutral is formed. The position of this neutral point will depend on the actual color balance. Adding yellow will shift the neutral point toward the highlights and taking yellow out will move it toward the shadows.

If it is desired, therefore, to have bluish light colors and yellowish shadows, this can be accomplished by an increase of contrast in the blue absorbing record only and an appropriate adjustment of color balance.

The opposite situation holds, of course, if the contrast of one record is lower than the other two. Thus if the yellow is of lower contrast, the intermediate case is yellow in the highlights and blue in the shadows. This situation has immediate practical applications. It was pointed out in an earlier chapter that when the eyes become adapted to colored illumination the brighter parts of the scene appear slightly of the color of the illuminant, whereas at some darker part this color is no longer visible and, for intensely colored illumination, the shadows may be complementary to the brighter parts. This is the result produced by decreasing the contrast of one or two of the records compared to the remainder and balancing the process to produce a neutral at the right point.

One of the customary situations of everyday life is seeing objects under incandescent illumination. Light sources and bright objects are seen as slightly yellowish, but everything darker than a medium gray looks normal. Shadows seldom look blue. This effect cannot be produced by a simple shift of color balance. The effect produced by a yellow shift in color balance is much more like that of late afternoon sun where the blue sky and still white clouds tend to hold our adaptation. Artificial light appearance can be imitated by making the contrast of the blue record slightly lower than the other two, with density all the way into the highlights, and then adjusting the balance so that dark shadows are neutral. If the over-all contrast is sufficient to give good blacks and if the blue record is of only slightly lower contrast, an excellent effect can be obtained. Other light sources can be handled in a similar manner but it must be remembered that few people are aware that such colors are present and hence the picture must merely suggest the effect rather than imitating the colors accurately.

It might also be pointed out that variation of single record contrast is one way of favoring certain colors. For nonobjective or abstract work such variation of all three records is a fruitful technique for modifying color schemes. In fact a black-and-white picture can be converted to a sequence of hues simply by taking the same record for all three dyes but printing them at widely different contrasts. The various color sequences that can be produced between white and black form an interesting problem in color mixture for the student.

It should be noted again here that the contrast of a color picture can be brought to any desired value up or down by the use of a silver contrast mask over the original before making separations, or over each separation negative during the next step. Such a mask if made by "white" light changes the contrast of all records by the same amount. A negative over a positive transparency decreases contrast and a positive

over a positive increases it, without direct change in hue or saturation in either case. (This was discussed more fully under Duplicating.)

Such a mask used with a single separation record produces a hybrid result in which the amount of dye controlled by that record is increased or decreased in proportion to the brightness of that part of the picture. This is a different result from simply changing the record contrast as this controls it only in proportion to the amount present in a color. Under some circumstances the use of the brightness mask produces a better imitation of colored illumination.

There are other means by which the contrast of a picture may be raised or lowered, but they will be discussed under other headings. Masks to brighten highlights or to darken shadows both have this effect, for example.

Under the heading of picture contrast also come such effects as "solarization" and "posterizing." The technique of solarization in black-and-white pictures gains its name from the fact that some black-and-white materials if exposed too heavily reverse their contrast in the most heavily exposed parts. Since sunlight is usually the only source strong enough for the effect, the name followed naturally. Actually, solarization as practiced is a different effect produced by taking the film out of the developer after the image has attained the desired stage, exposing it to light, and then proceeding further with the development. Similar effects can be produced in the same manner in color photography although as yet they have assumed little importance. Here as elsewhere it is not what you can do but what you accomplish that matters.

An effect similar to solarization can be produced in a more controllable fashion by simply exposing a very high contrast material to a color negative transparency so that only half of the full scale is exposed and then using this over the original when separations are made. This takes both highlights and shadows to white, the same as the usual solarization. The reverse effect of highlights and shadows to black can be produced by starting with a color positive.

The effect known as posterizing consists of reducing the tone scale of a picture to three or four separate tones. No simple way of doing it photographically exists but it can be performed by step-wise use of masks over the original. A first mask is made of the same contrast as the original but underexposed. This is placed over the original and a moderately high contrast negative is made. Another mask is then made from the original, underexposed more than the first. This, the original and the first negative are then combined and a second negative made. The second negative and the original are then combined to make a third negative. These three

negatives, placed on top of each other, represent a posterized version of the original. If the result is to be in colors, the operation has to be repeated making separation sets in place of each of the three negatives and the nine records so formed are printed in their appropriate colors to produce the final picture. It seems unlikely the result justifies the effort, especially in view of somewhat less difficult approaches we shall discuss later.

This latter technique gives some inkling of the wheels within wheels type of operation possible in color photography and which permits manipulation of nearly all the variables in the picture except the general drawing of the constituent objects.

Projection printing

We might stop a moment at this point to note again that in the printing operation we have the opportunity to decrease, increase or prevent the convergence of parallel lines. This is useful in two ways. If when the picture was made it was not possible because of lack of depth of field or insufficient movement of the film plane to prevent convergence of lines we wanted parallel, tipping of the enlarging easel gives further opportunity to do so. On the other hand, if the film plane had to be tipped in order to obtain sufficient depth of field, matters can again be straightened out in projection printing (Figure 9–1).

Beyond this there is the possibility of experimenting with various types of distortion if these are wanted, without losing the basic pictures from which they derive. Projection printing can well be the point at which just the change that is required in a picture is made.

Not the least of the results obtainable is the tremendous increase in depth of field that results from making a small picture originally and enlarging back to the desired size. In many picture problems this is the only possible solution. It is limited as we have seen by the graininess and resolving power of the original materials.

Projection printing also offers the possibility of diffusing the image to the desired extent. If the photographer knows that this facility is available, he can start with a sharp picture and diffuse it to just the required degree by successive experiments later. In this way he can be sure of getting what he wants in this respect. At this point, too, images can be optically stretched vertically or horizontally just as though a swing back had been used.

Figure 9–1. Convergence produced by camera has been corrected here in the enlarger.

Paper surface

Returning to the photographic as distinct from the optical variables, it was mentioned that paper surface was important in the final result. We need to look at this rather carefully from a number of angles to see just what is involved.

The identity of a reflection print as an object comes from the fact that it can be seen as such. Anything that is done to make more obvious the fact that it is an object adds to this insistence, and this in turn decreases the realistic appearance of the objects in the picture. It will be recalled that consciousness of the picture plane actually decreased the perceived depth in a given picture. If the same depth is to be perceived in pictures printed on papers with different surfaces, then other depth indications must be changed to compensate.

Changing the surface of the paper, accordingly, is one means by which pictures may be moved toward two-dimensional picture quality and away from realistic presentation. The effect must be used with some knowledge, however, or unwanted effects will be obtained. A portrait, for example, in three-quarter front view, taken in soft lighting with slight diffusion, and printed on a rough texture paper may seriously distort the apparent shape of the sitter's head. On the other hand, a contrast lighted sharp portrait may gain considerably in appeal on the same paper.

One extreme in the scale of surfaces is a high gloss finish. Like all surfaces its effect is two-fold. It is a high gloss surface on the print as object and may be desirable or objectionable for this reason. As far as the objects of the picture are concerned, it is the surface which least of all attracts attention to itself. To the extent that it is seen at all, objects are seen **through** it. It is also an extreme as far as the colors are concerned.

In the series from glossy to smooth but completely nonshiny (matte) surfaces there are a number of possible surfaces. They divide roughly into those that are smooth with varying degrees of matte and those that are rough with varying degrees of gloss—the roughness varying from very fine to a quite large pebbled structure. Textured surfaces with regular patterns are also available.

Several factors determine the choice of surface for a particular picture. When a picture is placed in a room with light, brightly illuminated walls, the surface of the print tends to reflect these walls. A high gloss surface under these conditions may nearly obscure the picture because all that can be seen is this reflection. For this condition, unless the print is totally

surrounded by bright walls, a fairly shiny pebbled surface will help because it will not reflect the walls uniformly over the whole area of the picture. A completely matte surface, on the other hand, is not much affected by its surroundings but looks essentially the same whether lighted by a single light or entirely by indirect light from the room. The completely matte surface, however, produces a quite different kind of picture.

We want then to see what the different surfaces do photographically. For simplicity of treatment we shall consider only the three types: smooth high gloss, pebbled medium gloss, and smooth dull matte.

The saturation of a color depends on the amount of difference between the absorption of the heaviest record for a given area and the lightest for the same area. It may help to think of it as the contrast between the records for a given area. The effect of white light reflecting from the surface of a print is to decrease this contrast between records by setting a minimum for the amount of apparent absorption. An example will make this clearer. Suppose that the blue and red records absorb 5 per cent of the light that passes through them and that is reflected from the paper behind out to the observer. (Note that the density of a deposit only has to be half as great for prints as for transparencies because the light goes through it twice.) For the same area the absorption of the green record, let's say, is 90 per cent. The reflections are accordingly 95 per cent and 10 per cent. This is a fairly saturated magenta color. Now suppose the outer surface of the print reflects 50 per cent of white light to the observer. This means that the observer sees a color consisting of 97½ per cent blue and red and 55 per cent green. Whereas before the contrast of the reflected red and blue to green was 9½ to 1, it is now less than 2 to 1. There has been a very severe loss in saturation of the color.

The main characteristic of a high gloss surface is its high reflectance. This reflection takes place, however, like a mirror rather than like a piece of white paper. A really good glossy surface, in fact, will reflect a mirror image. For this reason the amount of light reflected from a glossy surface depends on the brightness of this mirror image and on nothing else. If such a print is placed in a dark room and lighted from above or from one side, the observer does not see this reflection at all. Under these conditions the maximum saturation of the dyes is seen, and the picture has maximum contrast. For all other conditions and all other surfaces of paper the saturation is less than this for the same dye images. The effect of reflection on picture contrast as a whole obviously follows the same rule as contrast between the records. If the front surface reflects 50 per

cent, no brightness lower than this can be seen and the **maximum** brightness can be only twice this value.

The completely matte surface, on the other hand, has the characteristic that a considerable amount of white light is reflected from its front surface no matter where the light originates. With side lighting a matte print looks much the same as it does under any other conditions. For this reason the matte print has lower saturation and a relatively gray maximum black under all conditions.

The various semi-gloss pebbled surfaces fall somewhere in between these two extremes depending on their exact nature and the kind of illumination. Some are designed deliberately to make high saturation possible under conditions in which the smooth gloss would not be good. The pebbled surface breaks up the mirror image.

An interesting situation occurs when a glossy print is held in the hand. Although a mirror surface is always reflecting something and prints are seldom examined under a light in a dark room, a glossy print in the hand often gives the effect of high saturation to the observer. The reason for this lies in the lifelong experience of the observer with objects with polished surfaces. There is not much difference optically between a glossy print and, say, a piece of polished mahogany furniture. We see the color of the mahogany through the polish, and we do the same thing in the case of the print. The operation is an interesting one introspectively. What seems to occur is that we are aware that the reflection is separate from the picture. This arises easily from the fact that it moves with respect to the print when we tip it. At some point during this movement the surface reflects a **dark** object and at that point we see higher saturation and density than we do elsewhere. We have learned that this is the true nature of that area and we then assume that the whole picture is of that character. That this is the correct analysis can be shown readily by taking such a print into the open under an overcast sky. If held so that only the sky is reflected, it looks like a matte print.

The surface of the print accordingly controls the maximum saturation and contrast of the picture, being decidedly dependent on illumination for glossy smooth surfaces, relatively so for pebbled medium gloss, and hardly at all for matte, but the possibility of high saturation and contrast decreases in the same order.

We have not considered the nature of the matte surface as a characteristic of the print as object. In this respect also it is at an opposite extreme from high gloss. Whereas the colors and densities of a glossy print are seen as lying beneath the surface and the objects tend to be seen through

it, the matte print is seen to have the colors lying on the surface. The matte print therefore gives a much stronger feeling of a two-dimensional picture as opposed to depth. It has much more of the character of a colored piece of paper as opposed to a photograph of objects.

This characteristic of matte surfaces can be used to good advantage. For a decorative photograph in which representation is subordinated to design or the like, the matte will aid the effect materially.

In the same manner other surfaces are possible which have somewhat higher saturation and contrast possibilities but which call attention to the surface because of a visible texture. Unless such a texture is unusually coarse, however, any advantage to be gained is restricted to prints that will be seen from relatively short distances. At long viewing distances they nearly all become the same as the pebbled medium gloss papers.

Texture screens

The effect of calling attention to the surface and so decreasing the perceived depth in a picture may be produced also by what is known as a "texture screen." This is, in effect, a photograph of a surface showing a texture pattern which is placed over the transparency before proceeding with the printing process. The result is to add the texture to the picture. During the time when photography was trying to imitate painting such screens were used rather too frequently and now they are not considered proper in some quarters.

The chief difficulty with a texture screen is that although it represents a surface, the paper on which it is printed does not have it (Figure 9–2). Unless the whole concept is carefully handled, the result tends to look like a cheap imitation. On the other hand, with the power of color photography in the nonrepresentational field there is no reason why texture screens should not be used if they aid the subject of the picture. In pictures that are frankly decorative, for example, or where the intention is that of fabric pattern design, there is no reason why the fabric pattern cannot be so introduced since it is intended that the two be seen together in the end result and the pattern must be so designed. In this case we are not trying to produce the illusion of a picture having this texture but are producing a picture of a pattern on this texture and the result ceases to be anomalous. Screens can be used freely with some of the derivation techniques discussed in the latter part of this chapter.

Figure 9–2. *The same picture has been printed without and with a texture screen.*

White and black

Before closing this section on control of the customary representational picture, it seems well to consider separately the importance of white and of black in reflection prints.

The white of a print represents the brightest area it can contain. In a transparency the actual brightness of this compared to the surround may be made to have any value. In a print, however, the brightness of a white is the same as that of its border or of any other white nearby. If it is to represent a white, it must compare favorably with other whites. We have already noted the difficulty of using it to represent a brightness higher than white.

Unfortunately for this requirement, photographic processes tend to have relatively low contrast in the areas that approach maximum white. To get a good white this makes it necessary to make the whole print quite light and this in turn decreases the saturation of the colors. Although some compensation can be made by increasing the contrast, this has more effect on the saturated colors than on the lighter ones. The net result is loss of relative saturation in the lighter colors with corresponding harshness of the final picture. This effect can be avoided by the use of a so-called "highlight mask." The requirement is that the lightest parts of the picture (maximum brightness whites, reflections from shiny objects, etc.) print lighter relative to the rest of the picture than they would normally. For prints to be made from positive transparencies the procedure is as follows.

The original positive transparency is exposed by "white" light onto a very high contrast material, giving only enough exposure to catch those highlights where emphasis is wanted. A positive is then made from this highlight mask, and this is placed over the original. This adds density to all parts of the picture except the highlights, which now will be reproduced as brighter in subsequent printing. Because some form of masking is used in nearly all such printing, however, whether it is simple contrast masking, relative brightness, or dye impurity masks, it is possible to avoid one step in this operation. The negative highlight mask is made as before, but instead of making a positive, this negative is put over the original when the full scale mask is made. This holds back the highlight densities in the full scale mask. When it is finally used over the original to make separation negatives, the highlights act as though they were brighter relative to the rest of the picture. Such masks are less important in negative-positive processes because of their highlight gradation, but can still be made in much the same manner. In this case a full scale posi-

tive is first made by white light. This is then exposed to the high contrast material and this highlight negative is used over the original in later steps. Since other masks are seldom used, there is nothing with which to combine it.

The whites of a picture give it an interesting property, which illustrates their importance in the final result. If a large print that has even a fairly large amount of dye present in the whites is examined at a short distance, these whites look entirely satisfactory because of eye adaptation to the print itself. As the distance from the print is increased, however, these highlight densities become more and more noticeable and the whole print soon takes on a "muddy" appearance. The distance at which this occurs depends largely on the density of the deposit in the white areas and the size of the picture. The effect has come to be known as the "carrying power" of the print, the picture "carrying" to a greater distance the better the whites. The pigment tissue processes have some advantage in this respect since the maximum white can be that of the paper itself with no deposit over it. The other processes usually have a layer of gelatin and this often contains a stain even if it has no image forming dye.

The blacks of a picture do not often require emphasis compared to the rest of the picture because it is usually satisfactory to obtain them with a simple increase in contrast. If such emphasis is needed, however, shadow masks can be made in a manner entirely analogous to that for highlight masks. In this case, of course, density needs to be added to the shadows themselves rather than to the rest of the picture, although if it should be desired to lighten the blacks, this can be done also.

There is one control element in connection with shadows that might be mentioned since it throws an interesting light on the processes. We have seen that the maximum black in a picture is usually controlled by the nature of the surface reflection. Even with a very smooth high gloss surface under the best of conditions, however, it is unusual to obtain reflectances of less than $\frac{1}{4}$ per cent. These appear to the eye under all ordinary lightings as jet black. The amount of one or two of the three dyes necessary to use to make this black, however, is a moderately bright color of high saturation. It is only when all three are present that the deposit becomes very dark. For this reason the saturations of the purest colors are limited by the maximum amount required for the deepest black. If still more density were available, the pure colors would increase in saturation even though the maximum black did not appear to change. Since added dye does not change the maximum black, (limit set by surface reflection) it does not have to be added in the proper ratio for black. In other words, above this black point the balance of the

three dyes may be in any ratio without affecting the blacks. This permits one to force any of the colors by running a higher maximum density for that color record. Thus the reds can be increased in maximum saturation by having more magenta and yellow above that required for maximum black. Similar effects occur for the other colors. If such a print is examined locally in the blacks with a very strong light, the actual color may be seen but under all normal conditions it looks black. There is some loss of shadow detail.

Emphasis of fine detail

Another picture factor that can be controlled by the photographer is the contrast of fine picture detail as compared to coarse. This effect has been used somewhat in the past to obtain clearer pictures when pictures were to be reproduced by photoengraving or lithography and has often been obtained unintentionally when the method of control was used for other reasons.

Briefly the situation is this. All parts of a sharply focussed picture are obtained at the same contrast photographically. That is, except for highlight and shadow regions the contrast of any two areas in the picture bears much the same relation to the subject whether the areas are large or small. When such a picture is copied, there is a strong tendency in most processes to lose the contrast of the fine detail areas as compared to the large. Hence amplifying this fine detail contrast will tend to offset a subsequent loss.

The method by which this is accomplished is quite simple and straightforward. A simple white light contrast reduction mask is made which will noticeably decrease the contrast of the picture as a whole, but in making this mask, diffusion is introduced between the original and the masking material. Suitable diffusion can be produced by a thin layer of diffusing material between the two. This diffusion produces a lack of sharpness at the edges of all the areas of the picture. For those areas in which the extent of this unsharpness is comparable to the size of the area involved, no image at all is formed in the mask but only a uniform gray area. The size of the detail so eliminated from the mask depends on the amount of diffusion but may be made surprisingly large by thick diffusing glass and the like.

When such a mask is placed back over the transparency, it reduces the contrast of all areas that are imaged in it and does not decrease those that are not imaged. Accordingly, these fine detail areas now have higher

Figure 9–3. *Normal and increased fine detail contrast in printing with the large area contrast the same in both pictures. Note that the entire apparent contrast has increased.*

contrast relative to the rest of the picture. By raising the contrast in later steps of the process the large areas may be returned to their former contrast. The fine detail will then have higher contrast than it did originally, relative to these areas (Figure 9–3). In this way the fine detail may be made far more important if so desired, or it may simply be raised to the point where a subsequent loss is just balanced out. The amount of contrast increase depends on the amount of reduction of contrast of the rest of the picture by the diffuse mask. The size of the detail that is so affected depends on the amount of diffusion used. We shall return to this under derivations, but it might be noted in passing that this effect can also be made to depend on the color of the areas by using colored rather than white light to make the contrast reducing mask. In this case there is also a change in the brightness contrasts of the whole picture, which is dependent on the color of the areas, as we noted earlier.

Derivations from color photographs

In the fall of 1949 a photographer° and an engineer† working in the writer's laboratory were led to combine two known techniques to study the result from an artistic point of view. The result was sufficiently interesting and unusual to attract wide attention, particularly to the philosophy behind the attempt. It is interesting to sketch this philosophy since it is close to the thinking of many advanced workers who have arrived at it independently. We shall touch on the philosophy in more detail in the next chapter.

The photographer had reasoned that one of the difficulties with color photography, when an attempt was made to use it creatively, was the insistence of the objects in the picture and had made good progress in decreasing this insistence by "straight" photography. Some years before (in 1943) the writer had demonstrated that if a white light contrast reducing mask was used that took the contrast all the way to zero, almost all perception of depth in the picture disappeared, the image appearing to lie flat on the surface of the paper. It occurred to them that this might also be an approach to nonrealistic color photography as such prints made the objects look sufficiently unreal for anyone. Such prints, however, looked very unsharp and rather washed out, and they started looking for some way of increasing the apparent contrast without putting the depth back in. In considering the matter they reasoned that black-and-

*Miss Jeannette Klute
†Mrs. Dorothea Peterson

white pictures were an abstraction of the relative brightnesses of the subject and that the zero contrast was a corresponding abstraction of the colors aside from brightness. They accordingly started looking for a third abstraction which they could combine with the zero contrast. They found this in a line image technique which had been published° some three years earlier and which abstracts the contour lines of a picture. When the two abstractions were combined, sufficient contrast was obtained without gain in realism.

The process was published under the name *Derivations from Color Photographs*, although by that time the name was intended to include all the possible variants we are about to consider.†

The basic importance behind this work lies not in the specific techniques nor in the individual pictures that can be made. It lies in the release of the color photographer from the necessity of realistic treatment whenever such release is called for by his subject. It also, for the first time, places the photographer in the role of a designer of patterns direct from nature without intervening hand work.

We enter the maze of possibilities with some hesitation, conscious of the fact that there will be many who consider the subject either tommyrot or sacrilege. The philosophy behind the approach is two-fold. First, once you have departed from reality anything goes, and second, that however ridiculous a technique may appear before it has been used by an artist, it will not appear so afterward. Hence the following is not inhibited by any feelings of photographic propriety. The subject is infinite but we hope to see the main directions.

Although the so-called "line and color" derivations were the starting point for the present subject, we propose to take the various techniques separately and to try to show the possibilities of each as a component of a final picture. In essence they constitute a technique for taking the picture apart according to its visual variables and then recombining such parts of it as are desired for the final result. Its novelty lies in the separation into visual rather than photographic components.

An historical note might also be in order. When some of the prints were shown to Captain Steichen early in 1950 he recalled that before the war he had done some work along similar lines. He showed the writer and others a number of prints that had been made around 1942. In some of these a "black printer" negative of the type used in the graphic arts had been used as a mask, others had negative colors and positive bright-

*J. A. C. Yule, "Unsharp Masks and a New Method of Increasing Definition in Prints," *Photographic Journal*, 84: 321–327, 1944.

†Ralph M. Evans, " 'Derivations' from Colour Photographs," *Penrose Annual*, 45:81–83, 1951.

nesses, one had full face contrast with reduced background, etc. Although none of the results were identical with the techniques shown, they did indicate clearly that he had been working along similar lines at that time, except that he worked with photographic rather than visual variables. None of his material was published and the work was abandoned during his war activities.

The writer has also seen a number of prints by other workers that make it seem likely that many photographers have been thinking and working along similar lines for some time.

Zero brightness contrast

When the brightness contrast of a picture is reduced to zero by the use of a white light full contrast mask, a wholly new entity is produced. Not only do most pictures show complete loss of depth but also all traces of illumination disappear except where there has been a change in color. Even in these cases there is little feeling of illumination as such. For these reasons the objects that remain recognizable no longer seem real, and the rules that must be followed in the handling of realistic looking objects no longer hold. Any object may be made any desired color, for example, with no offense to the observer, providing it is not in poor taste.

Color in such pictures becomes part of the picture rather than part of the objects and can be so treated to nearly any desired extent. The freedom in this respect, given by color printing processes, is quite remarkable. The normal separation negative operation gives three records which normally control red, blue, and green absorbing dyes. If they are used to control the wrong dyes, new color schemes result. There are six ways in which this can be done including the normal way. There are, accordingly, six color schemes in which any picture may be printed without further operations.

If the contrasts of the three records are made very different, these may be printed at different balances (amounts of each record) as noted earlier to produce a large number of variations. These in turn may be handled by any of the six dye record combinations. Given complete freedom in contrast and density control, any **two** single areas may be made any colors desired but then the rest of the picture is fixed. The two areas, of course, have to be different colors to start with, and any area that matched one of them in the original will continue to match it regardless of what color it becomes. There is thus theoretically enormous freedom

in the color schemes that can be developed, although there are definite photographic limitations.

In the normal printing of zero brightness contrast pictures in which each record has the same contrast, there is also control over saturation. The saturation of the colors will vary directly with the contrasts (gammas) of the separation and print images. Increasing all contrasts will increase all saturations but will have only a second order effect on relative brightnesses. The inverse is true of reducing the contrast. The same is true also of the density of the picture. Making the whole darker will increase saturations up to a point and then decrease them. Decreasing the density will decrease saturations starting with a medium density picture.

Both for the variables just outlined and for many that are to follow, it is very convenient to make a zero contrast duplicate positive of the original. Final separations may be made from this as may many other intermediates. This may be thought of, in fact, as the first step in the operation of taking the picture apart. The white light full contrast silver mask is a complete record of the relative brightnesses of the picture. The zero contrast positive is the complete picture without the brightness differences. Separation negatives from this are records of the ratios of the dyes necessary to produce these colors. They represent the colors and the boundaries of the colors only. They do not even contain details unless these details showed color differences.

Line contour images

Wherever there is sufficient edge contrast between two areas in a picture and the edge is sharp enough, it is possible to produce a photographic image in which this shows as a simple line. The basic principle in the operation is as follows. A regular black-and-white, full contrast mask is made for the original just as is done to produce a zero contrast picture. This and the original transparency are now placed in register but back to back so that both bases are between the two images. The two are now laid on the surface of a very high contrast material sensitive to all colors. This is done in a dark room and a single light bulb is now moved around over it in a circle whose center is directly over the center of the picture. Light from this bulb passes down between the two films at an angle and wherever there was sufficient contrast, exposes the sensitive material. After development, a black line image results. This is the image that was described as added to the zero contrast pictures to pro-

duce the first of the derivations. The lines can be printed over the zero contrast picture in black or in any desired color (Figure 9–4).

Practically every step of this process is subject to variation and we shall consider a few of them. There is first involved the question of which side of the original and mask shall be placed on the sensitive material. The two positions produce quite different results. To understand them we shall have to consider the mechanism of the exposure. Suppose first that the positive color transparency positive is next to the sensitive material. Where the positive has a light area next to a dark one the negative has exactly the reverse. Accordingly light will shine through any light area of the negative diagonally and enters the light area of the positive a **short** distance. This is the light that produces the line; the distance it shines into the light area is the **width** of the line. With the positive on the bottom, therefore, the line forms **inside** the edge of any **lighter** area of the positive. This fact and the width of the lines are important for the fine detail of the image. Consider a relatively narrow white line on a dark background in the positive. Light will shine into this line from both sides. If the width of both lines formed is equal to or greater than the width of the white line, it will be filled up and appear as black in the line image. On the other hand a black line on a light ground will be represented by two lines, one on each side with a space the width of the line between them.

If the negative mask is on the bottom, of course, exactly the reverse occurs. White lines in the positive become double lines and black lines stay black. Hence as a generalization, putting the positive on the bottom produces lines which represent the inside of the light areas and putting it on top produces lines that are outside of the light areas (Figure 9–5).

The width of the lines may be varied over a wide range. In the first place the width of the line depends on the angle of the light passing through and on the distance between the negative and positive. The angle is determined by the distance of the light away from the center and its height above the film. The separation of negative and positive can be increased by layers of transparent sheeting or a piece of glass. These tend to give relatively sharp lines of various widths.

The sharpness of the lines may also be varied. Perhaps the easiest way is to introduce a layer of diffusing material between the bottom film and the sensitive material. The thickness and nature of the material will cause various degrees of diffusion, this diffusion occurring on both sides of the lines.

Because the positive is in colors, the lines may be made selective for color. Use of a color filter when exposing the lines will permit their for-

Figure 9–4. *Full scale and line image print from same original.*

Figure 9–5. *Line images formed on the outside (left) and inside (right) from same original.*

mation only at the edges of areas of this color and neutral. Low saturation colors with high background contrast will also print with nearly any color.

This latter technique suggests a possibility that also gives very interesting results. Since exposure through a color filter gives lines selected for the color of the area, there is no reason why red, green, and blue records cannot be obtained and the lines printed in color. Each line then has approximately the color of the lighter area at any boundary if the positive is on the bottom, and the darker area if it is on top. Such images are a wholly new picture medium as far as the writer is aware. Some made with a very low contrast white light record printed in gray as a background have looked particularly promising.

The lines may also be so produced that they are selective for orientation in the original. If instead of exposing with a light bulb that is moved in a horizontal circle during exposure, a single one is moved vertically from a position near the edge or a line lamp is used vertically at a single position, then lines will be produced only for contours that are approximately at right angles to this line. Thus if vertical lines only are wanted, they can be produced by a light source at one side. If the light is beside the left of the picture with the positive on the bottom, vertical lines only will appear, and only inside the left side of light areas. If the negative is

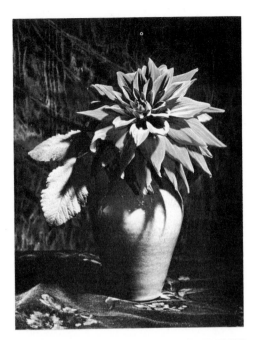

Figure 9–6. *Line image in which some of the background has been allowed to print through from original above.*

on the bottom (with the light on the same side relative to the picture) they will appear inside the left edge of dark areas. A light on both sides will give all verticals. Diagonal lines in different directions can be obtained also. Right and left or any pair of lines may be printed in different colors by making separate records.

One other variation on the lines can be interesting. It is assumed in the foregoing that exposure is sufficient only to expose the lines themselves. It is apparent that the degree of the exposure will determine how many lines are formed. With increasing exposure lines corresponding to darker and darker areas are formed. A point is soon reached, however, where stray light interreflected between the layers starts printing through the lighter parts of the whole picture rather than just the edges. In some pictures this can add quite interesting detail to the picture. If it is desired to accentuate this effect, it is only necessary to use a normal contrast rather than a very high contrast material. With such a material quite delicate full tone backgrounds can be produced in addition to the contour lines. These again are positive or negative depending on which is against the sensitive material (Figure 9–6).

It should be noted that the formation of the lines does not require the use of a color transparency. They can be made equally well from a black-and-white negative and positive. Actually if very high contrast film is not available that is sensitive to all colors, a full contrast positive made from the full contrast negative may be used with the negative and blue sensitive material.

Occasionally a line image will be sufficient by itself without the zero contrast or other abstraction with it. It can then be printed in black or any other color on a background of any color. Such images are sometimes better printed as white lines on a colored ground by using a negative rather than positive image.

One variation that was found suitable for a particular picture consisted of printing the line image in black on top of a print from the red light record which had been printed in a slightly bluish green. The many other possibilities will occur to any worker. The possibilities of a print of the highlight mask (dark ground and white highlights) printed in color and combined with line would appear to be considerable.

Highlights and shadows

One of the controls mentioned under regular printing was the use of highlight or shadow masks to emphasize or decrease highlight or shadow

contrast. In zero contrast prints the whole scale of grays including black and white are reduced to a single value of gray. Especially if there is much white in a picture this tends to produce a rather dull impression. Some contrast can be put back into such pictures by the use of a high-light mask. The mask is placed over the original when the full contrast negative is made, and then removed. The full contrast negative then does not hold back the contrast of the extreme highlights and these are retained as white in the zero contrast print. The technique often adds much to a picture, but there are many subjects which simply revert so closely to their original appearance that they destroy the whole point of the operation. Shadows can be handled similarly by adding the shadow mask to the full contrast mask at the time the color duplicate or the separations are made. Again this will tend to reintroduce the feeling for illumination and so may defeat the purpose.

One interesting possibility consists of printing the highlights or shadows, or both, separately on top of the zero contrast print. If a highlight mask image is printed over a print made with white highlights, its color will take the place of the white, if on a uniform density print the added color will mix with whatever is present. Here as elsewhere it should be remembered that no record has to be printed with a dye of the process. Dyes may be mixed to produce any desired color and such a mixture may be used for any of the records. As noted earlier, highlights printed in orange yellow give a strong feeling of yellow illumination, such as late afternoon sun or incandescent light.

If desired, of course, highlights and shadows can be printed in black to darken both and emphasize the colors of the middle tones. We shall see later under the discussion of texture other uses for them also.

Introduction of texture

It often happens in zero contrast pictures that removal of the brightness differences leaves an area too blank for the requirements of the subject. Although care must be taken to avoid making the result look mechanical, this can often be remedied by the introduction of a texture pattern into this area. The pattern may be obtained in any of a great number of ways and may be introduced into nearly any type of area. A few examples will indicate the general principle without attempting to cover all possibilities.

One quite desirable type of pattern because of its nonmechanical appearance is that of severe photographic graininess. Suppose it is desired

to introduce this into a too blank shadow area. A fairly high contrast underexposed print is made from the full contrast white light negative (or one made by colored light to get a different effect). This should be on the grainiest material available—X-ray film is good, or any very high speed negative material. This can then be duplicated once or twice using the same material to get more graininess if desired. A more noticeable pattern can be obtained by enlargement if the enlarging lens is good enough. To restrict this to the shadow area a piece of grainy film can be projected onto a transparent print of a shadow negative mask. This gives a shadow mask with the graininess superimposed. It can be introduced in other areas as need arises by exercise of a little ingenuity.

Other patterns can be purchased from photographic stores. There are texture screen transparencies for sale as well as Ben Day screens and the like, which are mechanically ruled patterns. One good way of getting what is desired is to photograph the desired texture and make your own texture screen on high contrast material. All of these textures can be introduced as positive or negative depending on the point in the operation at which they are introduced.

An interesting use of such texture screens is to superimpose them on the sensitive material at the time the line images are made. This breaks up the line according to whatever pattern is used. The lines can thus take on the appearance of soft pencil on rough paper, of hatched lines, of dots or any other pattern that is wanted.

Texture screens, of course, can be introduced into the over-all picture if desired. Care has to be taken since light reflected from the print surface will not show the same pattern and the result can look quite artificial.

If desired, screens can be introduced only into areas having a certain color, either by making colored texture screens (green absorbing ones will appear in the green) or by using them over only one or two of the separation negatives.

It is interesting to put the shadows back in as cross-hatched areas in black on top of a zero contrast print. Occasionally it may also be desirable to introduce a similar pattern in place of one of the color records indicating the color shift by shading rather than by the actual color.

This perhaps is sufficient to indicate the breadth of variation possible. Ingenuity and patience are the requirements—and good taste!

Fine detail images

The emphasis of fine detail in a picture by the use of a diffuse contrast reduction mask was discussed earlier. By extending this technique it is

possible to abstract the fine detail of a picture and obtain this as a separate record as was done for the other characteristics. To do this it is simply necessary to make a diffuse full contrast mask. This reduces everything but fine detail to low contrast (it does not eliminate high contrast edges). It is then necessary only to print this in register with the original onto a single black-and-white film to get the separate record. This can then be printed onto the picture in any of the various ways described earlier.

If preferred, of course, the fine detail can simply be left in color using this combination instead of the strictly zero contrast as the basic color image. For some purposes the fine detail record by itself is sufficient for the picture.

A high contrast highlight mask when sharp sometimes has a tendency to reverse the contrast of fine detail in the highlights. This can be avoided by making the highlight mask slightly diffuse. Doing so, however, sometimes introduces a diffuseness to the highlights, which gives them a peculiar appearance.

Interconversion of elements

To a somewhat limited extent the various elements of the picture that we have thus taken apart may be substituted for each other. As an example, hue can be concerted into texture. Each separation negative from a zero contrast picture is printed through a different kind of a texture screen in black. The various textures overlay each other to produce a black-and-white picture in which texture has taken the place of hue. A few such interconversions will be considered below, but they are rather extreme and in any case can be multiplied and expanded by the imagination of the operator.

Hue to brightness

The conversion of hue and saturation only to brightness alone is fairly simple, although gray cannot be separated out readily. It is necessary only to make a negative from a zero contrast duplicate by any desired color of light and to print this in black and white at any desired contrast.

The brightnesses of a colored picture may be made to depend on hue in the same manner. Using a negative made as above, either this or a transparent positive of it is simply placed over the zero contrast dupe when making separation negatives.

It might be noted here that although we have been referring constantly to zero contrast pictures, actually they are not quite what the expression implies. If the white light mask is carefully made, it is true that it reduces the original to zero contrast. However, when this is printed by another color process the natural brightnesses of the dye mixtures of this process appear in the print. This means that usually the blue is darkest shading up through cyan, green, red, and orange to yellow. Fortunately this also is the natural order of brightnesses in nature and is the basis of some schemes of color harmony. It would be more accurate, accordingly, to describe the pictures as having the natural order of brightnesses of the colors substituted for the lighting and object brightnesses of the scene. This dye brightness difference is usually large enough so that a black-and-white photograph of a line and color print has considerable contrast (Figure 9–7).

Brightness into hue

A black-and-white picture can be converted into one in which hue changes represent brightness differences. A rather fully exposed highlight mask is made of moderate contrast so that when placed over the original it just neutralizes the contrasts in the highlight region. A similar shadow mask is then made from the full contrast white light negative, and a print is made of this. This print should have uniform density everywhere but in the darker areas of the original, and hence it should neutralize the contrasts in the darker part of the scale when placed over the original. By placing both of these over the original it is now possible to get a record of the only middle tones by simply exposing the combination to medium contrast material by white light. This gives a negative of the middle tones. The highlight mask exposed from the original is a negative of the highlights. The shadow print used over the original is a negative of the shadow region.

These three negatives can be used as color records in the usual manner, the dye controlled by each determining the color sequence from highlight to shadow. Thus if the highlight negative controls yellow, the midrange magenta, and the shadow cyan, the sequence from light to dark will be yellow, orange, red, dark red and black. All sequences by this technique end in black and so tend to reintroduce at least some of the brightness contrast.

This black can be avoided by using the highlight negative, the shadow positive, and a mid-range positive made by the technique for imitating solarization described earlier in this chapter under the heading "Picture

Figure 9–7. *Black-and-white photograph of a line and color derivation made from the original, which has been similarly photographed below.*

Contrast." Each of these is made to control a dye. If the process requires negatives to make a positive, then each of these must be reversed so that the final picture consists of the three as described above. If the highlights are yellow, mid-tones magenta, and shadows cyan as before, the sequence now becomes yellow, orange, magenta, blue magenta, blue, and cyan. By printing the mid-tone record as a negative (that is full density for highlights and shadows) the sequence becomes red, orange, white, bluish magenta, blue, etc. The number of combinations possible is very large. Since the different tone ranges may be made to overlap very little each matrix may be dyed with mixed dye to produce any desired color scheme.

These prints, of course, can also be combined with line images, detail images, or nearly any of the others. The difficulty in all of them, as in the whole derivation range, is to work creatively rather than accidentally. To have a final picture concept and carry it through successfully requires mastery of the medium.

We have not covered by far all the possibilities in any of the directions indicated. This would seem sufficient, however, to give some lead on the directions in which it is possible to travel.

Handwork in print processes

It is not within the scope of this work to cover all the techniques of retouching and spotting that are possible in color photography. We can, however, note some of the principles involved.

Perhaps the most difficult of all retouching problems is that of modifying a too dark area in a color positive transparency. In some processes bleaches are known that will reduce the dye densities, but they are rather unreliable and the whole problem is one for the expert with years of experience. A too light area can be modified by the skillful application of water soluble dyes.

In separation negative or color negative print processes, however, the problem is not so difficult. Color negatives can be retouched with color pencils, and separation negatives can be separately retouched as desired. A too light area in the positive can be adjusted in the positive transparency if there is one, or by spotting in the final print if the area is not too large. If a major operation on a too light area is needed, it may be advisable to make separation positives first and then negatives for the final print from these.

One possibility for major modification consists in transferring to the surface of the positive or negative an emulsion layer from the Flexichrome process. This layer can either be dyed uniformly and the dye re-

moved where not wanted, or it can be colored locally. The latter operation is simpler if the transferred layer is a negative or positive Flexichrome image in register.

The possibilities of handwork in the derivation techniques are too numerous to attempt to describe except for noting that the same principle —too light areas can be taken out of positives and too dark out of negatives. This applies particularly to the line images where lines may be added or removed with the greatest of ease. A warning might be in order, however, that although the removal of lines does not affect the appearance of the result, and is often desirable, it is exceedingly difficult to imitate the perfection of drawing given by the camera, and lines are added at the worker's risk.

Presentation of the print

As in the last chapter, it may be well to conclude with a few notes on the effect of viewing conditions on the appearance of prints. As in the case of transparencies, there is a "natural" way of viewing prints. This consists of placing them at a reasonable distance from the observer in a well lighted room containing the normal number of familiar objects. Any isolation of the print by any technique favors it in a way which may be detrimental to its success in other environments. If the print is to be completely isolated in a darkened room and separately illuminated, it might better be a transparency with its longer scale or a projected picture of more convenient size.

A color print is an object that should be seen as an object. If the photographer has been really successul in his undertaking, it should look better when seen as an object among others than under any other condition. This is seldom true of a purely realistic color print, and there is serious doubt in the writer's mind that reflection prints are a suitable medium for this kind of photography, however necessary their use may be.

A fact which, perhaps, supports this doubt is the difficulty of using a realistic color photograph as a picture to hang on the wall in a home. Such pictures are often so realistic that they almost seem appropriate only where a wall case containing miniatures of the objects would be appropriate. No such difficulty is encountered with straight color photographs in which a sincerely nonrealistic approach has been used, nor with any of the derivation prints discussed above. Most of the latter frame beautifully and are entirely satisfactory—if well done—as wall decorations.

10

PHOTOGRAPHY
AS A
CREATIVE MEDIUM

It seems appropriate here at the end of the book to consider the general problem of photography as a creative medium. In the previous chapters we have considered systematically and rather fully both the variables at the disposal of the photographer and some of the restrictions involved. We have seen that the photographer has remarkable latitude in the way he can control his medium. Almost any aspect of a photograph can be modified widely with the single exception of the accuracy or, if you prefer, the consistency, of the drawing. It would seem that a medium so flexible must of necessity permit artistic expression, if not fine art.

This final chapter is a general survey of the directions in which creative work may be done. No attempt will be made to assess their values either as art or as commercial ventures.

Amateur photography

The processes at present at the disposal of the amateur for color photography are neither numerous nor flexible. The fact that he produces pictures with little skill and that he cannot afford expensive pictures demands mass production processes. The companies offering such processes have to find the average quality best suited for the average of the group

and then hold this quality as accurately as the difficulties permit. For this reason many of the controls we have discussed are beyond the reach of amateur photographers.

This does not mean, however, that the amateur (and by this is meant the more or less casual photographer, not the noncommercial expert) neither wants nor attempts to do creative work. It is the belief of the writer that a fair share of the billion or two snapshots that are taken every year are taken with, shall we say, serious creative hopes. This is somewhat at variance with commonly accepted notions. Yet the pride with which such pictures are shown to friends cannot derive entirely from the results obtained. Furthermore, no boy ever photographed his girl without at least the hope that the picture would display her to others as he sees her. That it usually does not is neither here nor there. The essence of the creative act is to try to create. There can be no doubt that among the millions of photographers there are many who fundamentally are creative artists attempting to use this as their medium.

It is an unfortunate fact and one it is hoped may some day be remedied that the riches of the medium are not available to them in a form they can master and enjoy.

In the meantime it can only be hoped that they will read of the necessity for shadow lighting to bring up the dark side of a face in sunlight, of the importance of balance in the elements of a picture, and of seeing the picture as it is in the finder, not as they imagine it to be from what they know is out front. For photography, to change the meaning of the word a little, "creates" whether we like it or not. By the motion of a finger a new entity is produced which, when seen by an observer, gives him sort of experience of a place, a person, or what not. The chances that this experience will be similar to what he would have had on the spot are somewhat remote, but the new entity that has been created has produced an experience. Perhaps ways will be found of making a higher percentage of these experiences deliberately aesthetic. There is no reason why one day the camera may not become the means of self-expression that is latent in it.

Narrative pictures

There is one field in which this is even now becoming a reality. The use of "home movies" has created a type of photographer who is keenly conscious of his medium and its potentiality. With the example constantly before him of the art to which motion pictures can occasionally

rise, he is conscious of the ability of his camera to tell a story. Much work, of course, is involved, but simple stories simply told can and do reach very high artistic levels.

Motion pictures hold today the place once held by the story-telling picture or painting. The success of the motion picture has in fact been one of the reasons that such earlier pictures have become discredited. An immobile realism grouped to tell what is going on and little else is mute indeed compared to even a simple silent movie. The same of course can be said for the realism itself but that is a different matter.

As far as still pictures are concerned, we have to assume that story telling subjects are on the wane. This does not mean, of course, that such pictures will not continue to be made, or that none of them will be important. In some cases they can become exceedingly important, but when they are it is because their subject transcends the story. Such pictures can carry great weight with the public—can act to benefit the whole of the community. This is not because they are more powerful or better than the motion picture, however, but simply because they can be seen under any conditions and require no equipment to present. In every case a motion picture would produce a stronger and more lasting effect. It seems safe to assume that this is the natural field of the motion picture and that no other medium, even including the literature from which it derives, can compete with it.

Perhaps the most notable field in which this is experienced is not the motion picture theater, although this is example enough, but the classroom. Results can be obtained with visual education that cannot be obtained by any other technique. If it were not for the expense of their production, it seems safe to say that nearly all of our teaching would be by motion pictures rather than by present methods. The armed services were well aware of this during World War II and made good use of it in all directions and for all branches of the services. The acceleration of the learning process was well worth the price paid.

With the addition of color the narrative motion picture has gained the major part of the realism it needs for its purpose. Sound pictures in color leave only the real third dimension and odors to the imagination, and processes for introducing both have been worked out. As a matter of fact these added elements are not necessary. The feeling of reality is now sufficient for all but trivial purposes of story telling.

When motion pictures step outside their major field and offer entertainment in which the story is simply a frame on which to hang their tableaux, they still lack the appeal of real flesh and blood and are successful only as a tolerated substitute for the real thing. Perhaps stereo-

scopic color photography in motion will eventually supply this lack also. On the other hand, it is said that Roman sculpture died because it got too realistic. People felt the statues were not good because they couldn't talk. If a motion picture image can talk and looks solid but the audience knows it cannot ad lib, perhaps the same thing may happen here.

Imitative photography

Photography when it was invented was hailed as the end of painting. Many of the painters of that day (and one of the inventors of photography was a painter) felt that the exact imitation of nature was the only true aim for art. In this way they were supported by many critics and by the general public. The feeling may have originated, as some claim, in the Christian religion. Whatever its source, it was a powerful force then dominating painting. With the advent of photography with its ability to draw accurately beyond the powers of the most expert, it was natural to believe that henceforth the camera was the supreme artist. In this they seem to have been in error in two directions. First, the implied assumption that because the camera draws accurately and reproduces the light relations from objects the result will look like the scene is incorrect, as we have seen. Second, that the art produced by these great painters was due to their ability to draw and paint accurately, at best now looks like an understatement.

In any event at about this time, or a little later, painting went in other directions. Some consider this a result of the invention of photography, which had made realism unattractive as a goal, and some feel it was a natural development that would have come anyway. The fact is that the two separated sharply. Since that time it has been considered about equally reprehensible to have a painting look like a photograph or a photograph like a painting.

In spite of this photographers, intentionally or otherwise, have tended to imitate painters in much of their work. Perhaps it would be more accurate not to say that the photographers have had this tendency, but rather that the art of painting has often been used as the criterion by which photographic results have been judged.

When so considered, photography is lacking in many respects. Much of the quality of a painting is connected with the medium itself. The quality of the paint that is used in a particular area, the way it is applied, and the relationship of these characteristics to the other and perhaps differently handled nearby areas are important. In photography

there is no corresponding variation. The quality of the medium in one area tends to be much the same as that of other areas. But just as an artist finds that he does not have great freedom in this respect without destroying the unity of his result, so also is this a force for unity in a photograph. It may be necessary to use wider variations in other things—perhaps color or form—to oppose this uniformity but this does not mean the uniformity is bad, it means simply that this is one characteristic of the medium. It means that photography is different from painting and should not be considered as the same.

In a similar manner the treatment of form cannot be considered on the same basis. It is difficult to imagine a successful photograph done in the manner of some of the later Cezannes. It probably would be possible to put such a thing together but the very freedom of the treatment of edges in the paintings is the one thing for which photography is not suited. If Cezanne had achieved his results by a rigid accurate drawing, photography could probably do it better, but he did not. It should be noted, however, that all the restrictions are not on the side of photography. Some of the things present-day nonobjective artists are attempting can be done better by photography. Wherever accuracy of drawing is a requirement photography has no equal. The freedom in the matter of form and arrangement is purely a matter of ingenuity.

In many other directions photography and painting should not be compared directly. These directions fall, however, pretty much under one heading. Wherever the painter has developed a style that is dependent on his treatment of contour as opposed to simple shape or tone relation and the like, he has moved in a direction not promising for photography. Perhaps Van Gogh is a suitable example. Those to whom this kind of treatment represents the height of art will not feel that photography is an art medium. There is no reason, however, why photography should try to go in this direction or why people who prefer this in paintings should not equally enjoy a different direction in photography. The crux of the matter lies in the question of importance. Can a photographic work of art, assuming that there can be such, become as important as a painting?

As in all discussions of art, apparently, this question immediately becomes involved in the meaning of a word, this time "importance." If we take the usual meaning of the word, the answer is certainly in favor of photography. For the present generation the picture of the Marines at Iwo Jima, of Karsh's great picture of Churchill, far transcend in public importance much work generally accepted as fine art in painting. But will they for future generations?

This raises an interesting question and one to which photographers who are attempting art should give careful consideration. A painting is of necessity a single object. The fact that it can be multiplied by photography and the graphic arts and broadcast over the world does not change the fact that somewhere it exists by itself as a single creative result of which there is only one in the world. For art to be considered as great is this an important requirement?

If we look at the other arts, the answer is not promising for photography. Etching does not appear to have the place of painting and certainly hand lithography and wood block printing are not accorded the same acclaim. On second sight, however, there is question whether or not it is the media themselves at fault, rather than number of objects produced. Water color, for example, produces just as unique a result as does oil painting, yet it also would seem to hold a lesser place.

Nevertheless, there is the fact that to people not expert in the subject, there is nothing unique about a photographic print. This is unfortunate in many ways. In the first place it is not true as far as the photographer is concerned, if he is a really critical worker. Even in black-and-white work it is not unusual for the fortieth print to be the first one to satisfy the photographer. In color it is to be expected that he will be unable to produce more than a very few that are just what he wants. In the second place, the criterion does serious injustice to the whole subject of art. The pains taken to get photographs of paintings that are as nearly as possible like the paintings themselves make the criterion seem a little foolish. The question, of course, is whether the value of paintings would decrease if they could be copied accurately enough to deceive an expert. This may one day become possible. It is not impossible theoretically and would require only economic justification.

The problem for the photographer is whether he must do the same thing that the etcher has found necessary and sign a statement that he has destroyed his original and all intermediates after a certain number of satisfactory prints. It seems regrettable that a medium that, at least in principle, can make the results available to large numbers of people, should be hampered in its recognition by this very fact.

The whole matter would appear to be for future generations to decide. Some museums have already started collections of photographs. Perhaps the enormous amount of work that can go into a single color print will some day be recognized. In the meantime it seems advisable for the photographer to try to develop his own medium without too much concern for the directions found appropriate for painting.

Photography has one further handicap that makes it even less desirable

for it to attempt to imitate the other arts. It is at the bottom of nearly all objections whether the critic realizes it or not. Photography does not depend on the skill of the hands. A quick survey of all plastic processes accepted as fine art will show that all of them do depend on it. Art, in other words, has been associated for centuries with the skill of the crafts-man, however much artists may deny it. Even architecture has been a little outside the pale on this account. In fact, however, this criterion is rapidly losing its force. In a culture in which skilled craftsmanship was admired and aspired to, this naturally became a sort of ideal. In the present century with its emphasis on design rather than execution, crafts-manship is rapidly becoming an ideal of a different sort. The emphasis is changing from "I wish I could do that" to "I wish I had thought of that." Handwork now requires that it look like handwork; it must be less perfect than can be done with complex tools. The objects that are taking the place of perfect execution are those containing important new ideas or competent solutions to difficult problems. To the extent that this change continues, photography, which is primarily a medium of ideas, should benefit. The idea is the reason for existence of the photograph. All details of execution and technique must contribute to it or be false. This does not mean that the photographer cannot develop a "style." This may be necessary. It means that the style too must contribute to the subject.

Reality vs. nonreality

We have seen that the semblance of reality can be so great in a color photograph as practially to eliminate its existence as a picture. We need to inquire briefly then whether the picture as such is important to the photographer, or whether a realistic resemblance to the objects can be a creative end in itself. There are obviously many uses for photography in which as accurate a reproduction of the object as possible must be ob-tained. The question really is whether or not such photographs are creative—and if so to what extent, and whether there is such a field as "straight" photography.

One of the fields in which a serious attempt is made to have the pic-ture produce the same perceptions as the object is the photography of art objects. It is sometimes even stated that the photographs have been certi-fied by a group of experts to look like the objects.

The reader of the earlier sections of this book will realize that, at least, there is nothing "straight" about such photography. To get a result that

really looks like the object calls for a very careful study of the object and considerable knowledge of lighting and the way lighting looks in a photograph. There is no such thing as a straight photograph not affected by the photographer's decisions.

To call such an operation creative, however, would be to stretch the meaning beyond its usual sense. The attempt has been to represent what the photographer believes the object should look like and hence is more properly called an interpretation of the object. The operation involved is that of craftsmanship.

The same thing is true actually of what appears to be the most straightforward picture that can be taken, that of a two-dimensional area. The appearance of the area (whether picture or not is immaterial) still depends on the lighting. The use of polarized light, for example, may increase the saturation far beyond that normally seen. In this case there is a conventional point of view, directly in front, but mangification still can change a great deal; it may change even the color harmony involved.

We have noted that the proper medium for the accurate presentation of objects is the color transparency in a dark room. Under these conditions there is perhaps a minimum of interpretation and a maximum perception of the real object. The object itself, however, is still subject to differing appearances in different illuminations and so forth, so that even here the same facts hold. In reflection prints extraneous effects are at a maximum. Real artistry is required to produce a satisfactorily similar perception.

We could go on with further examples but it seems that we must of necessity consider all realistic photography as interpretive of the objects in the scene. Even snapshot photographs are selective in what is omitted and hence may be classed almost in the same manner.

We want, however, to consider the relationship of realistic color photography to the creative act. The essence of the creative act appears to be an attempt on the part of the photographer to create a wholly new object. Although he might conceivably do this by so modifying the appearance of an existing one that it appears like a new object, this hardly seems to come within the meaning of the term. The new object he creates is normally a **picture** rather than a presentation of an object.

If we consider pictures, then, as the objective of creative photography, we can see at once what is involved in the realistic approach. To make a picture out of objects that appear real, he must so arrange and light them that a picture results when they are photographed. This is already a familiar art approach. It is the art of Carravagio, and to the extent that art is involved rather than illusion, the whole *trompe l'oeiul* school of

painting of which Harnett is a good example. Until quite recently this sort of painting was held in low esteem simply because it was so realistic. Interestingly enough by way of a circle through modern art there has been a revival of interest in Harnett and perhaps soon of Carravagio also. Many of the modernists, whether they stop to think of it or not, are painting exceedingly naturalistically as far as the handling of the individual components is involved. So realistic are some of the approaches in fact, that, as noted, an ingenious color photographer could often do better.

We have to inquire where the art could lie in such pictures. A little thought would show that it has to lie in the arrangement, lighting and use of color and texture. In other words to produce a picture through strictly realistic reproduction, the objects themselves must be so handled in front of the camera that they become an important unity. It is not for the writer to say whether art can be produced in this fashion. He has seen some splendid examples but does not consider himself an art critic. It seems that it must necessarily be true that if truly great art can be produced in this fashion it must be one of the most difficult of all possible media in which to work. The problem is to so handle real objects that they merge their individualities into the common needs of a subject when realistically presented. If it can be done, then color photography is the proper medium.

There is a peculiar side issue of some interest to photographers involved in this problem. It is probable that a painter if he is sufficiently sensitive and a good enough draftsman, can do a better job at representing the **actual appearance** of an object than can be done by photography. The artist is under no compulsion to paint things as they actually are. He is free to make his picture give the same **observer perceptions** as does the object. If a false presentation in terms of the light reaching his eye accomplishes this end, he is justified in using it. It follows from this that the best of the trompe l'oeiul paintings should produce a greater illusion of reality than the best photograph of the same objects. Or, perhaps we might say that a painter could handle some subjects successfully which the photographer could not. We thus find ourselves interestingly opposed to popular belief, with the artist producing the greatest naturalism and the photographer producing better results in some fields of modern art.

Returning to our subject, we want now to consider the place of non-realistic approaches to photography. In this, of course, there are many degrees and we want to start moderately rather than considering the extremes.

The starkly realistic approach ordinarily uses the greatest depth of field and the sharpest image available. If part of the subject must be out of focus, it is sometimes darkened to make it less noticeable. Shadows are well lighted so that detail can be seen. In general everything possible is done to make the perception of objects easy. None of these things is necessary. Each of them is done with the intent of being realistic. To a considerable extent the photograph will lose realism as each of these characteristics is changed. Thus dark shadows, or at least shadows without detail, will sometimes tend to decrease realism. Soft focus will sometimes decrease it to the point of distorting the objects. Perhaps most important when properly handled, depth of field can be restricted to selected objects for which prominence is desired.

The aim of decreasing realism, however, is to further the unity of the subject matter. Backgrounds out of focus without a reason for being so are simply annoying. The abuse of the technique has made it difficult to have such a picture accepted popularly. When done properly such subjects as deep woodland moods and the like are greatly enhanced.

Of the many other ways in which the images may be modified to look less real the reader may take his pick from the earlier chapters. We can only repeat the warning given earlier. The modification of the image must in all cases be such that the observer does not want to see it more clearly or less distorted. The focus can be as soft as will still leave all the important details, and so on. As long as the picture has the appearance of a photograph the observer will bring to it his years of experience in looking at both pictures and objects and try to see all he feels should be present. The picture can be completely out of focus if the needs of the subject are met, as a recent revival of this technique has shown. It is the intermediate stage of half out and half in that requires careful handling.

At the extreme of treatment for a picture that still shows real forms are the derivations described in the previous chapter. Although these show realistic outlines, the extreme lack of depth and shading removes them about as far from realism as is possible while still leaving recognizable objects. Many scenes are reduced completely to flat designs. At this extreme we are probably actually in the field of design. The unity of the picture is often that of a flat area. As a technique for design, it may open up new fields not hitherto explored. It seems likely, however, that if important individual works are to be produced they will come through modifications that return at least some little depth to the pictures. Perhaps not; it is possible that through economic use of all the multitude

of variables important works of kinds not hitherto experienced may be produced. Certainly in the field of color harmony the results can be quite wonderful.

Beyond this type of picture and on into the realm of the ridiculous come the pictures that are nonobjective—like no objects ever seen. They can be produced from real objects so treated as to be unrecognizable, often a simpler feat than might be desired. They can be made by any of the nonvisual techniques, X-ray and the like, although in this we leave color photography. In the ultraviolet a color process has recently been perfected for the separation of different types of tissue in microscope slides. The color records are simply made from two kinds of ultraviolet and blue, and treated as though they were R, G, and B.

One technique, originally suggested by Barbara Morgan as a sequel to her early work with moving lights swung in front of a camera, consists of similar moving lights but variable for color to emphasize certain parts of the pattern. Mili's pictures by Picasso are well known and could have been done in color in this manner.

The nonobjective picture, by definition, follows no rules. If done by photography, it should be because the nature of photography adds something to what the artist is trying to say. It is useless to attempt to discuss this field here. Instead let us step back a little to examine some of the bypaths we have omitted in our hurried survey.

Advertising and display

A rich field for inventiveness lies in the use of color photography for purposes of advertising and display. Here the demand is for pictures that simultaneously catch the eye, are in the mode of the moment photographically, and portray something as desirable. Most of the variations that have been mentioned in this and previous chapters have been used for this purpose at one time or another. This has been discussed earlier but one element of it should be mentioned here.

In this type of work it is often desirable that one part of the picture set the mood, another display the object attractively and still other parts convey the desired message. For this purpose a mixture of different treatments is often present in what appears to be a single picture. This can often be done by skillful photography. More often, however, it is done by simply making two pictures and carefully pasting the desired part of one on top of the other. What concerns us here is the fact that such "montage" pictures are so easy to accept visually. In spite of totally different

treatments, and often in spite of the fact that the superimposed object simply floats on the other, perception takes it all in its stride with no feeling of offense. If the two mix they are seen together, if they do not one is in front of the other. If makes one wonder if there is any self-contradiction possible in a picture that perception will not translate into something rational.

Make-up

We did not discuss earlier the possibility of extensive modification of the objects in order to produce the desired picture. In this field there is the same freedom as in the montage pictures above. The object can simply be painted or colored in any way necessary to get what is wanted. One of the most frequent situations in which this is desirable comes in close-up pictures of people in color. In black-and-white work with its restriction to brightness relations and with its ease of retouching it has not been found necessary to modify the color of peoples faces. In motion pictures, however, where retouching has been impractical, make-up has been the standard rule for all the actors from the very start. It seems likely that professional color photography will have to come to it, at least for part of its work. When the requirement is a natural appearing picture of a girl, the problem is relatively simple. A good street make-up carefully applied is satisfactory for all but extreme close-ups. For these, cream base make-ups are usually needed and require some skill to apply with enough perfection. The great problem lies in the photography of men. For some reason not clearly understood but possibly only because we look closely only at a picture, men's beards show more in pictures than in real life.

In any case the beard on some men's faces needs to be lightened in some manner. Few people who have not tried it realize how difficult it is to make up a man's face and still have him look like a man—or at least the same man. The writer has no solution to this problem but it is one that may have to be faced in the near future for color portraiture.

Make-up, however, does not have to be used to make a person look like himself or herself. It can be used to accentuate or disguise features, to move the individual's appearance toward nearly any possible ideal for their type of face. If portraits in color photography are to wholly satisfy the customer without retouching, it is probable that the problem could be solved in this manner. It seems to the writer that this is not likely and that ways will be found to do the necessary handwork on the pictures.

Make-up also does not have to be restricted to people, and here we have a fruitful field with unlimited possibilities. Before the advent of simple ways of polarizing light, it used to be more or less standard practice to block out unwanted highlights on shiny objects by the use of putty and the like. Each problem has its own solution, but the photographer need have no more fear of modifying his objects to meet the needs of his subject than he does of modifying the photographic handling of the final result.

Individual style

There is one problem in photography with which the future will have to deal and that thus far we have only glanced at in passing. It might be well to state it explicitly even though little contribution can be made to the statement. With few exceptions the great painters have developed styles that stamp their works indelibly with what amounts to a signature of the artist. This has been more true, of course, of artists of the last few centuries, but there has been such a tendency at all times. One great writer on the subject has recently defined art as 'that whereby forms are transmuted into style.''

Without entering any controversy over the matter the question becomes simply, "If desirable, could a photographer develop a style so characteristic that his works would be instantly recognizable as his?" There are a great many people in the world, not particularly versed in art who can recognize some of the more characteristic pictures of van Gogh, Seurat, Degas, Renault, Riviera, or Grant Wood, just as a past generation could recognize a picture by Maxfield Parish. Not many but experts, however, can recognize a photograph even by our greatest photographers. Is this because photographers have not tried to stylize their work? Is it because the great paintings have had more publicity, which they certainly have? Or is it because it is not possible to produce such a style by photographic means? Painters do not usually refer to these characteristic differences between painters as style; they speak of them as the painter's interpretation of the subject or as expressions of the artist's personality. It would seem that in the variables discussed above there is ample room in the photographic medium for the expression of almost anything, and there seems no good reason why a photographer should not develop a recognizable style. The question is whether or not he should try to do so.

The present writer feels that the question is purely academic. The

great virture of photography is its versatility of style. Whereas an artist may find it necessary to spend many years arriving at a style, the photographer in the same time may develop very many. Is it not this very fact that is unique to photography? The style can be suited to the subject.

This carries with it, however, an interesting corollary. Because styles are by definition idiomatic, it is necessary that the observer see more than one picture in order to interpret the results. The answer could lie in the production of groups of pictures of similar subject matter and the same style. There is much evidence that in photography the group plays the part of the single painted picture by an artist whose style is known.

BIBLIOGRAPHY

Psychology of Vision

Allen, F. H., "Effects of Binocular Vision," *Science,* 94: 486–487 (1941).
Ames, A., Jr., "'Assumptions' and the Role They Play in Perception," Hanover, Institute for Associated Research, 1949.
Ames, A., Jr., "Binocular Vision as Affected by Relations between Uniocular Stimulus Patterns in Commonplace Environments," *American Journal of Psychology,* 59: 333–357 (1946).
Ames, A., Jr., "Illusion of Depth from Single Pictures," *Journal of the Optical Society of America,* 10: 137–148 (1925).
Ames, A., Jr., "Nature and Origin of Perception: Preliminary Laboratory Manual for Use with Demonstrations Disclosing Phenomena Which Increase Our Understanding of the Nature of Perception," Hanover, Institute for Associated Research, 1946–1947.
Ames, A., Jr., and K. N. Ogle, "Size and Shape of Ocular Images. III. Visual Sensitivity to Differences in the Relative Size of the Ocular Images of the Two Eyes," Archives of Ophthalmology, 7: 904–924 (1932).
Auersperg, A., "Conjugate Movements of Eyes and Visual Perception," *Zeitschrift für die gesamte Neurologie und Psychiatrie,* 165: 209–213 (1939).

Baez, A. V., "Apparent Depth and the Virtual Caustic," *American Journal of Physics,* 14: 45 (1946).
Bales, J. F. and G. L. Follansbee, "The After-Effect of the Perception of Curved Lines," *Journal of Experimental Psychology,* 18: 499–503 (1935).
Bartlett, F. C., "An Experimental Study of Some Problems of Perceiving and Imagining," *British Journal of Psychology,* 8: 222–266 (1916).

Bartley, S. Howard, *Principles of Perception*, New York: Harper, 1958.

Benson, John Roby, *An Essay on Binocular Vision*, London: Hatton, 1950.

Blackwell, H. Richard, "Brightness Discrimination Data for the Specification of Quantity of Illumination," *Illuminating Engineering*, 47: 602–609 (1952).

Blake, Robert R. and Glenn V. Ramsey, *Perception — An Approach to Personality*, New York: Ronald, 1951.

Blank, Albert A., "Axiomatics of Binocular Vision. The Foundations of Metric Geometry in Relation to Space Perception," *Journal of the Optical Society of America*, 48: 328–334 (1958).

Blank, Albert A., "Luneburg Theory of Binocular Visual Space," *Journal of the Optical Society of America*, 43: 717–727 (1953).

Boring, Edwin G., "The Gibsonian Visual Field," *Psychological Review*, 59: 246–247 (1952).

Boring, Edwin G., *Sensation and Perception in the History of Experimental Psychology*, New York: Appleton-Century, 1942.

Boring, Edwin G., "Visual Perception as Invariance," *Psychological Review*, 59: 141–148 (1952).

Bouman, M. A., "On Mutual Interaction between Both Eyes," *Problems in Contemporary Optics* (reprinted, Istituto Nazionale) Di Ottica, Arcetri-Firenze, 511–518 (1956).

Bouman, M. A. and E. W. M. Blokhuis, "The Visibility of Black Objects Against an Illuminated Background," *Journal of the Optical Society of America*, 42: 525–528 (1952).

Boynton, Robert M. and Gillray Kandel, "On Responses in the Human Visual System as a Function of Adaptation Level," *Journal of the Optical Society of America*, 47: 275–286 (1957).

Bruner, J. S., R. D. Busiek, and A. L. Minturn, "Assimilation in the Immediate Reproduction of Visually Perceived Figures," *Journal of Experimental Psychology*, 44: 151–155 (1952).

Bruner, J. S. and A. L. Minturn, "Perceptual Identification and Perceptual Organization," *Journal of General Psychology*, 53: 21–28 (1955).

Burnham, R. W. and J. Edward Jackson, "Mach Rings Verified by Numerical Differentiation," *Science*, 122: 951–953, 1955.

Carr, Harvey A., *An Introduction to Space Perception*, New York: Longmans Green, 1935.

Chalmers, E. Laurence, Jr., "Monocular and Binocular Cues in the Perception of Size and Distance," *American Journal of Psychology*, 65: 415–423 (1952).

Chapanis, Alphonse and R. A. McCleary, "Interposition as a Cue for the Perception of Relative Distance," *Journal of General Psychology*, 48: 113–132 (1953).

Cibis, Paul A., "Problems of Depth Perception in Monocular and Binocular Flying," *Journal of Aviation Medicine*, 23: 612–622; 631 (1952).

Cibis, Paul A., Siegfried J. Gerathewohl, and David Rubinstein, "Depth Perception in Monocular and Binocular Vision," Randolph Field, Texas, USAF School of Aviation Medicine, January 1953.

Craik, K. J. W., "The Effect of Adaptation on Differential Brightness Discrimination," *Journal of Physiology*, 92: 406–421 (1938).

Diamond, A. Leonard, "Foveal Simultaneous Contrast as a Function of Inducing-Field Area," *Journal of Experimental Psychology*, 50: 144–152 (1955).

Ditchburn, R. W., "Eye Movements and Visual Perception," *Research,* 9: 466–471 (1956).

Doesschate, G. Ten, "On Imaginary Space Paintings," *Ophthalmologica,* 122: 46–50 (1951).

Douglas, Anna G., "A Tachistoscopic Study of the Order of Emergence in the Process of Perception," *Psychological Monographs,* 61: 1–133 (1947).

Duncker, K., "The Influence of Past Experience upon Perceptual Properties," *American Journal of Psychology,* 52: 255–265 (1939).

Dusek, Ralph E., Warren H. Teichner, and John L. Kobrick, "The Effects of the Angular Relationships between the Observer and the Base-Surround on Relative Depth-Discrimination," *American Journal of Psychology,* 68: 438–443 (1955).

Edwards, A. S., "The Relation of Light Intensity to Accuracy of Depth Perception," *American Journal of Psychology,* 37: 300–301, 1953.

Eggert, J., "Brilliance of the Surround and its Influence on Correct Subjective Representation," *Science et Industries Photographiques,* 20: 205–206 (1949).

Emsley, H. H., "Some Notes on Space Perception," *Proceedings of the Physical Society,* 56: 293–304 (1944).

Epstein, L. I., "Space Perception and Vertical Disparity," *Journal of the Optical Society of America,* 42: 145 (1952).

Ewert, F. H., "A Study of the Effect of Inverted Retinal Stimulation upon Spatially Coordinated Behavior," *Genetic Psychology Monographs,* 7: 177–363 (1930).

Fincham, Edgar F., "The Accommodation Reflex and its Stimulus," *British Journal of Ophthalmology,* 35: 381–393 (1951).

Fiorentini, Adriana, "Foveal and Extrafoveal Contrast Threshold at a Point of a Nonuniform Field," *Atti fondazione "Giorgio Ronchi,* 12: 180–186 (1957).

Fischer, F. P. and J. W. Wagenaar, "Binocular Vision Tests," *Ophthalmologica,* 103: 129–142 (1942).

Fischer, Gloria J., "Factors Affecting Estimation of Depth with Variations of the Stereo-Kinetic Effect," *American Journal of Psychology,* 69: 252–257 (1956).

Fleischer, Ernst, "Die Physiologischen Grundlagen des Tiefensehens," *Ophthalmologica,* 122: 91–105; 172–186 (1951).

Fraisse, Paul, "La Perception comme Processus d'Adaptation: l'Évolution des Recherches Récentes," *Année Psychologique,* 53: 443–461 (1953).

Freyman, S. I., "Physiologic Norms of Depth Perception for Distance," *Vestnik Oftalmologii,* 16: 262–269 (1940).

Fry, Glenn A., "Relation of the Configuration of a Brightness-Contrast to its Visibility," *Journal of the Optical Society of America,* 37: 166–175 (1947).

Fry, Glenn A., "Relation of the Length of a Border to its Visibility," *Journal of the Optical Society of America,* 36: 713 (1946).

Fry, Glenn A., "The Stimulus Correlate of Bulky Color," *American Journal of Psychology,* 43: 618–620 (1931).

Fry, Glenn A., "Visual Perception of Space," *American Journal of Optometry,* 27: 531–553 (1950).

Galifret, Yves, "La Perception du Relief et la Projection Cinematographique," *Revue Internationale de Filmologie,* 5: 197–207 (1954).

Gibson, Eleanor J. and Richard Bergman, "The Effect of Training on Absolute Estima-

tion of Distance over the Ground," *Journal of Experimental Psychology*, 48: 473–482 (1954).

Gibson, James J., "Adaptation, After-Effect, and Contrast in the Perception of Curved Lines," *Journal of Experimental Psychology*, 16: 1–31 (1933).

Gibson, James J., "Adaptation, After-Effect, and Contrast in the Perception of Tilted Lines. II. Simultaneous Contrast and the Areal Restriction of the After-Effect," *Journal of Experimental Psychology*, 20: 553–569 (1937).

Gibson, James J., "Adaptation with Negative After-Effect," *Psychological Review*, 44: 222–244 (1937).

Gibson, James J., *The Perception of the Visual World*, Boston: Houghton-Mifflin, 1950.

Gibson, James J., "A Theory of Pictorial Perception," *Audio Visual Review*, I(1) (Winter 1954).

Gibson, James J., "The Visual Field and the Visual World: A Reply to Professor Boring," *Psychological Review*, 59: 149–151 (1952).

Gibson, James J. and Dickens Waddell, "Homogeneous Retinal Stimulation and Visual Perception," *American Journal of Psychology*, 65: 263–270 (1952).

Gilinsky, Alberta S., "Perceived Size and Distance in Visual Space," *Psychological Review*, 58: 460–482 (1951).

Goff, M. R., "A Psycho-Physical Study of Stereo Slide Alignment," *Photographic Science and Technique*, (2)3: 42–53, No. 2 (May 1956).

Gogel, Walter C., "Perception of the Relative Distance Position of Objects as a Function of Other Objects in the Field," *Journal of Experimental Psychology*, 47: 335–342 (1954).

Grant, V. W., "Accommodation and Convergence in Visual Space Perception," *Journal of Experimental Psychology*, 31: 89–104 (1942).

Gumbel, Elton J., "A Study of Depth Perception in the Light and Dark Adapted Eye," *American Journal of Optometry*, 29: 613–623 (1952).

Hardy, Le Grand, Gertrude Rand, and M. Catherine Rittler, "Investigation of Visual Space," *Archives of Ophthalmology*, 45: 53–63, 1951.

Hardy, Le Grand, Gertrude Rand, and M. Catherine Rittler, "Investigation of Visual Space," *Archives of Ophthalmology*, 45: 53–63, 1951.

Hecht, S., J. C. Peskin, and M. Patt, "Eye: Intensity Discrimination," *Journal of General Physiology*, 22: 7–19 (1938).

Heinemann, Eric G., "Simultaneous Brightness Induction as a Function of Inducing- and Test-Field Luminances," *Journal of Experimental Psychology*, 50: 89–96 (1955).

Helson, Harry and Elizabeth V. Fehrer, "The Role of Form in Perception," *American Journal of Psychology*, 44: 79–102 (1932).

Hess, C. and H. Pretori, "Messende Untersuchungen über die Gesetzmässigkeit des Simultanen Helligkeits-kontrastes," *v. Graefe's Archiv fur Ophthalmologie* 40: 1–24 (1894).

Higgins, George C. and Keith F. Stultz, "Frequency and Amplitude of Ocular Tremor," *Journal of the Optical Society of America*, 43: 1136–1140 (1953).

Hillebrand, F., "Das Verhältnis von Accommodation und Konvergenz zur Tiefenlokalisation," *Zeitschrift für Psychologie*, 7: 97–151 (1894).

Hochberg, Carol Barnes and Julian E. Hochberg, "Familiar Size and the Perception of Depth," *Journal of Psychology*, 34: 107–114 (1952).

Hochberg, J. E., "Perception: Toward the Recovery of a Definition," *Psychological Review*, 63: 400–405 (1956).

Hofstetter, H. W., "The Proximal Factor in Accommodation and Convergence," American Journal of Optometry, 19: 67–76 (1942).

Holway, A. H. and E. G. Boring, "The Moon Illusion and the Angle of Regard," American Journal of Psychology, 53: 109–116 (1940).

Hopkinson, R. G., "Assessment of Brightness: What We See," Illuminating Engineering, 52: 211–222 (1957).

Hulburt, E. O., "A Stereoscopic Effect of Snow Sparkles," American Journal of Physics, 15: 279 (1947).

Ittelson, W. H., "The Constancies in Perceptual Theory," Psychological Review, 58: 285–294 (1951).

Ittelson, W. H., "A Note on 'Familiar Size and the Perception of Depth,'" Journal of Psychology, 35: 235–240 (1953).

Ittelson, W. H., "Size as a Cue to Distance," American Journal of Psychology, 64: 188–202 (1951).

Ittelson, W. H. and A. Ames, Jr., "Accommodation, Convergence, and Their Relation to Apparent Distance," Journal of Psychology, 30: 43–67 (1950).

Karwoski, Theodore Francis and Van Voorhees Lloyd, "Studies in Vision: V. The Role of Chromatic Aberration in Depth Perception," Journal of General Psychology, 44: 159–173 (1951).

Kilpatrick, F. P., Final Report on Perception, Princeton, N. J., Princeton University, 1955.

Kilpatrick, F. P., Some Aspects of the Role of Assumptions in Perception, Ph. D. Thesis, Princeton University, 1950.

Köhler, W. and D. A. Emery, "Figural After-Effects in the Third Dimension of Visual Space," American Journal of Psychology, 60: 159–201 (1947).

Köhler, W. and J. Fishback, "The Destruction of the Müller-Lyer Illusion in Repeated Trials," Journal of Experimental Psychology, 40: 267–281; 398–410 (1950).

Köhler, W. and H. Wallach, "Figural After-Effects: An Investigation of Visual Processes," Proceedings of the American Philosophical Society, 88: 269–357 (1944).

Künnapas, Theodor M., "An Analysis of the 'Vertical-Horizontal Illusion,'" Journal of Experimental Psychology (reprinted), 49: 134–140 (1955).

Lane, H. C., "Binocular Vision and Stereoscopic Reconstitution," Photographic Journal, 90B: 2 (1950).

Lawrence, Merle, "An Inquiry into the Nature of Perception," Hanover, Institute for Associated Research, 1949.

Lay, S. D., "Brightness Patterns and Visual Fields," Transactions of the Illuminating Engineering Society (London), 16: 172–183 (1951).

LeGrand, Yves, "Les Mouvements des Yeux," Scientia (reprinted), 49: 6 (1955).

Leibowitz, H., F. A. Mote, and W. R. Thurlow, "Simultaneous Contrast as a Function of Separation between Test and Inducing Fields," Journal of Experimental Psychology, 46: 453–456 (1953).

Leibowitz, H., Nancy A. Myers, and P. Chinetti, "The Role of Simultaneous Contrast in Brightness Constancy," Journal of Experimental Psychology, 50: 15–18 (1955).

Lloyd, Van Voorhees, "The Interaction of Stimulus Area and Intensity as Cues in the Perception of Distance," Journal of General Psychology, 49: 167–183 (1953).

Lowry, E. M., "The Luminance Discrimination of the Human Eye," Journal of the Society of Motion Picture and Television Engineers, 57: 187–196 (1951).

Lowry, E. M. and J. G. Jarvis, "The Luminance of Subjective Black," Communication No. 1815, *Journal of the Society of Motion Picture and Television Engineers,* 65: 411–14 (August 1956).

Luckiesh, M., *Visual Illusions, Their Causes, Characteristics and Applications,* New York: Van Nostrand, 1922.

Luneburg, Rudolf K. *Mathematical Analysis of Binocular Vision.* Princeton, N. J.: Princeton, 1947.

Luneburg, Rudolf K., "The Metric of Binocular Visual Space," *Journal of the Optical Society of America,* 40: 627–642 (1950).

MacAdam, D. L., "Stereoscopic Perceptions of Size, Shape, Distance and Direction," *Journal of the Society of Motion Picture and Television Engineers,* 62: 271–293 (1954).

Mach, Ernst, "Über den Physiologischen Effect Räumlich Vertheilter Lichtreize," *Sitzungsberichte der Mathematisch-Natur-wissenschaftlichen Abteilung II der bayerischen Akademie der Wissenschaften zu München,* (Wien) 54: 131–144; 393–408 (1866).

MacLeod, R. B., "Brightness-Constancy in Unrecognized Shadows," *Journal of Experimental Psychology,* 27: 1–22 (1940).

MacLeod, R. B., "An Experimental Investigation of Brightness Constancy," *Archives de Psychologie,* No. 135, 5–102 (1932).

Marsh, J. E. and H. D. Abbott, "An Investigation of Afterimages," *Journal of Comparative Psychology,* 38: 47–63 (1945).

Marshall, W. H. and Samuel A. Talbot, "Recent Evidence for Neutral Mechanisms in Vision Leading to a General Theory of Sensory Acuity," *Biological Symposia,* 7: 117–164 (1942).

Morse-Peckham, R., "The Principles of Binocular Fusion and Stereoscopic Vision," Clinical Research Report, Optical Research Institute, No. 6, 1940.

Mull, H. K., K. Arp, and P. Carlin, "Indications of a Central Factor in Uncontrolled and Controlled Shifts in Cube Perspective," *American Journal of Psychology,* 65: 89–90 (1952).

Murphy, G. and J. Hochberg, "Perceptual Development, Some Tentative Hypotheses," *Psychological Review,* 58: 332–349 (1951).

Newhall, S. M., "Effects of Visual Angle on Visual Perception," *Journal of the Society of Motion Picture and Television Engineers,* 65: 273–279 (1956).

Obonai, Torao, "Induction Effects in Estimates of Extent," *Journal of Experimental Psychology,* 47: 57–60 (1954).

O'Brien, V., "Contour Perception, Illusion and Reality," *Journal of the Optical Society of America,* 48: 112–19 (February 1958).

Ogle, K. N., "The Induced Size Effect," *Journal of the Optical Society of America,* 30: 145–151 (1940).

Ogle, K. N., "On the Limits of Stereoscopic Vision," *Journal of Experimental Psychology,* 44: 253–259 (1952).

Ogle, K. N., "On the Resolving Power of the Human Eye," *Journal of the Optical Society of America,* 41: 517–520 (1951).

Ogle, K. N., "Precision and Validity of Stereoscopic Depth Perception from Double Images," *Journal of the Optical Society of America,* 43: 906–913 (1953).

Ogle, K. N., "Some Aspects of the Eye as an Image-Forming Mechanism," *Journal of the Optical Society of America*, 33: 506–512 (1943).

Ogle, K. N., "Space Perception and Vertical Disparity," *Journal of the Optical Society of America*, 42: 145–146 (1952).

Peterson, J. and J. K. Peterson, "Does Practice with Inverting Lenses Make Vision Normal?" *Psychological Monographs*, 50: 12–37 (1938).

Phemister, Margaret R., "An Experimental Contribution to the Problem of Apparent Reality," *Quarterly Journal of Experimental Psychology*, 3: 1–18 (1951).

Pirenne, M. H., "The Absolute Sensitivity of the Eye and the Variation of Visual Acuity with Intensity," *British Medical Bulletin*, 9: 61–67 (1953).

Pirenne, M. H., "Binocular and Uniocular Threshold of Vision," *Nature*, 152: 698–699 (1943).

Pi-Suñer, Auguste, "Le Relief des Images Projetées," *Année Psychologique*, 50: 359–370 (1951).

Pi-Suñer, Auguste, "The Third Dimension in the Projection of Motion Pictures," *American Journal of Psychology*, (reprinted) 60: 116–118 (1947).

Pitt, F. H. G., "The Nature of Normal Trichromatic and Dichromatic Vision," *Proceedings of the Royal Society*, B132: 101 (1944).

Pratt, C. C., "The Role of Past Experience in Visual Perception," *Journal of Psychology*, 30: 85–107 (1950).

Riesen, A. H., "The Development of Visual Perception in Man and Chimpanzee," *Science*, 106: 107–108 (1947).

Riggs, Lorrin Andrews, John C. Armington, and Floyd Ratliff, "Motions of the Retinal Image during Fixation," *Journal of the Optical Society of America*, 44: 315–321 (1954).

Riggs, Lorrin Andrews, Floyd Ratliff, Janet C. Cornsweet, and Tom N. Cornsweet, "The Disappearance of Steadily Fixated Visual Test of Objects," *Journal of the Optical Society of America*, 43: 495–501 (1953).

Ronchi, Lucia and G. Toraldo di Francia, "Response of the Human Eye to Light Stimuli Presenting a Spatial or Temporal Gradient of Luminance," *Journal of the Optical Society of America*, 47: 639–42 (July 1957).

Rose, Heinrich W., "Monocular Depth Perception in Flying," *Journal of Aviation Medicine*, 23: 242–245 (1952).

Rule, J. T., "Geometry of Stereoscopic Projection," *Journal of the Optical Society of America*, 31: 325–334 (1941).

Rule, J. T., "Shape of Stereoscopic Images," *Journal of the Optical Society of America*, 31: 124–129 (1941).

Schlosberg, H., "A Note on Depth Perception, Size Constancy, and Related Topics," *Psychological Review*, 57: 314–317 (1950).

Schlosberg, H., "Stereoscopic Depth from Single Picture," *American Journal of Psychology*, 54: 601–605 (1941).

Sheard, C., "Dark Adaptation: Some Physical, Physiological, Clinical, and Aeromedical Considerations," *Journal of the Optical Society of America*, 34: 464–508 (1944).

Shipley, Thorne, "Convergence Function in Binocular Visual Space. I. A Note on Theory," *Journal of the Optical Society of America*, 47: 795–803 (1957).

Shipley, Thorne, "Convergence Function in Binocular Visual Space. II. Experimental Report," *Journal of the Optical Society of America*, 47: 804–821 (1957).

Smith, William M., "Effect of Monocular and Binocular Vision, Brightness, and Apparent Size on the Sensitivity to Apparent Movement in Depth," *Journal of Experimental Psychology*, 49: 357–362 (1955).

Smith, William M., "Sensitivity to Apparent Movement in Depth as a Function of Stimulus Dimensionality," *Journal of Experimental Psychology*, 43: 149–155 (1952).

Smith, William M., *A Study of the Influence of Past Experience on Apparent Size and Distance*, Dissertation, Princeton University, 1950.

Spindler, Frank M., *The Sense of Sight*, New York: Moffat, Yard, 1917.

Stein, A., "A Certain Class of Binocularly Equivalent Configurations," *Journal of the Optical Society of America*, 37: 944–962 (1947).

Stratton, G. M., "Vision without Inversion of the Retinal Image," *Psychological Review*, 4: 341–360; 463–481 (1897).

Taylor, D. W. and E. G. Boring, "Apparent Visual Size as a Function of Distance for Monocular Observers," *American Journal of Psychology*, 55: 102–105 (1942).

Teichner, Warren H. and John L. Kobrick, "Effects of Viewing Distance with the Howard-Dolman Apparatus," *Journal of the Optical Society of America*, 46: 837–840 (1956).

Teichner, Warren H., John L. Kobrick, and E. Ralph Dusek, "Commonplace Viewing and Depth Discrimination," *Journal of the Optical Society of America*, 45: 913–920 (1955).

Teichner, Warren H., John L. Kobrick, and Robert F. Wehrkamp, "The Effects of Terrain and Observation Distance on Relative Depth Discrimination," *American Journal of Psychology*, 68: 193–208 (1955).

Thomson, L. D., "Stimulation of the Retina with Light Fields of Small Size," *British Medical Bulletin*, 9: 50–54 (1953).

Thouless, R. S., "Phenomal Regression to the Real Object," *British Journal of Psychology*, 21: 339–359 (1930) and 22: 1–30 (1931/32).

Van Beuningen, E. G. A., "Eine Normalkurve der Tiefensehschärfe für den Klinischen Gerbrauch," *Graefe's Archiv fur Ophthalmologie*, 148: 269–276 (1948).

Vernon, M. D., *A Further Study of Visual Perception*, New York: Cambridge University, 1952.

Vernon, M. D., "The Perception of Distance," *British Journal of Psychology*, 28: 1–11 and 115–149 (1937).

Vos, J. J., A. Lazet, and M. A. Bouman, "Visual Contrast Thresholds in Practical Problems," *Journal of the Optical Society of America*, 46: 1065–1068 (1956).

Wald, George, "On the Mechanism of the Visual Threshold and Visual Adaptation," *Science*, 119: 887–892 (1954).

Wallach, Hans, D. N. O'Connell, and Ulric Neisser, "The Memory Effect of Visual Perception of Three-Dimensional Form," *Journal of Experimental Psychology*, 45: 360–368 (1953).

Walls, G. L., "The Common-Sense Horopter," *American Journal of Optometry*, 29: 460–477 (1952).

Walls, G. L., "Factors in Human Visual Resolution," *Journal of the Optical Society of America*, 33: 487–505 (1943).

Wapner, Seymour and Heinz Werner, *Perceptual Development*, Worcester, Mass.: Clark University, 1957.

Weale, R. A., "Stereoscopic Acuity and Convergence," *Journal of the Optical Society of America*, 46: 907 (1956).

Weiner, Melvin, "The Effects of Differently Structured Visual Fields on the Perception of Verticality," *American Journal of Psychology*, 68: 291–293 (1955).

Werner, H., "Toward a General Theory of Perception," *Psychological Review*, 59: 324–338 (1952).

Westheimer, Gerald and Irving J. Tanzman, "Qualitative Depth Localization with Diplopic Images," *Journal of the Optical Society of America*, 46: 116–117 (1956).

Wilner, Burton I., F. W. Weymouth, and M. J. Hirsch, "Distance Discrimination. VIII. Influence of Red Brightness and Background Illumination in Howard-Dolman Test," *A.M.A. Archives of Ophthalmology*, 45: 523–527 (1951).

Woodworth, Robert S. and Harold Schlosberg, *Experimental Psychology*, New York: Holt, 1954.

Wright, W. D., "The Perception of Depth; The Relative Influence of the Monocular and Binocular Factors in Three-Dimensional Pictures," *Problems in Contemporary Optics*, Proc. Florence Meeting, 235–340, 1954.

Wrignt, W. D., *The Perception of Light*, London: Blackie, 1938.

Wright, W. D., "The Response of the Eye to Light in Relation to the Measurement of Subjective Brightness and Contrast," *Transactions of the Illuminating Engineering Society*, 4: 1–16 (1939).

Wright, W. D., "Role of Convergence in Stereoscopic Vision," *Proceedings of the Physical Society*, B64: 289–297 (1951).

Wulfeck, Joseph W. and John H. Taylor, *Form Discrimination as Related to Military Problems*, Washington, National Academy of Sciences—National Research Council, 1957.

Photography

Abel, Charles, *Commercial Photographic Lighting*, New York: Greenberg, 1948.

Adams, A., *Basic Photo Series, Camera and Lens* (1948); *The Negative: Exposure and Development* (1948); *The Print: Contact Printing and Enlargement* (1950); *Photography by Natural Light* (1952); *Photography by Artificial Light* (1956); *Twelve Photographic Problems*, New York: Morgan & Lester.

Archer, F., *Fred Archer on Portraiture*, 2nd ed., San Francisco: Camera Craft, 1954.

Armbruster, L. A. and W. F. Stolle, "Optimum Screen Brightness for Viewing 16mm Kodachrome Prints," *Journal of the Society of Motion Picture and Television Engineers*, 61: 248–56, No. 2 (August 1953).

Arnheim, Rudolf, *Film As Art*, Berkeley: University of California Press, 1957.

Ashton, G., *Taking Color Photographs*, London: Fountain, 1955.

Berg, W. F., *Exposure, The Fundamentals of Camera Technique*, 2nd ed., London: Focal, 1955.

Bomback, E. S., *Photography in Colours with Kodak Films*, London: Fountain, 1957.

Bond, F., *Color . . . How to See and Use It*, San Francisco: Camera Craft, 1954.

Brewer, W. L., "Important Characteristics of Color Photographic Materials," *Photographic Science and Technique* (2)3: 134–37, No. 4 (November 1956).

Chernoff, G. and H. Sarbin, *Photography and the Law*, New York: American Photographic, 1958.

Clerc, L. P., Photography: Theory and Practice, 3rd English ed., London: I. Pitman, 1954.

Dempster, N. B., "Note on 'Inverted Relief' in Photographic Illustrations," Corrosion, 11: 312–14 (July 1955).
Deschin, J., New Lighting Techniques in Photography, New York: Crown, 1953.

Estes, R. L., "Effects of Stray Light on the Quality of Projected Pictures at Various Levels of Screen Brightness," Journal of the Society of Motion Picture and Television Engineers, 61: 257–72, No. 2, Part II (August 1953).
Evans, R. M., " 'Derivations' from Colour Photographs," Penrose Annual, 45: 81–83 (1951).
Evans, R. M., "Visual Processes and Color Photography," Journal of the Optical Society of America, 33: 579–614 (1943).
Evans, R. M. and W. L. Brewer, "Observer Adaptation Requirements in Color Photography and Color Television," Journal of the Society of Motion Picture and Television Engineers, 63: 5–14, No. 1 (July 1954).
Evans, R. M. and J. Klute, "Brightness Constancy in Photographic Reproductions," Journal of the Optical Society of America, 34: 533–540 (1944).

Feininger, A., The Anatomy of Nature, New York: Crown, 1956.
Feininger, A., Feininger on Photography, Chicago: Ziff-Davis, 1949.
Feininger, A., Successful Color Photography, New York: Prentice-Hall, 1954.
Friedman, J. S., History of Color Photography, Boston: American Photographic, 1944.

Galifret, Yves, "Perception of Depth in Motion Pictures," Revue Internationale de Filmologie, 5: 197–207, No. 18–19 (July–December 1954).

Hanson, W. T. Jr. and W. L. Brewer, "Subtractive Color Photography: The Role of Masks," Journal of the Optical Society of America, 44: 129–34 (February 1954).
Hazeltine Laboratories Staff, Principles of Color Television, New York: Wiley, 1956.
Henney, K. and B. Dudley, Handbook of Photography, McGraw-Hill, 1939.
Holm, W. R. (editor), Elements of Color in Professional Motion Pictures, New York: Society of Motion Picture and Television Engineers, 1957.
Hoult, R. L., "An Approach to Wide-Angle Motion Picture Photography," British Kinematography, 30: 43–51 (February 1957).

Judge, A. W., Stereoscopic Photography, New York: American Photographic, 1935.

Klute, J., Woodland Portraits, Boston: Little, Brown, 1953.

Laylander, P. A., "Panel on Photogeology: Performance Estimate Comparing Conventional Geological Mapping with that Accomplished with the Aid of Color Photographs," Photogrammetric Engineering, 22: 853–57, No. 5 (December 1956).
Leibowitz, H., T. Bussey and P. McGuire, "Shape and Size Constancy in Photographic Reproductions," Journal of the Society of Motion Picture and Television Engineers, 47: 658–61 (July 1957).

MacAdam, D. L., "Color Balance for Television," Proceedings of the Institute of Radio Engineers, 43: 11–14 (January 1955).

MacAdam, D. L., "Perceptions of Colors in Projected and Televised Pictures," *Journal of the Society of Motion Picture and Television Engineers*, 65: 455–69 (September 1956).

MacAdam, D. L., "Quality of Color Reproduction," *Journal of the Society of Motion Picture and Television Engineers*, 56: 487 (1951) and *Proceedings of the Institute of Radio Engineers*, 39: 468 (1951).

MacAdam, D. L., "Reproduction of Colors in Outdoor Scenes," *Proceedings of the Institute of Radio Engineers*, 42: 166–74 (January 1954).

Mees, C. E. K., *Photography*, New York: Macmillan, 1937.

Mees, C. E. K., *The Theory of the Photographic Process*, 2nd rev. ed., New York: Macmillan, 1954.

Miller, O. E., "The Red-Eye Effect in Flash Color Photography," *Journal of the Photographic Society of America*, 18A: 425–26; 444 (July 1952).

Murroughs, T. R., "Depth Perception with Special Reference to Motion Pictures," *Journal of the Society of Motion Picture and Television Engineers*, 60: 656–670 (June 1953).

Newhall, Beaumont, *The History of Photography*, New York: Museum of Modern Art, 1949.

Newhall, S. M., "Effects of Visual Angle on Visual Perception," *Journal of the Society of Motion Picture and Television Engineers*, 65: 273–79 (May 1956).

Nichols, J., "Make Your Reflections Work for You," *American Photography*, 47: 71–77 (April 1953).

Oestreich, D., "Right and Left in Pictures," *Leica Photographie*, English Edition, 13–18, No. 1 (January–February 1953).

Percy, F. T. and T. G. Veal, "Subject-Lighting Contrast for Color Photographic Films in Color Television," *Journal of the Society of Motion Picture and Television Engineers*, 63: 90–94, No. 3 (September 1954).

Rackett, G. F., "The Production of Motion Pictures in Color, 1930–1954," *Journal of the Society of Motion Picture and Television Engineers*, 63: 138–40, No. 4 (October 1954).

Raxworthy, W. K., "Some Aspects of Color Perception in Viewing Color Prints," *Journal of the Photographic Society of America*, 18A: 654–56; 710–12, (November, December 1952).

Selme, P., *La Pratique de la Photographie en Couleurs*, Paris: Photo-Revue, 1955.

Smith, F., "Principles of Colour Masking. I–V," *Functional Photography*, 5: 24–6, No. 2, November; 5: 22–4, No. 3, December (1953); 5: 22–3, 25, No. 4, January; 5: 22–4, No. 5, February; 5: 22–4, No. 6, March (1954).

Sorem, A. L. and C. N. Nelson, "Spectral and Luminance Requirements for Color-Transparency Illuminators," *Journal of the Optical Society of America*, 43: 690–97 (August 1953).

Spencer, D. A., *Colour Photography in Practice*, 3rd ed., London: I. Pitman, 1948.

Troland, Leonard T., "Some Psychological Aspects of Natural Color Motion Pictures," *Transactions of the Society of Motion Picture and Television Engineers*, 11: 680–98 (1927).

von Hofe, C., "Depth of Focus in Photographic Pictures," *Optik,* 10: 389–98, No. 8 (1953).

Wall, E. G., *The History of Three Color Photography,* Boston: American Photographic, 1925.

Williams, R. G., *Lighting for Color and Form,* New York: Pitman, 1954.

Winch, G. T., "Colour Television: Some Subjective and Objective Aspects of Colour Rendering," *Proceedings of the Institution of Electrical Engineers,* 99: Part IIIa, 854–60 (1952).

Wolfe, R. N. and F. H. Perrin, "Depth of Field and Perspective Considerations in Wide-Screen Cinematography," *Journal of the Society of Motion Picture and Television Engineers,* 65: 37–42 (January 1956).

Yule, J. A. C., "Unsharp Masks and a New Method of Increasing Definition in Prints," *Photographic Journal,* 84: 321–327 (1944).

Yule, J. A. C. and R. E. Maurer, "A Simplified Posterizing Technique," *Penrose Annual,* 50: 119–20 (1956).

Color

Bouma, P. J., *Physical Aspects of Color,* Eindhoven, Holland: N. V. Philips Gloeilampenfabrieken, 1947.

Bouman, M. A., "Peripheral Contrast Thresholds for Various and Different Wavelengths for Adapting Field and Test Stimulus," *Journal of the Optical Society of America,* 42: 820–831 (1952).

Brindley, G. S., "The Effects on Colour Vision of Adaptation to Very Bright Lights," *Journal of Physiology,* 122: 332–350 (1953).

Bruner, J. S., L. Postman, and J. Rodrigues, "Expectation and the Perception of Color," *American Journal of Psychology,* 64: 216–227 (1951).

Burnham, R. W., "Bezold's Color-Mixture Effect," *American Journal of Psychology,* 66: 377–385 (1953).

Burnham, R. W., "Comparative Effects of Area and Luminance on Color," *American Journal of Psychology,* 65: 27–38 (1952).

Burnham, R. W. and J. R. Clark, "Color Memory Test," *Journal of the Optical Society of America,* 44: 658–59 (August 1954).

Burnham, R. W., Ralph M. Evans, and Sidney M. Newhall, "Influence on Color Perception of Adaptation to Illumination," *Journal of the Optical Society of America,* 42: 597–605 (1952).

Burnham, R. W., R. M. Evans, and S. M. Newhall, "Prediction of Color Appearance with Different Adaptation Illuminations," *Journal of the Optical Society of America,* 47: 35–42 (January 1957).

Burnham, R. W. and S. M. Newhall, "Color Perception in Small Test Fields," *Journal of the Optical Society of America,* 43: 899–902 (October 1953).

Clark, C. N., "The Why of White Fluorescent Lamps," *General Electric Review* 56: 15–18, No. 6 (November 1953).

Cohen, J. and D. A. Gordon, "Prevost-Fechner-Benham Subjective Colors," *Psychological Bulletin,* 46: 97–136 (1949).

Committee on Colorimetry Optical Society of America, *The Science of Color,* New York: Crowell, 1953.

Edwards, Austin S., "Effect of Color on Visual Depth Perception," *Journal of General Psychology*, 52: 331–333 (1955).

Evans, R. M., *An Introduction to Color*, New York: Wiley, 1948.

Evans, R. M., "Light Sources and Colored Objects," *Illuminating Engineering*, 44: 47–54 (1949).

Evans, R. M., "On Some Aspects of White, Gray, and Black," *Journal of the Optical Society of America*, 39: 774–779 (September 1949).

Fisher, S. C., C. Hull, and P. Holz, "Past Experience and Perception: Memory Color," *American Journal of Psychology*, 69: 546–560 (1956).

Foss, Carl E., "Color Order Systems," *Journal of the Society of Motion Picture and Television Engineers*, 52: 184–96 (1949).

Granit, R., "A Physiological Theory of Colour Perception ('dominator-modulator' theory)," *Nature*, 151: 11–14, 1943.

Graves, M., *Color Fundamentals*, New York: McGraw-Hill, 1952.

Halbertsma, K. T. A., *A History of the Theory of Color*, Amsterdam: Swets and Zeitlinger, 1949.

Halsey, R. M. and A. Chapanis, "Number of Absolutely Identifiable Spectral Hues," *Journal of the Optical Society of America*, 41: 1057–58 (December 1951).

Hardy, A. C., *Handbook of Colorimetry*, Cambridge, Mass.: Technology, 1936.

Harper, R. S., "The Perceptual Modification of Colored Figures," *American Journal of Psychology*, 66: 88–89 (1953).

Hartridge, H., *Colours and How We See Them*, London: Bell, 1949.

Helson, H., "Color and Seeing," *Illuminating Engineering*, 50: 271–78 (June 1955).

Helson, H., "Color and Vision," *Illuminating Engineering*, 49: 92–93 (1954).

Helson, H., "Fundamental Problems in Color Vision. I. The Principle Governing Changes in Hue, Saturation, and Lightness of Non-selective Samples in Chromatic Illumination," *Journal of Experimental Psychology*, 23: 439–476 (1938).

Helson, H. and V. B. Jeffers, "Fundamental Problems in Color Vision. II. Hue, Lightness, and Saturation of Selective Samples in Chromatic Illumination," *Journal of Experimental Psychology*, 26: 1–27 (1940).

Helson, H., D. B. Judd, and M. Wilson, "Color Rendition with Fluorescent Sources of Illumination," *Illuminating Engineering*, 51: 329–46 (April 1956).

Holmes, J. G., "Recognition of Colored Light Signals," *Nature*, 147: 423–424 (1941).

Hunt, R. W. G., "The Effects of Daylight and Tungsten Light-Adaptation on Color Perception," *Journal of the Optical Society of America*, 40: 362–371 (1950).

Hunt, R. W. G., "Light and Dark Adaptation and the Perception of Color," *Journal of the Optical Society of America*, 42: 190–199 (1952).

Hunt, R. W. G., *The Reproduction of Colour*, London: Fountain, 1957.

Hunter, Richard S., "The Measurement of Color and Gloss," *Product Engineering*, 27: 176–182 (1956).

Hurvich, L. M. and Dorothea Jameson, "Spectral Sensitivity of the Fovea; III. Heterochromatic Brightness and Chromatic Adaptation," *Journal of the Optical Society of America*, 44: 213–222 (1954).

Ives, R. L., "The 'Purple-ring' Illusion," *Journal of the Optical Society of America*, 32: 119–120 (1942).

Jameson, Dorothea and L. M. Hurvich, "Spectral Sensitivity of the Fovea; II. Dependence on Chromatic Adaptation," *Journal of the Optical Society of America*, 43: 552–559 (1953).

Judd, D. B., *Color in Business, Science and Industry*, New York: Wiley, 1952.

Judd, D. B., *Colorimetry*, Washington, D. C.; National Bureau of Standards, 1950.

Judd, D. B. and Kenneth L. Kelly, "Method of Designating Colors," *Journal of Research of the National Bureau of Standards*, 23: 355–85 (1939).

Judd, D. B., "Response Functions for Types of Vision According to the Müller Theory," *Journal of Research of the National Bureau of Standards*, 42: 1–16 (1949).

Judd, D. B., "Standard Response Functions for Protanopic and Deuteranopic Vision," *Journal of the Optical Society of America*, 39: 252 (1949).

Katz, D., *The World of Color*, London: Kegan Paul, Trench, Trubner, 1935.

Kelly, K. L. and D. B. Judd, *The ISCC-NBS Method of Designating Colors and a Dictionary of Color Names*, Washington, D. C.: National Bureau of Standards, 1955.

Letouzey, V., *Colour and Colour Measurement in the Graphic Industries*, translated by V. G. W. Harrison, London: I. Pitman, 1957.

Luckiesh, M., *Color and Its Applications*, New York: Van Nostrand, 1915.

MacAdam, D. L., "Influence of Color of Surround on Hue and Saturation," *Journal of the Society of Motion Picture and Television Engineers*, 57: 197–205 (1951).

MacAdam, D. L., "Influence of Visual Adaptation on Loci of Constant Hue and Saturation," *Journal of the Optical Society of America*, 41: 615 (1951).

MacAdam, D. L., "Loci of Constant Hue and Brightness Determined with Various Surrounding Colors," *Journal of the Optical Society of America*, 40: 589 (1950).

MacAdam, D. L., "Visual Sensitivities to Color Differences in Daylight," *Journal of the Optical Society of America*, 32: 247–274 (1942).

Maerz, A. and M. Rea Paul, *A Dictionary of Color*, 2nd ed., New York: McGraw-Hill, 1950.

Martin, L. C. and W. Gamble, *Colour and Methods of Colour Reproduction*, London: Blackie, 1926.

Martin, L. C., F. L. Warburton, and W. J. Morgan, *Reports of the Committee on the Physiology of Vision. XIII. Determination of the Sensitiveness of the Eye to Differences in the Saturation of Colours*, Medical Research Council Special Report Series No. 188, London, His Majesty's Stationery Office, 1933.

Martin, M. F., "Film, Surface and Bulky Colors and Their Intermediates," *American Journal of Psychology*, 33: 451–480 (1922).

Middleton, W. E. K., "Colors of Distant Objects." *Journal of the Optical Society of America*, 40: 373, 1950.

Middleton, W. E. K. and Eleanor G. Mayo, "Appearance of Colors in Twilight," *Journal of the Optical Society of America*, 42: 116–121 (1952).

Mitra, S. C. and A. Datta, "Influence of Color on the Estimation of Area," *Indian Journal of Psychology*, 14: 91–94 (1939).

Munsell Color Company, *Munsell Book of Color*, Baltimore: Munsell, 1950.

Murray, Elsie, "Alleged Cures of Color Blindness," *American Journal of Psychology*, 58: 253–261 (1945).

Murray, Elsie, "Binocular Fusion and the Locus of Yellow," *American Journal of Psychology*, 52: 117–121 (1939).

Murray, H. D., *Colour in Theory and Practice*, London: Chapman & Hall, 1952.

Newhall, S. M., "Chromatic Perceptions of Achromatic Presentations," *Journal of General Psychology*, 51: 277–289 (1954).

Newhall, S. M., "Warmth and Coolness of Colors," *Journal of the Optical Society of America*, 30: 271 (1940).

Newhall, S. M., R. W. Burnham, and J. R. Clark, "Comparison of Successive with Simultaneous Color Matching," *Journal of the Optical Society of America*, 47: 43–56 (January 1957).

Newhall, S. M., R. W. Burnham, and R. M. Evans, "Color Constancy in Shadows," *Journal of the Optical Society of America*, in press.

Nickerson, D. and S. M. Newhall, "A Psychological Color Solid," *Journal of the Optical Society of America*, 33: 349; 419–422 (1943).

Ostwald, W., *Color Science*, Part I. "Colour Theory and Standards of Colour" (1931); Part II. "Colour Measurement and Colour Harmony" (1933), authorized translation with an introduction and notes by J. Scott Taylor. London: Winsor & Newton.

Parsons, J. H., *An Introduction to the Study of Color Vision*, London: Cambridge University, 1924.

Pickford, R. W., "Binocular Colour Combinations," *Nature*, 159: 268–269 (1947).

Pickford, R. W., *Individual Differences in Colour Vision*, London: Routledge and Kegan Paul, 1951.

Pierce, W. O'D., *Reports of the Committee on the Physiology of Vision. XI. Individual Differences in Normal Color Vision*. Medical Research Council Special Report Series No. 181, London, His Majesty's Stationery Office, 1933.

Pirenne, M. H., "Limits of the Visible Spectrum," *Research*, 4: 508–515 (1951).

Priest, I. G., "Blue Sky and White Snow," *Journal of the Optical Society of America* (abstract) 13: 308 (1926).

Priest, I. G., "Gray Skies and White Snow," *Journal of the Optical Society of America* (abstract) 11: 133 (1925).

Purdy, D. M., "Bezold-Brücke Phenomenon and Contours for Constant Hue," *American Journal of Psychology*, 49: 313–315 (1937).

Richter, M., *Grundries der Farbenlehre der Gegenwart*, Dresden und Leipzig: Verlag von Theodor Steinkoff, 1940.

Schmeckebier, L., "Die Erscheinungsweisen Kleinfläschiger Farben," *Archiv für die gesamte Psychologie*, 85: 1–40 (1932).

Sloan, L. L., "Congenital Achromatopsia: A Report of 19 Cases," *Journal of the Optical Society of America*, 44: 117–128 (1954).

Spencer, D. E., "Adaptation in Color Space," *Journal of the Optical Society of America*, 33: 10–17 (1943).

Sproson, W. N., "A Determination of Subjective White under Four Conditions of Adaptation," *B. B. C. Quarterly*, 8: 176–192 (1953).

Stiles, W. S., "Basic Sensation Curves of the 3-Colour Theory," *Journal of the Optical Society of America*, 36: 491–492 (1946).

Stiles, W. S., "Mechanism of Colour Vision," *Nature*, 160: 664–666 (1947).

Stiles, W. S., "Visual Properties Studied by Subjective Measurements on the Colour-Adapted Eye," *British Medical Bulletin,* 9: 41–49 (1953).

Talbot, S. A., "Recent Concepts of Retinal Color Mechanism. I. Contribυtions from Psychophysics," *Journal of the Optical Society of America,* 41: 895 (1951).
Talbot, S. A., "Recent Concepts of Retinal Color Mechanism, II. Contribution from Anatomy and Physiology," *Journal of the Optical Society of America,* 41: 918 (1951).
Taylor, I. L. and F. C. Sumner, "Actual Brightness and Distance of Individual Colors when their Apparent Distance is Held Constant," *Journal of Psychology,* 19: 79–85 (1945).
Thompson, L. C., "A Review of Ideas on Color Perception," *Ophthalmic Literature,* 6: 3–40 (June 1952).
Thompson, L. C. and W. D. Wright, "Convergence of the Tritanopic Confusion Loci and the Derivation of the Fundamental Response Functions," *Journal of the Optical Society of America,* 43: 890–894 (1953).
Tinker, M. A., "Effect of Stimulus-Texture upon Apparent Warmth and Affective Value of Colors," *American Journal of Psychology,* 51: 532–535 (1938).

U. S. Department of Commerce, National Bureau of Standards, *The ISCC-NBS Method of Designating Colors and a Dictionary of Color Names,* Washington, D. C.: U. S. Government Printing Office, 1955.

Wallach, H., "Brightness Constancy and the Nature of Achromatic Colors," *Journal of Experimental Psychology,* 38: 310–324 (1948).
Wallach, H. and A. Galloway, "The Constancy of Colored Objects in Colored Illumination," *Journal of Experimental Psychology,* 36: 119–126 (1946).
Wassef, Elaine G. T., "Application of the Binocular Matching Method to the Study of the Subjective Appearance of Surface Colours," *Optica Acta,* 2: 144–150 (1955).
Weale, R. A., "Colour Vision in the Peripheral Retina," *British Medical Bulletin,* 9: 55–60 (1953).
Wenzel, A., "Air Light and Its Influence on the Colors of the Landscape," *Optik,* 10: 330–38, No. 7 (1953).
Wright, W. D., *The Measurement of Color,* New York: Macmillan, 1958.
Wright, W. D., *Researches on Normal and Defective Color Vision,* St. Louis: Mosby, 1947.

Optics

Ames, A., Jr., G. Gliddon, and K. N. Ogle, "Size and Shape of Ocular Images," *Archiv für Ophthalmologie,* 7: 576–597 (1932).
Ames, A., Jr., and C. A. Proctor, "Dioptrics of the Eye," *Journal of the Optical Society of America,* 5: 22–84 (1921).

Brenner, Berthold, "Note on Gloss Measurement and Tolerance of Photographic Paper," *Journal of the Optical Society of America,* 44: 494–496 (1954).

Cox, A., *The Technique of Definition,* New York: Pitman, 1949.

Gliddon, G. H., "An Optical Replica of the Human Eye for the Study of the Retinal Image," *Archiv für Ophthalmologie*, 2: 138–163, (1929).

Hammond, Harry K. and Isadore Nimeroff, "Measurement of Sixty-Degree Specular Gloss," *Journal of Research of the National Bureau of Standards*, 44: 585–598 (1950).

Hardy, Arthur C. and Fred H. Perrin, *The Principles of Optics*, New York: McGraw-Hill, 1932.

Harrison, V. G. W., *Definition and Measurement of Gloss*, Printing and Allied Trades Research Association, 1945.

Harrison, V. G. W., *Gloss*, Brooklyn: Chemical, 1949.

Harrison, V. G. W. and S. R. C. Poulter, "Gloss Measurement of Papers—the Effect of Luminance Factor," *British Journal of Applied Physics*, 2: 92–97 (1951).

Harrison, V. G. W. and S. R. C. Poulter, "Gloss of Papers," *Nature*, 171: 651 (1953).

Hayes, J. D., "Depth of Focus and Depth of Field of Photographic Objectives," *Journal of the Photographic Society of America*, 19B: 128–29, No. 3 (August 1953).

Helmholtz's Treatis on Physiological Optics, Editor, J. P. C. Southall, 3 vols. The Optical Society of America, New York, 1924–25.

Hunter, R. S., "Methods of Determining Gloss," *Journal of Research of the National Bureau of Standards*, 18: 19–39 (1937).

Hunter, R. S. and D. B. Judd, "Development of a Method of Classifying Paints According to Gloss," *Paint and Varnish Production Manager*, 19: 152 (1939).

Jenkins, F. A. and H. E. White, *Fundamentals of Physical Optics*, New York: McGraw-Hill, 1937.

Jones, L. A., "The Gloss Characteristics of Photographic Papers," *Journal of the Optical Society of America*, 6: 140–161 (1922).

Judd, D. B., "Gloss and Glossiness. A Tentative Outline of Concepts, Definitions and Terminology," *American Dyestuff Reporter*, 26: 234 (1937).

Kingslake, R., *Lenses in Photography*, New York: Garden City, 1951.

Kingslake, R., "Myths About Lenses," *Modern Photography*, 18: 52–7; 92–5 (September 1954).

Middleton, W. E. K. and A. G. Mungall, "An Instrument for the Measurement of Distinctness-of-Image Gloss," *Canadian Journal of Technology*, 31: 160–167 (1953).

Pfund, A. H., "The Measurement of Gloss," *Journal of the Optical Society of America*, 20: 23–26 (1930).

Southall, J. P. C., *Introduction to Physiological Optics*, London: Oxford University Press, 1937.

von Rohr, M., *Theorie und Geschichte des Photographischen Objektiv*, Vienna: Springer, 1899.

Wood, R. W., *Physical Optics*, 3rd ed. New York: Macmillan, 1934.

Art

Ames, A., Jr., "Depth in Pictorial Art," *The Art Bulletin*, 8: 4–24 (1925).
Ames, A., Jr., Charles A. Proctor, and Blanche Ames, "Vision and the Technique of Art," *Proceedings of the American Academy of Arts and Sciences*, 58: 1–47 (1923).
Arnheim, Rudoph, *Art and Visual Perception*, Berkeley: University of California, 1954.

Beebe-Center, J. G., *The Psychology of Pleasantness and Unpleasantness*, New York: Van Nostrand, 1932.
Beiderman, Charles, *Art as the Evolution of Visual Knowledge*, Red Wing, Minnesota, Published by author, 1948.
Berenson, Bernard, *Aesthetics and History*, New York: Pantheon, 1948. Doubleday Anchor Books, A36.
Birkoff, G. D., *Aesthetic Measure*, Cambridge: Harvard University, 1932.

Chambers, Frank P., *The History of Taste*, New York: Columbia University, 1932.
Chandler, Albert R., *Beauty and Human Nature*, New York: Appleton-Century, 1934.
Collingwood, R. G., *The Principles of Art*, London: Oxford University, 1950.

Ivins, William M., Jr., *Art and Geometry*, Cambridge: Harvard University, 1946.

Ogden, Robert M., *The Psychology of Art*, New York: Scribner's, 1938.
Opdyke, G. H., *Art and Nature Appreciation*, New York: Macmillan, 1932.

Phillips, L. March, *Form and Colour*, London: Duckworth, 1925.
Pope, A., *The Language of Drawing and Painting*, Cambridge: Harvard University, 1949.

Rood, R., *Color and Light in Painting*, New York: Columbia University, 1941.

Vivas, E. and M. Krieger, *The Problems of Aesthetics*, New York: Rinehart, 1953.

General

Adrian, E. D., *The Physical Background of Perception*, Oxford: Clarendon, 1947.
Allport, F. H., *Theories of Perception and the Concept of Structure*, New York: 1955.

Bartley, S. H., *Vision, A Study of Its Basis*, New York: Van Nostrand, 1941.
Beardslee, David C. and Michael Wertheimer, *Readings in Perception*, New York: Van Nostrand, 1958.

Cornish, Vaughn, *Scenery and the Sense of Sight*, Cambridge University, 1935.

Ellis, Willis D., *A Source Book of Gestalt Psychology*, New York: Harcourt, Brace, 1938.

Gamble, C. W., *Modern Illustration Processes*, 3rd ed., London: I. Pitman, 1950.
Granit, R., *Sensory Mechanisms of the Retina*, New York: Oxford University, 1947.

Hartridge, H., *Recent Advances in the Physiology of Vision*, London: Churchill, 1950.
Hering, E., *Grundzüge der Lehre vom Lichtsinn*, Berlin: Springer, 1920.

Kilpatrick, Franklin P., Editor, *Human Behavior from the Transactional Point of View*, Hanover, N. H.: Institute for Associated Research, 1952.
Koffka, K., *Principles of Gestalt Psychology*, New York: Harcourt, Brace, 1935.
Köhler, W., *Dynamics in Psychology*, New York: Liveright, 1940.
Köhler, W., *The Place of Value in a World of Facts*, New York: Liveright, 1938.

LeGrand, Yves, *Light, Colour and Vision*, New York: Wiley, 1957.
Luckiesh, M., *Light, Vision and Seeing*, New York: Van Nostrand, 1944.
Luckiesh, M. and F. K. Moss, *The Science of Seeing*, New York: Van Nostrand, 1937.

Minnaert, M., *Light and Colour*, New York: Dover, 1954.
Moon, P., *The Scientific Basis of Illuminating Engineering*, New York: McGraw-Hill, 1936.

Ogle, Kenneth N., *Researches in Binocular Vision*, Philadelphia: Saunders, 1950.

Parsons, J. H., *An Introduction to the Theory of Perception*, Cambridge University Press, 1927.
Pieron, H., J. Piaget, and A. Michotte, *La Perception*, Paris: Presses Universitaires de France, 1955.
Pirenne, M. H., *Vision and the Eye*, London: Pilot, 1948.
Purkinje, J. E., *Beobachtungen und Versuche zur Physiologie der Sinne*, 2, Reimer, Berlin, 1825.

Thorndike, Edward L. and Irving Lorge, *The Teacher's Word Book of 30,000 Words*, New York: Bureau of Publications, Teachers College, Columbia University, 1944.
Troland, L. T., *The Principles of Psychophysiology*, 3 vols. New York: Van Nostrand, 1929.

Walls, Gordon L., *The Vertebrate Eye and its Adaptative Radiation*, Bloomfield Hills, Mich.: Cranbrook Institute of Science, Bulletin No. 19, 1942.
Whitehead, A. N., *Modes of Thought*, New York: Macmillan, 1938.

INDEX

401

Date Due

OCT 16'63			
OCT 22 1964 DEC 17 1964			
FEB 19 1968			
FEB 2 '68			
FEB 15 '68			
MAR 19 '68			
MAY 7 '68			
𝒢ℬ	PRINTED	IN U. S. A.	